IT WAS VULGAR & IT WAS BEAUTIFUL

IT WAS VULGAR & IT WAS BEAUTIFUL

HOW AIDS ACTIVISTS USED ART TO FIGHT A PANDEMIC

JACK LOWERY

BOLD TYPE BOOKS

New York

Bold Type Books
116 East 16th Street, 8th Floor, New York, NY 10003
www.boldtypebooks.org
@BoldTypeBooks

Printed in the United States of America

First Edition: April 2022

Published by Bold Type Books, an imprint of Perseus Books, LLC, a subsidiary of Hachette Book Group, Inc. Bold Type Books is a co-publishing venture of the Type Media Center and Perseus Books.

The Hachette Speakers Bureau provides a wide range of authors for speaking events. To find out more, go to www.hachettespeakersbureau.com or call (866) 376-6591.

The publisher is not responsible for websites (or their content) that are not owned by the publisher.

Print book interior design by Amy Quinn

Library of Congress Cataloging-in-Publication Data

Names: Lowery, Jack (Writer), author.
Title: It was vulgar and it was beautiful : how AIDS activists used art to fight a pandemic / Jack Lowery.
Description: First Edition. | New York : Bold Type Books, 2022. | Includes index.
Identifiers: LCCN 2021031572 | ISBN 9781645036586 (hardcover) | ISBN 9781645036593 (ebook)
Subjects: LCSH: AIDS (Disease). | AIDS activists. | Communication in art.
Classification: LCC RA643.75 .L69 2022 | DDC 362.19697/92—dc23
LC record available at https://lccn.loc.gov/2021031572

ISBNs: 9781645036586 (hardcover), 9781645036593 (e-book)

LSC-C

Printing 1, 2022

For Mark Simpson

CONTENTS

INTRODUCTION
ANOTHER KIND OF
PROPAGANDA

THEN

Just before trading began on September 14, 1989, seven AIDS activists snuck into the New York Stock Exchange. They walked in through the Broad Street entrance, having falsified Bear Stearns badges, and filed in with the crush of brokers and traders. Underneath their two-piece suit business drag, they concealed everything needed for the morning's action: marine airhorns, two cameras loaded with high ASA film, a handwritten banner, metal chains, handcuffs without keys and wads of fake paper cash.

As those seven activists walked into the New York Stock Exchange, the AIDS crisis was entering its ninth year and showed no signs of abating. The United States would soon pass ninety thousand AIDS deaths, and without a single safer-sex initiative from the federal government, infections continued to climb. There was but one approved medication to stem the HIV virus, AZT. Though AZT sometimes provided short-term benefits, its debilitating side effects deterred many from taking it, and the drug had no long-term efficacy. There were no promising treatments on the horizon, much less a cure or a vaccine.

Inside the exchange, two of the seven peeled off and stood on the floor, readying their cameras. The other five ducked underneath a rope and climbed a staircase that led to a balcony, which overlooked the exchange's storied floor. Then they threaded their metal chains through the balcony's

spindles and locked themselves into place, in the hopes of delaying their inevitable arrests.

Then they lowered their banner, which read "Sell Wellcome," an imperative to ditch the stocks of Burroughs Wellcome, the pharmaceutical company that manufactured AZT. At the time, AZT was the most expensive pharmaceutical ever brought to market, and it was one of Burroughs Wellcome's biggest profit makers.

Seconds before the opening bell commenced trading, they pulled out their airhorns.

That day, nobody inside the exchange heard the ringing of the opening bell. If those on the trading floor didn't immediately understand the demonstration's purpose, it soon became clear. Fake ten-, twenty- and hundred-dollar bills began raining over the floor. The back of each denomination respectively read,

White Heterosexual Men Can't Get AIDS . . .
DON'T BANK ON IT.

WHY ARE WE HERE?
Because your malignant neglect KILLS.

FUCK YOUR PROFITEERING.
People are dying while you play business.

The front of each bill was unaltered, save for the treasury signature, which had been replaced with a cursive script logo, that of the artist collective Gran Fury.

Producing images, branding and rhetoric, Gran Fury's ten members described themselves as a "band of individuals united in anger and dedicated to exploiting the power of art to end the AIDS crisis." It was a collective born out of ACT UP (the AIDS Coalition to Unleash Power), a grassroots group dedicated to ending AIDS, which had begun in New York City before blossoming into a worldwide movement with almost 150 chapters.

This demonstration at the New York Stock Exchange epitomizes how Gran Fury was integral to ACT UP's efforts. Though ACT UP identified the pharmaceutical company Burroughs Wellcome as a target, and organized the demonstration itself, Gran Fury supplied much of the action's messaging, and ACT UP's successes often relied upon the sloganeering of Gran Fury's posters, stickers, T-shirts, pins and billboards. The stock exchange demonstration also shows the effectiveness of these combined efforts. Just days later, Burroughs Wellcome reduced AZT's price by 20 percent.

ACT UP is perhaps the most well-branded protest movement ever, and that's largely due to Gran Fury, whose members often thought about their work in relation to the field of advertising. To aid ACT UP's efforts, Gran Fury employed marketing concepts traditionally reserved for selling products, but to much different ends. Gran Fury's bloody handprint graphic, for example, branded one of ACT UP's most successful demonstrations, Seize Control of the FDA, which demanded the FDA overhaul its approval process for HIV and AIDS medications. Through posters and T-shirts worn by ACT UP's members, Gran Fury's bloody handprint became ubiquitous that day, and through the day's press coverage, millions of people ultimately saw it.

Though Gran Fury was rarely credited in these sorts of photo ops, the collective's work constantly appeared in news coverage of the crisis and became a conduit by which ideas germinating in ACT UP permeated the world. Ideas that many of us now take for granted, like nationalized healthcare being a human right, were popularized through the work of Gran Fury before assuming a more widespread acceptance.

Initially, Gran Fury relied upon the press, and particularly photojournalists, to disseminate their work to a wider audience, as they did with the bloody handprint at the FDA action. But after their initial successes, Gran Fury began to place their work in spaces reserved for more traditional advertisements: billboards at Manhattan's busiest intersections, advertisements in New York City subways, buses in America's major cities, television commercials and magazines. During its years-long campaign lobbying the Centers for Disease Control and Prevention (CDC)

to recognize HIV in women, ACT UP even purchased a full-page ad in the *New York Times*, proclaiming one of Gran Fury's best-known slogans: *Women don't get AIDS, they just die from it.*

Advertising was a visual language that Gran Fury could easily mimic, as several of its members worked in advertising or as art directors. *Kissing Doesn't Kill*, one of Gran Fury's signature projects, is perhaps the best example of this, as it was frequently mistaken for an actual Benetton advertisement, the clothing company whose work Gran Fury had purposefully copied.

But Gran Fury also borrowed from advertising's motives. Rather than making work to sell a product, Gran Fury hawked ideas, swayed minds and shifted perceptions about AIDS. Though Gran Fury officially called itself an art collective, its members more often described their work as propaganda, a form that shares many of advertising's methods and goals. I suspect that they publicly characterized their work as art, in part, because Gran Fury eventually began to court the financial support of museums and arts institutions, to place their work in these more commercial spaces, and it's hard to imagine the Whitney Museum funding a group of self-avowed propagandists.

Of course, propaganda has an insidious connotation because of its association with authoritarian regimes, and there is an understandable aversion to making or celebrating it. But the story of Gran Fury invites us to reconsider this, as not all propaganda is alike. In his book *How Propaganda Works*, the philosopher Jason Stanley argues that there is a kind of propaganda that can even repair democracy, what he calls "civic rhetoric." When a marginalized or disenfranchised group of citizens does not have an equal say in their government and the creation of its laws, Stanley argues, civic rhetoric is one of the few ways in which they can reclaim power.

I promise you that this is not an academic book on civic rhetoric, and that Stanley is the last philosopher I will quote in these pages. Rather, this book tells a story that elucidates this concept, a story that I think will be more useful (and hopefully more fun) than studying civic rhetoric in the abstract, as Gran Fury is a live example of what civic rhetoric looks

like, how it's made and what it can do. This is also a story of civic rhetoric's limitations. Gran Fury embodies that too.

Any kind of propaganda requires believers to carry its message, and in the case of Gran Fury, this was often done by ACT UP's members. Gran Fury often received the information for their posters from other groups within ACT UP, and Gran Fury similarly relied upon thousands of other ACT UP members to disseminate their work. What often made Gran Fury so effective was that scores of people would hold the same sign, wear the same pin or don identical T-shirts. Gran Fury's *Read My Lips*, a T-shirt of two kissing sailors produced to combat homophobia, is such an iconic image only because ACT UP's membership made it so ubiquitous. Shirts like this visually identified ACT UP and gave ACT UP a visual cohesion. What an army gains from its uniform, ACT UP drew from Gran Fury.

But propaganda also assumes that there are people who need to be swayed, whose minds need to be changed, and this was often Gran Fury's audience. Gran Fury sometimes worked to elicit outrage, or to coerce its viewers into action. But just as often, Gran Fury's work advocated that you adopt or dismantle a particular mindset, perspective, assumption or worldview. Instead of thinking X, we want you to think Y. Often, Gran Fury tried to dispel notions that were a hindrance to ACT UP's efforts or bolster ideas that underpinned ACT UP's demands. An example of this is Gran Fury's *All People with AIDS Are Innocent*, which first appeared as a poster and was later repurposed as a banner that was hung in the United States and Europe. At the time, hemophiliacs and children with HIV were often described as the "innocent victims" or "most innocent victims" of AIDS. Those delineations suggest that some people are more deserving of AIDS than others, which was anathema to ACT UP's notion that people with AIDS deserve healthcare, not blame. The only demand of *All People with AIDS Are Innocent* is that you think differently about people with AIDS: instead of assuming that there is a hierarchy of guilt predicated on how someone contracted HIV, think of someone's HIV status without any moral implication, that no one is more deserving of this disease than another.

Both art and propaganda force ideas onto their viewers (or listeners, or readers). But the distinction between art and propaganda, or at least, how I delineate between those terms here, is that propaganda has a more predetermined outcome that it tries to elicit. The overarching goal of Gran Fury's propaganda was to actualize a better world for queer people and people with AIDS. Often, their work addressed the federal government, but that wasn't always the case. For example, they produced a fake front page of the *New York Times*, which they wrapped around actual copies of the *Times* that had been distributed throughout Manhattan. It showed what more informed and comprehensive news coverage of AIDS would look like, but just as importantly, it imagined a world where the media reflected the lives of queer people and people with AIDS, rather than ignoring them.

Making this kind of work was not without risk or consequence. At the 1990 Venice Biennale, Gran Fury provoked outrage over their criticism of the pope's reluctance to admit that condoms and clean needles prevent the spread of HIV. Seven of Gran Fury's members were almost arrested and charged with "blasphemy," an actual crime that still carries a hefty prison sentence in Italy.

Aided by Gran Fury, the cumulative efforts of ACT UP brought about one of the most staggering shifts in the history of medicine, in part by lobbying the federal government to expand its budget for AIDS research. At multiple points in the pre–ACT UP years of the crisis, the Reagan administration actually tried to reduce the budget for AIDS research, despite the fact that the number of Americans dying of AIDS was doubling or tripling every year. Those kinds of cuts were unthinkable once ACT UP became a constant presence in American life. In the pre–ACT UP years of the crisis, 1981 through 1986, the federal government cumulatively spent a quarter of a billion dollars on AIDS research, and that was spread over six years. By 1991, at the height of ACT UP's influence, the federal government was spending almost a billion dollars on AIDS research every single year. The National Institutes of Health (NIH) quadrupled its budget for AIDS research in the first three years of ACT UP's existence. And those in power understood that there was a direct

correlation between ACT UP's efforts and this increase in spending. "The more you're demonstrating," Anthony Fauci once told an ACT UP member, "the more money I'm going to get to work with."

That kind of shift didn't come from a single demonstration or group within ACT UP. It came from years of cumulative work, though it wasn't until the mid-1990s that these efforts fully came to fruition.

That increase in spending helped bring about a new wave of treatments called protease inhibitors, which make it possible to live a full life with HIV. Back in 1987, when ACT UP formed, people who tested HIV-positive were often told that they had two years to live. Because of protease inhibitors, the life expectancy for an HIV-positive American is now just two years short of an HIV-negative counterpart. By the time protease inhibitors came to market, fifty thousand Americans were dying of AIDS every single year, a number that surely would have continued to rise without this intervention. When protease inhibitors came to market, the number of American AIDS deaths decreased for the first time in the history of the epidemic, and it has continued to decrease ever since. Worldwide, over twenty million people now take this lifesaving HIV drug that ACT UP's efforts helped bring to market.

ACT UP undeniably changed the world. And yet, it was a relatively small group. ACT UP's largest demonstration fielded around five thousand people, a number that pales in comparison to other movements in American history. Demonstrations for enacting civil rights and ending the Vietnam War drove hundreds of thousands of Americans to Washington, DC. The Climate Strike, March for Our Lives, iterations of the Women's March and the protests to oust Puerto Rican governor Ricardo Rosselló all had over a million attendees. Up to twenty-six million Americans participated in demonstrations following the murder of George Floyd and the slew of other Black lives lost.

Any book about ACT UP must then try to explain how such a small group of people so drastically shaped the world in which we now live. And one undeniable factor is the work of Gran Fury.

◎

This book tells a story that has been constructed through archival research, interviews and the writing of others. Of Gran Fury's ten members, nine outlived the worst years of the AIDS crisis, and all nine agreed to be interviewed for the purposes of this book. Mark Simpson, who died in 1996, was the only core member of Gran Fury who wasn't interviewed, but in the last years of his life, Simpson began work on a memoir, mostly of his childhood and young adult years in Texas. His memoir was unfinished at the time of his death and has not been published, but his sister, who is the executor of his estate, allowed me to draw from it. Another of Gran Fury's members, Avram Finkelstein, has also written about his own life and activism, most extensively in his book *After Silence*. I also interviewed about fifty living ACT UP members and relied upon interviews conducted by other individuals, most notably the ACT UP Oral History Project, organized by Sarah Schulman and Jim Hubbard. Gran Fury's archive is held by the New York Public Library (NYPL), and both the Lesbian Herstory Archives and the NYPL have archived ACT UP's materials and ephemera, including transcripts of meetings with government officials, internal memos, financial statements and meeting minutes.

This book's title actually came out of one of my interviews. One of Gran Fury's members, Donald Moffett, and I were talking about other depictions of ACT UP—what other books and documentaries had either captured or misrepresented. I had expressed my dissatisfaction with other depictions of ACT UP, that too often we've received a PG-13'd version of the actual movement, and suggested that "what made ACT UP so effective was that it was kinda vulgar and raunchy." Moffett agreed, with one qualification. "I think the only thing that you're misstating is the 'kinda,'" he replied. "It *was* vulgar. It was all those things. It was vulgar and beautiful."

In these pages, the first member of Gran Fury you will meet is Finkelstein, whose journey toward AIDS activism began after he lost the person who he thought would be his soulmate. Finkelstein's story, though harrowing, was also common. Half of Gran Fury's members lost their partners to AIDS, and all of them lost close friends. Seeing all of this, most of Gran Fury's members lived with the constant dread that they

too would die of AIDS. This was felt most acutely by the members who knew or suspected that they were HIV-positive, but much of Gran Fury, regardless of their status, experienced this dread on some level.

Beyond the loss of those individuals, all of them experienced the wider loss of an entire community. Though it was painful to lose a partner or a best friend, it was often just as traumatizing to watch the constant deterioration of colleagues, coworkers, fellow activists, artistic collaborators, friends and people they saw around their neighborhoods but whose names they didn't know—the guy at the coffee shop or the person at the pharmacy. Like much of their generation, the members of Gran Fury spent their twenties and thirties going to funerals, often weekly but sometimes more.

This is a book about how ten people confronted that reality. The first act chronicles Finkelstein's attempts at working with a collective predating Gran Fury, the beginnings of ACT UP and the opportunity that launched Gran Fury. Act two, the book's longest, begins with Gran Fury's first poster and ends with the last projects to which all of its core members contributed. Their first poster wasn't very good, and much of their work wasn't successful. In their oeuvre, there are as many duds as there are smash hits. This is a story about both, about the work that has become iconic and the work that is largely forgotten, because both are integral to understanding how Gran Fury effected change. Gran Fury dissolved before the advent of protease inhibitors, but their work outlived the collective itself, and many of its members continued their AIDS activism. The book's final act traces Gran Fury's slow dissolution, how a few of its members completed one final poster and how the advent of protease inhibitors both did and did not change the AIDS crisis and the lives of Gran Fury's members.

NOW

During the height of Gran Fury's output, its members often lamented that they had no way of knowing whether their work was having any effect. Marketers often confront a similar predicament: "Half the money

I spend on advertising is wasted," goes the old marketing maxim. "The trouble is I don't know which half."

But from the vantage of today, it's clear that Gran Fury's work has had an incredible impact. Underpinning all of ACT UP's efforts was a belief that public policy and personal health are inextricable, a perspective that's now largely taken for granted. While this attitude may no longer seem novel, it once was. During the AIDS crisis, politicians like Senator Jesse Helms would vehemently oppose federally funded safe-sex campaigns but claim that people living with AIDS "got sick as a result of deliberate, disgusting, revolting conduct." This statement not only characterizes the period's blatant homophobia but also embodies an attitude that divorces government policy from the public's well-being. Personal health is a matter of political consequence, not just individual habits: that perspective, which was integral to ACT UP's efforts, filtered into the world, in no small part through the work of Gran Fury.

ACT UP and Gran Fury did not invent the idea that our government plays a significant role in the health of its citizens. While the mantra "healthcare is a human right" originated in ACT UP, and was popularized as a chant at ACT UP's demonstrations, ACT UP was not the first to argue something in this vein.

But Gran Fury did manage to give these ideas a more public platform in American life, thus encouraging a more widespread acceptance. To accomplish this, Gran Fury afforded no ambivalence in its messaging: "The government has blood on its hands," reads one of their posters. Another rhetorically asks, "When a government turns its back on its people, is it civil war?" Now thirty years old, these posters could easily be commenting upon one of America's growing public health crises. Indeed, during the 2018 midterm elections, Gran Fury's original *Welcome to America* billboard was resurrected in Norfolk, Virginia, a city straddling two congressional districts, one of which Democrats wrestled from Republican control in that election. When Gran Fury first mounted the billboard in 1989 it read, "Welcome to America, the only industrialized country besides South Africa without national healthcare." To update the billboard for 2018, Gran Fury only had to omit the qualifier reading "besides South Africa."

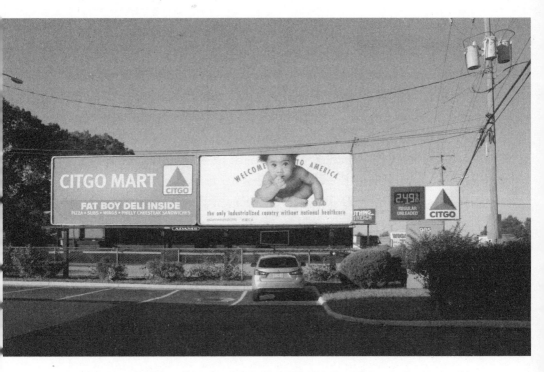

Welcome to America, Gran Fury, 2018. Photograph courtesy of Gran Fury.

Like *Welcome to America*, much of Gran Fury's work would require little alteration to comment on one of our growing health crises, as the collective's work prefigures many of our current attitudes toward public health. Looking at online versions of Gran Fury's *Kissing Doesn't Kill*, across the bottom of the poster, you'll see the phrase "Corporate greed, government inaction and public indifference make AIDS a political crisis." But this was not how it first appeared, as the project's funder censored this rejoinder text, worried it might upset their corporate sponsors.

If you doubt the consequence of Gran Fury's work, take the rejoinder text of *Kissing Doesn't Kill* and replace the word "AIDS" with one of America's other public health crises, like the opioid crisis or the COVID-19 pandemic. If that statement sounds obvious or intuitive, it's in part because of the groundwork laid by Gran Fury. To examine their work is to follow the choices that got us here.

◎

TOMORROW

The past success of Gran Fury's work, along with its current influence, inevitably raises a question about how their work might serve as a model in the future. This was something that often arose in my conversations with Gran Fury's members, the most memorable example being my second interview with Moffett, who brought up the writing of author and activist Naomi Klein. Toward the end of her book *On Fire: The (Burning) Case for a Green New Deal*, Klein puts forward a seemingly counterintuitive proposition: that art could be integral in bringing about the kind of radical change necessary to avert a climate catastrophe. Ambivalent about the proposition, Moffett gave it a "maybe" but was interested nonetheless. "Art Is Not Enough," reads one Gran Fury poster, and it's true: paintings cannot repair the irreparable damage done to the Great Barrier Reef, nor can songs halt rising sea levels.

Climatologists have concluded that we need to embrace "rapid foundational changes to transportation, housing, energy, agriculture, forestry, and more" in order to preserve the planet. What inhibits this from happening, Klein argues, is that too many people doubt that such change is possible or worthwhile. "The biggest obstacle to the kind of transformative change that the Green New Deal envisions is not that people fail to understand what is being proposed," she writes. "It's that so many are convinced that humanity could never pull off something at this scale and speed." The pessimism of some who believe in climate change is just as detrimental as those who deny it outright. A mass shift in public opinion is necessary if we are to avoid a climate catastrophe, and Klein notes that these sorts of changes have often begun in art.

Klein points to the original New Deal to convey how art has previously been used to sway public opinion. The New Deal envisioned well-paying construction jobs that could repair the country's infrastructure while boosting the economy and ending the Great Depression. These sorts of "hand up, not hand out" programs were coupled with increased banking regulations, in the hopes of avoiding another depression spurred by the financial sector. In retrospect, these sorts of solutions may seem obvious

and necessary. But at the time, Republicans dismissed these programs as fascist or tyrannical, and Klein notes that centrists cautioned about moving too quickly. Visual art, literature and music thus became an integral part of convincing the public that these sorts of programs were, in fact, essential and urgent.

In addition to infrastructure jobs, affordable housing and banking regulations, the original New Deal also included public arts programs, such as the Federal Art Project, the Federal Writers' Project and the Federal Music Project. Not all of the artwork funded by these programs was explicitly political. Some of it simply provided a respite from the dismal realities of the Depression. But much of this publicly funded art demonstrated the need for the kinds of government relief programs envisioned in the New Deal, and that this kind of relief was necessary and urgent, possible and humane. As Klein notes, "The power of art to inspire transformation is one of the original New Deal's most lasting legacies," and she concludes that, in the same way, art could now be used to convince the public that avoiding a climate catastrophe is both necessary and possible.

Part of the problem, as Klein sees it, is that this kind of shift, precipitated by art, "is not something for which most of us have any living reference," and that we have to look back to the New Deal for precedent. But I don't think we need to look so far back. What I hope this book demonstrates is that Gran Fury could serve as a model for the kind of change that Klein is describing, one in which art (or propaganda) made by ordinary citizens precipitates a mass shift in public opinion.

Maybe the most important lessons from Gran Fury aren't about AIDS explicitly, or even about pandemics, but rather about the ability for this kind of work to sway public opinion, to shape our attitudes and to change our worldviews. The need for this kind of work has only become more apparent with the crisis of COVID-19 and the failure of the public health campaigns surrounding it. As I write this, the United States currently has a surplus of COVID vaccine doses, and yet the pandemic is not over, largely because so many people refuse to get vaccinated. For all the scientific ingenuity that went into producing and distributing a vaccine, science alone is not going to end this pandemic.

I think what's now needed, more than science, is work like that of Gran Fury, work that changes minds and shapes people's attitudes. We need more than just campaigns to encourage vaccination. We need work that addresses the underlying reasons for why so many people continue to refuse a public health measure that is proven to be effective and safe. We need images that better people's relationship to science, that mold their sense of civic responsibility, that better shape their ideas of freedom and choice. It's harder work, but necessary. Gran Fury isn't just an example of how ordinary citizens have done this in the past. It's also a reminder of how badly this kind of work is needed now.

A ROSTER OF GRAN FURY'S MEMBERS, IN THE ORDER THAT THEY APPEAR

Avram Finkelstein: Self-described Machiavellian propagandist. Hairdresser and art director.

Mark Simpson: A Texan and the consummate southerner. Painter and construction worker.

Michael Nesline: A cab driver who became a nurse in an AIDS ward. Has a reputation for being vicious with his words.

Donald Moffett: Gran Fury's other Texan. Was once described as "the nice one in Gran Fury." Graphic designer and artist.

Tom Kalin: Chicagoan and Gran Fury's youngest member. Ambitious video artist and self-described motormouth.

John Lindell: The only Gran Fury member who has ever been described as quiet or reserved. Architect and artist.

Marlene McCarty: Kentucky born and Swiss educated. Showed the Gran Fury guys how to design graphics on a computer. Graphic designer and artist.

Loring McAlpin: Gran Fury's resident WASP. Photographer and artist.

Robert Vazquez-Pacheco: Manages the local buyers club. Initiates and welcomes new ACT UP members. Is often the public face of Gran Fury.

Richard Elovich: A playwright who became a scientist. One of Gran Fury's native New Yorkers.

ACT I

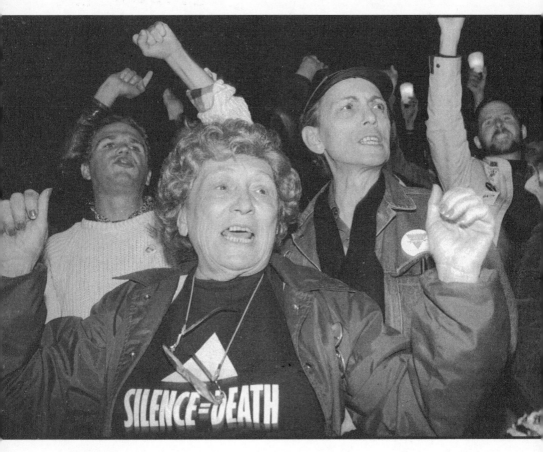

Photograph by T. L. Litt.

CHAPTER 1
OUT OF SILENCE

The closet is turning into a coffin.
 —Avram Finkelstein's journal, 1986

he first time that he met his in-laws, Don Paul Yowell struck a high fever. Yowell and his boyfriend, Avram Finkelstein, had been spending the weekend with Finkelstein's parents out on Long Island. As they slept on the living room floor, Finkelstein woke to this familiar sight. It wasn't the first time that Yowell's temperature had spiked in the middle of the night. And like all the others that had preceded it, Yowell's fever came in the night and broke before morning.

The next day, as Finkelstein washed the breakfast dishes with his mother, he broached the subject of Yowell's health. "He has these fevers," he told her. "They come and go." But the night fevers were just one symptom in a constellation of maladies. "He has sinusitis," he added. "No one can tell what it's from—they treat him, it comes back." There were skin issues too. For the past two years, all of Yowell's ailments had followed this pattern: a doctor would treat him and the ailment would subside, but inevitably it returned.

Finkelstein's mother, a biomedical research scientist, thought that it might all be related. "There's something wrong with his immune system," she hypothesized.

This was the moment that Finkelstein started to worry seriously about Yowell's health. It was 1982, and for years now, they had been hearing about a puzzling disease spreading throughout New York City. "Everyone in New York knew about it," recalled Finkelstein, though Yowell worried about it much more than Finkelstein had. It had been dubbed the "gay cancer" by the *New York Native*, the nation's largest gay newspaper. Even the *New York Times* had run an article the previous year describing a "Rare Cancer Seen in 41 Homosexuals." The Centers for Disease Control and Prevention (CDC) first called it GRID (gay-related immune deficiency or deficiencies), which they described as a network of health problems stemming from "the gay lifestyle." It was also briefly referred to as the 4-H virus, propelling a myth that only four "H groups" could contract the disease: hemophiliacs, homosexuals, heroin users and Haitians. Its name seemed to always be changing. People didn't even know what to call it, let alone how to talk about it.

Soon after the visit to Finkelstein's parents, another fever struck Yowell, this time with shortness of breath. Yowell was a cabaret singer and songwriter and had neither health insurance nor a regular doctor. So Finkelstein called an ambulance, which took him and Yowell to Bellevue Hospital. They soon learned why Bellevue had a reputation for being a snake pit. First, they were told that Yowell could see a doctor in the morning, but then one never came. Yowell finally secured a room, but the orderlies refused to enter it and opted to leave his food in the hallway. An earlier patient's blood had pooled underneath Yowell's bed, and the nursing staff left Finkelstein and Yowell's sister to clean it up themselves. "I literally went into the nurses' station and started screaming at them," recalled Finkelstein. In retrospect, it seems as if the hospital staff had recognized Yowell's symptoms before any of the doctors officially diagnosed him.

After days of waiting for a doctor, one finally visited Yowell. He diagnosed Yowell with having pneumocystis pneumonia, a life-threatening lung infection; this confirmed that Yowell's immune system was indeed

compromised, as Finkelstein's mother had speculated. The attending doctor then diagnosed Yowell with a disease that had only recently been named AIDS (acquired immunodeficiency syndrome). It was the first time Yowell had ever heard it by that name.

Only a few hundred AIDS cases had been reported nationwide when Yowell received this diagnosis. A test for the virus was still years away, so no one could be sure if Yowell had it, but it seemed certain, given that Yowell's symptoms matched a growing number of cases in the New York City area. Without any medications available, being diagnosed with AIDS was an almost certain death sentence.

Yowell stayed in the hospital until his congestion cleared and the fever subsided. On their way out, Finkelstein and Yowell rode in an elevator with an orderly. When the doors opened and someone else tried to enter the elevator, the orderly raised his hand, gesturing for them to take the next one.

These were the earliest days of the epidemic, and without any clear information about its transmission, many worried about the possibility HIV was airborne. What little information did exist was often contradictory. When Yowell received his diagnosis in 1982, the CDC denied that the virus could be transmitted sexually while also maintaining that homosexuals had a greater chance of contracting the disease. Rumors about the virus's origins and modes of transmission supplanted real facts. Some scientists blamed poppers, an inhalant drug popular at gay nightclubs, as being the source. No one was sure if it came from a single exposure or repeated ones. Only Yowell was leaving the hospital with a diagnosis, but Finkelstein felt as if he had received one too.

Yowell was intensely secretive about having AIDS. He made Finkelstein swear to not tell anyone, reasoning that he wouldn't be invited on tours if other musicians knew. Nonetheless, this diagnosis effectively ended what had once been a promising songwriting career for Yowell. In 1981, just as he had begun to show signs of immunosuppression, Yowell had cowritten a song for Aretha Franklin, "There's a Star for Everyone." Thereafter he had begun finding steady work as a songwriter, with musicians like Luther Vandross. All of that came to an end with his AIDS

diagnosis. One of his former collaborators recalled that Yowell "just disappeared."

Besides his family and Finkelstein, Yowell only let two people know about his condition: Peter and Chris Lione, an eccentric pair of gay brothers who had once lived in the same building as Yowell. Before introducing Finkelstein to the Lione brothers, Yowell described them as being "like lunatic nuns, only hilarious, and they fight bitterly, like spouses." The Lione brothers shared an apartment, in what would now be called TriBeCa. Peter said their rent was $240 a month, with utilities. Chris *insists* that it was $260. What's even more indicative of the era is that their building was subsidized, because nobody wanted to live in TriBeCa back then. Their living situation exacerbated their polarities. "I would come home at eight o'clock in the morning from some disgusting after-hours bar," Chris recalled. "And find Peter, in his robe, vacuuming." Though Yowell told only Peter that he had AIDS, there was an implicit understanding that Peter would tell his brother, and no one else.

For Chris Lione, Yowell encapsulated the late seventies in New York: the half decade that was post-Stonewall and post-Vietnam, but pre-AIDS. Yowell didn't seem to have any inhibition about being openly gay, something Chris Lione found fitting for the times. "Donnie was a popular boy," Chris recalled. "He was cute, he was springy, and he was totally free. If he found someone attractive in a restaurant, he'd just walk up to them and say, 'You're really darling. Can I give you my number?'" After Yowell learned that he had AIDS, it seemed to Chris that the late seventies had come to an end. "Everything changed," he recalled: everything in Yowell's life had changed, and the world in which they had lived now seemed to be disappearing.

Soon after Yowell was discharged from Bellevue, his pneumonia returned. Instead of returning to Bellevue, Yowell asked Finkelstein to take him to a hospital in New Jersey, wanting to be closer to his family and hoping that another hospital might offer more humane treatment. Yowell then moved out of the apartment he shared with Finkelstein and into his parents' house in New Jersey, where he shuttled in and out of the hospital for the rest of his life.

The Yowells had always been accepting of their son's sexuality. In high school, he had openly dated a football player, daring for someone in his suburban New Jersey town. Chris had had the opposite, and more typical, experience for their generation. He had to leave high school after his freshman year because he had been bullied so terribly for being gay.

When the Yowells first met Finkelstein, they greeted him warmly. "They seemed to clamor for me," Finkelstein recalled. "As if they'd been waiting for me their entire lives." The Lione brothers and Finkelstein had always been welcome at the Yowell household, even for family dinners, where they might have somewhere between three and six different pasta shapes cooking on the stove.

But after Yowell learned that he had AIDS, his family began to treat Finkelstein and the Lione brothers alike with suspicion, and even outright hostility. The Yowells were especially cold to Finkelstein, Chris Lione recalled, and if Finkelstein spoke, the Yowells would often ignore whatever he had said. "Within months," Finkelstein noted, "I went from the inner circle to being the sole focus of waiting room screaming matches."

During one of these screaming matches, Yowell's mother revealed why the family had begun to treat Finkelstein with such hostility. She accused Finkelstein of infecting her son with the virus that had now consumed his life. A test for HIV wouldn't be available for years, and when Finkelstein finally did get tested, his results came back negative. But by then, Yowell had been dead for years and Finkelstein hadn't spoken to the Yowell family in just as long.

Finkelstein and the Yowell family had very different ideas about how Yowell should be treated. The Yowells had a family friend who was a natural healer and began giving him herbal remedies. After this healer prescribed him a garlic and olive oil mixture, Yowell took to chewing whole garlic cloves, and Chris Lione recalled that, during the last years of his life, Yowell's breath always reeked of garlic. "We all were in denial," he said. "We all believed in any hocus pocus that anyone came up with." Yowell began to restrict his diet and stopped eating meat. Chris often sensed that he was hungry but really did want to believe that these

treatments would work. "It was just a great hook for all of us because we could imagine that Donnie was going to make it," he said. "I fell into that trap. I couldn't imagine that Donnie was going to die."

Finkelstein was not content with these natural remedies. He knew that nothing could treat the underlying virus, but it was possible, though difficult, to secure medications that could treat individual infections. To treat Yowell's pneumonia, Finkelstein had to requisition pentamidine from the CDC's headquarters in Atlanta, as the drug had stalled in the FDA's approval process and wasn't fully available. By 1983, most of the CDC's pentamidine supply had been sent to New York City and San Francisco, while pharmaceutical companies had declined to produce more of a drug still considered to be niche.

None of this necessarily surprised Finkelstein, as it confirmed some of his long-held skepticism about the confluence of medicine and business. As a child, Finkelstein had once asked his mother, then a lab technician, if there could ever be a cure for cancer. "Never," she said. "It's too big a business."

The seriousness of Yowell's illness became clearer when he began exhibiting symptoms of dementia. Once, while visiting Yowell in New Jersey, in late 1983 or early 1984, Chris Lione took off a pair of cheap gloves and Yowell accused him of having stolen his own pair: "You took my gloves!" he shouted at Chris. "Those are *my* gloves!"

Even toward the end of his life, Yowell couldn't admit to his friends that he was actually sick, despite his illness being so visible. Days before he died, Yowell and Finkelstein went to the ballet and bumped into one of their friends, Vincent Gagliostro, who also lived in the same building as the Lione brothers but who had been kept in the dark about Yowell's worsening condition. Gagliostro was shocked by how awful Yowell looked.

"You wanna go eat?" Gagliostro asked Finkelstein and Yowell.

They declined. Yowell said that he had to get up early the next day and fly to London for a record that he was working on, even though he was clearly in no shape to fly.

You're fucking lying, Gagliostro thought.

Days later, Yowell was admitted to the hospital for the final time. One night, he began a death rattle, but rallied the next morning and was conscious. Hanging on seemed to drain him. After his family left the room, Yowell said to Finkelstein, "It's too much pressure." Later that day, Yowell was admitted to the intensive care unit (ICU), and it really did seem to be the end. Finkelstein called the Lione brothers, who then caught a bus out to New Jersey. The hospital staff wouldn't allow the three of them to see Yowell, but the Lione brothers managed to sneak into the ICU, where they found Yowell, lying on his back, heaving from the force of the ventilator. Chris took Yowell's hand, and felt that it was cold. "He's dead," Chris said to his brother.

That night, Gagliostro came home to a message on his answering machine. Peter Lione had called and told him to come up to their apartment, 33B. When Peter opened the door, Gagliostro said to him, "Yeah, I know."

"Who told you?" Peter asked him.

"Believe me," Gagliostro said. "I know."

Nobody took this harder than Finkelstein, who recalled that he was inconsolable after Yowell's death. Not yet forty, he was already a widower, and imagined that he was destined for a similar fate.

Finkelstein still lived in the apartment he had once shared with Yowell, and he was too shell-shocked to return to a place that was so full of memories of their life together. The Lione brothers offered to take him in, and Finkelstein accepted, even though he only knew the Lione brothers as Yowell's eccentric friends.

When it came time for the funeral, Finkelstein wasn't invited by Yowell's family. But he showed up anyway and was treated, in Chris Lione's recollection, as "a nonperson." Besides the Lione brothers and a few of Yowell's friends, nobody spoke to Finkelstein. "They just froze him out," recalled Chris Lione. "He wasn't the widow or the widower of the person who died. He wasn't treated with any respect whatsoever."

Soon after the funeral, the Yowell family asked Finkelstein if they could collect Yowell's possessions from the apartment that Finkelstein had once shared with their son. Chris Lione joined Finkelstein for emotional

support, but the Yowell family essentially took everything. "They took all his music cassettes and his demo tapes, every picture of him and all of his clothes," recalled Finkelstein. "They took things I had made for him, things he had given to me, and clothes that were mine but he loved to wear. They removed all evidence of him, without asking what was his or mine, without offering to leave a single keepsake of our lives together."

The Lione brothers encouraged Finkelstein to continue staying with them, so he crashed on their couch for the interim month between Thanksgiving and Christmas of 1984. The Lione brothers loved collecting antiques, particularly holiday decor. For much of the time that Finkelstein stayed with the Liones, they sat around restringing antique Christmas beads. "It was just something to do between crying," Chris Lione recalled.

What compounded this sense of loss for Finkelstein was a concern about his own health. Without any way to know for sure, Finkelstein assumed that he too was HIV-positive. He began eating six meals a day, wanting to avoid questions about looking skinny, which he described as innuendo for "Are you sick?"

As the news began to spread through New York City's music scene, Jorge Socarrás caught wind of Yowell's death. Socarrás and Yowell had once been collaborators and found that they had worked well together. They had composed a ballet score for Peter Reed, a dancer who was often memorialized in the photographs of Robert Mapplethorpe. Of course, once Yowell had learned that he had AIDS, he stopped pursuing those sorts of opportunities, and Socarrás was one of those left in the dark.

For Socarrás, the AIDS crisis had begun with the death of one of his best friends and musical collaborators, the producer Patrick Cowley, whose music provided much of the soundtrack for the half decade of gay life that preceded the AIDS crisis. He produced two of the period's most well-known disco songs, Sylvester's "You Make Me Feel (Mighty Real)" and "Do You Wanna Funk." While Cowley produced music for bigger acts that would get played on the dance floor, his own records were an

unabashed celebration of what he called the "Mechanical Fantasy Box," the back rooms of these bars and clubs where gay men would rendezvous for public sex. In other words, if you were a socially active gay man during these years, you had to go out of your way to not hear Cowley's music.

In 1980, Cowley was hospitalized. Doctors alternately diagnosed him with a parasite or food poisoning, but couldn't explain why his symptoms persisted. Socarrás got a call from a mutual friend in 1981, still a year before AIDS even had a name, that he should get to San Francisco if he wanted to see Cowley, whose health was spiraling. Cowley died in November 1982, just weeks after the CDC officially began using the term AIDS.

As a native New Yorker who had begun his music career in San Francisco, Socarrás was rooted in the two epicenters of the AIDS crisis. By 1983, New York City was handling 42 percent of the nation's AIDS cases. San Francisco reported a third as many cases, despite having only a tenth of New York's population. In the years after Cowley's death, the crisis began to explode. In 1982, the number of AIDS deaths in America increased fivefold. That number then tripled over the course of 1983 and tripled again in 1984. "When people are dying in those kinds of numbers, you can't stop and grieve every time," reasoned Socarrás. "So you switch into other modes of coping."

Socarrás began to keep a list of friends, lovers and collaborators who had died of AIDS. His list quickly surpassed a dozen names, then twenty-five, then fifty and then seventy-five. "I didn't want to go past a hundred," recalled Socarrás. "It was when I got to a hundred names that I realized that the list wasn't going to do it for me anymore."

One night in 1985, as Socarrás walked down Broadway toward Astor Place, he became overwhelmed by grief. "I wanted to hurl myself onto the sidewalk and pound my fists and wail to heaven," he recalled. "I just couldn't take it anymore, the weight of so much death, having reached that number a hundred." Socarrás then thought, *Okay, you could do that, and you will be seen as a madman. Or, you can channel that energy in a different way.* So he decided to reach out to Finkelstein instead.

"I had no idea what we were going to do," recalled Socarrás, who suggested that he and Finkelstein get together, commiserate and share their

grief. The two first met at a diner in 1985, then began having dinner regularly. One night, Socarrás brought a friend named Oliver Johnston, a southern dandy working in graphic design. Unable to square their differences, Finkelstein was baffled that these two men could be friends. Johnston wore pastels and red statement glasses, while Finkelstein described Socarrás as looking like a vampire.

But these minor incongruences didn't hobble their conversation. They talked about AIDS in an uninhibited way that Finkelstein had never done with anyone else. "They both seemed so utterly free from any conflict about speaking about AIDS," Finkelstein recalled. "Which I found exhilarating after so many years of secrecy." All of them agreed that their straight friends had no frame of reference for what they were experiencing, and that many of their gay friends preferred to ignore what was happening.

Over the course of the evening, the three of them decided to form a consciousness-raising group of gay men, a forum for discussing what it meant to be gay in the age of AIDS. They each decided to invite one other person, bringing the total to six. Johnston invited an art director named Charles Kreloff, and Socarrás invited a photographer friend, Brian Howard. Finkelstein instinctively invited Chris Lione, who immediately said yes.

All of them happened to share a background in visual art or graphics. Finkelstein was a hairstylist and art director for Vidal Sassoon, and Lione likewise did art direction for magazines. Johnston and Kreloff both worked in graphic design, and Howard was a photographer. As the group's only musician, Socarrás might have seemed like the odd man out. He was then the lead singer of Indoor Life, a band with a small but devout following. Andy Warhol loved their music and once described them as "one of the few modern practitioners of beautiful music." But he had studied visual art in college, and all of them were immersed in the same downtown melting pot of music, art and culture. "We all thought in images," Socarrás recalled.

They quickly gelled, and there were quite a few mutual connections among the six. Chris Lione soon realized that he and Johnston had gone to art school together and fondly recalled how Johnston would Rollerblade

through the Parsons cafeteria wearing hot pants and a shirt cropped just above his belly button. Coincidentally, Kreloff's older brother had been one of their professors.

Finkelstein liked Howard and found him affable, but he was particularly impressed by Kreloff and his background in political organizing. Kreloff was the son of Bea Kreloff, an out lesbian and veteran activist who had been part of the anti-war movement, second-wave feminism and the emerging gay rights movement. If his mother was dating someone new, she'd invite her son over for dinner to meet them. Once, Kreloff went over to his mother's place to meet her newest fling and found himself sitting across from Audre Lorde.

For their first few meetings, they chose quiet restaurants, but Kreloff recalled that they quickly found it difficult to talk about AIDS in such a public space. Not wanting to feel hushed, they soon began hosting each other for potluck dinners in their apartments. Initially, this was not a group dedicated to talking about anything beyond the realm of the personal. "It wasn't quite a therapy group," Kreloff recalled. "But it sort of was." All of them were at risk, and so talking about sex felt unavoidable. Chris Lione recalled that they would often talk about "the fact that none of us had boyfriends, how unhappy we were, how lonely we were, how horny we were." Presiding over this was a sense of their own mortality. At one meeting, Chris blurted out, "Which of us will be first?"

In these early months, this cohort found it difficult to maintain the kind of openness on which their group was predicated. Johnston first told Kreloff, his oldest friend in the group, that he had tested HIV-positive but insisted that Kreloff not tell the other four. Kreloff felt that this put him in a very difficult position, as the entire purpose of this group was to have open and honest discussions about AIDS. Johnston's keeping a secret like this, and asking Kreloff to keep it too, contradicted everything that the group was supposed to be.

Kreloff also felt that Johnston had to disclose his HIV status because he knew that Johnston and Socarrás were sleeping together, on and off, and had been for years. Kreloff assumed that the rest of the group had intuited as much, but actually this was hidden too.

For Kreloff, Johnston's HIV status became the elephant in the room at their weekly meetings, and after a few weeks, Kreloff essentially forced Johnston to reveal his status. "I am so sorry," Kreloff said to Johnston at one of their meetings. "But I cannot hold onto this any longer. If you don't tell them what's going on with you, I'm going to have to tell them."

Finkelstein handled it poorly. "I was furious that he didn't feel safe enough to tell us earlier," Finkelstein recalled. "Which was not the appropriate response, but that is how it went down." Johnston's disclosure had called the group's original purpose into question. This was, after all, supposed to be a consciousness-raising group about what it meant to be a gay man in the age of AIDS, and yet one of its members hadn't felt comfortable enough to share that he had tested HIV-positive.

"Avram is somewhat Biblical in his moral standings," Kreloff said. "Sometimes, I think he sees the world in a more black-and-white way than I do." Kreloff understood that there was moral ambiguity around Johnston's decision to hide this, and he was comfortable with it being a gray area. "I didn't see it as this grand betrayal, in the way that Avram did," Kreloff said. "I saw it as Oliver and Jorge not being very honest with themselves."

For Socarrás, this was the moment he learned that Johnston was HIV-positive. However, the revelation didn't really faze him. "It sounds selfish," Socarrás recalled, "but I had only topped him, so I really wasn't worried about it." And by that point, Socarrás had lost so many former boyfriends and lovers to AIDS that he assumed that he too was probably living with the virus.

Johnston's concealing his HIV status caused a rift, but one that proved to be momentary. Though Finkelstein and Socarrás both assumed they were positive, Johnston was the first in the group to know for sure. Now they all had to consider Johnston's silence and the roots of it, why even in a group like this, someone wouldn't feel comfortable talking about their HIV status.

These dinners, which had begun as a forum to talk about their own experiences as gay men, were growing increasingly political. Over the course of an evening, it was natural for the conversation to evolve from

a discussion of their own lives to a discussion about their community. Questions about meeting someone would lead to a discussion of safe sex, which might yield questions about safe-sex programs and why it was so hard to find definitive safe-sex information, which might lead to questions about what the government was doing to curb the AIDS crisis.

Against the backdrop of these discussions, AIDS was quickly becoming a national news story, in a way that it hadn't been before. On July 25, 1985, the actor Rock Hudson publicly announced that he was living with AIDS, after traveling to France for an experimental treatment and collapsing in his hotel room. Hudson's announcement prompted a new wave of journalism covering the HIV/AIDS epidemic. It infuriated Finkelstein that a single closeted celebrity had managed to turn AIDS into a news story when thousands of Americans had already lost their lives. Hudson's announcement didn't compel them into discussing these dimensions of the crisis, but the abundance of news stories did provide fodder, and Finkelstein and his cohorts started to bring press clippings, in addition to their appetizers.

What they found in these clipped news stories was bleak. Because the Food and Drug Administration (FDA) had failed to approve any drugs that curbed the virus, community advocates had begun illegally importing medications approved in other countries. But even these medications failed to halt or deter the virus. Federal, state and local governments refused to fund safe-sex programs, and so the gay community resorted to publishing and distributing its own safe-sex manuals.

What came into focus, for Finkelstein and his cohorts, was the extent to which AIDS was being depicted as an exclusively gay virus. Rooted in the earliest reports about AIDS, the idea of a "gay cancer" only solidified as the crisis grew. At the 1984 Republican National Convention breakfast, the president of American Airlines opened his speech by joking that "gay" was an acronym for "got AIDS yet?" Hudson's announcement that he was dying of AIDS, and his subsequent outing, reinforced this budding perception. Weeks after Hudson's death in 1985, Houston's former mayor outlined his own plan for ending the crisis during a reelection bid: if you want to stop AIDS, he said, "shoot the queers."

For Finkelstein and his cohorts, it was becoming clearer that the government's lax response and the blatant homophobia were inextricable, and that the perception of AIDS as an exclusively gay virus permitted such an apathetic response. "I began to sense there was an enemy out there," recalled Finkelstein, "and it wasn't simply the disease."

What seemed to epitomize the government's inadequate response to AIDS was the near total silence from President Ronald Reagan. Up until Hudson's announcement, Reagan had not even commented upon the growing crisis. But Reagan's longtime friendship with Hudson necessitated some kind of response. Hudson had actually visited the White House, and was photographed with Ronald and Nancy Reagan, just weeks before his HIV test results came back positive. In the interim months between Hudson's announcement and his death, Reagan made his first public response to the AIDS crisis. He described AIDS as one of his administration's "top priorities." It was a confounding statement, as Reagan had never publicly addressed AIDS before, wouldn't publicly address AIDS again in 1985, and publicly mentioned the disease only once the following year.

The president's few public remarks about the AIDS crisis often questioned established scientists and their findings. When confronted with claims from scientists at the National Institutes of Health that the current levels of AIDS funding were totally insufficient to combat the growing epidemic, Reagan dismissed these concerns. "I think with our budgetary constraints and all," he said, "it seems to me that $126 million in a single year for research has got to be something of a vital contribution."

Reagan also doubted the science surrounding HIV transmission, describing it as inconclusive, even though there was already a scientific consensus. The week before Reagan's first public remarks about AIDS, eleven thousand New York City schoolchildren had been kept home by their parents, in protest of the school board's decision to allow an HIV-positive second grader to attend class. By then, scientists had well established that casual contact could not possibly transmit the HIV virus, and Reagan's

first briefing on AIDS was originally supposed to quell the fears of these parents. His notes for this briefing initially read, "As far as our best scientists have been able to determine, AIDS virus is not transmitted through casual or routine contact."

But five days before Reagan first addressed the crisis publicly, his assistant counsel, John G. Roberts Jr., suggested that this sentence—drawing on science to call for calm—be deleted. Instead, Roberts reasoned that it be changed to, "There is much to commend the view that we should assume AIDS can be transmitted through casual or routine contact." In his memo to the president, Roberts claimed that the science surrounding HIV transmission had "been attacked by numerous commentators," though he failed to say who, exactly, had doubted these conclusions. Reagan ultimately sided with Roberts and publicly sympathized with the parents who kept their children home in protest.

Twenty years later, Roberts was confronted about this decision when sitting before the Senate Judiciary Committee as George Bush Jr.'s nominee for chief justice of the Supreme Court. Asked about this memo, Roberts said that "it could have been disastrous" had they been wrong about HIV transmission. But Roberts failed to note that the decision to doubt established science, without any basis, had been disastrous as well. In the years after Reagan cast doubt upon the science of HIV transmission, children with the HIV virus were routinely denied access to public schools, and the cost of fighting this in the court system often had violent repercussions. One family's home was firebombed by an arsonist a week after a judge ruled that their three children, who had all contracted HIV through a blood transfusion, could attend their local public schools. The home of a middle schooler who was fighting a similar court battle was hit by gunfire. The misinformation and silence propagated by the Reagan administration had deadly consequences for people with AIDS.

While Reagan spoke sparsely about the AIDS crisis, he signaled a very clear stance on the epidemic through his cabinet positions, specifically those with the most public-facing roles. The White House press secretary, Larry Speakes, was known to crack jokes about AIDS in his press briefings. When a reporter asked if the president had heard about a recent

announcement from the Centers for Disease Control, Speakes quipped, "*I* don't have it. Do you?" Other officials in the Reagan administration didn't bother couching their phobias in the form of jokes. Two years before he was hired as Reagan's communications director, Pat Buchanan wrote, "The poor homosexuals—they have declared war upon nature, and now nature is extracting an awful retribution."

By no means was there a consensus within the Reagan administration about AIDS. But the administration dealt with this by effectively silencing proponents of safer-sex initiatives. Reagan's surgeon general, C. Everett Koop, was one of the few cabinet members who advocated for safer-sex education. "If ever there was a disease made for a Surgeon General," reasoned Koop, "it was AIDS." Though he was openly homophobic, Koop had a relatively progressive view on sex education: that it should be taught, from a young age, as a scientific matter and that sex education should not put a value judgment on heterosexual or homosexual sex acts. Koop recalled that in his first years as surgeon general, from 1981 to 1985, he was "cut off from AIDS discussions and statements" taking place within the Reagan administration. He chalked this up to "intra-department politics that I can still not understand fully," but had no doubt that "my exclusion from AIDS was just another facet of Washington politics, especially the disturbing interplay between politics and health." During press conferences with Koop, Reagan's assistant secretary for health would instruct journalists that they were not to ask him questions about AIDS, and that Koop would not be speaking about the virus either.

The internal memos circulated by the Reagan administration and the intradepartmental politics wouldn't have been known to Finkelstein and his cohorts. As with Roberts's memo, much of this only became public information in later years. But it was becoming clearer that silence was pervasive, and that overcoming it would be a prerequisite for change.

A year after Finkelstein and co. had begun meeting, they reevaluated their charter of solely being a forum for discussion. "Something physical has to come from this," Finkelstein told them. He suggested making a

poster, urging the gay community into action. With their shared background in graphic design, it seemed like an obvious thing to do. "Five of us came out of art school, four were graphic designers and two were art directors," reasoned Finkelstein. "No one was remotely perplexed by the suggestion. . . . It was instantly and unanimously agreed on."

Kreloff had a slightly different take on the group's decision to pivot away from solely being a support group. He had started to tire of constantly having to share their fears and anxieties, what he described as a weekly "emotional striptease." And he also felt that making a poster was a way of ignoring the personal dynamics between the six of them. For Kreloff, Johnston's handling of his HIV status still stung, and if they were going to continue as a support group, then they would have had to deal with their interpersonal dynamics. The poster gave them a distraction from all this.

New York City had always had a vibrant poster culture. The apex of this had been during the anti-war movement, which Finkelstein had seen, and noted. As a teenager, Finkelstein could always find out about upcoming demonstrations just by walking down Eighth Street or down Manhattan's other thoroughfares.

Still, despite seeing these anti-war efforts, Finkelstein didn't think that something similar could happen with AIDS. It seemed infeasible in part because there had never been a coalition of activists organizing around a disease. But it also seemed unlikely to Finkelstein because there wasn't a long history of organizing in the gay community. "Gay history was recent," he recalled. This was only seventeen years after the Stonewall Riots; in their aftermath many groups had formed, but most petered out by the mid-1970s. There had been small pieces of resistance since then—for example, many gays had boycotted Coors beer because the company refused to hire homosexuals—but it seemed far-fetched, to Finkelstein, that gays could organize en masse around a single political issue.

Instead, Finkelstein hoped that they could inspire small cells of individuals, like themselves, to intervene in the AIDS crisis. For this, there *was* precedent. At the dawn of the crisis, for example, a trio of gay men had cowritten and distributed *How to Have Sex in An Epidemic*, the

handbook that invented the idea of safer sex. In 1985, a lone protester had chained himself to a federal building in San Francisco, in protest of the government's lackluster efforts in the AIDS crisis. This was the sort of scale that Finkelstein and his cohorts could imagine for their group's poster, though they did hope it would inspire more confrontational action. "What we were imagining was much closer to what seemed possible," Finkelstein recalled. It seemed impossible, to them, that hundreds, let alone thousands, might band together as a unified organization.

Of all the posters Finkelstein saw during the anti-war movement, one remained lodged in his mind: the Art Workers Coalition's *And Babies* (1969). It was an infamous photo of the My Lai massacre, in which US soldiers had killed hundreds of unarmed Vietnamese. The poster's text came from an exchange between Mike Wallace from *60 Minutes* and Paul Meadlo, a US soldier who had participated in the massacre. This exchange was printed by the *New York Times* as follows:

Q. So you fired something like sixty-seven shots?
A. Right.
Q. And you killed how many? At that time?
A. Well, I fired them on automatic, so you can't—you just spray the area on them and so you can't know how many you killed 'cause they were going fast. So I might have killed ten or fifteen of them.
Q. Men, women and children?
A. Men, women and children.
Q. And babies?
A. And babies.

This 1969 poster often arose in discussions among Finkelstein and his cohorts. It was compelling: an easily recognizable image with a minimal amount of text, calibrated to provoke outrage. In many ways, the poster they produced would follow a similar formula.

As Finkelstein and his cohorts began to work on their poster, the Supreme Court delivered one of the most significant blows to gay rights in American history. In 1986, the court upheld a Georgia law criminalizing

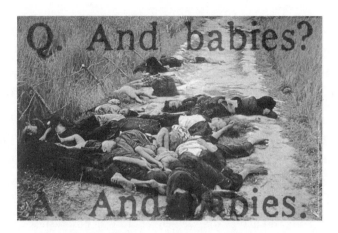

And Babies, The Art Workers Coalition, 1969.

sodomy. Michael Hardwick had been arrested for having consensual oral sex with another man in his own bedroom. The case, which became known as *Bowers v. Hardwick*, ascended through the court system before the Supreme Court upheld the original law, 5–4. In the majority opinion, penned by Justice Byron White, the court declared that the Constitution did not confer "a fundamental right upon homosexuals to engage in sodomy." Chief Justice Burger cited "millennia of moral teaching" in his concurring opinion, noting that during the sixteenth-century English Reformation, Sir William Blackstone had described sodomy as "the infamous crime against nature," an act of "deeper malignity" than rape, its mention "a disgrace to human nature," and a crime "not fit to be named." It's noteworthy that, of all the laws historically condemning sodomy, Chief Justice Burger relied upon Blackwell's characterization, which admonishes *talking* about sodomy as much as it does the act itself. Perhaps it's unsurprising then that the poster made by Finkelstein and his cohorts would be about silence and its consequences, and that their poster came to define the period of activism that followed this ruling.

For their poster, Finkelstein and his cohorts wanted an image that could serve a dual purpose: They wanted to urge the gay and lesbian communities of New York into action, to encourage their peers to organize politically and demand that the government do something, or anything, about the growing crisis. But they also wanted this poster to speak to

those *outside* of their community, to suggest that this organizing within the community had already taken place.

Finkelstein described this as their "marketing problem," a term unabashedly borrowed from the lexicon of advertising. Though partially inspired by anti-war posters, Finkelstein and his cohorts also drew upon the strategies of commercial advertising, something they felt was fitting to their particular moment. In the 1960s, they reasoned, people would stop and read a full manifesto plastered on a wall. Now, however, the group had no illusions that anyone would take this time. Their poster had to instantly grab and arrest the viewer. There was no room for wordiness.

For both audiences, they wanted their poster to demonstrate the degree to which homophobia so clearly shaped the dialogue surrounding AIDS. They seized upon one particularly egregious example of this. In March 1986, the conservative columnist William F. Buckley wrote an op-ed in the *New York Times* proposing that "everyone detected with AIDS should be tattooed in the upper forearm, to protect common needle users, and on the buttocks to prevent the victimization of other homosexuals."

Though he is most often remembered as a television commentator, Buckley was a trusted, albeit informal, advisor to President Reagan, who bragged about reading every issue of Buckley's *National Review* from cover to cover. The two maintained a close friendship throughout Reagan's presidency, and in one correspondence following this *New York Times* op-ed, Buckley joked to Reagan that his proposed tattoos should read, "Abandon hope, all ye who enter here," over the buttocks.

For Chris Lione, Buckley's proposal to tattoo those who tested HIV-positive recalled an emblem with a long history in the gay and lesbian communities. Lione had recently visited Dachau, the first concentration camp constructed by the Nazis. It was here that he reencountered the pink triangle, a symbol that the Nazis had used to brand homosexuals. The pink triangle had long been co-opted by gays and lesbians, first reclaimed by German gay liberation groups in the early 1970s, as both a memorial to those who were lost and as a reminder of ongoing oppression. Seeing the pink triangle at Dachau, while mired in the AIDS crisis, made it all the more resonant for Lione.

Finkelstein and his cohorts didn't immediately agree upon the pink triangle. It prevailed by process of elimination rather than being something universally loved by the collective. Other symbols could have spoken to the gay and lesbian communities of New York, but all of them had drawbacks. The lambda, in their estimation, had classist undertones from its association with higher education. The rainbow recalled the hippy movement and didn't seem apropos for such dire circumstances. With the pink triangle, the group had reservations about using such a charged symbol. Half of their group was Jewish, and as Finkelstein put it, "Jews don't take Holocaust analogies very lightly." The group's gentiles were even more averse to using the pink triangle, as they worried that it might come across as flippant. At the time Buckley proposed tattooing anyone who tested HIV-positive, around eighteen thousand Americans had died of AIDS. This was a horrifying number but didn't approach the magnitude of the Holocaust.

Still, Finkelstein foresaw this image as being recognizable, and this trumped any reservations about the aptness of a Holocaust analogy. "Before anything else, I am a propagandist," he reasoned. "I have a very elastic sense of ethics. I will do anything if it gets the point across."

That choice to use the pink triangle was ultimately prophetic. As the crisis grew, so did the triangle's resonance. And it was a growing crisis: by the time their poster reached the printer around the end of 1986, twenty-five thousand Americans had died of AIDS.

For their poster, they considered posing a tattooed body, but Chris Lione warned against this, as rendering one person might potentially exclude others. "What gender would the arm be?" they asked themselves. "What color would the butt be?" They considered using a black-and-white image, to camouflage the subject's race, and wondered if a close-up shot could obfuscate gender. They eventually settled on a stand-alone shape: a pink triangle against a black backdrop.

The pink triangle, both in its original usage and in its first reclamations, pointed down. But Chris Lione, misremembering the triangle's direction, told the group that it pointed upward, like a pyramid. He chided the group for doubting him. "Boys, I *just* came from that concentration

camp," he told them. "I know what I'm talking about." Johnston was supposed to research the direction of the triangle but failed to do so. And so it went to the printer upside down. This inversion of the triangle came to be read as a gesture of empowerment, and Finkelstein would later hawk it as such. But in actuality, the pink triangle facing upward was essentially a printing error.

While the poster's image came after much hemming and hawing, the text came rather quickly. Finkelstein suggested an entry from his journal that read, "Gay silence is deafening." Johnston suggested "Silence is death," which could double as a critique of President Reagan's reluctance to speak about AIDS. Another suggested changing the *is* to *equals*. "Someone else said, 'It should be an equal sign,'" recalled Finkelstein. "And literally everyone screamed."

This was a political poster, but one with an intensely personal significance, particularly for Finkelstein. Consider the role that silence played in Yowell's death. After the Bellevue hospital staff avoided Yowell's room for days, Finkelstein had to yell at the nurses to receive attention. Later, by asserting himself as Yowell's rightful caretaker, Finkelstein provoked screaming matches with Yowell's family. And though nothing could have stopped his partner's death, Yowell's refusal to speak about his own diagnosis eroded much of his would-be support network. For Finkelstein, *Silence=Death* signaled a next step in grieving Yowell's death. As he put it, "Fear and grief faded away when I discovered action."

While *Silence=Death* is most often remembered for its pink triangle and uncompromising slogan, what dominates the poster, in terms of pure space, is the surrounding blackness. Many of the design choices made by Finkelstein and his cohorts emphasized this negative space rather than the poster's slogan and symbol. They paid extra to have the poster printed on a larger-than-usual sheet, just to add more negative space, leaving the poster's top quarter entirely black. Its pink triangle is comparatively small: it could have been triple the size and still fit comfortably within the frame.

Choosing a solid black background was first done out of necessity. Finkelstein and his collaborators wanted the poster to appear in the

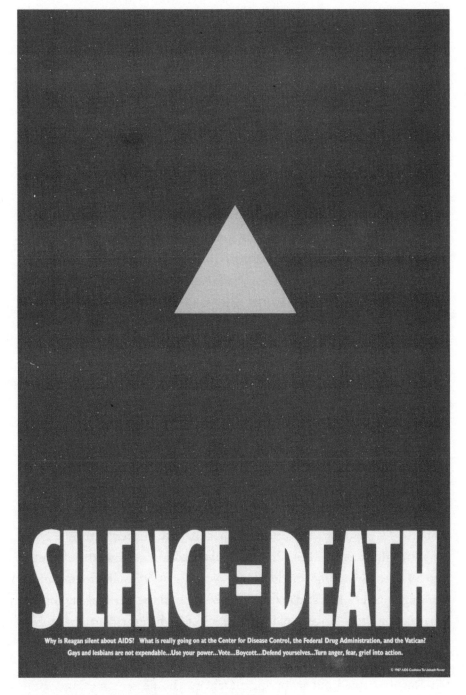

Silence=Death, the Silence=Death collective, 1987.

same thoroughfares where anti-war posters once had. In its concision, *Silence=Death* was unprecedented for these sorts of spaces. Walking along the fenced-off construction sites where this poster would soon appear, one expected to see flyers for club nights and bills for punk bands cluttering these walls. A black background distanced their message from this competing visual noise. But this solid black background also spoke to the complete void of political discussion surrounding the AIDS crisis. The government's silence on AIDS was frustrating, but so was the gay community's inability to talk about this as a political issue. By this point, Finkelstein had realized that "we were in the midst of a political crisis, and outside of our group, hardly anyone seemed to be talking about it."

The power of *Silence=Death* was that it didn't limit itself to one kind of silence, and that it fought against silence at virtually every level of society: Johnston's silence about his HIV status, Reagan's silence about HIV transmission, the lack of media coverage in the pre–Rock Hudson days of the epidemic, and the sense that the gay community wasn't addressing the politics that enabled the AIDS crisis. In the worldview offered by this poster, all of that was deadly.

To distribute the *Silence=Death* poster, Finkelstein contacted a "snipping" company, a semilegal operation, rumored to be controlled by the mafia, that was used by the advertising industry as a cheaper alternative to billboards. A *New York Times* article that appeared later in 1987 described the operation of James Rogers Jr., the snipper whom Finkelstein contacted to paste the *Silence=Death* poster around Manhattan. Armed with glue buckets and eight-inch brushes, Rogers would load a night's worth of posters into his blue El Camino and head into New York City well after midnight, working until just before dawn. "We drive around the city looking for new construction sites," Rogers told the *Times*. "And when they put up the sidewalk bridges, I'm there." Finkelstein wasn't sure that Rogers would agree to take on an AIDS-related project that wasn't strictly an advertisement, but Rogers turned out to be indifferent to the poster's message. Rogers charged them $1.50 a poster and Finkelstein footed the bill, paying for nine hundred posters to appear on walls in the East Village, Lower

Broadway, SoHo, the West Village, Chelsea, Hell's Kitchen and parts of the Upper West Side.

One of the peculiarities of New York, and particularly Manhattan, is that there is no other place where a poster like this could have such an effect. If you carpet the right ten neighborhoods in New York, you can reach a sizable majority of the people who work in publishing, broadcasting and print news—either where they live, work or socialize. (It would be a different ten neighborhoods today, but the same is still true.) Los Angeles, the nation's other major media market, is too large and sprawling for this kind of tactic, as one hundred posters saturate a neighborhood in New York, in a way that can't be done in Los Angeles. *Silence=Death* wasn't going to reach most of the country by being wheat-pasted around

Credit: Archive of Avram Finkelstein.

Manhattan. But it was going to reach a lot of the people who decide what the rest of the country reads, hears and sees.

Snipping had flourished in part because of the proliferation of construction sites around New York City. Spurred by city-sponsored redevelopment that had begun in Times Square and then radiated throughout Manhattan, the city was now lined with construction walls. Finkelstein and his cohorts saw these walls as an opportunity—not a barrier, but a canvas.

Unbeknownst to Finkelstein, and almost concurrently, another small group of AIDS activists had co-opted the pink triangle too. Just after the *Bowers v. Hardwick* ruling, a group formed, calling themselves the Lavender Hill Mob. In February 1987, a few members of the Lavender Hill Mob flew to Atlanta, hoping to disrupt a CDC meeting and demand that the government distribute safer-sex materials to help combat the growing epidemic, in addition to more funding for AIDS research. In advance of this trip, they had fashioned costumes for themselves, dying white dress shirts purchased from the Salvation Army gray and affixing pink triangles, to make themselves look like inmates in a concentration camp. It would seem to be a pure coincidence that both the *Silence=Death* collective and the Lavender Hill Mob adopted the pink triangle concurrently, as the *Silence=Death* poster debuted in New York City while the Lavender Hill Mob was in Atlanta.

That weekend in Atlanta, the Lavender Hill Mob dogged researchers, beginning with the conference's opening cocktail reception. Striding in with their uniforms that first night, "the cocktail chatter died down," recalled Michael Petrelis, one of the mobsters in attendance. He looked across the room and saw Mathilde Krim, the founder of amfAR (the Foundation for AIDS Research) and a well-known AIDS researcher, who had a rather bemused look on her face.

The Lavender Hill Mob continued these sorts of theatrics throughout the conference, convened to discuss whether HIV testing should be mandatory for anyone admitted to a hospital. Threats of an HIV quarantine

were very real during this period of the AIDS crisis, and so in one flyer, the Lavender Hill Mob reimagined the CDC's acronym to read, "The Center for Detention Camps."

Throughout the weekend, the Mob managed to gain significant media attention, despite the fact that only a few of them had flown to Atlanta. The *New York Times*, the *Washington Post*, the *Boston Globe*, *USA Today* and a smattering of smaller local papers all covered the Mob's disruption. The group even got a call from CNN, who wanted one of their members to appear on *Crossfire*. The Mob elected one of their members, Bill Bahlman, to represent them.

Bahlman was well-known in the New York community. When not disrupting CDC conferences in Atlanta, he was a DJ at Danceteria, a downtown nightclub where Socarrás's band Indoor Life often played. During these years, Danceteria was the epicenter of downtown New York nightlife, and the club is noteworthy for having had a string of employees who became famous later in the 1980s. LL Cool J operated the club's elevators. Madonna would take your cocktail order, Sade would make it and Keith Haring would collect your empty glass. The Beastie Boys were either the porters or the main act, depending on the night.

Bahlman also had a long history of organizing within the gay community, having joined the Gay Activists Alliance (GAA) just after it formed in the wake of Stonewall. In 1972, Bahlman organized a demonstration protesting the American Psychiatric Association's classification of homosexuality as a mental disorder, a demonstration that launched a yearlong campaign and that ultimately proved to be successful. But when it came to the AIDS crisis, Bahlman found that mainstream gay rights groups were reluctant to take on AIDS seriously, as these groups were reluctant to stage protests and demonstrations—the kind of action that ultimately proved to be necessary. It was out of this frustration that Bahlman joined the budding Lavender Hill Mob.

Bahlman appeared on CNN's *Crossfire* program, which pitted two interlocutors against each other, and sat opposite Congressman William Dannemeyer, a well-known homophobe and representative of Orange County, California. Bahlman recalled that, after he debated Dannemeyer

briefly, the commentator turned and said to the camera, "When we get back, we'll ask Mr. Bahlman about an AIDS activist plot to pollute the water supply with HIV in Texas."

Though Bahlman was shocked to hear something this outlandish, these sorts of sensationalized news stories aired frequently, even in mainstream outlets. When they came back from a commercial break, Bahlman explained that such a contamination was scientifically impossible, and that there were much more pressing issues to be discussed. Still, the whole experience was vexing. "Doing this was not easy," Bahlman recalled. "It was second nature to us, but it's hard work and very emotionally draining." He had agreed to the interview wanting to talk about the Mob's demands—mainly more money for AIDS research and safer-sex programs. He hadn't agreed to debunk some ridiculous conspiracy theory.

Bahlman and some of the mobsters flew back to New York shortly after the CNN interview and took a bus back from the airport. It was on this bus ride that they first saw the *Silence=Death* poster, which had debuted while they were away and was now pasted on construction sites all over Manhattan. Finkelstein and his cohorts had designed the *Silence=Death* poster to be readable from a moving vehicle. Bahlman and his fellow mobsters had no trouble reading it from the bus, and they immediately understood what the poster meant. "We were thrilled," Bahlman recalled. "We knew exactly what the message was."

Coming back to New York and finding these posters was immensely encouraging to their efforts. "Because mainstream gay organizations weren't supportive of us, we had to know, from within ourselves, that what we were doing was right," Bahlman recalled. "So coming back home, and seeing these *Silence=Death* posters everywhere, was incredibly heartwarming." The six designers of *Silence=Death* hadn't provided any contact information or a way of getting in touch, but the Lavender Hill Mob and those responsible for *Silence=Death* would be serendipitously meeting soon enough.

After its debut, *Silence=Death* began raising awareness and getting attention. "It woke people up," Bahlman said. Others who rallied around

this cause had a similar recollection. "It was like the Bat Signal," recalled one person who became an AIDS activist soon after seeing *Silence=Death* around Manhattan. *Silence=Death* on its own was not going to accomplish what the Lavender Hill Mob had set out to do, but the appearance of *Silence=Death* still marked an important step. The silence was about to be broken.

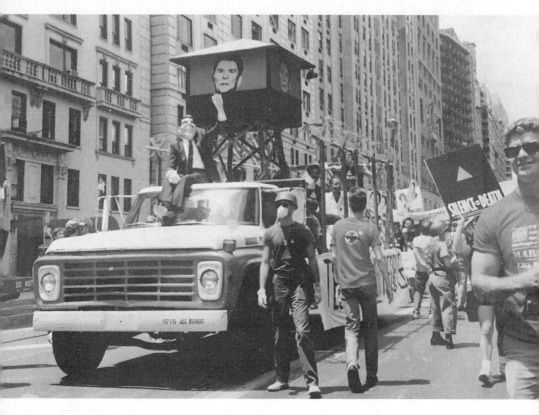

ACT UP's concentration camp float for the 1987 Pride Parade. Credit: Archive of Avram Finkelstein.

CHAPTER 2
OFF THE WALL

I was ready to go. I just needed collaborators and
that's what everyone found within ACT UP.

—Donald Moffett

A s *Silence=Death* began appearing around Manhattan, Avram Fin-
kelstein read in the *New York Native* that Larry Kramer, the mer-
curial playwright, was to give a speech about the AIDS crisis.
Instead of having their usual potluck dinner, Finkelstein and his cohorts
elected to go see Kramer's talk, which he was to deliver on March 10,
1987, at the Lesbian and Gay Community Services Center on West Thir-
teenth Street.

From the earliest days of the AIDS crisis, Kramer had been mocked
for overexaggerating its severity. He had characterized the epidemic in
apocalyptic terms, just weeks after the first reports of a budding virus in
1981. A former scriptwriter, he was best known for his 1978 novel *Fag-
gots*, which satirized the kind of sexual freedom that epitomized gay life
in the 1970s. It had garnered Kramer a reputation for being prudish, and
his concern about the AIDS crisis was, initially, seen in a similar light, as
just another example of Kramer's views on sex and monogamy. His early
warnings about AIDS were largely dismissed, especially when he began

to liken AIDS to the Holocaust, an analogy that had seemed overblown to many, especially in those early years.

Frustrated by the lack of concern he found in the gay community, Kramer cofounded Gay Men's Health Crisis (GMHC), the world's first organization dedicated to providing services for people living with AIDS.

GMHC provided essential services for people living with AIDS, the kinds of services that hospitals often refused to provide, even at private institutions like Lenox Hill and New York University Medical Center. "People lay in shit and trays sat outside their room unless we went over there," recalled Rodger McFarlane, a GMHC cofounder. In these early years of the crisis, Beth Israel and Columbia Presbyterian refused to accept dental patients who were HIV-positive. Memorial Sloan Kettering Hospital instituted an outright ban on people with AIDS. The city of New York was likewise reluctant to help. "A fire goes out in a school furnace on the West Side, I get three thousand phone calls in one afternoon," a deputy mayor once told McFarlane. "Don't talk to me about three hundred faggots who fucked each other to death."

While GMHC filled a necessary role, Kramer was not content with the scope of its mission. He dismissed GMHC's efforts as "candy striping," and wanted the organization to be more confrontational, take a more proactive stance and push for the development of treatments. Others were similarly discontent with GMHC's charter. When Michael Petrelis of the Lavender Hill Mob learned that he had AIDS, his doctor suggested that he seek out GMHC's help in drafting his will. "I don't want to write my will!" the twenty-six-year-old shouted back. "I want a cure!"

In Kramer's estimation, GMHC's problem was that it had dozens of staffers, and not a single lobbyist in Washington. Some of his cofounders at GMHC felt that Kramer's stance was a liability—they wanted to court government agencies for funding and believed that Kramer's criticisms of public officials would impede this. Kramer's nemesis at GMHC was its president, Paul Popham, who refused to speak to the press or represent the organization in any public way because he was worried that he might lose his job on Wall Street if he came out publicly. Popham even tried to have the word "gay" removed from the title of GMHC.

All this frustrated Kramer endlessly, and so he left GMHC just a year after its founding. "Everything, everything, is too little, too late," he told the *New York Times*. "By our silence we have helped murder each other."

Five years later, just after the Lavender Hill Mob returned from Atlanta, Kramer reached out to them and suggested that they come see him speak on March 10th. Unbeknownst to them, the six men responsible for *Silence=Death* had decided to attend as well.

"The Center," where Kramer was to speak, was in a state of disrepair, reflecting the perilousness of the community it was serving. Rats and vermin ruled the upper floors. If it rained outside, it often rained indoors as well. The room in which Kramer was to speak, a cavernous space in the middle of the first floor, had all the ornamentation of a parking garage. Metal folding chairs were lined into loose rows. There were no windows, and it was often cramped, hot and uncomfortable. About 250 people attended this speech. This included a few friends Kramer had enlisted himself, GMHC volunteers who were similarly frustrated, the Lavender Hill Mob and the six men responsible for *Silence=Death*. The actor Martin Sheen, who had recently starred in the London production of Kramer's play *The Normal Heart*, was also there. Sheen's best friend had died of AIDS that day, and he sat in the audience sobbing.

Kramer began his speech by recounting what he had written about the AIDS crisis four years ago and asked the audience to consider how little had changed, and how relevant it still seemed:

> If this article doesn't scare the shit out of you, we're in real trouble. If this article doesn't rouse you to anger, fury, rage and action, gay men may have no future on this earth. Our continued existence depends on just how angry you can get. . . . I repeat: Our continued existence as gay men upon the face of this earth is at stake. Unless we fight for our lives, we shall die. In all the history of homosexuality we have never been so close to death and extinction.

When Kramer first wrote this, there were 1,112 reported cases of AIDS nationwide. By the time he gave this speech, there were 32,000. Kramer's imperative hadn't changed.

He also noted that the worst was yet to come. The average incubation period for HIV was then thought to be five and a half years. He asked those assembled to consider their sexual habits back in 1981, when the concept of safer sex was still years away, and to think about what that meant for their futures.

"Last week, I had seven friends who were diagnosed," he continued. Then Kramer illustrated what that might feel like in this room. He asked half the room to stand, then shouted, "You could be dead in less than five years!"

Powerful, Finkelstein thought.

Kramer characterized this reluctance for gay men to save their own lives as internalized homophobia. "I sometimes think we have a death wish," he continued. "I think we must want to die. I have never been able to understand why for six long years we have sat back and let ourselves literally be knocked off man by man—without fighting back."

"I don't want to die," Kramer told them. "I cannot believe that you *want* to die."

These are the most widely excerpted and most well-remembered parts of Kramer's speech from that night. The anecdote about asking part of the room to stand up (some say it was half the room; some say two-thirds) then telling them they'd all be dead soon (some recall it being in one year; some recall it being in five) is almost inevitably recounted in every origin story of AIDS activism.

What's less often recounted and remembered is what Kramer said afterward. He recounted, in fairly granular detail, the FDA's approval process and stories of how the nation's leading AIDS doctors were being stonewalled by the agency's bureaucracy, and how the FDA had only approved AZT (a failed and toxic cancer drug) even though leading AIDS researchers said that five other drugs in the FDA's pipeline had already proved to be less toxic and more effective. "A new drug can easily take ten years to satisfy FDA approval," Kramer bellowed. "Ten years! Two-thirds

of us could be dead in less than five years." The burden to change this, Kramer said, fell to those assembled before him. As he put it, "No one is going to do it for us but ourselves."

Kramer then noted the Lavender Hill Mob and how successful the five of them had been at the recent CDC protest in Atlanta. "They got more attention than anything else at that meeting," Kramer bemoaned. "They protested. They yelled and screamed and demanded and were blissfully rude to those arrogant epidemiologists who are ruining our lives."

Then Kramer asked if the rest of those assembled would join in on this kind of activity. It had only taken five members of the Lavender Hill Mob to become headline news across the country. Kramer now had 250 people assembled before him, and they too seemed ready to act. "Do we want to start a new organization," Kramer asked, "devoted solely to political action?"

Overwhelmingly, those assembled said yes.

At either the next meeting or the meeting after, just as it was about to commence, a member of the Lavender Hill Mob, standing at the back of the room, mused that "there are all these *Silence=Death* posters up all over the city. Who's doing this?"

It prompted a murmur throughout the room. "Yeah, who did that?" seemed to be everyone's response.

Finkelstein, Johnston and Lione, all sitting together, looked at each other, unsure of what to do. Bill Bahlman was standing behind them and could see them whispering and shooting glances at each other, quietly deciding what to do. "They didn't know whether or not to come out!" Bahlman joked.

"Should we tell?" Johnston whispered to Finkelstein. "Should we say it?"

Finkelstein shrugged, and as soon as he did, Johnston stood up. "It's us," he told the room. "We did it."

"So who are you?" somebody asked.

"We're a small consciousness-raising group," Finkelstein said. The room broke into applause, a small ratification of *Silence=Death* and its message.

Soon thereafter, the budding organization settled upon a name. "I always had this idea," a social worker named Steve Bohrer told them. "It would be great to form a group called ACT UP, and it would be the AIDS Coalition to—and I don't know what the UP would stand for, but it would be a great name." They quickly decided upon the U and the P: Unleash Power.

From the get-go, ACT UP differentiated itself from GMHC and other AIDS advocacy groups by addressing the politics of the crisis. Rather than ensuring housing or supplying medical information, ACT UP agitated the government agencies who worked without urgency and bargained with pharmaceutical companies that were profiting from the epidemic. In effect, ACT UP became the sort of lobbying group that Kramer had wanted out of GMHC. "I helped found Gay Men's Health Crisis and watched them turn into a sad organization of sissies," Kramer later recalled. "I founded ACT UP and have watched them change the world."

To hear Kramer tell the story, one might think that gay men sat around, waiting to die, until he convinced them otherwise. This is the received wisdom about ACT UP: that Kramer was the sole catalyst of action.

But the emergence of *Silence=Death*, just weeks before ACT UP, along with the concurrent Lavender Hill Mob demonstration, indicates it wasn't *just* Kramer's speech that roused everyone. Though *Silence=Death* became intertwined with ACT UP, and the Lavender Hill Mob ultimately folded itself into the larger organization, both happened independently of each other and had preceded Kramer's speech.

Furthermore, Kramer had been making these sorts of cataclysmic declarations for years, without generating any sort of response. The tirade that launched ACT UP was, at this point, a rather familiar stump speech.

What was it, then, about March of 1987? Why was it that ACT UP, *Silence=Death* and the Lavender Hill Mob all emerged independently and within weeks of each other? And why were people suddenly receptive to Kramer's stump speech, when they hadn't been for years?

For one, the direness of the crisis had only become fully apparent in March of that year. It was only in 1983 that scientists identified the HIV virus, confirming it as the cause of AIDS in the following year. As soon as the virus had been isolated, premature talk of a vaccine or cure began permeating the media. In 1986, the *Wall Street Journal* reported, "Scientists Take a Possible Step to AIDS Vaccine." Similarly optimistic news was reported in the *San Francisco Chronicle*, with headlines like "AIDS Vaccine, Treatments in Sight, Researcher Says." As long as an AIDS vaccine or cure seemed feasible, Kramer could be dismissed as an overreactionary. Robert Gallo, one of the scientists who had isolated the HIV virus, had a more cautiously optimistic outlook about the feasibility of an AIDS vaccine but correctly predicted to the *New York Times* that "the answer will come in 1987."

On March 3, 1987, just a week before Kramer's speech, the *Times* reported that the prospects for a vaccine now seemed bleak. "The emerging portrait of the AIDS virus and its mode of attack," the paper explained, "show that it will be a difficult vaccine target." Judging by the media coverage, an AIDS vaccine had seemed plausible, or even imminent, up until the week before ACT UP formed.

Furthermore, Kramer's argument assumed that the spread of the HIV virus was being enabled by government neglect at the highest levels. In 1982, when he began perfecting his stump speech, that seemed, to many, like a conspiracy theory. But as 1986 turned to 1987, this proposition—that AIDS was a crisis enabled by politics—started to seem more plausible, and even likely.

Though *Bowers v. Hardwick* was decided in June 1986, the full impact of the ruling only became apparent the next year. Sodomy laws, though rarely enforced, were still technically on the books in twenty-five states. Lower courts soon began using the *Bowers v. Hardwick* ruling as precedent for discriminating against homosexuals. In January 1987, a lesbian mother lost custody of her child, with the judge citing *Bowers v. Hardwick* as the precedent. The Lambda Legal Defense and Education Fund, a team of New York–based lawyers fighting for gay rights, quickly articulated how *Bowers v. Hardwick* could also be used to exacerbate the AIDS

crisis, particularly when it came to the distribution of safer-sex materials. "Hardwick puts health groups in a peculiar position of wanting to, in effect, advise people how to break the law in a safer way," reasoned Thomas Stoddard, Lambda's executive director.

Now that an AIDS vaccine suddenly seemed remote, just as the country's highest court sanctioned discrimination against homosexuals, Kramer now seemed prophetic for arguing that AIDS was a crisis enabled by politics. It wasn't that his argument or reasoning changed. Rather, it was only in March 1987 that his audience was primed for this message.

At the time that Finkelstein joined ACT UP, he was dating the head window dresser at Barneys, Simon Doonan. One day, Doonan's team was cleaning out their studio, and they were about to trash a pile of foam-core signs advertising a recent sale at Barneys. Doonan hesitated and set the signs aside.

Doonan suggested to Finkelstein that they affix the *Silence=Death* poster to the signs and bring them to the next ACT UP demonstration. Up until this point, *Silence=Death* had only appeared as a wheat-pasted poster around Manhattan. Doonan was suggesting that they take the poster off the wall and put it in the hands of ACT UP's members.

Finkelstein wasn't initially enthused about the idea. "I don't feel comfortable bringing posters without the floor's consent," he told Doonan.

"Don't be ridiculous," Doonan replied. "Everyone brings their own posters to a demo."

"Yeah, but not stacks of them," said Finkelstein.

Doonan offered to take the blame. "Just give me a bunch," he told Finkelstein. "It'll be out of your hands."

Finkelstein relented, and the next Saturday, Doonan came back to work with copies of the *Silence=Death* poster and a half dozen cans of Spray Mount. Cheap, lightweight and durable through inclement weather, foam core proved to be the perfect material for holding up signs. It could also be smacked and played like a drum.

The power of *Silence=Death* in the hands of ACT UP's members became clear at their second demonstration. It was a prime photo opportunity, staged on the marble steps ascending to the General Post Office building in Midtown Manhattan, located across from Pennsylvania Station, one of the city's central transit hubs, and Madison Square Garden. The demonstration was set for April 15, the last day to file income taxes, and media outlets often sent camera crews to cover citizens rushing to mail their returns before midnight.

At the time of the post office demonstration, ACT UP was relatively small and new: its few dozen members had only been meeting for a month in a rat-infested building. But one would have never known this judging by their appearance. Having a single poster for the demonstration gave the impression that this was a really organized group. With ACT UP's members standing in rows on the post office steps, the repetition of the poster created a cascading effect. *Silence=Death* seemed to multiply infinitely. The media didn't need to know that everyone was holding repurposed Barneys sale signs. For the sake of appearances, ACT UP looked organized, cohesive and diligent.

An architect named Terence Riley was walking down Eighth Avenue when he happened upon the demonstration. He first noticed their uniformity and arrangement. "I remember thinking how smart the whole thing looked, how savvy it was in terms of the media," recalled Riley, who noted ACT UP's potent combination of "fantastic graphics and very good looking people." Riley pulled off to the side and watched the demonstration. He then saw a group of teenagers start to heckle the sixty or so ACT UP-ers lining the marble steps. "You're sick!" one shouted. "You people, you're all gonna die!" Riley had never been involved in a demonstration like this before, but he constantly fretted about being HIV-positive. If he felt a cold coming on, he'd call his doctor, worried that he had AIDS. Almost instinctively, Riley felt compelled to join the group and their chants.

In terms of tangible outcomes, this demonstration at the General Post Office building was not especially meaningful. It didn't shift any government policies or cause massive upheaval. But the appearance of *Silence=Death* as a portable message, something that could be carried like a

banner, proved that graphics could be integral to ACT UP's success. They sort of happened upon this tactic, which signaled that ACT UP's demands should be taken seriously. And so while looking cohesive through their graphic imagery was not, at first, a conscious strategy, it very quickly became one.

Recognizing this, ACT UP started to merchandise the *Silence=Death* graphic, first with buttons and then with T-shirts. That May, ACT UP elected to produce a thousand *Silence=Death* buttons, which were sold for a dollar a piece at AIDS Walk New York. They sold the entire first run that day, and that thousand dollars became the initial trust of ACT UP.

"*Silence=Death* was a work of pure imagining," Finkelstein said. "It was meant to project a level of organizing and financing that didn't actually exist." But of course, once ACT UP began to ratify *Silence=Death*, that imagined level of financing and organizing very quickly materialized. *Silence=Death* first imagined that this existed, then helped actualize it.

At an ACT UP meeting on May 18, 1987, the organization decided to produce another five thousand buttons and do a test run of *Silence=Death* T-shirts. Granted, not everyone found this discussion to be useful or productive. "You sissies!" hissed the mercurial Kramer. "People are dying and you're talking about *T-shirts*!"

Kramer had, by then, left ACT UP and returned—one of many such exits and re-entrances that would characterize his involvement. Despite this to-ing and fro-ing, he clung to the title of ACT UP's founder, much to the frustration of virtually everyone else. Kramer's speech may have launched the organization, but he wasn't actually around that much. Less of a founder, he was more akin to ACT UP's absentee father.

But with each successive iteration of *Silence=Death*, it became clearer that this image was speaking to a larger and larger group, and that ACT UP was doing more than just talking about T-shirts. When they had first begun meeting, Finkelstein and his cohorts had felt utterly alone in seeing AIDS as something enabled by government neglect. The widespread acceptance of *Silence=Death* demonstrated that this was hardly the case. Clearly, many others felt this way too. They just hadn't known how to find each other. *Silence=Death* didn't just speak to a community. Its

widespread acceptance also articulated that a community actually existed. And it also helped bring that community into being.

Silence=Death debuted nationally that summer, in Washington, DC, at the Third International AIDS Conference. What's noteworthy in the coverage of this conference is that ACT UP isn't mentioned by name— they're referred to, rather obliquely, as "demonstrators." But ACT UP's posters were already beginning to capture the media's attention, even before ACT UP solidified its reputation.

By then, the *Silence=Death* collective had produced a second poster, *AIDSGATE*. It was a stencil of Ronald Reagan's bust, printed onto lime-green paper with garish pink eyes. Its text, "AIDSGATE," likened Reagan's handling of the AIDS crisis to Richard Nixon's Watergate scandal and demanded that the Reagan administration be investigated in a similar fashion.

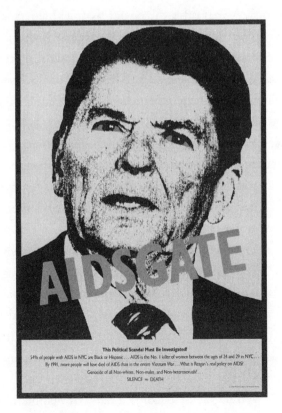

AIDSGATE, the Silence=Death collective, 1987.

AIDSGATE was noted in the *Los Angeles Times*'s coverage of the conference, and two weeks later, *Silence=Death* and *AIDSGATE* appeared in the pages of *Time Magazine*, along with a photo of Larry Kramer, in handcuffs, with the White House as a backdrop.

Though *Silence=Death* was widely accepted by the immediate circle of ACT UP, this was not immediately beloved by the gay community writ large. Finkelstein recalled that when he wore a *Silence=Death* button to dinner one night, his waiter, a gay man, registered his disapproval. "That's a very violent button," he told Finkelstein.

"These are very violent times," Finkelstein shot back.

These sorts of confrontations were not uncommon. One ACT UP member named Joe Ferrari recalled wearing a *Silence=Death* shirt on Fire Island and being spit on by another gay man.

But those who clung to this image peddled it constantly, and it soon became ubiquitous. A year after the poster first debuted, Susan Sarandon pinned a *Silence=Death* button to her gown at the 1988 Academy Awards. She donned identical pins for appearances on David Letterman, Johnny Carson and *Good Morning America*. And it wasn't just Hollywood celebrities who understood this image. The same year that Sarandon began publicly wearing her *Silence=Death* pin, ACT UP's Peter Staley appeared on the CNN show *Crossfire* wearing a *Silence=Death* sweater. He sat opposite Reagan's former communications director, Pat Buchanan, who noted Staley's sweater and said curtly, "I gather that means you're a homosexual."

Silence=Death had become a nationally recognized symbol of AIDS activism, entirely because of its association with ACT UP, and undoubtedly benefited from the coincidence that it debuted just before ACT UP's formation. "If ACT UP had started six months later, *Silence=Death* might have come and gone," Charles Kreloff reasoned. Finkelstein felt similarly. "We designed the poster," he said, "but ACT UP created it," meaning that *Silence=Death* gained its significance by how many within ACT UP ratified its message. "We put it on a wall," mused Chris Lione. "ACT UP put it on the map."

Silence=Death would quickly become a hallmark emblem of the AIDS activist movement, something worn by thousands of people who felt

compelled by its simple equation. And a version of its slogan would be co-opted by virtually every significant protest movement that has since followed in American history.

But its origins were much humbler. Before *Silence=Death* was adopted by this community, and before it was riffed upon so many times, it began as a personal statement about Finkelstein and the five other men he met with weekly, a statement about their lives, their initial silence about AIDS and their attempt to overcome this. "We weren't really attempting to articulate what a community was experiencing," recalled Finkelstein. "As far as we knew, there was no community to give voice to at all. We were talking about ourselves." Only as thousands of others began to ratify *Silence=Death* did they start to understand that they were hardly alone.

When Finkelstein and Lione had been at work on the *Silence=Death* poster, one friend of theirs named Mark Simpson had repeatedly offered to help. Finkelstein had said no, feeling that six members was plenty, but he had found Simpson's enthusiasm to be meaningful and not quickly forgotten. During the production of *Silence=Death*, Finkelstein would explain the concept to friends, who mostly dismissed the idea. "People thought it was the stupidest thing they had ever heard," recalled Finkelstein. Besides those in the *Silence=Death* collective, only Simpson had believed in the potential of their poster before it began appearing around Manhattan.

Simpson had come to New York in the mid-seventies, and worked at Spring Street Natural, one of the first actual restaurants in SoHo. It was through this job that he became best and lifelong friends with one of his coworkers, Hali Breindel, who was then waitressing but eventually went on to costume design for television and film. Simpson became an unofficial member of the Breindel clan, and Hali's mother, Annette, was like a mother to him too. "He had every holiday with us," Hali recalled. "He loved the Jewish holidays. He loved to hear about the story of Exodus. He liked the drama of things, the plagues." Simpson's being informally adopted by the Breindels is of importance to his later work with ACT

UP. Annette happened to be next-door neighbor to the Lione brothers, and through her, Simpson became enmeshed in both the Breindel family and the friend group that included Don Yowell, the Lione brothers and Finkelstein, though Simpson wasn't privy to Yowell's decline. "A circus of oddballs" was how Chris Lione described them all.

Hali recalled that Simpson seemed a bit exotic to them all. Simpson was a Texan and the son of a Southern Baptist minister. His family had moved often throughout his childhood, mostly along the Gulf Coast of Texas, before eventually settling in Dallas when Simpson was a teenager. "He probably moved at least twenty times in his first twenty years of life," his sister Linda recalled. The frequent moves were just one facet of their chaotic childhood. One or both of their parents were often absent. Simpson's mother struggled with mental illness, and was later diagnosed with borderline personality disorder, though the family suspects that she was probably bipolar too. She was first subjected to insulin shots and electroshock therapy before finally being committed to a psychiatric hospital, from which she eventually escaped. "Mother left to wander the United States," Simpson wrote in his memoir. Their father was often absent too, for work or other reasons. When his parents filed for divorce a second time, Simpson's mother accused their father of infidelity, which seems to have been at least partially true, considering that Simpson's father remarried on the day that his divorce to Simpson's mother was finalized. When both were gone, Simpson and his siblings would be left in the care of neighbors and extended family, or else they would fend for themselves.

Their family life revolved almost entirely around the church. In Simpson's memoir of his childhood, he describes identical scenes, of the family devolving into violent matches right before church begins, which involved beatings from their father and Simpson's mother throwing every breakable thing in the house, and then a sudden rush to get Simpson and all of his siblings into their church clothes, to at least give the appearance of a nice preacher's family.

Simpson took respite from his family life in the animals that he adopted as pets: the horny toads of Texas's Red River Valley, the amphibians of Lake Charles, a Siamese cat he had to give away in one of the frequent

moves and later, a donkey named Sandy. He loved animals, and as an adult lived with an untold number of pets in New York. There was his parrot, Tweetie Bird, a cat named Precious Darling and a whippet named Perfect Angel, who later committed suicide by jumping out the window. He named all of his small birds, mostly Gouldian finches, "Sweet as Pie" and numbered them sequentially, so that Sweet as Pie One occupied the top cage, Sweet as Pie Two lived below it and so on.

Before coming to New York, Simpson had lived in Austin for about five years, having stayed after dropping out of architecture school at the University of Texas. Once Simpson moved to New York in the mid-seventies, he didn't have much contact with his family for the next fifteen years, the notable exception being a trip that he and Hali took to Texas in 1978. Hali recalled how Simpson's father, whom everyone called Daddy, collected them from the airport in a convertible Cadillac. "With his cowboy boots on too," Breindel added. The first night at dinner, Simpson's father, without any prompting, began recounting Jesus's parable of the prodigal son, a coded but unsubtle indicator of how he felt about his son visiting from New York.

The other respite that Simpson had had as a child was books, and he loved history in particular. He had read the entire Bible by the age of eleven, and elected to read, cover to cover, the entire *Encyclopedia Americana* too. He discovered "painting" in Volume P, and was particularly struck by the work of Thomas Gainsborough, Diego Velázquez and J. M. W. Turner's *Slave Ship*.

It was known among his chosen family in New York that Simpson spent much of his time painting, though it wasn't often discussed. "He was always painting," Hali recalled, "but I don't think that people took him as seriously about his painting." Part of this lack of seriousness probably had to do with Simpson's reputation for not being the most reliable worker. Simpson got by working under-the-table construction jobs, and did good work, but Chris Lione recalled that if you hired Simpson, you did so understanding that he might show up with his toolbox in one hand and a six-pack in the other, or that you might have to pull him off his barstool halfway through the day.

But Simpson's paintings did find recognition, albeit outside of their friend group. One day, Simpson was walking through the East Village and stumbled upon Civilian Warfare, a new gallery in the neighborhood's budding scene. He chatted up the gallerists and offered to show them his work. They were large cityscapes painted with luster dust, to give his surfaces a phosphorescent sheen. Civilian Warfare started to exhibit these regularly, and Simpson quickly became friends with Alan Barrows, one of the gallery's co-owners. There's a black-and-white group shot of a Civilian Warfare opening from 1984, just as AIDS was beginning to wreak havoc, and you can see Simpson and some other fixtures of the scene here: David Wojnarowicz, who also showed at Civilian Warfare, is chatting with his mentor, the photographer Peter Hujar. The writer Gary Indiana talks with Barrows. On the right, Simpson stands alone, smoking and with his legs crossed.

Photograph by Andreas Sterzing.

By the time he joined ACT UP, Simpson had shed his long locks, what one friend described as his "post-Austin hippy homo look," for a shorter, slicked haircut. This gave him a resemblance, according to another ACT UP friend, to the playwright Sam Shepard.

Civilian Warfare managed to sell a good amount of Simpson's work, mostly to banks and building lobbies, but Simpson's paintings didn't manage to gain a foothold within the scene. "A lot of people had a hook to their art," Barrows said of their contemporaries, meaning a particular image or signature that reappeared throughout their work. David Wojnarowicz had his burning house stencil, Basquiat his crown. Or else they had a style that was unmistakably theirs, like Keith Haring's cartoon figures, or Greer Lankton's lifelike sewn dolls. Their work was well branded, in the sense that you knew it was theirs without having to ask. Simpson's art didn't have that immediate recognizability, or a signature motif.

By the end of 1986, Civilian Warfare was beginning to falter. Barrows's co-owner had sunk the gallery's finances with his heroin usage, and the larger scene that contained the gallery had started to wane. Barrows decided to file for bankruptcy, and the gallery folded in 1987. With it, Simpson's art career seemed to have ended too.

Simpson joined ACT UP just as this was happening. "I like the name," Simpson told Barrows. "It sounds like children acting up." He gravitated toward the projects where he could lend his construction skills, and quickly roped Finkelstein into building ACT UP's float for the 1987 Pride Parade.

It was initially suggested that ACT UP's members carry coffins through the parade. One ACT UP member living with AIDS, Griffin Gold, lobbied against this. "Can't you folks think of any other way to represent people with AIDS other than carrying coffins?" he snapped back. "We are *living* with AIDS," he proclaimed, "not *dying* with AIDS!" Make no mistake, people were dying, and Gold himself would die of AIDS less than two years later. But you can see, in this conversation, an attempt to represent this community as fighting for their lives, not content to die. And so instead of carrying coffins, they decided to extend the

Holocaust metaphor of *Silence=Death* and construct a mock concentration camp float, one in which ACT UP's members would be very much alive.

ACT UP's concentration camp float took wing from the growing concern over an HIV quarantine. Two weeks before that year's Pride Parade, Senator Jesse Helms appeared on CBS's *Face the Nation* and declared, "I think somewhere along the line that we're going to have to quarantine if we are really going to contain this disease. We did it back with syphilis, did it with other diseases, and nobody even raised a question about it." These comments followed those of Education Secretary William Bennett, who had proposed that HIV-positive prison inmates be confined beyond their sentences, as they might purposefully spread HIV upon their release as a way of taking "revenge on society."

The quarantining and hospitalization of sex workers who had contracted an STI was commonplace in the early twentieth century. But Helms evaded the fact that, once these women were treated and stopped displaying symptoms, they were free to go. Conversely, HIV was—and still is—incurable. Helms wasn't just calling for an HIV quarantine. Had he had his way, testing HIV-positive would have effectively been a life sentence.

Helms was not alone in this position. A 1985 poll conducted by the *Los Angeles Times* found that a majority of Americans favored a quarantine of those living with HIV. In the moment that ACT UP formed, the possibility of an HIV quarantine seemed imminent. In 1986 and again in 1988, the state of California voted on identical propositions that would have quarantined those living with AIDS. Both measures were soundly defeated, but the possibility of an HIV quarantine was by no means remote.

The day before the 1987 Pride Parade, Finkelstein and a few other ACT UPers ventured out to Simpson's residence in an industrial neighborhood of Brooklyn, what would now be called Bushwick or East Williamsburg but then seemed like the end of the world to the downtown-centric universe of ACT UP. He lived in a building at the base of a smokestack, and one friend described his home as being "a bunker." But Simpson had beautifully retrofitted the interior with new kitchen appliances, two

bedrooms and a separate painting studio. He had also collected dozens of exotic houseplants, in addition to his many pets.

Simpson didn't have much in the way of neighbors: his apartment was bordered by a junkyard and a parking lot, where Finkelstein and a few others from ACT UP constructed the float. Granted, Simpson himself wasn't much help. "Mark was both stoned and drunk," recalled Finkelstein. "So he laughed more than he hammered."

For Pride, Simpson was going to drive the float with his best friend, Michael Nesline, whom he had met in Austin over a decade earlier.

Simpson had been a recognizable figure around Austin. "I knew him from afar before I actually met him," Nesline said. He recalled Simpson walking around town wearing a pair of khaki shorts, white knee socks, saddle shoes, a T-shirt and a bright green sari. "He was this sort of mythological creature," Nesline recalled. Nesline was equally struck by Simpson's looks: "Mark was one of those really interesting beauties. Because if you looked at him from one angle, he was utterly hideous. And if you looked at him from another angle, he was drop-dead gorgeous."

Nesline began dating one of Simpson's best friends, Joe Hollis, with whom he had an on-again, off-again relationship for the next ten years. "Joe Hollis was one of the most beautiful men that I've been lucky enough to see," Nesline recalled. "He was kind as could be, and he didn't have a vain bone in his body, although he did feel beleaguered by his beauty because he knew that people found him to be beautiful. And that was a burden to him, because he didn't know if people were responding to him or to his appearance. He was the kind of person who, when you're talking to him, he looked directly in your eyes and you just felt so flattered that the most beautiful man in the world was paying complete attention to you and you exclusively."

By the mid-1970s, Simpson had moved to New York, and Nesline soon followed him. Nesline came to New York with a vague idea of getting involved in theater. He wound up driving a taxicab and was happily adrift in his life before ACT UP. What he looked forward to in life was

"just getting by," and before AIDS, Nesline recalled, "I was not the sort of person who particularly had any ambitions."

When it was warm enough, he'd go cruising at the West Side Piers, which had been left largely abandoned as the shipping industry moved farther north up the Hudson River. Nesline was particularly fond of Pier 46, which jutted out into the Hudson from the West Side Highway, between Charles and Perry Streets. They'd lie out, sunbathe, cruise and hook up on the crumbling pier, while passing speedboats slowed to ogle them.

At the end of the pier, an abandoned warehouse with corrugated tin siding had been adorned with a multistory mural of two Zeus-esque hippies jacking off to each other. Between them, a door led to what Nesline called a "Felini-esque" wonderland. A fire had once burned so hot that the structures' steel girders had melted, and now they drooped to the floor. The melted girders cordoned off a series of alleys, like the stacks of a library, offering the slightest bit of privacy. Up a metal staircase, clanging with each step, there was a catacomb of what had once been offices. Artists like Keith Haring and David Wojnarowicz left cryptic murals here, scrawled among obscenity-laced graffiti. "It was beyond imagination," Nesline recalled.

But Nesline's main stomping ground was a bit more notorious. On the triangular strip formed by Fourteenth Street, Tenth Avenue and the West Side Highway, was a three-sided after-hours club called the Anvil, where Nesline was well-known. Walking into the Anvil, you were first met with a makeshift vestibule with a glassed-off booth, like at a movie theater, lit with orange light. You'd slip the attendant your five dollars, and they'd buzz you in through the black-painted door. Inside the triangular club, bars lined all three walls, the countertops of which became impromptu stages. Westside drag queens and East Village performance artists would take turns doing their acts, while everyone danced on the sawdust floor. If you want an idea of how small and insular gay life in New York City was at this point, Bill Bahlman, later of the Lavender Hill Mob, was one of the Anvil's resident DJs and spun their new wave nights, providing a respite from the usual disco churn.

At one end of the club, a stairwell descended into the Anvil's basement, for which it was best known. At the bottom of the staircase, a lone man sat upon his stool next to a coat rack. Behind him was a labyrinth of tunnels and rooms, rumored to extend all the way to the waterfront, and which according to some had once been used as old bootlegging tunnels.

"Gentlemen in the back rooms," the lone coat checker would call out every so often, "watch your wallets!"

"I had my wallet pickpocketed at least three times," Nesline recalled.

When Nesline would leave the Anvil at eight or ten the next morning, he'd have to walk through the Meatpacking District, past the sides of beef hanging from hooks, as this was still Manhattan's hub for slaughterhouses and packing plants. In the winter, Nesline would have to skitter and skate over the gutters, which had frozen over with beef blood.

When Hollis followed Nesline to New York in 1980, the two resumed their relationship and were soon back to their on-again, off-again ways. "Joe would come to New York with the aspirations of being a performer," Nesline recalled. "Within a week, he had found a cute little apartment, and a cute little job, and a cute little circle of friends, and some cute little gig playing guitar with his mediocre talents. And six months later, when he was not yet the toast of Broadway, he'd get miffed and go back to Austin." This routine, of Hollis coming to New York and then leaving six months later, happened at least three or four times over the next couple of years. Nesline didn't have infinite patience for it. "Come, go, stay—I don't care, motherfucker," he eventually told Hollis. "Just *do* something."

Soon after he returned to New York, for what proved to be the last time, Hollis was hospitalized with pneumocystis pneumonia, the same pneumonia that Don Yowell had had. It was March 1985, four years into the crisis, and a test still wasn't available, so they couldn't be sure, but given the symptoms he was presenting, it was all but certain that Hollis had AIDS. Hollis first called his family in Georgia and asked them if he could come home. Learning that their son was gay and had AIDS, Hollis's family disowned him and told him that they never wanted to see him again.

Simpson and Nesline then tried to figure out how to best care for Hollis. They both recognized that Hollis couldn't keep living alone, and given that his family wasn't going to help, they figured that Hollis would have to come live with one of them. Simpson first suggested that Hollis come live with him and his boyfriend in Brooklyn. But Nesline knew that Hollis hated Simpson's boyfriend, and so Nesline suggested that Hollis come live with him instead. Hollis agreed and moved into Nesline's East Village apartment. Though Hollis had stayed with Nesline before, both of them recognized that this would be different, as their relationship had clearly evolved into something more serious. "It was obvious that we were in this for the long haul," Nesline recalled. "And so we made that commitment to each other."

As 1985 progressed, Hollis's health stabilized. He began taking a daily dose of Bactrim, a prophylactic for pneumocystis pneumonia, and even managed to enroll in an experimental study for AZT. During those good months, Hollis and Nesline went to see Larry Kramer's play *The Normal Heart*, a roman à clef of his time at GMHC. "I don't know who this Larry Kramer guy is," Hollis told Nesline, "but you should go do something with that guy. That guy knows what he's doing." This was two years before ACT UP formed, and was ultimately prophetic.

Hollis and Nesline began contemplating moving into a bigger apartment together. But soon thereafter, Hollis's health quickly deteriorated. He was diagnosed with petechiae—a condition in which the capillaries start bursting and form small brown bruises on the skin. Hollis had a low platelet count, and even after receiving infusions his platelet count continued to drop.

Nesline was present when Hollis's doctor suggested that they remove Hollis's spleen.

"I prefer to just let nature take its course," Hollis told his doctor and Nesline.

"What does that mean, then?" Nesline asked the doctor.

"Then it's just a matter of time before Joe will die," she said.

"Are we talking days or weeks or months?" asked Nesline.

"No," she said. "We're talking probably days or weeks."

Nesline quickly realized that actually this was just going to be a matter of hours. "Over the course of the night, I watched him get weaker and weaker," he recalled. By morning, it was clear to Nesline that Hollis would be dead by the afternoon.

Nesline wanted Simpson to get to the hospital before Hollis passed. Just before this last hospitalization, Hollis and Simpson had had a blowout argument, the details of which Nesline doesn't recall. Nesline wanted them to mend this rift, and knew that he had just a few hours.

"I think I gotta call Mark Simpson," Nesline said to Hollis.

"What do we need that asshole for?" Hollis retorted.

"Well you may not need him," Nesline said. "But I do."

Nesline called Simpson and told him to get to the hospital. Simpson arrived soon and was understandably frazzled by the whole situation. Recognizing that he needed to ground Simpson, Nesline gave him something really tangible to do. "Take this water pitcher," Nesline told Simpson. "Go down the hall, get some ice and bring it back." He did, and Nesline recalled that by the time Simpson returned with the pitcher of ice, he was fully present and calm.

Nesline and Simpson went into Hollis's room, clutched each other and sobbed while they watched Hollis pass. Simpson was losing one of his best friends, and Nesline was losing his partner. Though Nesline and Simpson had known each other for over a decade, they hadn't been the closest of friends. But standing together and watching Hollis die cemented their friendship in a way that it hadn't been before. They were now bosom buddies, as Nesline put it, and were nearly inseparable for the next few years.

Joe Hollis died on September 14, 1985, a date that had a particular significance for Nesline. It happened to be the twenty-fifth anniversary of the death of Nesline's mother. "That had great emotional resonance for me," Nesline recalled. "And it had a real transformative effect on my life. Losing Joe made me realize that I needed to do something more constructive."

Just months after Hollis's death, Nesline enrolled in nursing school, and opted to be a nurse who worked with AIDS patients. He eventually began working in the AIDS ward at Bellevue Hospital, where Yowell had

first been hospitalized and where he had received his diagnosis. During the worst years of the crisis, Bellevue treated more AIDS patients than any other hospital in the country. A nursing supervisor at Bellevue once described AIDS as a "nurse's disease," not a "doctor's disease," because at that point, there wasn't much that doctors could prescribe, and for people living with AIDS, one's experience was often dependent upon the small comforts that could be offered by the nursing staff. At the ward in which Nesline worked, a sign was hung in the nurses' station that read, "The Only Difference Between This Place and the Titanic Is . . . They Had a Band!"

Through Simpson, Nesline had become part of the friend group that included the Lione brothers, the Breindel family and Finkelstein. And it was actually Chris Lione who took Nesline to his first ACT UP meeting. Even though he was still in nursing school, Nesline soon began devoting all of his free time to ACT UP. "It pretty much took over my life, which was okay with me," he recalled.

Finkelstein, Simpson and Nesline were something of a trio within ACT UP, though Simpson and Nesline would occasionally make barbed comments about Finkelstein. Finkelstein saw himself as an ardent Marxist and bragged about being a red-diaper baby, as his parents had similar political leanings. "I argued from the factory floor," Finkelstein recalled of his time in ACT UP. Simpson and Nesline would roll their eyes when Finkelstein made comments like this, seeing Finkelstein as being more radical chic than actually radical. "He'd go *racing* through Barneys and come out with ten five-hundred-dollar cashmere sweaters," recalled Nesline, who added, "That's only a slight exaggeration." Finkelstein would take notes on ACT UP meetings in a black leather journal from Comme des Garçons, which seemed to be at odds with his leftist proclamations. "He's smart as fuck," Nesline said of Finkelstein. "And he sees things that other people don't see. But his delusions about himself are laughable."

When Nesline dove headfirst into ACT UP, he sometimes took on roles for which he wasn't necessarily qualified. He volunteered to be ACT UP's first treasurer, despite the fact that "I can't balance my own

checkbook." Being the treasurer wouldn't be difficult, he reasoned, as the organization didn't have much money to account for anyway.

At one of the first ACT UP meetings, Nesline was sitting in the second row waiting for the meeting to begin. Whoever was supposed to facilitate the meeting didn't show, and someone leaned over and asked Nesline, "Will you facilitate the meeting?" Never one to pass up a speaking opportunity, Nesline agreed. He facilitated that ACT UP meeting and, feeling that he was suited for the role, became one of ACT UP's main facilitators. This meant that Nesline decided who spoke and when, and he often decided that he himself would do the speaking.

As a facilitator of ACT UP's meetings, Nesline developed a reputation for being a bit vicious. "He was no-nonsense," said one future collaborator. "He was such a sour grape, and he could just shout down anybody." One ACT UP member affectionately described him as "the best at being a bitchy queen." No small feat in this group.

On road trips and at dull moments, ACT UP's members would sometimes tease each other about which Golden Age Hollywood actor or actress would play each of them if ACT UP's endeavors were ever made into a film. (Everyone agreed that Larry Kramer would be played by Margaret Hamilton, best known for her role as the Wicked Witch of the West in *The Wizard of Oz*.) Nesline always insisted that he would be played by Eve Arden. "She never got the man," Nesline reasoned, "but she always had the last word."

After nine months with Nesline facilitating ACT UP's meetings, the organization decided to hold elections for the position. Unsurprisingly, Nesline lost. His ability to "shout down anybody" seemed to be popular only among his own friends. But it was through his time as a facilitator that Nesline honed an important skill. Nesline would always remember that a facilitator's role required the "ability to listen to what people are saying" and to thread together a central conversation with subconversations. He had to be able to listen to a person's comments, then synthesize what might be a long-winded diatribe into a concise and easily digestible statement, to "distill what was being said into something

comprehensible." This ability—to take a winding conversation and boil it down into a concise statement—later became integral to Nesline's work with Gran Fury.

Driven by Simpson and Nesline, ACT UP's concentration camp float was wonderfully out of place at Pride. A typical float would have been from the Monster, a piano bar and cabaret, whose floats usually featured undulating dance music, a disco ball and scantily clad men. ACT UP's concentration camp float stood in stark contrast to that sort of fun. Barbed wire was strung between two-by-fours, enclosing ACT UP members who wore iron-on pink triangles. They had constructed a guard tower behind the truck's cab, upon which a besuited man in a Ronald Reagan mask sat and pantomimed laughter, pointing at the float's prisoners. Along the truck's flank hung a sign that read, "Test drugs, not people." Masked guards wearing rubber gloves, then customary for police officers who handled AIDS activists, roamed the perimeter of the float, passing out flyers for the next ACT UP meeting.

Essentially a piece of street theater, the concentration camp float exemplified why art was such a necessary part of ending the AIDS crisis, for it ignited rage in a way that sheer statistics couldn't. When the parade started at Columbus Circle, a few dozen ACT UP members trailed the float. But as they traveled south toward the West Village, parade goers lining Seventh Avenue began to join. A GMHC volunteer named G'dali Braverman, who had lost his partner to AIDS in 1985 and was HIV-positive himself, was one of those who saw the float and joined instinctively. "I just immediately knew," he recalled. "That's where I needed to be." It wasn't hard to learn the group's six-syllable chant: "ACT UP! Fight Back! Fight AIDS!" Nesline recalled that, "By the time we got down to the village, we were huge." Along the way, hundreds had joined in, and by the parade's end, the float's tail stretched back five or six blocks.

Even Kramer, who had called his fellow ACT UPers "sissies" for talking about T-shirts, started to see the power of this imagery. He began

shoving *Silence=Death* T-shirts into the faces of parade-goers, demanding they buy one. Seeing this, Nesline said to Kramer, "Larry, you sissy. People are dying and you're selling T-shirts."

"And he had no idea what I was referencing," Nesline added.

At a designated time, the parade went quiet, dedicating a whole minute to those who had died of AIDS. When the minute was over, the growing contingent of ACT UPers started a new chant: "We'll never be silent again! ACT UP!"

One of those who attended that year's Pride Parade, and who subsequently joined ACT UP, was a young graphic designer named Donald Moffett.

Born in San Antonio, Moffett had left for New York in 1978, soon after he graduated from college. He was twenty-three when he landed in the midst of the city's pre-AIDS gay mecca. To Moffett, it felt seedy and sexy. Gay men were still confined to their ghettos, but New York City offered a kind of freedom that San Antonio hadn't.

But the horror of AIDS began to creep into Moffett's life, and became unavoidable when his partner, a television producer named Bob Earing, began to get sick. "When Bob needed too much help to live alone," Moffett recalled, "he moved in with me and my near-sainted roommate." It was a 450-square-foot apartment in Chelsea, with paper-thin walls. Moffett has a particularly foreboding recollection of this time. The three of them had a neighbor, a beautiful, modelesque man who was awful to them. "He was disturbingly mean," Moffett said. "A snob, barely spoke to us and acted like he thought we were trash." The walls in this building were so thin that one night, Moffett and his partner overheard their neighbor talking on the phone, and telling whoever was on the other end that he had just tested HIV-positive. "Then it started," Moffett recalled. "For the rest of the night, the most heartbreaking, uncontrollable wailing and cries of despair you can imagine. It was the end of his life as he had perceived it." A few months later, the neighbor was dead. "It was devastating," Moffett reasoned. "Mean or not."

A similar decline unfolded more slowly in Moffett's own apartment. Watching Earing get progressively sicker both devastated Moffett and compelled him toward action. "This need to do something, this desperation to do something, came from that sadness and heartbreak," Moffett recalled. "It was one of the ways through it."

Moffett channeled this into the production of a poster, which he designed at the Madison Avenue advertising firm where he worked. It was a diptych of Ronald Reagan and a bull's-eye. The words "He Kills Me" captioned a smirking Reagan, lips pursed together like he's holding back a fit of laughter.

Moffett had little money to get the poster printed, and so he took his mechanical to a small, one-press print shop. But with each run of prints, Moffett would find a different blemish. "I was demanding," Moffett said. "I wanted a perfect run of however many we had agreed to, but it never really got there." The printer, however, was kind enough to give Moffett

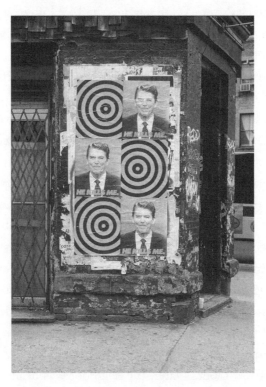

Courtesy of Donald Moffett.

all of the test prints. Moffett paid the printer the agreed upon amount, but left with many more than he had originally planned for, though they were all imperfect.

Moffett didn't have the resources that Finkelstein had had with *Silence=Death*. So he, along with a few friends, wheat-pasted the poster themselves around Manhattan. It just so happened that *He Kills Me* actually debuted almost concurrently with *Silence=Death*, in the weeks leading up to ACT UP's formation.

But it was at that year's Pride that Moffett was compelled to join ACT UP. "The float was exceptional," he recalled. "It was full of lively, animated and gorgeous people. And I was like, I gotta go there." Moffett's partner, however, refused to go. Still, Moffett was undeterred, and insisted on attending. "I was hoping ACT UP could save him," Moffett recalled. "Or me."

Moffett then began attending ACT UP meetings, and as Finkelstein had done with *Silence=Death*, he soon offered up his *He Kills Me* poster for any purpose the organization deemed fit. It was a fair trade for what ACT UP provided him. "ACT UP did save me," Moffett added. "It gave me somewhere to put that rage and heartbreak."

Just as *Silence=Death* had begun as an autobiographical statement on behalf of six men, *He Kills Me* began as one person's expression of loss and the ensuing grief. But it too became part of this larger movement. Though not as ubiquitous as *Silence=Death*, *He Kills Me* would continually appear at ACT UP demonstrations in the coming years, and the format of the poster, a public official's headshot next to a target, has been riffed on ever since.

Moffett was part of the wave of younger gay men driven to ACT UP after the concentration camp float made its debut. "After the concentration camp float, all of the East Village was in that room," recalled Finkelstein. Before the float, eighty people might attend an ACT UP meeting. After the float, those weekly meetings grew to five hundred attendees.

With those new members, ACT UP was becoming a less homogeneous group, but in small, incremental steps. In its first months, ACT UP was mostly gay white men in their thirties—Simpson, Nesline and

Finkelstein fit the typical profile. The concentration camp float helped bring in gay men that skewed a bit younger, but overall, this new wave of members was only slightly more diverse. A veteran activist named Maxine Wolfe was one of the few women who joined following that year's Pride. Wolfe was already planning to check out an ACT UP meeting when she saw the concentration camp float at that year's Pride Parade. She was marching with City University of New York Lesbian and Gay People, which wound up being right behind ACT UP's float. At Pride, Wolfe walked up to Maria Maggenti, one of ACT UP's other facilitators and one of the few visible women in the float.

"Are there women in the group?" Wolfe asked her.

"Oh, yeah," Maggenti replied.

At the next ACT UP meeting, Wolfe saw about four women among hundreds of men—not quite the turnout she was expecting. Nor was she enthused by the lack of familiar faces. "As a person who had been active politically in New York for so many years, I walked into that room and hardly knew anybody," she recalled. But she stayed because she liked the way that ACT UP had organized itself and their meetings—it felt truly democratic in that anyone could stand up and say what they thought, propose an action or just vent their rage. And she found herself doubly compelled by the sense of urgency at those meetings, how tangible AIDS seemed. "People felt that lives depended on them," Wolfe recalled. "It wasn't like an abstract form of politics. There were people in that room who were infected. There were people in that room who had lovers who had died. . . . It was not an interesting political point. It was real. And that came through in that room."

As ACT UP's attendance had boomed, "the whole nature of ACT UP had changed," recalled Nesline. "Hundreds of people were in the room, and what had been a sort of insular and a familial kind of thing became a lot more complicated." For one, ACT UP became a much more social group. At one point, Nesline found himself standing in the back of the room and realized, "My God, it's like a major cruising scene back here, and this has, obviously, been going on for months, and I've been completely oblivious to it, because I've been up at the front of the room,

shooting my mouth off." Kramer had a similar recollection. "It became the best cruising ground in New York," he later recalled. "All the hot young men were there. Ask some of them how many guys they fucked in the cloakroom. That's a part of ACT UP people don't talk about."

As it grew, ACT UP developed a cell-like structure, composed of what became known as "affinity groups." Affinity groups often formed for particular demonstrations and were composed of people willing to take similar levels of risk and similar kinds of actions. But these groups often outlived their purpose at demonstrations and became social circles too. Often, your affinity group was whom you got drinks with after ACT UP's Monday night meetings, and whom you met up with before or at a demonstration. These affinity groups could be a bit like cliques in a high school cafeteria. There were the jocks, a group known as the Swim Team, who were mostly hairless, usually shirtless, and all looked as if they were standing around a high school pool deck. "As many bodies in search of a brain," one ACT UP member said of them. There were also those who had the patience to pore over scientific research papers and clinical drug trial information, who were seen by many as the nerds. That's part of what made ACT UP so dynamic. People who would have never otherwise talked to each other found common ground on a single issue.

There were also artists, graphic designers and others working in creative fields who began to congregate at ACT UP. Riley, the architect who had joined ACT UP's post office demonstration, was now regularly attending the Monday night meetings, as was Moffett. It was here that Finkelstein, Nesline, Moffett and Simpson would soon lay the groundwork for what became Gran Fury.

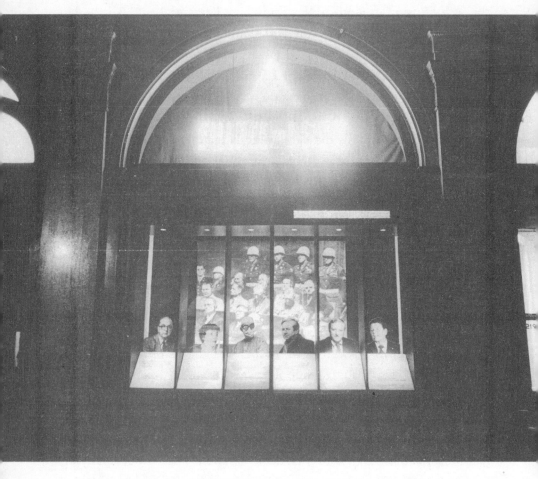

Let the Record Show . . . (Full), ACT UP ad hoc group, 1987.

CHAPTER 3
COLLECTIVITY

In making *Let the Record Show* . . . a bunch of crotchety and opinionated people found a way to work together. And it made us all feel less scared.
—Tom Kalin

ater in the summer of 1987, just weeks after the debut of the concentration camp float, a curator at the New Museum named Bill Olander decided to contact the designers of the *Silence=Death* poster. Then located on Broadway in SoHo, the New Museum had a street-facing window display, which housed rotating exhibitions. Olander wanted ACT UP to mount an installation.

A mutual friend offered to put Olander in touch with Avram Finkelstein, though Finkelstein wasn't enthused about the idea. "He knows ACT UP is a political organization," Finkelstein asked his friend, "not an art collective, right?" Finkelstein was assured that Olander understood this, but Finkelstein still wasn't interested. He believed it would be "too art-specific," and wouldn't have an impact beyond that rarified space. But their mutual friend convinced Finkelstein that he couldn't make the choice for ACT UP, and that it was ultimately the floor's decision. Finkelstein relented.

Though Olander had known he was HIV-positive for at least five years, he didn't tell this to Finkelstein, nor did he initially disclose this to any of his coworkers at the New Museum. One of Olander's coworkers speculated that, in addition to being a very private person, Olander might have been worried about losing his job and health insurance, not knowing how the New Museum's board might react if they learned he was HIV-positive. "He knew the museum needed money," recalled his coworker. "And he just didn't know if they could afford to pay his medical expenses." As it happened, the New Museum wound up covering Olander's medical expenses until he died in March 1989. But this wasn't something that Olander foresaw happening, making it all the more understandable that he would be so affected by a poster equating silence and death. "For anyone conversant with this iconography, there was no question that this was a poster designed to provoke and heighten awareness of the AIDS crisis," Olander later wrote. "To me, it was more than that: It was among the most significant works of art that had yet been done which was inspired and produced within the arms of the crisis."

Finkelstein recalled the following telephone conversation that happened in August 1987:

Olander: I want to offer the museum windows to ACT UP to stage a "demonstration" in, starting November 19th, for eight weeks. You'll need to consider the lack of climate control since the window isn't heated, and we have capacity for multiple projections.
Finkelstein: So we can do anything we want?
Olander: Anything.
Finkelstein: No content restrictions?
Olander: None.
Finkelstein: We can be as confrontational as we want?
Olander: I'm counting on it.
Finkelstein: We can name corporations and use corporate logos, even if they're museum sponsors?
Olander: Of course.

Finkelstein: Can we do street interventions that connect back to the museum, without restriction?

Olander: Yes, of course.

Finkelstein: What if we decided to wheat-paste the surrounding areas or the museum window itself?

Olander: What a great idea.

Finkelstein: You're sure about this? Once I bring it to the floor, anything can happen and there's no calling it off.

Olander: Absolutely.

Though he still wanted no part in the window, Finkelstein agreed to bring the idea to the floor of ACT UP nonetheless. But that would be the extent of his involvement.

From the get-go, Mark Simpson was enthusiastic about the window and spearheaded its production. Michael Nesline joined his best friend instinctively. Terence Riley, the architect who began attending ACT UP meetings after the post office demonstration, joined them too. Donald Moffett came over and volunteered as well, seeing this opportunity as being a perfect match for his skill set. "For those within ACT UP who considered themselves artists," Moffett reasoned, "it wasn't hard to say yes to Olander's offer, and it wasn't hard to know that that was where you needed to be."

"The New Museum Committee," as they began to call themselves, quickly decided to further the Holocaust metaphor seen in *Silence=Death* and the concentration camp float, opting to restage the Nuremberg trials, only with enablers of the AIDS crisis serving as defendants. If *Silence=Death* and the concentration camp float evoked suffering, then a restaging of the Nuremberg trials forecasted accountability. It offered a reflexive look of their own moment, imaging how future generations would see the present. "Invoking the Nuremberg trials was an act of hope," said Riley, "because it not only implied that these people were guilty, but also that they would eventually be called to justice."

On September 27, 1987, Riley and Simpson approached the floor of ACT UP, asking for supplies and assistance to produce their mock trial.

In a smaller breakout session, a relatively new ACT UP member volunteered himself. "I make photo murals," Tom Kalin told the rest of the committee. "I'm going to Chicago tomorrow and I have the negative you need."

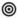

Though Kalin had only recently joined ACT UP, his activist inclinations, or aspirations, stretched back to his childhood. Being more than a decade younger than Nesline, Finkelstein and Simpson, Kalin felt like he had missed out on the experience that their generation had had with activism. "I was so full of despair that I had been born a decade too late," Kalin recalled. "I so wanted to be part of 1968." Up until his senior year of high school, Kalin dressed like a hippy, had shoulder-length hair and listened to acts like Janis Joplin and the Doors, despite all of this being a decade out of fashion. In 1978, he attended a ten-year reunion of the 1968 Chicago Convention March, attended by thirty washed-up socialists, who revived their old chants of "The whole world is watching!" despite all evidence to the contrary.

By 1979, Kalin had caught up to his own generation, having buzzed his head, bleached his hair and gotten hip to Roxy Music and the Talking Heads. It was also around this time that he began to develop as an artist, first trying out painting before he gradually transitioned into video work.

Kalin's emergence as an artist happened almost concurrently with the emergence of AIDS, and as such, his work began to deal with the crisis more explicitly as the crisis mushroomed. *Like Little Soldiers*, his first video piece responding to the crisis, was a continuous close-up shot of Kalin manically washing his hands, trying to pick off brown and white specs of paint. It captured a paranoia that's particular to the era, but wasn't the kind of overt political commentary that characterized *Silence=Death*, *He Kills Me* or the concentration camp float.

Though Kalin didn't have much actual experience in activism yet, he had a very clear sense of its history, albeit from an academic context, and was particularly versed in the history of political art. While getting his

MFA at the School of the Art Institute of Chicago, he had studied the history of political art, like the anti-Nazi propaganda of John Heartfield and the animal rights–driven illustrations of Sue Coe. Others who coalesced for the New Museum window were familiar with some of this history, but nobody had studied it as formally as Kalin, and few had such a full view of its breadth and potential.

After finishing his MFA, Kalin came to New York for the Whitney Museum's Independent Study Program, where he studied with icons of his, like Barbara Kruger. It was through one of his fellow Whitney students, Amy Heard, that Kalin first caught wind of ACT UP. "You've got to go to these meetings," Heard told Kalin. "They're completely amazing."

Kalin did, and loved what he found. "It was like the sixties again," Kalin recalled of his first ACT UP meeting. Or at least, what he had imagined the '60s to be like. "It had that romantic whiff to it, because it seemed utterly urgent, completely improvised, totally responsive and nimble in that early stage." There was an energy to the room that some found intolerable and others found intoxicating. Kalin was one of those who was enthralled. "There was no brochure," he recalled. "There was no orientation, there was no narrative to receive. You walked into this completely chaotic room that was bristling with ideas and energy and you just kind of grabbed the tail of it and held on."

For Kalin, part of ACT UP's allure was the feeling that they were carrying forward previous movements, the kind of activism that Kalin felt he had missed out on. "There was an explicit sense of an intergenerational hand off," he recalled. Here, there were veritable icons who had participated in the civil rights movement, second-wave feminism and the anti-war efforts. Maxine Wolfe had emerged as something of an elder stateswoman, and a lot of women who had backgrounds in the reproductive rights movement were bringing that organizing experience to ACT UP. There were people like Ortez Alderson, a Black Panther affiliate, dedicated anti-war activist and gay icon in Chicago. There were also a lot of older gay men who had been politically active since the Stonewall

Riots, like Vito Russo, the film historian who had written *The Celluloid Closet*, which arguably marked the birth of queer media studies. When Kalin was in high school, he had looked up "homosexuality" in the library card catalog and found Russo's name. His writing had become hugely influential for Kalin, and there was a certain thrill for Kalin to be here, working together with one of his icons. The two even became friendly, and Russo once lent Kalin some rare footage from his extensive film archive.

But Kalin was most compelled by the way ACT UP was confronting the AIDS crisis. It wasn't just people nervously palpating their glands every ten minutes. Those in ACT UP really wanted to do something about the AIDS crisis, and the energy of the room made that seem possible. "I just felt a sense of community and a sense of calm and purpose, being there," Kalin recalled. "And it was just irresistible. There was no way not to be involved." He quickly became a fixture on the New Museum Committee, and they began meeting in the studio that Kalin had received through the Whitney Independent Study Program.

By October 19, 1987, the New Museum Committee had selected their defendants and solidified a title for the installation, *Let the Record Show . . .*, a phrase borrowed from the language of court proceedings. It's a phrase often used to marshal evidence that could go unheeded, as if to say, *let the record show that government neglect enables the AIDS crisis*, or, *let the record show that not all idled.*

The New Museum Committee put on trial six public figures: Jerry Falwell, a televangelist; William F. Buckley, the columnist who had suggested tattooing all HIV-positive persons; Senator Jesse Helms, a leading proponent for an HIV quarantine; Cory SerVaas, from the Presidential Commission on the HIV Epidemic; an anonymous surgeon; and President Ronald Reagan.

They decided upon an egregious quotation from each of them, to evince their misdeeds. While spitballing, Simpson had the idea to engrave their words into stone. Moffett then suggested enlisting Don Ruddy, an ACT UP member with a concrete studio in Chelsea. Ruddy agreed to manufacture concrete slabs inscribed with quotes, but he needed help cutting

Let the Record Show . . . (Partial), ACT UP ad hoc group, 1987.

the foam letters for each mold. So on October 26th, Riley returned to the floor of ACT UP, calling for volunteers.

For the next three Wednesdays, Riley hosted around thirty volunteers at his architecture firm, as their eight drafting boards could be used as communal tables if laid flat. These letter-cutting parties, as they were later known, became the office's second life for a short time. "It was a big mess," recalled Riley. "We were like kids throwing a party at night. Everything had to be cleaned up before people came into work the next morning. It was like a condensed version of *Risky Business*." These were

not exclusive events. If you could hold a pair of scissors, you could join the club.

Two people who became core to these efforts made themselves known here. John Lindell was an artist and architect living in the East Village. He had heard about ACT UP from a friend who had attended that year's Pride, and had been enthralled by the concentration camp float like so many others. Lindell began attending ACT UP meetings too, and then roped his friend, Marlene McCarty, into working on the New Museum window. Lindell and McCarty already had some experience working collectively together, as the two had just completed a collaborative public art project. It was ten consecutive panels, placed at eye level along Eighth Avenue, that spelled out the word "Compassion." Each panel detailed a different AIDS organization. Most were for GMHC-type service

Compassion, ad hoc group, 1987. Courtesy of John Lindell.

organizations, but the "C" was for ACT UP. At the Keenan and Riley offices, McCarty immediately hit it off with Moffett, both being southerners who worked in graphic design. Moffett roped Lindell into the group right away. With McCarty, it would take another year of prodding.

It was at these letter-cutting parties that the New Museum Committee got to know each other socially. Everyone was smoking. They put on music and ordered pizza. Get-togethers like the letter-cutting parties provided a respite in the midst of the constant shock of the AIDS crisis. "Every weekend you were at some memorial service," McCarty recalled. "Or you'd see someone for the first time in six months and they'd have Kaposi sarcoma lesions." Hanging out revived their energy and helped them persevere through the crisis, and also provided some of the glue for this budding collective. "It was brutal," recalled McCarty. "But we had such a good time. It was a horrific time. But there was also joy and sexiness. It was special."

Kalin and Simpson quickly developed an intense friendship, one with an almost familial bond. "Mark and I instantly recognized each other," Kalin recalled. "I had a big rambling family like he did." Kalin being the youngest of his siblings and Simpson having often filed a parental role with his own siblings, they developed a brotherly relationship that fit the family dynamics they already knew. "We were curled into each other like two cats," Kalin recalled. The two soon became roommates and had moved into an apartment on East Ninth Street before the New Museum window even debuted.

In the days before the window's opening, the committee gathered at night, after the New Museum had closed, to install their miniature proscenium. One of the committee members, a set production designer named Neil Spisak, seamed the public officials to their cardboard backing and hung a lighting rig, so that the installation would be visible at night. The cutouts stood shoulder to shoulder, like a police lineup. A concrete slab, inscribed with a quote, sat before each official. They read as follows:

"The logical outcome of testing is a quarantine of those infected." Jesse Helms

"It is patriotic to have the AIDS test and be negative." Cory SerVaas
"We used to hate faggots on an emotional basis. Now we have a good
reason." Anonymous Surgeon

"AIDS is God's judgment of a society that does not live by His rules."
Jerry Falwell

"Everyone detected with AIDS should be tattooed in the upper fore-
arm, to protect common needle users, and on the buttocks to prevent
the victimization of other homosexuals." William F. Buckley

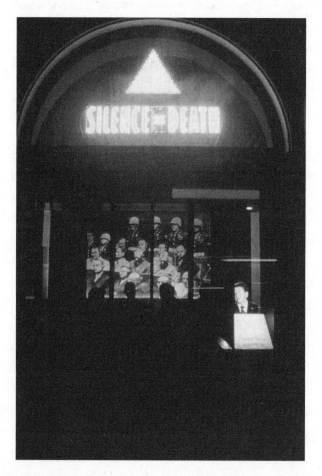

Let the Record Show . . . (Partial), ACT UP ad hoc group,
1987.

Ronald Reagan's slab was simply inscribed with an ellipsis, reflecting his silence on the crisis.

An LED sign hung over the cardboard cutouts and shuffled through statistics and information on the epidemic, namely, that twenty-five thousand Americans had already died of AIDS (we now know that, by then, it was actually closer to forty) and that Reagan still refused to speak about it extensively. ACT UP's rallying chant flashed between each statistic: "ACT UP! Fight Back! Fight AIDS!" A neon *Silence=Death* sign christened the display, like a Christmas tree topper. Including the neon *Silence=Death* sign, which literally outshone the rest of the window, signaled that ACT UP would be seen by future generations as having guided the trajectory of the AIDS crisis.

"It seemed like a transitional moment for them," recalled Hali Breindel, Simpson's surrogate sister. "It was this extraordinary validation of what they were doing. They had arrived. It felt like they were having an impact, that they were being heard and being seen."

The committee was proud of its work. In the minutes from ACT UP's next meeting, a note reads, "New Museum—window is 'fabulous' and open for ten weeks." They weren't the only ones who thought so. Shortly after its debut, a German curator, Frank Wagner, commissioned *Let the Record Show . . .* to appear in neue Gesellschaft für bildende Kunst, a contemporary art museum in Berlin.

Even Finkelstein, who had initially boo-hooed the idea, came to the opening. When Finkelstein saw the neon sign, hanging as it would have in a storefront, he thought, *ACT UP is open for business.* Standing in front of the window, he chatted with Kalin and Simpson about the possibility of working together on more projects.

Soon after the debut of *Let the Record Show . . .* an art historian and critic named Douglas Crimp cemented the importance of this kind of work. Crimp edited *October,* an arts journal with a small but influential readership of curators, gallery owners and arts administrators. As an ACT UP member himself, Crimp had watched the development of *Let the Record Show . . .* from afar, and he also happened to be in a reading group with Kalin. Crimp was, at this moment, dissatisfied with art being

made in response to the AIDS crisis, and found *Let the Record Show . . .* to be a perfect antidote to the kind of sentimentalizing and lyrical work he was seeing elsewhere. He dedicated that winter's issue of *October* to art made in response to the AIDS crisis, highlighting *Let the Record Show . . .* as something exemplary. "We don't need a cultural renaissance," he wrote in that issue of *October.* "We need cultural practices actively participating in the struggle against AIDS. We don't need to transcend the epidemic; we need to end it."

"What might such a cultural practice be?" Crimp rhetorically asked. He offered *Let the Record Show . . .* as a prime example, arguing that this particular kind of art could be used to end the AIDS crisis.

Crimp's recognition wasn't necessarily meaningful to all. "I didn't know who Douglas Crimp was from a hole in a wall," recalled Nesline. But others recognized this as something that could lead to other opportunities. "That was a pretty big spotlight to be hitting us right away," Kalin said. That spotlight didn't go unnoticed. Crimp had established this group as something worth paying attention to, and virtually every curator or arts administrator who would later fund this ragtag collective first heard of them through *Let the Record Show*

Like Kalin, Simpson saw an opportunity here and encouraged the committee to keep working together. "Mark was like a stage mother who pushed for it," Finkelstein recalled. Simpson hosted a potluck dinner, inviting everyone who had worked on *Let the Record Show . . .* , in the hopes of maintaining their momentum. That led to a smaller meeting at Riley's apartment, around the New Year of 1988, a meeting that was likely attended by Kalin, Simpson, Moffett, Lindell and Nesline.

At Riley's apartment, the group talked about designing posters, à la *Silence=Death*, that could be cheaply produced and wheat-pasted around the city. Everyone at Riley's apartment regularly attended ACT UP meetings, and so, at the onset, the group decided to produce posters in conjunction with ACT UP's demonstrations. "There was a big culture at that period of time—beyond AIDS activism or politics—of the street being the place to get information," recalled Kalin. "You could find a babysitter,

a dog walker—you could find out the newest band. Everything was going on in the street." And so that's where they wanted to be.

A logistical issue plagued the group: they didn't have a name, and "The New Museum Committee" was a mouthful. One day, Lindell walked by the New York Police Department's Ninth Precinct, on Fifth Street in the East Village, and spotted a few Plymouth Gran Furys, which was standard issue for NYPD patrol cars.

Lindell pitched the name Gran Fury and it stuck. "By bringing the name, John's position was solidified from the very first moment," Moffett recalled. The way in which he had suggested the name was also indicative of how Lindell would contribute to Gran Fury. "He wasn't the most verbose person in the room," Nesline recalled. "But whatever he had to say was genuinely contributory to the project at hand. Other people would just blather on forever, and somewhere in that word salad would be the germ of an idea, but you had to clear through the brush to get to it. With John, you never had to do that."

And of course, the name Gran Fury insinuated a kind of fabulous outrage. "Our fury *was* grand," Moffett reasoned. "It was big, and we liked that out front in the name." The group had a southern contingent and the name was suitably gothic. It sounded like a play by Tennessee Williams. But the name Gran Fury also communicated one of ACT UP's essential tenets, that performing anger effected change and that theater could be more than just spectacle.

At the fifth ACT UP meeting, months before *Let the Record Show . . .* debuted, Finkelstein noticed a new member. Actually, everyone seems to have noticed him. Steven Webb looked like a superhero, said Charles Kreloff, and he stood out from the more slender and lithe physique of guys like Nesline and Finkelstein. "Almost as quickly as I'd first noticed him," Finkelstein recalled, "I determined he was out of my league." But Webb must have noticed Finkelstein too, as he soon began volunteering for all the committees that Finkelstein joined. If

Finkelstein volunteered to do something, Webb was inevitably the next to raise his hand. For a demonstration in Boston, Webb insisted that he and Finkelstein travel together and stay with one of Webb's friends. It was here that Webb seduced him, and the two soon became intertwined in the eyes of everyone else within ACT UP. Since Webb bore a resemblance to the actor Richard Burton, this meant that Finkelstein was now going to be played by Elizabeth Taylor in the film version of ACT UP's endeavors.

It was Finkelstein's most significant relationship since Yowell's death. "Love came at a time when I thought that love could never exist for me again," Finkelstein wrote in his journal. "Steve reminded me of something I had completely forgotten . . . that my life had not ended, and with his love came hope, and hope is what we all need now more than anything else."

Within ACT UP, Webb was the collective object of desire. He worked out seven days a week and had an almost manic obsession with physical perfection. But as Finkelstein got to know him better, he started to realize that Webb had a complicated history with sex and his own physical attractiveness. As a teenager, Webb began having sex with a sports coach, one of his father's close friends. When Webb's father learned of the affair, he disowned his son. In his journal from the time, Finkelstein described Webb as having been in love with his coach, this being the man who had "brought Steve out of the closet." But as the years progressed, Finkelstein seems to have developed a more complicated understanding. In one interview, Finkelstein described this relationship as abuse, then backtracked this comment, saying that it was consensual, or at least, as consensual as it can be for a high schooler to be having sex with someone their parents' age.

Since moving to New York, Webb had supported himself as a call boy. He joined ACT UP soon after he tested HIV-positive, and enmeshed himself in this world. Webb was actually one of the architects of ACT UP's structure. Nesline recalled how, in its early days, ACT UP's meetings would often get bogged down by everyone's venting about their anxiety and the awfulness of AIDS. This continued week after week, and got

to be a bit repetitive. "You would have to have this whole preamble about how awful it all was," Nesline recalled. "It seemed like there was a lot of steam being wasted."

At one meeting, a member named Stephen Gendin suggested that ACT UP could organize itself into committees and that they could structure their meetings around each committee report upon its activities.

But it was Webb who actually outlined this structure, in what became known as "The Working Document." Here, Webb expanded upon Gendin's idea and devised the committees that would handle the more logistical aspects of ACT UP, with each committee sending a representative to brief the floor each week, so that discussions of budgets and logistics wouldn't take up too much time or suck the energy out of ACT UP's meetings. While the anger and outrage that thrived at ACT UP's meetings could propel the organization, they needed to organize themselves, and the kinds of demonstrations that they envisioned required a huge amount of administrative work and logistical planning. The structure that Webb outlined allowed these two necessary facets—the intensity of ACT UP's meetings and the time-consuming administrative work—to thrive in conjunction.

More than just an expert bureaucrat, Webb possessed a charisma the organization could rally behind. "Steven would sit so quietly in the back of the room emanating all of this kind of gravitas and power," Nesline recalled. "Then could stand up and very succinctly say something that everyone would agree with." Within such a contentious room, where discussions could often devolve into screaming matches, that ability to build consensus was invaluable. "Everyone was in awe of him," recalled Nesline.

Finkelstein and Webb dated from April to December of 1987. Just before the winter holidays, Webb broke off their relationship without any explanation. It baffled Finkelstein that Webb had pursued him so avidly, only to end things so abruptly, and without any particular reason.

The *Silence=Death* collective was still meeting when Webb broke up with Finkelstein, and the group still functioned as a forum for discussing their personal lives. Around the New Year of 1988, Finkelstein

began bugging his cohorts with questions about Webb. Why had Webb oddly positioned a bookshelf in his bedroom? Why had Webb refused Finkelstein's Christmas gift, despite having broken up? Why had Webb said thank you instead of saying goodbye? After these questions dominated several consecutive meetings, Jorge Socarrás finally grew tired of Finkelstein's constant fretting: "Stop it! I can't take this anymore!" Socarrás told the collective that, after Webb broke up with Finkelstein, he had seen Webb at the Spike, a leather bar on Manhattan's West Side. "He was with someone else," Socarrás told Finkelstein. "He doesn't want to be with you. It's over and I can't listen to this. It's over and he's not interested in you anymore. Why can't you just accept it and move on?"

That argument ended the *Silence=Death* collective. They made three posters, one of which became the defining graphic of the AIDS activist movement and gave the rationale for forming Gran Fury. After the argument about Webb, their output stopped, and Finkelstein wouldn't meet with them again for another two years, and only did so to plan the memorial service for Oliver Johnston, who died of AIDS in 1990.

The *Silence=Death* collective ultimately proved to be something of a one-hit wonder. *Silence=Death* became ACT UP's de facto logo, and is one of the most iconic and enduring political posters ever. After the incredible success of this first poster, their efforts seemed to be getting successively weaker. *AIDSGATE* didn't have the same longevity as *Silence=Death*, and their third poster was undoubtedly their weakest. It a redux of their first, and included an American flag instead of a black background, with the word "Vote" underneath the pink triangle and their eponymous text.

Though Gran Fury never made anything as singular as *Silence=Death*, they instead produced a significant body of effective projects, and managed to last a number of years. Gran Fury also differentiated itself from the *Silence=Death* collective by emphasizing that it was not an emotional support group. Whereas Johnston not disclosing his HIV status was a rift in the *Silence=Death* collective, such a disclosure was never expected in Gran Fury. In Gran Fury, you weren't expected to bring an appetizer, or lay bare your anxieties about AIDS. "With political

issues, things would be talked about in the open, scorching, bright light of day," Kalin said of Gran Fury. "But interpersonal issues were like a game of telephone." One person who later joined Gran Fury said that, even decades after the fact, he still didn't know everyone's HIV status in the collective.

Besides the argument over Webb, there were other underlying reasons for why the *Silence=Death* collective ended. Kreloff and Johnston had gotten into blowout arguments over their second and third posters, and Kreloff didn't have the energy to keep doing this. "The *Vote* poster did us in," Kreloff recalled. "I no longer had the energy to keep fighting with Oliver about design stuff like that, because it was just driving me crazy." And like the other members, Kreloff didn't feel motivated to go join something like Gran Fury. "At that point, I didn't want to keep banging my head against the wall with another collective," he said. But Finkelstein had a different outlook, and this was apparent to the other members. "Avram was really hungry for it," Kreloff recalled. "*Silence=Death* whet his appetite." But after the argument over Webb, that appetite would not be satiated here.

A few days after the last *Silence=Death* meeting, Webb took his own life. Tracing the months between their breakup and Webb's suicide, Finkelstein uncovered a troubling pattern: Webb had begun distancing himself from those to which he was closest. He even made a point of visiting his therapist to say that he was fine, and it soon became clear to Finkelstein that abruptly ending their relationship was part of Webb's months-long plan to kill himself.

Webb might not have been the first ACT UP member who died, but his suicide was the first death that was widely felt throughout the group. "Steven Webb's death was an enormously disturbing event in the life of ACT UP," recalled Nesline. AIDS had engendered an acute sense of life feeling precarious, and ACT UP prided itself in resisting that precarity. For Webb to commit suicide, especially while he still seemed healthy, was incredibly demoralizing.

Finkelstein flew to St. Louis for Webb's open-casket funeral. Before they shut his coffin, Finkelstein snuck an early mock-up of the *Silence=Death* poster into one of Webb's pockets.

When he returned, Finkelstein organized a memorial service for Webb, and after giving a eulogy, he invited others to share their memories of Webb. In his typical fashion, Nesline caustically mused that, if Webb had wanted to die, then why not take Jesse Helms with him?

But as others began to speak, it became clear that, for most of those assembled, Webb had been little more than eye candy. One after another, people got up to talk about how good-looking Webb had been. "I remember him on Fire Island," one person recalled for those assembled. "The first time I saw him and how he looked in a bathing suit." To Finkelstein, all of it seemed doubly insensitive, both to say this immediately after the impassioned eulogy he had given and to reduce Webb to a piece of meat at his own memorial service.

Finkelstein left the room in tears and went on an impromptu trip. He packed a bag, boarded a bus and headed east out to Long Island, to stay with a friend who lived out at the beach. With his parents just a drive away, Finkelstein's father came to console him. They started to talk about what Finkelstein was doing with ACT UP, and Finkelstein's father tried to temper his son's expectations for what they could reasonably accomplish. "You know, I really love what you're doing, Av," his father told him. "But there will never be a revolution in America so long as there's television." Finkelstein's father was a bit of a fatalist when it came to change, and felt that nothing short of a full overhaul of American capitalism would produce a meaningful difference. Finkelstein's father had said a version of this many times before, and Finkelstein had been willing to engage with it in the past. But with Webb's death so fresh in his mind, Finkelstein wasn't willing to indulge this conversation again.

"This is the last time we're having this conversation," Finkelstein told his father. "I have two choices: I can do nothing—and I know what happens if I do nothing. People continue to die. Or I can try something. Maybe it will work, and maybe it won't. And if it doesn't work, I'll try

something else. And maybe less people will die. So, we're never having this conversation again. It doesn't matter whether there will be a revolution. People are dying. There really isn't a choice."

By the end of that February, Finkelstein had made his choice. He was joining Gran Fury.

ACT II

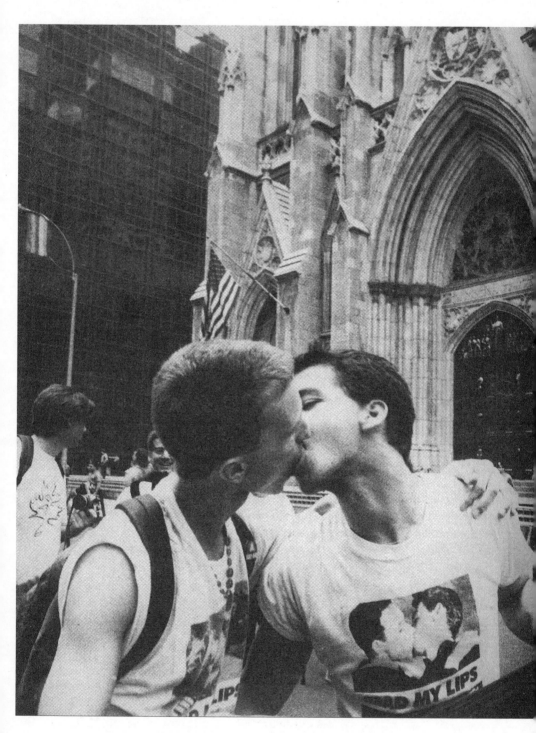

Photograph by Ben Thornberry.

CHAPTER 4
FALSE STARTS

If you're angry enough and have a Xerox machine and five or six friends who feel the same way, you'd be surprised how far you can go with that.

—Loring McAlpin

In the fall of 1987, Maxine Wolfe hosted a dinner for the women of ACT UP, the first of many, and what became known as the Dyke Dinners. When Wolfe had attended her first ACT UP meeting, just after the debut of the concentration camp float, she saw about four other visible women in the room. By the end of 1987, there were more, but still few. So Wolfe began organizing these dinners as a forum for the lesbians of ACT UP to get together and talk about their place in the organization. AIDS seemed to primarily affect gay men and intravenous drug users, and ACT UP was overwhelmingly gay white men. What were they, as women who didn't fit either of those categories, doing in ACT UP? Why were they there?

One day in January 1988, an ACT UP member named Rebecca Cole brought a recent copy of *Cosmopolitan* magazine to a few of the other women in ACT UP, and with it brought an answer to these questions. Cole had been shocked by the magazine's Cindy Crawford–clad cover that read, "A Doctor Tells Why Most Women Are Safe from AIDS."

Inside the magazine, a professor of obstetrics and gynecology at New York Medical College, Robert Gould, told *Cosmopolitan*'s readership, "There is almost no danger of contracting AIDS through ordinary sexual intercourse"—ordinary being defined as "penile penetration of a well-lubricated vagina." Only sharing needles and anal sex could transmit HIV, he alleged, and the virus "will not be transmitted during vaginal sex from an infected person to his or her partner" if both are free of lesions. Attempting to explain the high rates of heterosexual transmission in Africa, he wrote that "many men in Africa take their women in a brutal way, so that some heterosexual activity regarded as normal by them would be closer to rape by our standards and therefore would be likely to cause vaginal lacerations through which the AIDS virus could gain entry into the bloodstream."

On January 11, Cole came to the floor of ACT UP and proposed a demonstration at *Cosmopolitan*'s Fifty-Seventh Street headquarters. Even the men were enthusiastic about it, and the date of January 15, the coming Friday, was selected. At that point in time, Cole happened to be best friends with Mark Simpson. The two had just spent Christmas together with Cole's family, Simpson being estranged from his own, and Cole had learned firsthand of Simpson's obsession with collectible dinnerware after she woke up one morning to find Simpson and her mother vigorously debating the merits of different china and majolica patterns. So perhaps it's unsurprising then that the newly formed Gran Fury decided to produce something in conjunction with the upcoming demonstration.

Cole recalled an anecdote that's telling about how Simpson approached these sorts of projects. Years later, Cole wanted to start a gardening business but told Simpson that she doubted her capabilities. "I don't even know where to buy flowers," she told him.

"What's your favorite flower shop?" Simpson asked her.

"VSF in the West Village," she said.

"Let's go pick through their garbage," Simpson suggested. "We'll find their receipts and we'll figure out where they get their shit from."

That was the kind of gung-ho attitude that Simpson brought to Gran Fury. "He was the essence of fearless," said Cole. "Gran Fury was Mark.

He was the heart and soul of it all, the bravery of it all. They wouldn't have gotten as far as they did if it wasn't for him." But with the demonstration just four days away, it was a seemingly impossible time frame. *Let the Record Show . . .* had taken months to complete, and *Silence=Death* was the better part of a year's work. Nor did a project for the *Cosmo* demonstration have any guidelines or parameters that helped conceptualize an idea. *Let the Record Show . . .* had certain givens, like an installation date, a budget and dimensions for the window—limitations that helped narrow the scope of possibilities. The concentration camp float had similar guardrails, as their entry for Pride had to be some sort of float or mobile contingent. Without any guidelines or constraints, it could be anything.

But their efforts were buoyed by a newly released and shocking statistic. Two days after Cole approached the floor of ACT UP, the *New York Times* ran an article detailing how one in every sixty-one babies born in New York City had antibodies for AIDS. A child born with antibodies surely meant that the mother was HIV-positive, and an estimated 40 percent of these newborns had contracted the virus themselves.

Gran Fury seized upon this statistic, as it disproved Gould's claims of heterosexual immunity while also explaining why heterosexual transmission wasn't a bigger news story. The locale of HIV-positive newborns varied in telling ways: in primarily white upstate New York, 1 in 749 babies was born with HIV antibodies; in the primarily Black and Latinx Bronx, it was 1 in 43.

They titled their poster "AIDS: 1 in 61," reflecting the overall number of HIV-positive newborns in New York City, and coupled this with a stencil of a seemingly discarded baby doll, along with four separate blocks of text arguing that the myth of heterosexual immunity was directly tied to the fact that these babies were primarily Black and Latino.

Most members of Gran Fury consider *AIDS: 1 in 61* to be one of their worst posters, and it's easy to see why many of them groan when recalling it. Unless you stopped to read the entire poster, the correlation between the title and the stenciled baby is unclear. For some future projects, Gran Fury would create an alternate poster with a Spanish translation. Here, they crammed both translations onto the same poster. Even without the

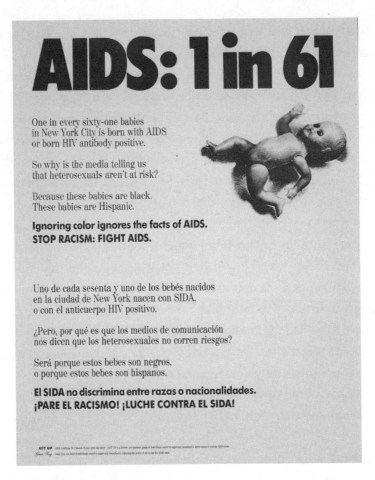

One in every sixty-one babies
in New York City is born with AIDS
or born HIV antibody positive.

So why is the media telling us
that heterosexuals aren't at risk?

Because these babies are black.
These babies are Hispanic.

Ignoring color ignores the facts of AIDS.
STOP RACISM: FIGHT AIDS.

Uno de cada sesenta y uno de los bebés nacidos
en la ciudad de New York nacen con SIDA,
o con el anticuerpo HIV positivo.

¿Pero, por qué es que los medios de comunicación
nos dicen que los heterosexuales no corren riesgos?

Será porque estos bebes son negros,
o porque estos bebes son hispanos.

El SIDA no discrimina entre razas o nacionalidades.
¡PARE EL RACISMO! ¡LUCHE CONTRA EL SIDA!

AIDS: 1 in 61, Gran Fury, 1988.

Spanish translation, *AIDS: 1 in 61* looks text heavy. Almost without exception, Gran Fury made its best work when prioritizing succinctness, as wordiness often proved to be the enemy of good poster making. While Avram Finkelstein and co. had wanted the *Silence=Death* poster to be legible from a moving vehicle, *AIDS: 1 in 61* is hardly readable, even from a couple of feet away.

Furthermore, it doesn't seem as if Gran Fury actually produced *AIDS: 1 in 61* in time for the demonstration, as the poster doesn't appear in any of the footage captured that day. And without the context of the demonstration itself, the line "So why is the media telling us that heterosexuals

aren't at risk?" reads as vague, as it's unclear who within the media is supposedly telling us this.

In any case, ACT UP seems to have fared without the poster. Despite its being one of the coldest days of 1988, with a low of five degrees, they fielded a decent turnout at *Cosmopolitan*'s Midtown headquarters. The next Monday, Cole and a few other women from ACT UP publicly confronted Gould on a local television program, *People Are Talking*. Here, Gould reiterated an earlier claim that women living with AIDS were lying about having had anal intercourse. He cited a study in which 60 percent of women said they had had anal sex, and reasoned, "That doesn't include the others who didn't want to admit it." After they tried to disrupt the all-male panel, the show's host, Richard Bey, had security eject them. By the end of that week, Gould had gained a national audience, appearing on Ted Koppel's program *Nightline* along with *Cosmopolitan*'s editor-in-chief, Helen Gurley Brown. Koppel seems to have shared some of ACT UP's skepticism. He asked Brown, "When your readership, ten million mostly young women, read an article like that, and draw the conclusion that, therefore, maybe they don't need to urge their partners to use condoms, do you feel entirely comfortable with that?"

"I feel quite comfortable with this," Brown said.

To this day, no one from *Cosmopolitan* has ever recanted what Gould wrote. (As of this writing, that issue is curiously absent from *Cosmopolitan*'s otherwise comprehensive ProQuest archive.)

But the cumulative efforts of ACT UP did manage to bring public attention to the lies propagated by this article. Dr. Anthony Fauci soon denounced the article. C. Everett Koop, the surgeon general, similarly identified this article as extremely dangerous when he testified before Congress weeks later. "It is just not true," he said. Buoyed by this success, the women who coalesced around the *Cosmopolitan* demonstration decided to continue working together and formed a caucus within ACT UP dedicated to addressing the ways in which the AIDS crisis affected women and sexism exacerbated the crisis.

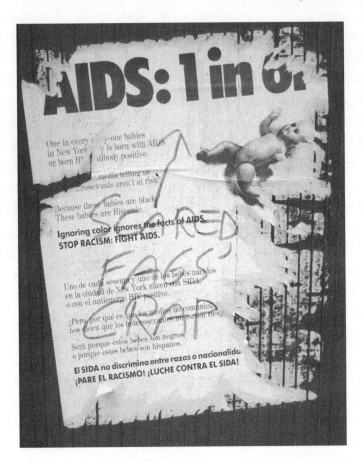

Photograph courtesy of Gran Fury.

But it's difficult to see Gran Fury as having meaningfully contributed to any of these efforts.

AIDS: 1 in 61 failed in every imaginable way, except for one. Across the bottom of the poster, in small type, it reads, "Gran Fury is a band of individuals united in anger and committed to exploiting the power of art to end the AIDS crisis." It was the first time that Gran Fury had articulated what it was. If Douglas Crimp had called for art that could end, not transcend, the AIDS crisis, then this was Gran Fury positioning themselves as the answer to his provocation. If nothing else came from *AIDS: 1 in 61*, at least Gran Fury had defined itself.

◎

Loring McAlpin was walking up Broadway when he happened upon *Let the Record Show . . .* He was an artist who had recently joined ACT UP, and the window had left quite an impression upon him, as it stood out from the usual wheat-pasted flyers that McAlpin saw around the Lower East Side. It was explicitly political, but it also was of a high production value, a winning combination that he wasn't seeing elsewhere around the neighborhood.

For McAlpin, the AIDS crisis began just as he came out. Being the son of a Presbyterian minister, McAlpin had often moved throughout his childhood, though he had spent his early years, a bit of high school and the beginnings of college in Princeton, New Jersey. After completing part of his education at Princeton University, McAlpin took some time off. He intended to return but felt that he needed to come out first, and that he couldn't do so in the confines of his hometown.

McAlpin went to San Francisco in 1980, transferring to an art school there. "I had a hard time coming out, even in San Francisco," McAlpin recalled. "Which at that time seemed like the gayest place in the entire universe." McAlpin finally came out in the summer of 1981. The same week that he began to tell his friends and family that he was gay, the *New York Times* reported upon the first AIDS cases. "I remember sitting in the kitchen nook of my communal apartment in San Francisco's Mission District," he recalled. "Reading the paper, wondering what kind of mess I was in even as the relief of coming out resonated inside me." Over the coming years, McAlpin and his friends struggled to figure out what this all meant for their lives. The HIV virus had yet to be identified, and all of them were trying to figure out how this new thing was transmitted, having barely had any experience with sex itself.

By the mid-1980s, McAlpin had finished his studies at Princeton and moved to New York City. It took him a few years to situate himself as a gay man. "I hadn't really found a community in bars or in nightlife," he recalled. "I'd go out occasionally, but I didn't really find that fulfilling. But I knew that I needed some community to be a part of." He started to volunteer at the GMHC hotline but still wasn't finding the kind of community with which he felt satisfied. Then through the hotline he

heard about ACT UP, and brought along some of his friends. "It was a really important way of orienting myself in New York," McAlpin recalled, and it also became a way for him to see his friends in a setting that wasn't a bar or a club, and for them to be part of something that felt important. And it was also a way of overcoming the sense of fear about AIDS that he had felt since coming out. "It felt prophylactic," he recalled of joining ACT UP, "because you were transmuting this interior dread into action."

McAlpin could be a bit shy, and though he loved going to ACT UP meetings, he found the larger floor to be intimidating. "I was not the kind of person that threw myself into discussions on the floor," he said. "I just needed to get involved in a smaller group of people, and that's what I did."

At an ACT UP meeting, soon after he saw the window, McAlpin learned that it would be deinstalled soon. He offered to help, and stayed with Gran Fury.

Through the rumor mill of ACT UP, it quickly became known among the rank and file that McAlpin was a Rockefeller. McAlpin was, like everyone else here, a complicated and multifaceted person, someone who was looking for a sense of gay community that he wasn't finding in the bars and clubs, and who aspired to be a visual artist. But he never outlived his reputation as being the rich kid. His penthouse loft on Great Jones Street certainly didn't help with this.

While most of ACT UP's members might make snide remarks about this, his family pedigree played out differently within Gran Fury. Some of the collective's other members saw McAlpin as someone whose family background gave him an innate understanding of how arts institutions, galleries and museums tended to operate. "We operate in one way," Donald Moffett said of Gran Fury's southerners. "We're loud, and we had to push our way in. Loring was already in. He knew how it all worked, whereas we could only bulldozer our way through." McAlpin could be a bit more calculated and was someone who understood how power operates, in ways others in Gran Fury didn't. "He's very discreet," Moffett recalled, "but he would gently use those skills and that knowledge base to Gran Fury's advantage."

Granted, not everyone in Gran Fury saw McAlpin in this way, and the collective seems to have been genuinely split over whether or not McAlpin's family pedigree endowed him with a greater ability to intuit the ways in which power operates. And McAlpin also doubted the idea that his background actually imbued him with this knowledge. "My father was a Presbyterian minister who worked with Habitat for Humanity," McAlpin reasoned. "Not some finance guy on Wall Street."

Though ACT UP provided McAlpin with the kind of community he had been craving, working with Gran Fury illustrated the difficulties of maintaining this. "It was by no means an easy group to be in," McAlpin said. "I often felt that I had to fight really hard to be heard and to get a point across, and I really put in a lot of effort to stay in good graces there. And do a lot of shit work."

"When I didn't feel supported by the rest of the group, I knew I could count on Mark Simpson," McAlpin recalled. "He was a really solid guy and I knew that he would stand up for me." Several members of Gran Fury described Simpson as the collective's glue, and being the collective's oldest member, he filled an almost parental role, especially for some of the younger members. "Mark was so deficient in taking care of himself and tending to himself," Tom Kalin recalled. "But he was really attuned to other people and trying to bring together a group." And it was Simpson's drive that helped propel Gran Fury through its initial failures. "Gran Fury would not have happened without Mark," recalled Finkelstein, who had joined Gran Fury by this point. "I was drawn into Gran Fury because of Mark," he added. "I felt this allegiance towards him that I didn't feel towards anyone else in Gran Fury."

McAlpin joined Gran Fury just as ACT UP was about to commemorate its first anniversary with a trip to Wall Street. Little had changed in the past year. AZT was still the only drug approved to fight HIV, and it was becoming clearer that the drug's potential was limited. No generic existed, and the FDA had yet to approve other drugs for slowing the progression of HIV. In 1987, the federal government promised to stage a nationwide campaign to educate the public on HIV transmission. By 1988, one still didn't exist. And the number of people dying of AIDS

was still climbing rapidly. When ACT UP first formed, over twenty-five thousand Americans had died of AIDS. Now, that number was close to fifty thousand.

This would be ACT UP's second of many such demonstrations on Wall Street (and a full year and a half before they managed to sneak into the New York Stock Exchange). Instead of a poster, Gran Fury printed a series of fake paper bills for this anniversary demonstration, with slogans crafted by different members. The size of the bills forced them to be a bit more concise than they had in *AIDS: 1 in 61*. Here, you can see the beginnings of a distinctive voice, one that would become synonymous with Gran Fury's work.

White Heterosexual Men Can't Get AIDS . . .
DON'T BANK ON IT.

WHY ARE WE HERE?
Because your malignant neglect KILLS.

FUCK YOUR PROFITEERING.
People are dying while you play business.

Xeroxing sheets of fake ten-, fifty- and hundred-dollar bills onto green construction paper, they cut the bills by hand, to be passed out at the demonstration.

Those bills would later find their way onto the floor of the New York Stock Exchange, but they first appeared on the morning of March 24, 1988, as ACT UP's members gathered on Wall Street to block traffic. They organized themselves into predetermined "waves," so that one wave would walk into the street, sit down and wait to get arrested. With traffic stopped, the members of Gran Fury handed out their fake currency, pinning it to windshields or throwing it at cars. With one group arrested, the next wave replaced them, and so on. From Gran Fury, John Lindell, McAlpin and Moffett were all arrested that morning and charged with disorderly conduct, along with over a hundred ACT UP members. The

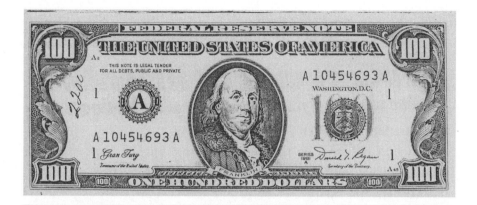

Wall Street Money, Gran Fury, 1988.

police first threatened to hold them for the weekend, but then released them promptly, and all three eventually had their charges dismissed.

Gran Fury's *Wall Street Money* fit in with the larger theme of the demonstration, which was the role of money in the AIDS crisis: "No more business as usual," as ACT UP put it. But rather than make a singular demand, ACT UP was free associating about this correlation between AIDS and money. They were, at once, demanding more money for AIDS research, while also advocating for a lower cost of AZT, while protesting those who stood to profit from the epidemic. All of those topics are related to the intersection of money and AIDS, but it became difficult to parse, exactly, what ACT UP wanted out of this demonstration.

There were also seeming gaps in logic between the location of the demonstration and what they were demanding. Though it was a publicly traded company, Burroughs Wellcome, the manufacturer of AZT, didn't

actually trade on the New York Stock Exchange. Nor are the bodies responsible for appropriating funding for AIDS research located on Wall Street.

But ACT UP did manage to secure significant media attention, despite the variety of their demands. *Newsday* ran a lengthy article on the demonstration with two photos of ACT UP's members, and some ACT UP members appeared on the evening news. Even the *New York Times* covered the demonstration, albeit deep into the Metropolitan section.

What's striking about the coverage of the demonstration was the extent to which newspapers and passersby echoed the language of ACT UP's posters, which were clearly beginning to filter into the public's consciousness. One passerby, an insurance consultant, seemed to reiterate the logic of *Silence=Death* when speaking to a reporter from *Newsday*. "I think they should speak up," she said. "It's akin to the Holocaust if they don't."

But Gran Fury's *Wall Street Money* failed to make an impact, at least on this trip to Wall Street. Part of the problem with *Wall Street Money* is that it doesn't photograph well from a distance, something that later became integral to the dissemination of Gran Fury's work. And since the slogans printed on their fake cash were directed at stockbrokers and day traders, the project backfired when handed to anyone else. Lindell mused, "What message did those grandmothers and secretaries get, exactly, from 'Fuck your profiteering'?"

Even for those bankers and traders who did receive the bills, it became easy to toss them aside. Richard Deagle, one of those who participated in this Gran Fury project but quit soon thereafter, recalled that he handed a bill to a pedestrian who read "Fuck your profiteering" and shoved the bill back into Deagle's coat. City dwellers, especially New Yorkers, are accustomed to either avoiding paper handouts or throwing them away. That a bunch of New Yorkers rushing to work would accept Gran Fury's bills, pause, read their message and genuinely reflect upon it was wildly optimistic. *Wall Street Money* had a very specific audience, and Gran Fury hadn't yet figured out how to hold them captive. So they shelved the project, albeit only temporarily.

On April 5, a week after the Wall Street demonstration, the members of Gran Fury approached ACT UP's coordinating committee, asking for money to help fund their projects. ACT UP's general meetings may have been the life of the organization, but the coordinating committee was where major decisions were often made. An insular group, it had much leeway over ACT UP's trajectory and had plenty of discretion when it came to spending. If you needed money from ACT UP, you went to the coordinating committee, and as 1988 wore on, the name "Gran Fury" increasingly began appearing in the minutes from their meetings.

Financing was, from the get-go, a near constant struggle for Gran Fury. Projects like *Wall Street Money* could be easily xeroxed, usually at someone's office after working hours. But anything more complex than a single color, or anything much larger than a standard sheet of paper, required paying a professional printer. *Let the Record Show . . .* , the only real success that Gran Fury could claim, had been quite expensive. "They gave us $200," as Simpson put it, "and we spent $2,000." If Gran Fury was going to succeed, then they would need a consistent source of funding.

One member of the coordinating committee, Jim Eigo, recalled that Gran Fury's request for money launched a rather contentious discussion. Bob Rafsky argued passionately against giving Gran Fury any money. Rafsky was one of ACT UP's most recognizable members; he often acted as a spokesperson and was one of the progenitors of the organization's media strategy. He had once been a senior vice president at one of the city's top public relations firms, Howard J. Rubenstein Associates, but he had quit and dedicated himself to ACT UP once he tested HIV-positive.

Rafsky was skeptical of Gran Fury. "They were pitching themselves as being our poster factory," recalled Eigo. But it wasn't clear that ACT UP actually needed something like this. They already had *Silence=Death*, which had become their de facto logo. Another graphic designer, Ken Woodard, often made posters for individual demonstrations, as did a host of other graphic designers. At the recent Wall Street demonstration Woodard's *AID$ Money* poster had captured much more media attention than Gran Fury's *Wall Street Money* project. Furthermore, the coordinating committee had already given Gran Fury $500 for the cost of printing its projects. *AIDS: 1 in 61* hadn't panned out, nor had their fake cash.

The only real success they could claim was *Let the Record Show . . .* This wouldn't have swayed Rafsky much. "Rafsky was in advertising," recalled Eigo. "He had no use for artists who weren't pushing product."

Still, Gran Fury did have some vocal supporters on the committee. "I was the only committee member that spoke strongly in favor of it," Eigo recalled. In his estimation, having artists, museums and writers addressing AIDS signaled the importance of the crisis, thereby rationalizing ACT UP's efforts. ACT UP had planned a series of demonstrations called the Nine Days of Rage, consecutive protests to address different facets of the AIDS crisis at locales around the city. Eigo felt that having Gran Fury produce a poster for each day of rage would significantly aid ACT UP's efforts. Furthermore, Gran Fury was only asking for a couple hundred dollars, so it didn't seem like much of a commitment. Ultimately, the coordinating committee sided with Eigo, and Gran Fury received a couple hundred dollars for the production of these posters. Rafsky chose to abstain rather than cast a nay vote.

At this point, Gran Fury had an open and often rotating membership. Four people might show up to one meeting, then twenty at the next. They hadn't yet found their process, and many core members recalled that, at these early meetings, time would often be wasted in explaining what had happened the previous week. Gran Fury's contributions to the Nine Days of Rage reflected these early problems. They divvied the work, and various members volunteered for different days of rage. It was a working method they soon abandoned. Some members of Gran Fury, like Moffett, could produce a poster on their own, as Moffett had with *He Kills Me.* But not everyone had the requisite graphics skills to see a poster through to completion. Someone like Michael Nesline was a natural wordsmith. His copywriting skills were invaluable to the collective, and his experience as a nurse in an AIDS ward later provided an on-the-ground perspective that would become integral to Gran Fury's work. He had always had a knack for language. "When I was a kid, the nuns had us diagramming compound-complex sentences," Nesline said. "And I loved it." But Nesline wasn't someone who could conceptualize and produce a poster on his own. When he was assigned to produce something for ACT UP's kiss-in,

a demonstration that riffed on the sit-ins of the civil rights movement, Nesline was totally lost. "I had no fucking idea what I was going to do," he recalled.

"Tom, help me," Nesline told Kalin.

Lucky for Nesline, Kalin had a kernel of an idea. Kalin recalled that he had been searching for slogans, the way that his mentor Barbara Kruger would. The phrase "read my lips" had been buzzing through Kalin's head, and he figured that maybe this phrase could be the beginning of a poster for ACT UP's kiss-in.

"Read my lips: no new taxes" was George H. W. Bush's central campaign promise for the 1988 presidential election, and Kalin recalled that he first heard Bush use the phrase "read my lips" before bringing this slogan to Gran Fury. However, the first available record of Bush using this phrase is in August 1988 at the Republican National Convention, several months after Gran Fury's *Read My Lips* debuted. Still, Kalin insists that he had heard Bush use it before bringing it to Gran Fury, and that Bush must have been testing this phrase on the campaign trail before using it at the National Convention. Either way, Bush enunciating "Read my lips: no new taxes" at the National Convention only bolstered the popularity and significance of Gran Fury's first success.

"Read my lips," as a slogan, happened to pair with an image that came to them serendipitously. After Gran Fury invited anyone from ACT UP to work on these posters, an ACT UP member named Mark Harrington came to the next Gran Fury meeting smirking, and brought along a photograph of two sailors, kissing and with their dicks hanging out.

Though Harrington's tenure with Gran Fury was brief, he was instrumental in two of the collective's most well-known projects, *Read My Lips* being the first. He had joined ACT UP shortly before the group's anniversary demonstration at Wall Street and was arrested in the third wave of activists who blocked traffic, a group that went on to be known as Wave III. One of those who was arrested with Harrington that morning was Marsha P. Johnson. Known as the "Mayor of Christopher Street," Johnson was a trans icon who is often credited for having begun the 1969 Stonewall Inn Riots, effectively launching the modern-day gay liberation

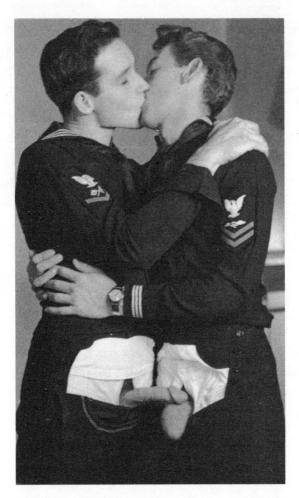

Courtesy of the Kinsey Institute.

movement. Sitting at the precinct together, Harrington asked Johnson what had been playing on the jukebox when the police raided the Stonewall Inn. Marvin Gaye, she told him, "I Heard It Through the Grapevine."

All of that invigorated Harrington. He was, like many others in these early years, overly optimistic about what it would take to end the AIDS crisis. "We all felt then that if we just worked hard enough for a year or two, we could uncover some sort of cure and get it distributed," Harrington recalled. "And also, along the way, end legalized homophobia, bring pharmaceutical capitalism crashing to its knees . . . and, just possibly, establish national healthcare." A tall order for a year's work.

Coupled with this optimism was a very obvious intelligence. For his undergraduate thesis at Harvard, Harrington had co-translated a Walter Benjamin essay, "Central Park," which hadn't been previously available in English. But after college, Harrington hadn't yet found his niche, either in life or in ACT UP. He had a vague idea that he wanted to be in "the arts" but on any given day felt like that could mean being a DJ, a visual artist, a scriptwriter, a musician, a collagist or any number of creative professions. Within ACT UP, he similarly bounced around between committees, and his brief tenure with Gran Fury was part of this. "I was doing my mid-twenties with great glee and abandon," he recalled. He had been fired as a waiter, twice, after which he began a part-time data-entry job at a film archive. It was here that Harrington found the image of the two kissing sailors. It seemed to be the perfect match for Kalin's "Read My Lips" slogan, something Finkelstein recalled as being one of Gran Fury's "rare 'Aha!' moments."

Without anything more advanced at his disposal, Harrington used a Xerox machine to enlarge the original photo and added a halftone effect, giving it a grain. Kruger gave Kalin the contact information for her typesetter in Chinatown, where Gran Fury had the poster typeset. Kalin suggested that they use Futura Extra Bold Italic for the typeface, parroting Kruger's work. When she saw the poster, Kruger feigned mock annoyance, as it was clearly a rip-off of her work. She later came around though. Years later, one member of Gran Fury bumped into Kruger at an art opening and told her, "You know, we owed you a lot."

"I know," Kruger replied. "But I'm glad that you did it."

One of the most important decisions that Gran Fury made when crafting this poster was to crop the source image, though accounts differ as to when this actually happened. Finkelstein is absolutely certain that Harrington brought in the full, uncensored version, and that they then decided to crop it. Kalin is just as certain that Harrington brought in a cropped version, and that they only saw the full version later. Harrington doesn't remember which version he brought to them. Either way, cropping the image did more than just edit out the sailors' penises. In the source image, the sailors are clearly presenting their penises for the

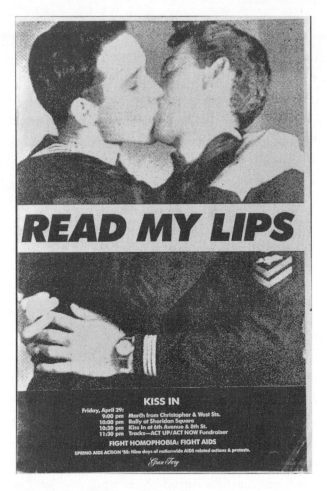

Read My Lips (Men's vers.), Gran Fury, 1988.

viewer. How they angle their bodies suggests that they are keenly aware of the presence of a camera, that they are being photographed and ogled. Cropping out their lower halves removes the suggestion that someone else is in the room. Seen just from the waist up, they appear to be entirely focused on each other. Their pleasure is for themselves.

If you consider the projects that preceded it—*Silence=Death, AIDS-GATE, AIDS: 1 in 61, Wall Street Money*—*Read My Lips* was a tonal shift for ACT UP's graphics. "You could start to feel the sexiness coming back," recalled McAlpin. "You had a sense of '*Yes. We can have sex. But we just have to have safer sex.*'"

The fact they were sailors, and that the image is clearly historic, recalls *V-J Day in Times Square*, the famous photo of a sailor kissing a nurse in Times Square. In choosing two sailors, *Read My Lips* implicitly emphasizes how common it is to see heterosexual couples kissing. And once you make the connection to the sailor at Times Square, the composition of *Read My Lips* becomes all the more important. In *V-J Day in Times Square*, the nurse is forced into a stance where she cannot stand on her own, and has to rely upon the grasp of the sailor to not fall. In *Read My Lips*, both of the sailors can stand independently of each other. Notice all the symmetry and right angles: They are the same height, almost twin-like, and both of their arms form right angles. It's compositionally serene. This sort of symmetry was often used in classical paintings to denote reason and order, a correct way of being. It's ordered, reasonable and natural, which is to say, the opposite of what is being said of gay men in this moment.

Lip reading is a cross-sensory experience, trying to use one's eyes to compensate for what should be heard by the ears. Read my lips, which is to say, trust your eyes. Believe what you see rather than listening to the

Photograph by Victor Jorgensen.

static. To say "read my lips" is a bid for attention first, then focus, a commandment to not look away, an immensely powerful gesture since this was a poster designed to appear in a city street, an environment with an infinite number of ever-changing distractions.

Gran Fury also tried to create a lesbian counterpart to *Read My Lips*, though it took several attempts to find something to match the verve of the sailors. Vintage gay pornography was easy to come by, but when they went searching for an image of two kissing women in the Lesbian Herstory Archives, the most comprehensive archive of lesbian history and culture. Even here, their options were limited. They settled upon an image of two flappers gazing into each other's eyes and made a poster almost

Read My Lips (Women's vers. 1), Gran Fury, 1988.

identical in composition to that of the sailors. ACT UP's Women's Caucus wasn't too thrilled with it. Compared to the sailors, it looked so sterile and inhibited.

But Gran Fury showed a willingness to try and improve upon its previous failings, especially when it came to issues of visibility and representation. They made another version, with two Victorian women kissing, which was a bit better but still didn't have the same sense of passion as the two sailors. They started to realize that they were confronting a greater dilemma. If they couldn't find a better image in the Lesbian Herstory Archives, then it seemed to point toward a larger problem with lesbian representation. Of the few images that they could find of two women kissing, all of them were similarly lackluster. It would take another year to find a suitable counterpart.

Read My Lips (Women's vers. 2), Gran Fury, 1988.

Read My Lips first debuted as a poster, and the kiss-in that it advertised was massively successful. According to Kalin, the kiss-in was planned to fake out the police. ACT UP's members had begun to march toward the West Village, and instead of staging a protest or holding signs as the police expected, everyone just started kissing each other. It was pouring rain that night, and while some brought umbrellas others seemed content to get soaked. They kissed their lovers, friends and strangers, all with the same full-mouthed passion of Gran Fury's sailors. Then they formed two parallel lines, facing each other but moving in opposite directions, to maximize the number of people that they could kiss. It was like an assembly line for pecking. The writer Wayne Koestenbaum recalled happening upon the demonstration in his essay "My 1980s": "A stranger smooched me during a 'Read My Lips' kiss-in near the Jefferson Market Public Library: festive politics. 1985? I stumbled on the ceremony. Traffic stopped."

Gran Fury produced a few other projects for the Nine Days of Rage, but with the efforts divvied among a fluctuating membership, only a few were completed. In these posters, you can see the traces of its members and their personalities more clearly than in some of the collective's later work.

Lindell made a stark black-and-white poster for this series of demonstrations that read, "All People with AIDS Are Innocent," a refutation of how hemophiliacs and children born with AIDS were often spoken of as the disease's "most innocent victims," a statement that implies that some are more deserving of AIDS than others. "It seemed so adamant and objective to do it in black and white," Lindell reasoned. The poster likewise captured Lindell's personality and his contributions to Gran Fury. As when Lindell had suggested the name Gran Fury, his ideas were carefully considered, already thought through and brief. He preferred not to blather and think out loud, as some of the other members did. "The look of *All People with AIDS Are Innocent* could not be more John Lindell," Kalin reasoned. "The cleanness of it. The white space of it. The use of the caduceus. So yes, that's Gran Fury. But it's Gran Fury through the very specific lens of John."

All People with AIDS Are Innocent, Gran Fury, 1988.

Similarly, *Read My Lips* undeniably bore traces of Kalin. The homage to his teacher Barbara Kruger, an obsession with kissing and his interest in the history of gay men all congealed here.

With one of these other projects for the Nine Days of Rage, Gran Fury didn't bother to censor their pornographic material, as they had with *Read My Lips*. Donald Moffett walked into a Gran Fury meeting with the finished version of *Sexism Rears Its Unprotected Head*, a poster with a disembodied and erect penis. "Moffett was coy about the source material when he presented it to the rest of the collective," recalled Finkelstein, who described an "adolescent ribbing as speculation" about who from ACT UP had posed for Moffett. The more everyone asked Moffett about who had modeled for it, the more evasive he became.

"We were not subtle," added Lindell.

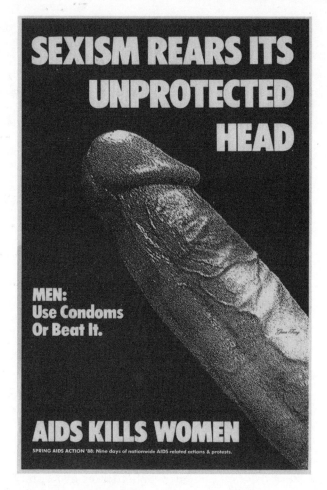

Sexism Rears Its Unprotected Head, Gran Fury, 1988.

Though most of Gran Fury remembers him as the poster's originator, Moffett doesn't recall making the poster. Asked about Finkelstein's version of events, he admitted that it sounded like something he would do, saying that at the time, "I was into a lot of porn and hard-ons."

Kalin was one of the few Gran Fury members who was hesitant, and cautioned the group to consider the ACT UP Women's Caucus. Ultimately, the rest of Gran Fury overrode Kalin's objections, and they went ahead and printed it.

And Kalin turned out to be wrong about the Women's Caucus possibly taking issue with the poster. "We all loved it," Wolfe recalled. "We

thought it was brilliant." Wolfe noted that, around this time, she had begun to see safer-sex advertisements around New York, reminding straight women to carry condoms with them in their purse when they went out. None of these ads were directed at men. To Wolfe, the logic of all this seemed off. Women don't wear condoms, so why were they being asked to carry them? Why was nobody asking straight men to bear any of the responsibility for this? *Sexism Rears Its Unprotected Head* seemed to encapsulate all of this.

Like the other posters for the Nine Days of Rage, they wheat-pasted *Sexism Rears Its Unprotected Head* themselves, but the poster didn't stay up for long. "It was ripped down almost as fast as it was put up," Wolfe recalled. "We used to joke: Put a pair of breasts on a wall, and they'll stay there forever. But men do not want to look at their own dicks."

Several of these posters would come to serve as source material for future projects that would become infinitely more successful than the originals. This effectively became Gran Fury's way of working: try and fail, then try again, then try once more. In a way, *Read My Lips* followed a similar trajectory. Though it debuted as a poster, the real success of *Read My Lips* came *after* the kiss-in for which it was first intended, a success that was somewhat dependent upon efforts beyond Gran Fury.

ACT UP had a new member steering its fundraising and merchandising operations, a former bond trader named Peter Staley, who was starting to see that these graphics could be an integral part of ACT UP's financial operations. Staley had gotten his start in AIDS activism as the financial backer of the Lavender Hill Mob and soon thereafter began seeing *Silence=Death* posters plastered around his apartment building in the East Village, which had attuned him to the growing movement. (In fact, it was Staley who later debated Pat Buchanan on television while wearing a *Silence=Death* sweater.) In Staley's estimation, "The *Silence=Death* poster deserves as much credit as Larry Kramer for sparking ACT UP."

Throughout his first year as an ACT UP member, Staley often stood out from this jean-clad, Doc Martens–wearing milieu, as he often wore

a suit, having come directly from his job on Wall Street. At Staley's first ACT UP meeting, he handed Nesline, then ACT UP's treasurer, a check for a thousand dollars to help jump-start the organization's bank account. Nesline said this was the moment that "I decided I was going to marry Peter Staley."

And they did get together, briefly. It was a supernova of a relationship: Staley and Nesline became boyfriends, moved in together and broke up, all within a span of three months. But in those three months, Nesline handed Staley the reins of ACT UP's fundraising operation. To Staley, fundraising was the perfect way to get more involved with ACT UP, as he wanted to become more active in the organization but didn't want to be part of its public face, which would have meant coming out of the closet and potentially losing his job on Wall Street. And it made financial sense for ACT UP, as Nesline was a nurse in training who couldn't balance his own checkbook and Staley was a Wall Street bond trader. But Staley's takeover of the fundraising did have the optics of a power play. "I got accused early on of sleeping my way to the top," recalled Staley, who found himself on the coordinating committee after Nesline handed off the fundraising operation.

Soon after joining ACT UP, Staley watched his health begin to deteriorate, coincidentally as the stock market took a dive on the Black Friday of October 1987. He had tested HIV-positive two years before but hadn't faced any major health setbacks until the stress of a recession began to take its toll. "My T4s crashed with the Dow," as he put it. The day that the stock market crashed, Nesline came back to their apartment to find Staley smashing dinner plates against the wall. "I was having a little meltdown," Staley recalled. And so by March 1988, Staley had left Wall Street to dedicate himself to ACT UP full time.

Staley's health, along with the finances of ACT UP, benefited greatly from his leaving Wall Street. ACT UP was increasingly spending money on its frequent demonstrations. And while ACT UP was certainly making headlines in New York City, they still hadn't found a way to impact AIDS on a more national level. AIDS hardly factored into that year's presidential election, one of many such signs that a more

national effort was needed. Though New York City was the epicenter of the AIDS crisis, much of what enabled and exacerbated the crisis was elsewhere. The Centers for Disease Control in Atlanta, the National Institutes of Health in Bethesda, the Food and Drug Administration in Rockville, the White House: the course of the AIDS crisis was being decided there.

If ACT UP wanted to effect change on a national level, they were going to need to travel and find a way to mobilize thousands of demonstrators. That kind of activism was not going to be cheap.

Initially, ACT UP tried to pay for their demonstrations by throwing fundraisers, usually at gay nightclubs that were sympathetic to ACT UP's cause. They'd suggest a potentially slow night for the club, which would keep all the bar sales, with a $5 or $10 cover charge going to ACT UP. While these events fetched a decent sum, they were sporadic sources of income, meaning that ACT UP's bank account would spike. And with a fundraiser, there's a certain amount you can't control. For example, if a snowstorm carpeted Manhattan the night before their next fundraiser, it could Hobble ACT UP financially.

Staley could court wealthy donors to support ACT UP's activities, but this had pitfalls too. The record mogul David Geffen, for instance, once bumped into Staley on the beach at Fire Island and after the two started talking, he handed Staley $3,000 in cash so that ACT UP could drape a thirty-five-foot canvas condom over the home of Senator Jesse Helms. Wealthy donors, like fundraisers, can be fickle too. "We scared the bejesus out of the queer elites," recalled Staley. ACT UP's members were out, proud and angry, something that was not going to translate into donations from older, wealthy gay men. But Staley recognized that there was broad support for ACT UP's activities, especially among younger gays and lesbians, who could contribute smaller sums of money. He had seen how quickly Nesline and others had sold a thousand *Silence=Death* buttons at the previous year's AIDS Walk—the first $1,000 to fund ACT UP—and imagined that this merchandising could scale. By then, most ACT UP members already owned something emblazoned with *Silence=Death*. Why not turn them all into repeat customers?

Read My Lips debuted as a T-shirt at the 1988 Pride Parade. The previous year's Pride had been hugely successful for ACT UP, in every imaginable way. It was that day that the *Silence=Death* T-shirt had debuted, along with the concentration camp float that had driven hundreds to their first ACT UP meeting, including Moffett. *Read My Lips* was supposed to be the hallmark graphic of Pride 1988, and Staley hoped to replicate the financial success that they had had the year before.

The night before that year's Pride, Staley drove to the outer-borough print shop of Dee Finch, a printmaker whom Finkelstein described as a "scrappy, working-class dyke, really funny and soulful." For years, she printed all of ACT UP's T-shirts, always at a discount, and had stored them for Staley in advance of that year's Pride Parade. When Staley got back to Manhattan, no parking garage wanted to house his rented van overnight. So he parked the van full of merchandise on the street in the East Village, just across from his apartment.

When Staley awoke the next morning, he looked out his window and saw that the back door of the rental van was wide open. A crew of thieves was unloading the boxes of *Silence=Death* and *Read My Lips* T-shirts he had picked up the night before. By the time that Staley got to the street to try and scare them away, about two-thirds of ACT UP's merchandise was gone.

Staley relocked the van and drove over to Christopher Street, where ACT UP had set up its merchandise table. He got out of the van, crying, and explained to the other ACT UP members what had happened. This was going to be a huge financial loss for ACT UP, and Staley felt personally responsible. "We lost it all," Staley told them, sobbing. "I lost it all."

It's not clear, exactly, how they figured out where the merchandise had landed. Finkelstein recalled that a group of junkies hanging out in front of Staley's apartment had tipped them off. But Staley recalls that someone, en route to the Pride festivities, had spotted the T-shirts at a discount clothing store on the Lower East Side. In any case, Staley, Finkelstein and Nesline came to learn that the T-shirts had been boosted to a clothing purveyor on Orchard Street. So they enlisted a few other ACT UP members in their recovery mission, loaded into Staley's van and

decided to pay this T-shirt purveyor a visit. The day's festivities were set to begin soon, and they were not going to let a band of T-shirt thieves ruin their Pride.

When they walked into the store and saw that ACT UP's merchandise was already for sale, it was clear that the lone purveyor had been outnumbered. Finkelstein started screaming at the store owner to try and distract him, while Nesline, Staley and others scrambled to gather the stolen merchandise and load it back into the van. ACT UP's treasury records indicate that Staley actually reimbursed the purveyor for what he had spent on the stolen goods. But the purveyor was essentially strong-armed into this agreement. "He was livid and screaming at us," recalled Staley. "But luckily we had enough muscle on hand that it didn't become violent." Staley, Nesline and Finkelstein didn't manage to retrieve all the stolen merchandise but recovered enough that they were able to sell tens of thousands of dollars' worth of T-shirts and buttons at that year's Pride festivities.

Not long after the 1988 Pride celebrations, ACT UP's New York headquarters fielded a phone call from a Los Angeles man who wanted to speak with the creators of *Read My Lips*. "I thought there was a lawsuit coming," recalled Finkelstein, who was forwarded the call from ACT UP's manager.

Finkelstein dialed the man's phone number and explained that he was part of the collective responsible for *Read My Lips*.

After exchanging pleasantries, the caller told Finkelstein, "I'm one of the men in that picture."

"Wow. Really?" asked Finkelstein. "What can you tell me about it?"

"The other man was actually my boyfriend," he said. "We met in the navy, stationed on the same ship. We were on leave in San Diego at the time. . . . One night we were approached by a photographer at a local gay bar. . . . He asked if they could take pictures of us, and we said, 'Sure.' So we went back to the studio with them and he started taking our picture. . . . He asked if we would kiss, so we did, and we got a little carried away. I thought no one would ever see it. . . . You can imagine how surprised I was when I saw someone wearing that T-shirt at Gay Pride here

in LA! Anyway, I just wanted you to know how great it is for me to know it could be used to help the community, especially now. It makes me so proud, and I just wanted to say thank you."

Finkelstein offered to send him a *Read My Lips* shirt. "Oh, god, no," the former sailor replied. "I would never feel comfortable wearing it."

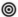

As Bush continued to use his "Read my lips: no new taxes" mantra on the campaign trail, Gran Fury's *Read My Lips* became increasingly poignant and continued to be a massive source of income for ACT UP. ACT UP's merchandise sales soon began raking in a hundred thousand dollars a year, most of which went toward funding ACT UP's elaborate demonstrations. Staley estimates that between 1987 and 1992 they sold about a million dollars' worth of merchandise. Gran Fury by no means monopolized the ACT UP catalog. The artist Keith Haring contributed too, as did a number of other graphic designers within ACT UP, in addition to the work made by the now defunct *Silence=Death* collective. But according to Staley, *Read My Lips* outsold them all, even *Silence=Death*.

Gran Fury was, of course, more than a source of income for ACT UP. But the financial success of *Read My Lips* provided the perfect counterpoint to the argument that Gran Fury wasn't worth sponsoring. They could no longer be dismissed as *just* an art project.

That year's Pride also marked the debut of *Read My Lips* beyond New York City, and it quickly became a nationally recognized symbol of AIDS activism. By not trademarking its name or logo, ACT UP enabled chapters to quickly spring up around the nation. And not just in major cities like Los Angeles and San Francisco but also in smaller college towns like Madison, Wisconsin and Ann Arbor, Michigan. An ACT UP chapter sprung up in Little Rock, Arkansas, as well as in Shreveport, Louisiana, the state's third most populous city. Even international chapters began forming. One of the advantages to working with short, concise statements like "Read My Lips" or "Silence=Death" is that they're easily translatable. ACT UP's activists and customers would never be limited to an English-speaking audience.

One ACT UP member, Jon Winkleman, recalled being in a hardware store in Providence, Rhode Island, wearing a *Read My Lips* shirt days before an upcoming ACT UP demonstration. He noticed a woman following him around the store, and he was beginning to worry that she might confront him about the content of his shirt. He tried to avoid her, then turned a corner and found himself face to face with her.

"I'm looking at your T-shirt," she told him. "I know where you're going this weekend," seeming to reference the imminent demonstration. Then Winkleman realized that she was nearly in tears. "My brother had AIDS," she told him. "He died, and my family won't let me talk about it. When you go down there, just know that you're going down there for me. Because there's a lot of us who've lost family members, and we're not allowed to talk about it."

That's part of what made T-shirts and clothing such an integral part of ACT UP's mission. A shirt like *Read My Lips* or *Silence=Death* wasn't just a way of signaling one's dedication to ACT UP. It was also a way of providing comfort and solace to others, people who otherwise might have felt entirely alone.

ACT UP's Seize Control of the FDA demonstration on October 11, 1988. Photograph
by Tom McKitterick.

CHAPTER 5
SEEING RED

I didn't want people to learn that I was queer from my obituary.
—Richard Elovich

O n July 19, 1988, the *New York Times* reported upon an alarming statistical revision. That day, the city's commissioner of health, Stephen C. Joseph, had halved the estimated number of HIV infections in New York City. As recently as two months before, the city had estimated that 400,000 New Yorkers were living with the HIV virus. Joseph now claimed those numbers were incorrect, telling the public that the new estimate was 200,000, a number he arrived at by significantly reducing the estimated number of HIV-positive gay men in New York City. Whereas before, New York City estimated that 250,000 gay New Yorkers were living with HIV, Joseph now claimed that there were only 50,000.

The timing of all this seemed suspicious to Mark Harrington, as Joseph's announcement came inamid a growing wave of criticism over the city's handling of the epidemic. At this point, New York City was reluctant to provide its residents with safer-sex information, and instead tried to curb the spread of HIV by shuttering gay bars, clubs and bathhouses, sites that many felt could be used to educate those most at risk of contracting HIV. And in comparison to San Francisco, the nation's other

epicenter, New York City spent a paltry amount of money on AIDS care facilities.

The city's mayor, Ed Koch, was of little help, and had become increasingly unpopular within the gay community. Many felt that he kept the gay community at arm's length because of rumors that Koch himself was a closeted gay man, rumors that had dogged Koch since the beginning of his mayoralty. When Koch ran against Mario Cuomo for New York City mayor in 1977, a series of posters reading "Vote for Cuomo, not the homo" began appearing in the Italian quarters of Brooklyn and Queens, and reappeared when Cuomo and Koch squared off again in the state's 1982 gubernatorial primary. (Though the Cuomo family has always denied responsibility for these, the posters are widely rumored to have been the work of Cuomo's 1982 campaign manager and political heir, his son Andrew.) Many within ACT UP felt these sorts of rumors had an outsized influence on Koch's current response to the AIDS crisis, as the public perception of him caring too much about a supposedly gay issue might reinforce the notion that he was closeted.

Like Harrington, many suspected that Joseph was cutting the numbers to justify Koch's and the city's inadequate response to the crisis. The state's comptroller, Ed Regan, responded to Joseph's new estimate by saying, "Now the city is tailoring its estimate to fit the money it will have available." Harrington found Joseph's epidemiology to be especially dubious, as Joseph had arrived at this new number by extrapolating the number of HIV infections in San Francisco and overlaying this with New York City's estimated number of gay men. In essence, Joseph had arrived at this estimate without actually examining New York City's HIV rates.

ACT UP responded almost immediately, deciding to stage a demonstration outside of Joseph's office at the Department of Health. "Stephen Joseph says you don't exist," read a flyer publicizing the demonstration. "Prove him wrong! Show up!"

While 250 ACT UP members chanted and picketed outside the Health Department, Harrington and a group of eleven others snuck past the building's few security guards, hoping to confront Joseph directly. When they learned that he was out for the afternoon, they instead

occupied his deputy's office and refused to leave until Joseph agreed to meet with them. They were arrested and handcuffed, then greeted with cheers as police escorted them out of the building, and released quickly enough to rejoin the demonstration before it ended.

One week later, on August 3, Harrington and ten others returned, again to confront Joseph. When the elevator opened on the health commissioner's floor, a lone security guard cried out, "No! Not again!" Having already infiltrated the building once, Harrington and the others knew the floor's layout and quickly found their way to Joseph's office.

Joseph recalled that he was in the midst of a meeting. "Suddenly, through a side door, burst eleven ACT UP members," he later wrote. "Complete with video camera and lawyer, screaming demands, obscenities, and incomprehensible questions. They surrounded the conference table and shouted that they were not leaving until I met with them and satisfied their demands."

Joseph dismissed the protests as "theater."

"It's not theater," one ACT UP member responded. "People are dying!"

Then Joseph stood up, pushed his way past an ACT UP member, locked himself in his office and called the police, as the building's security was clearly overrun. When the police arrived, Joseph reentered the room and sat at the head of the table, fuming. A mustached ACT UP member named Spree, wearing a red dress and high heels, tried to defuse some of the tension by posing with Joseph for a photograph. Some yelled questions at him while others chanted, "Resign! Resign!"

Half an hour after entering his office, all eleven were arrested and charged with criminal trespassing. They were released that afternoon and celebrated with margaritas and Mexican food at El Sombrero on the Lower East Side.

Several ACT UP members recalled that while occupying Joseph's office, his calendar was lifted from his desk. But an internal memo circulated by Harrington offers a slightly different telling. "Through friendly sources in the Health Department," he wrote to the rest of the coordinating committee, "we received their inside phone list and Dr. Joseph's schedule for the coming weeks."

With Joseph's upcoming itinerary in hand, Harrington approached the rest of Gran Fury and proposed that they create a graphic to work in tandem with a campaign to harass Joseph. Joseph had blood on his hands, they reasoned, and they soon came to the idea of using a bloody handprint to stalk him around the city. For the posters, they used the handprints of Donald Moffett and Harrington, as theirs best fit the aspect ratio for the poster. "It was a day's work," Moffett recalled, who banged out the poster with Harrington in one weekend. They emerged from their session with two posters. "You've got blood on your hands, Stephen Joseph," one poster read. "The cut in AIDS numbers is a lethal lie."

You've Got Blood on Your Hands, Stephen Joseph,
Gran Fury, 1988.

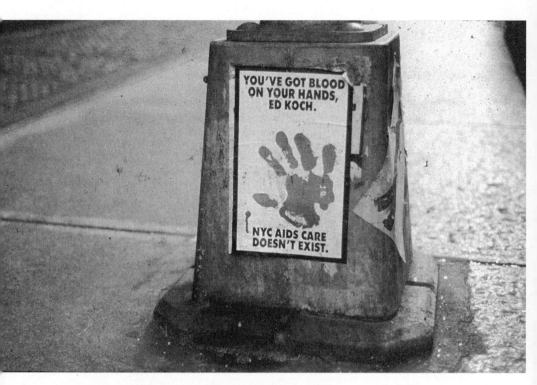

You've Got Blood on Your Hands, Ed Koch, Gran Fury, 1988.

A second version was made for Koch, but with the tagline "NYC AIDS care doesn't exist." It played into Koch's supposed paranoia about HIV transmission. According to one rumor, Koch had run for the bathroom after handing out cookies at an AIDS ward for children, afraid that he might contract HIV from hand-to-hand contact.

The next Monday, August 8, 1988, Loring McAlpin and Avram Finkelstein came to the floor of ACT UP to unveil the two posters. But they also brought buckets of red paint. With gloved hands, McAlpin and Finkelstein showed the rest of ACT UP how they could stamp any surface, leaving behind a bloody handprint, just like the one on the poster. "We thought we were so genius to have rubber gloves," recalled Finkelstein. Their thinking was that, if the police came, you could take off the glove, throw it in a bucket and walk away. Finkelstein and McAlpin encouraged ACT UP's members to join them in making the image seem

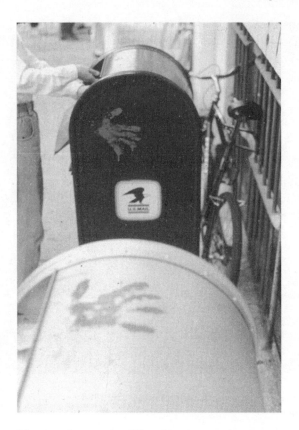

Photograph courtesy of Gran Fury.

ubiquitous around the city: the more ubiquitous the bloody handprint, the more omnipresent ACT UP would seem.

Finkelstein recalled that there weren't many takers, but it didn't take too many teams to carpet downtown Manhattan with bloody handprints. He and a new boyfriend, Phil Montana, took a route through the East Village, across lower Broadway and into SoHo. They walked on opposite sides of the street, leaving a twinned trail of bloody handprints along the way. By the time they reached the area around Washington Square Park, Finkelstein's boyfriend started to abandon caution. "Phil got carried away," Finkelstein recalled. "Instead of just hand-printing commercial spaces, he was hand-printing the glass windows of NYU." The police soon arrived and confronted Montana. As planned, Finkelstein ditched his bucket, threw in his glove and walked into a grocery store, watching

from afar to make sure that his boyfriend wasn't arrested and taken to the local precinct. Finkelstein soon realized that ditching the glove into the bucket wasn't as genius as he thought. Looking down, he saw that his pant leg was covered with red paint.

Montana effectively talked his way out of getting arrested "in this very white way," recalled Finkelstein, who pantomimed his ex-boyfriend with a fey squeal: "*Oh, officer. I'm a grad student here and got carried away. It's water-based paint. It'll be gone by the first rain.*" After some back and forth, the police let him go.

If the pink triangle of *Silence=Death* could awaken people to the growing crisis, then maybe a similarly ubiquitous image could galvanize the public about the dangers of Joseph's cut in AIDS numbers. *You've Got Blood on Your Hands* only works as an image that repeats itself. The more ubiquitous the image, the more pervasive AIDS seems as a problem, and the more urgent the poster's message becomes. And if Joseph's accounting seemed to erase much of New York's gay population, the bloody handprint had the converse effect, effectively telling the city that gay men haven't gone anywhere.

Though blood is one of the fluids by which the HIV virus is transmitted, a bloody handprint also recalls the field of forensics, of accountability being traced through a mark left by a human. Had Gran Fury simply placed bloody handprints on City Hall or Joseph's office and home, it would have confined the ramifications of their actions to these spaces. But by weaving these handprints throughout the city, it implied a much more widespread impact, one that could not be contained by these spaces. In ascribing blame to Joseph rather than to carriers of the virus, it subverted assumptions about who was responsible for the spread of HIV. There was ample evidence of how New York City had failed people with AIDS, but this evidence existed in private spaces: hospital wards, waiting rooms and apartments. *You've Got Blood on Your Hands* didn't just ascribe blame: it furnished public evidence.

The efforts to carpet Manhattan were ultimately successful, and this was when Gran Fury began to fold their work into the city's visual landscape. The *New York Times* columnist Frank Bruni confirmed this, later

writing that "it used to be difficult to walk a few blocks in Manhattan without seeing a rendering of a bloody handprint."

As the bloody handprint began to dot Manhattan, the campaign to harass Joseph continued. The day after McAlpin and Finkelstein brought buckets of red paint to the floor of ACT UP, Joseph was confronted at the Ford Foundation, where ACT UP's members knew he would be attending a daytime meeting. As Joseph tried to walk through the building's revolving door, one member, Bill Monahan, slipped into the same compartment with him, blocked the door from moving and stood face-to-face with Joseph. "What do you want, you little fuck?" Joseph asked him. "Lay one finger on me and you won't even know what hit you."

Undeterred, ACT UP again confronted Joseph the next day, as he lunched at Tenbrooks, a small bistro near his office. As Joseph ate his entree, ACT UP members stormed the restaurant and handed him envelopes stuffed with fact sheets and stamped with bloody handprints, again chanting, "Resign! Resign!" The more that Joseph ignored ACT UP's efforts, the more it seemed to enrage them. "Anytime Stephen Joseph would be having lunch in a small, out-of-the-way restaurant in Chinatown, we would just pop in the middle of his lunch, surround the table and just start," Spree recalled. "We literally made that man's life a living hell."

The climax of this harassment campaign led ACT UP to Joseph's home, a brownstone on the Upper West Side, where ACT UP staged a demonstration on the evening of September 15, 1988. Joseph was enraged when he came home that night. "Fuck you!" he yelled. The *Guardian* reported that police had to physically restrain Joseph after he jabbed a finger at an ACT UP member, and Joseph later wrote in his memoir that "had the police not been there to pull me off, I would have hit him."

Eventually, ACT UP's members dispersed, but not without reminding Joseph of his misdeeds. The next morning, Joseph awoke to find his portico plastered with ACT UP posters and bloody handprints, along with the word "murderer" scrawled in chalk on the street.

The cumulative efforts of ACT UP's harassment campaign ultimately did pay off, but in little ways. Two weeks after their visit to his brownstone, Joseph announced that he would have a panel examine the revised estimates that had incited ACT UP. It was a victory, technically, but it didn't really feel like one. In Harrington's estimation, the campaign to demonize Joseph didn't really have a tangible outcome. "In New York, the health commissioner has more influence than power," Harrington came to realize. "Most programs for people with AIDS were administered by other agencies." And none of those agencies had revised their policies. ACT UP had helped solidify their reputation by exercising their anger, but nothing had been achieved in the way of tangible outcomes. The campaign, to many, felt fruitless.

Harrington was also beginning to see how ACT UP could effect change in more productive ways. Earlier that summer, he had attended a teach-in hosted by other ACT UP members on the drug approval process in the United States. At first, the soup of acronyms and jargon flummoxed him. There was, first, the HIV virus itself and a host of untested antiviral drugs that could possibly slow or mitigate the virus's spread. Then, there were all the possible infections, diseases and complications stemming from AIDS, and all those maladies had drugs that could possibly treat them but were in various stages of the FDA's complicated approval process. Finally, there was the entire network of federal agencies, university research centers, hospitals and drug companies, a tangled web of corporations, government bureaucracy and for-profit, nonprofit and semiprofitable entities.

But Harrington didn't let his confusion stop him from trying to follow the conversation. What he did, instead, was write down every word and acronym that befuddled him—all the experimental drug names, academic jargon and bureaucratic acronyms swirling around him. Then, on his own, he began to research these individual terms and wrote down their definitions. Almost accidentally, he began putting together a glossary, which reinvigorated his sense of purpose within ACT UP. If he could translate Walter Benjamin from German to English, surely he could mold the bureaucratic jargon of clinical drug trials into laymen's terms too.

After it began circulating throughout ACT UP, the success of Harrington's glossary prompted him to volunteer his writing skills elsewhere. The same summer that ACT UP stalked Joseph, a few within ACT UP were beginning to conceptualize a demonstration at the headquarters of the Food and Drug Administration. Harrington, along with a few others, wrote the *FDA Action Handbook*, a forty-page document outlining the FDA's history, its role in the AIDS crisis and why ACT UP should stage a demonstration at its headquarters.

With ACT UP's fundraising in full swing, it would be easy to bus hundreds of demonstrators to Rockville, Maryland, where the FDA was headquartered. But ACT UP's members still needed to be convinced of the demonstration's potential, as the FDA was not an obvious target. Most people don't know what the FDA does, if they even know what its acronym stands for. An artifact of this is the *Silence=Death* poster. In small type along the bottom of the poster, they questioned the hesitancy of the CDC and FDA. But Finkelstein and his cohorts printed the wrong name for both: it's the Food and Drug Administration, not the Federal Drug Administration, and it's Centers for Disease Control, not Center. Nor are the FDA headquarters an iconic protest location. Located in suburban Maryland, the FDA is headquartered in a blockish and unassuming office building and doesn't have the kind of activist history tied to locales like the National Lawn or the White House.

Harrington became integral to convincing the rest of ACT UP that the FDA was a worthy target, and what could be won through a demonstration at their headquarters. As Harrington put it in a video intended to rally support for the demonstration, "Only the FDA has the power, under existing laws and regulations, to release the drugs that we want released now."

The FDA was the beginning of ACT UP's attempts to go beyond demonizing individuals and working to actually reform systems that were detrimental to people with AIDS. It also marked another shift within ACT UP. "ACT UP initially was defensive," recalled Gregg Bordowitz, one of the FDA demonstration's organizers. In its first year and a half, ACT UP was mostly responding to the actions of other people: threats

of quarantine, proposals to tattoo people who had tested HIV-positive, officials slashing the estimated number of AIDS cases. "What the FDA did was shift the group away from a defensive posture to an offensive posture," Bordowitz reasoned. Instead of simply being responsive, ACT UP was now trying to set the agenda, to lead the conversation rather than follow it.

By the end of the FDA planning sessions, Harrington had left Gran Fury, electing to devote his time to ACT UP's Treatment and Data Committee, a group that pored over clinical trial data. It was quickly becoming one of ACT UP's central committees, and Harrington dedicated himself to it for the remainder of his time with ACT UP.

Mark Harrington's last meeting with Gran Fury happened to be the first for a new member.

For Richard Elovich, the AIDS crisis had entered into his life just as he was beginning a new chapter. In 1982, Elovich had just finished a stint in a Minnesota rehab facility and had moved into a nearby halfway house. Here, he bumped into an old friend from his native New York, a performer from the Pyramid Club who went by the stage name Ammo. Elovich was a performance artist too, and they knew each other through the downtown scene. It was here, talking with Ammo at the halfway house, that Elovich first heard about AIDS, and immediately knew that his past behavior had jeopardized his future.

Before entering treatment, Elovich had been using heroin, and it was clear, even then, that this was an epidemic concentrated among gay men and intravenous drug users. Though gay white men became the first group of people visibly associated with AIDS, we now know that HIV was first an epidemic among intravenous drug users and communities of color, going back at least to the 1960s and '70s. Before the scientific recognition of HIV, intravenous drug users knew the symptoms of AIDS by more colloquial terms. What was called "the dwindles" is what we now know of as wasting syndrome, and what was called "junkie pneumonia" was actually PCP pneumonia. In the '70s, the New York State

Division of Substance Abuse Services had noticed a steady and unexplained increase in pneumonia deaths among intravenous drug users. No one really bothered to investigate why this was the case. Only when gay men who could regularly access the healthcare system began showing symptoms en masse did it become apparent that the crisis had already been raging for years.

Elovich immediately knew that he was doubly at risk: "I was using needles; I was getting fucked," as he put it. There was no way of knowing for sure, as an HIV test was still years away, but Elovich assumed the worst. "I thoroughly expected that I had AIDS," he recalled.

It was around this time that Bob Wilson, the legendary director, came to Minneapolis to stage a collaboration with David Byrne of Talking Heads. Wilson knew of Elovich's work, and knew that Elovich was in Minnesota, so he asked Elovich to dramaturge the play. Elovich moved in with Wilson, sleeping on his couch and working on the Byrne play. It wasn't the ideal situation for someone who was newly sober. Wilson would stay up late, drinking and snorting cocaine while doing his charcoal drawings. Elovich, maintaining his sobriety, would crash early and get to the bakery where he worked around five in the morning.

It was through working with Wilson that Elovich started to get the theater bug. He wanted to return to the downtown theater world in which he had immersed himself before rehab. He figured that AIDS would cut his life short, and he was itching to get back to work. His counselors failed to deter him. "Don't go back to New York," they would say, as they berated him with statistics about heroin relapses and program slogans. "Stick with the winners. You'll use again."

But Elovich was undeterred. He had managed to stay sober around Wilson and felt confident that he could maintain this. When Elovich did return to New York, he did stick with the winners, albeit not in the way that his cohorts had advised him to. He started attending Alcoholics Anonymous meetings, not because he was an alcoholic, but because AA had a higher success rate than Narcotics Anonymous. It was dubious logic, but this decision ultimately changed the course of Elovich's life. In AA, Elovich met a fellow performance artist named John Bernd,

and Elovich soon realized that neither of them were actually alcoholics. Bernd had joined AA because he was living with AIDS and this was the closest thing he could find to a support group.

Bernd had likely contracted HIV before the *New York Times* reported upon a cluster of forty-one gay men who were experiencing the disease's telltale symptoms. And from the outset of the epidemic, he had been very public about living with AIDS. Bernd's 1981 "Surviving Love and Death" is possibly the first piece of theater to address the AIDS crisis, though Bernd couldn't have fully known what, exactly, was ravaging his body when he staged this. "John had come out very early on, in terms of being a person out in the open," recalled Elovich. "And then he suddenly realized the consequences of this." After Bernd began publicly talking about living with AIDS, he found that his friends wouldn't share a glass of water with him, and that his sister would no longer let him see his nephews. This sent Bernd reeling. "In a sense, John started denying that he had AIDS," Elovich said. "He actually went in reverse." Bernd's denial of his own prognosis stemmed, in Elovich's estimation, from Bernd's inability to reconcile that AIDS was going to cut short his artistic ambitions. Bernd was a young artist, at what should have been the beginning of his career, not the end. "There were all these things he wanted to do," Elovich recalled. "So it's totally understandable that death just seemed like it shouldn't happen."

Elovich recalled one particular instance that seemed to epitomize Bernd's increasing denial about his prognosis. Bernd, Elovich and another of Bernd's caretakers went to breakfast one morning, ostensibly to discuss Bernd's long-term prospects. The NYU co-op where Bernd was living could no longer sufficiently care for Bernd's ailing health, and Elovich needed him to consider his next steps. Bernd refused to discuss it. Instead, he fixated on his eggs, and that the waitress hadn't gotten his order right. "So there we are," Elovich recalled, "trying to have this momentous conversation with him about the next steps in his life, and about dying. And John was just talking about the egg yolks. And it was just so clear that he was putting every bit of strength he had into not acknowledging this."

Elovich himself dreaded getting tested. He figured that if his results came back positive, then he'd have to reconnect with his family, from whom he had been estranged since he was a teenager. Elovich's mother had had Munchausen by proxy, and would manipulate doctors into performing unnecessary surgeries on him. When Elovich's mother took him to a psychiatrist because he couldn't socially interact with other kids, someone finally noticed that something was seriously wrong. "She's dangerous," the psychiatrist told him. So at the age of fourteen, Elovich had left home. If it turned out that he had AIDS, Elovich worried that he would have to rely upon them to care for him at the end of his life. "I was just terrified," Elovich said. "Because I knew how many people had to go back to their families when they got sick."

In 1987, Bernd wanted to attend the year's Pride Parade but wasn't feeling well enough to go. And so Elovich went on his behalf. As Elovich watched the floats proceed down Seventh Avenue, one stood out. It was a flatbed truck lined with barbed wire, with a masked Reagan perched atop a mock guard tower. A growing group of protesters, many wearing *Silence=Death* T-shirts, trailed behind. It was the concentration camp float that had been constructed in the abandoned lot next to Mark Simpson's apartment. Radical activism wasn't necessarily new to Elovich—when he had turned eighteen, Elovich had been obliged to enlist in the draft for the Vietnam War, and in protest, he traveled to Washington, DC, and burned his draft card in front of the Pentagon. But what Elovich found most appealing about the float was that it clarified exactly how he was feeling. "I had been going to a funeral a week, and I hadn't been able to find my feelings about what was happening all around me, or what was happening with John," he said. "But when I saw the float, I just connected with the anger." On the spot, Elovich decided to join ACT UP, along with the hundreds of others who did that day. "I just knew it was where I belonged," he said.

Though Elovich identified with this sense of collective anger, he also felt alienated from its manifestations in people like Larry Kramer. Elovich likened the vitriol expressed by some of ACT UP's members to Mark Twain's novel *The Prince and the Pauper*, in which the prince finds that his

privilege has been stripped away after being locked outside the castle. In Elovich's eyes, AIDS had done something similar to gay white men, and ACT UP was the most visible example of the ensuing anger. These were men who had once been able to rely upon the healthcare system, and for whom sex had been of little consequence, who now found themselves living outside the privilege they had once held. "These were privileged people who lost their privilege because of who they fucked," as Elovich put it. "And they were outraged."

Having lost their privilege, these men now found themselves relying upon the expertise of veteran reproductive rights organizers, the only ones in the room whose experience of political organizing overlapped with concerns about the healthcare system. Some of ACT UP's figureheads like Maxine Wolfe, Marion Banzhaf and Jamie Bauer all had over a decade's worth of organizing experience by the time they joined ACT UP, most of it having to do with access to abortion and reproductive rights.

This confluence of circumstances meant that a lot of the gay men in ACT UP were now working, socializing and interacting with women in a way that they hadn't before, and because of this, they were having to confront their sexism and misogyny for the first time. "In ACT UP, a small number of the men were feminists and a small number were misogynists," Wolfe recalled. "And the vast majority were well intended, but badly trained." In his pre–ACT UP life, Elovich had had a more or less bisexual existence, whereas many of ACT UP's gay men had previously existed in exclusively homosocial circles. "Most of my straight male friends had to correct themselves because they were involved with women of my generation," Elovich recalled. "The gay men who had only ever socialized with other gay men had never had to deal with their own misogyny and sexism."

What compelled Elovich to stick with ACT UP was finding, for the first time, a place within the gay community that he could see himself being part of. Instead of the stereotypes of gay life, Elovich found gay men who were politically engaged, and he recalled that ACT UP's weekly meetings were the first place where he had ever seen gay men who weren't cruising each other. (Elovich joked that he must have been oblivious to

this because of his Asperger's, as everyone else in ACT UP recalled that the back wall had become New York's best cruising stretch, akin to an indoor version of the Chelsea Piers.) Here, he no longer felt out of step. "It was an answered prayer," he said. "Through the activism, through showing up, I could be part of a world that was bigger than myself, and bigger than my grieving. Because I didn't know how to embrace grief."

For the next year, Elovich juggled ACT UP meetings with simultaneously being part of Bernd's caretaking group, until Bernd's death in 1988. It was during this time that he rebooted his performance career. When traveling to Chicago to stage one of his pieces, Elovich began talking with the lighting designer of the show and mentioned that he was involved with ACT UP. The lighting designer told Elovich that he happened to have a good friend involved in ACT UP too. That friend was Tom Kalin, who then invited Elovich to join Gran Fury.

Elovich was intrigued by Gran Fury's use of advertising strategies and found that the collective functioned very much like an ad agency in how they developed concepts and in their working conditions. "If you're going to use advertising strategies, then there's a certain kind of rigor to it," Elovich reasoned. "And that's not touchy feely." This was a group where, if somebody thought that a newly proposed idea was stupid, they'd say exactly that. "I knew that, in order to bring an idea to Gran Fury, I was going to have to tolerate being the object of a certain amount of bitchiness," Elovich said. "But I also felt that that was critical to Gran Fury being Gran Fury." This was a group of people who understood that lives were at stake, and that in order to have an impact, they needed to be brisk.

Occasionally, that emphasis on not being "touchy feely" could veer toward extremes. "Gran Fury was anything but a lovefest," Elovich recalled. He described a dynamic similar to that of *The Boys in the Band*, a play about a friend group of nine gay men who don't bother waiting for someone to leave the room before dishing about them. Gran Fury could be an intimidating group of people, one that required a bit of thick skin. "Avram and Nesline scared the shit out of me," Elovich said. Nowhere did he see this hostile dynamic clearer than in the oil and water relationship between McAlpin and Finkelstein, whom Elovich jokingly

referred to as "Avram Guevara." Unsurprisingly, the red diaper baby and the Rockefeller didn't quite get along.

Despite these interpersonal tiffs, Elovich felt compelled to stay in Gran Fury. "The fact that we could do that, that we could finish things, was just nothing short of amazing," he recalled. "That was the miracle. The surprise was not that we fell apart. The surprise was that we came together."

Elovich joined Gran Fury just as ACT UP was preparing for the FDA demonstration. To him, the FDA campaign felt like a much more productive course of action than the campaign to harass Joseph. Though Elovich figured that Joseph had manipulated the statistics for political reasons, he felt that ACT UP could have better spent its outrage, and that the demonization of Joseph was, as Elovich put it, "a bunch of gay men feeling the indifference of the father figure."

While it was Harrington who explained the FDA's rationale to the rest of ACT UP, it was left to Gran Fury and ACT UP's media committee to translate ACT UP's position to the wider public, to distill these findings even further. Once Gran Fury decided that they should produce a poster to accompany the FDA demonstration, Kalin said to Finkelstein, "You understood iconography. What do you think we should do?"

"Nationalize the bloody hand," Finkelstein replied. And that's exactly what they did.

Gran Fury produced a series of ephemera reading, "The government has blood on its hands. One AIDS death every half hour." They printed this on stickers, posters, T-shirts and even white lab coats, like the ones researchers wear, and distributed them to ACT UP members. Beyond providing a logo for the FDA demonstration, the bloody handprint project provided the logic that underscored ACT UP's demands. If the government has blood on its hands, as the T-shirt says, then wearing a bloody handprint implies that one's life has been touched by government inaction. It's a way of personalizing bureaucracy, of relating the actions of an institution to the lives of an individual. And while *The Government*

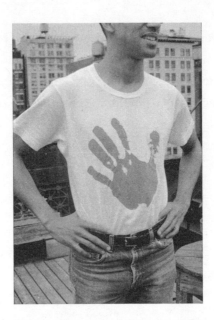

Photograph courtesy of the New York
Public Library.

Has Blood on Its Hands doesn't provide a remedy for that system, the poster's logic provided the underlying assumptions that guided ACT UP's argument for speedier drug approvals.

Part of what made the bloody handprint such a widely recognized symbol of AIDS activism was an ingenious press campaign from the media committee, ACT UP's in-house media team, who publicized the demonstration extensively. Michelangelo Signorile, who led these efforts for the FDA demonstration, had worked as a public relations executive in the entertainment industry before dedicating himself to activism. Because of this, he knew that every major newspaper in the country had a bureau chief in Washington, DC, a short drive from the FDA's headquarters. And the media committee made sure that reporters would, in fact, be there. A subcommittee dubbed the Little Publicists sent out glossy press kits to newsrooms around the country, then followed up with calls asking, "Did you get our press kit? There's this huge action coming. It's going to be huge news—the largest thing since the storming of the Pentagon."

Fifty thousand anti-war demonstrators had stormed the Pentagon in 1967 to protest the Vietnam War. Signorile knew that ACT UP could only

field a tiny fraction of this number. But Signorile had his Little Publicists repeat that mantra—"largest thing since the storming of the Pentagon"— as if they could will it into existence through repetition. And they almost did. The night before the demonstration, ACT UP's members sat in their motel rooms, a short drive from the FDA's headquarters, and watched as a local newscaster proclaimed, "The FDA is gearing up for what is going to be the largest demonstration since the storming of the Pentagon."

Camera and lighting crews arrived even before ACT UP did. "AZT is not enough," the demonstrators chanted as they marched up to the FDA's headquarters. "Give us all the other stuff!"

ACT UP didn't stage marches or rallies with speeches. Their demonstrations were more like happenings, with each affinity group staging its own event. That day, twenty-five different affinity groups staged actions. Elovich's affinity group, Wave 3, donned the white lab coats stamped with bloody handprints, and tried to actually take over a building on the FDA's campus. An effigy of Ronald Reagan was hung. Another affinity group staged a die-in with cutout tombstones, also stamped with bloody handprints, in front of the FDA's front awning. With all these affinity groups doing separate things and acting independently, Gran Fury's bloody handprint provided a visual choreography, giving these disparate units within ACT UP a larger cohesion, and making it seem like a unified whole.

Though ACT UP had branded the demonstration as "Seize Control of the FDA," the protest, to many, felt more dainty. "It looked like some sort of little medieval war," recalled Michael Nesline, "where all of these different little bands of peasants were storming the gates of the FDA."

With the demonstration underway, Signorile and the rest of the media committee instructed members of the press to speak with representatives from their locales. Signorile had individual members of ACT UP hold signs advertising where they were from, so that each local newspaper could interview and photograph someone from the city they represented. That made the difference, Signorile reasoned, "between the protests getting page five in the Arizona paper or the *Dallas Morning News* and being on the front page."

Throughout the day, ACT UP's members echoed Gran Fury's contributions, chanting, "The FDA has blood on its hands. We're! Seeing! Red!" Most had bloody handprint ephemera, though some made posters reimagining the FDA's acronym. One read, "Fucking Disaster Area." "Federal Dyke Administration" was another.

In the midst of all this, Peter Staley walked up to the entrance of the FDA's headquarters. Another ACT UP member gave Staley a leg up, hoisting him onto an awning over the front entrance. With Staley on the ledge, ACT UP members handed him a *Silence=Death* banner, which Staley hung over the entrance. With the banner secured, he raised his arms in triumph, as if they really had seized control, though Nesline recalled this in much less heroic terms, saying that his now ex-boyfriend looked like Ralph Macchio from *The Karate Kid*.

Then ACT UP's members started handing Staley posters: Moffett's *He Kills Me*, the *Silence=Death* collective's *AIDSGATE* and a few others, which he secured to the FDA's windows with duct tape. "In a lot of ways, we took over the outside of that building," recalled Wolfe. "Visually, if you looked at that place, it was ours." And it was the posters that accomplished that.

With the awning fully adorned, Staley negotiated with police officers, arranging to come down if he would be released back into the crowd. With Staley off the awning, a crew of firefighters and police officers marched over a ladder, hoping to quickly remove the *Silence=Death* banner and the other posters Staley had taped to the windows. Trying to delay the inevitable, ACT UP members dove to block their path so that the banner could hang over the FDA entrance just a bit longer. It was a momentary delay that provided a perfect photo opportunity. Before the *Silence=Death* banner and the attendant collection of ACT UP posters could be pulled down, an Associated Press photographer, J. Scott Applewhite, snapped one of the most iconic photographs of an ACT UP demonstration. A gloved police officer walks among ACT UP demonstrators who are holding tombstones adorned with the bloody handprint, forming what looks like a living graveyard. In the background hangs *Silence=Death* and a smattering of other ACT UP posters. "Those signs

and posters would captivate the media," recalled Signorile. And that's exactly what happened at the FDA.

Because of Applewhite and other photographers, the bloody handprint appeared on the front pages of newspapers nationwide: *USA Today*, the *Washington Post*, the *Dallas Times Herald*, the *Houston Chronicle*, the *Baltimore Sun* and the *Boston Globe*. Even smaller, more local newspapers like the *Orlando Sentinel*, the *St. Louis Post-Dispatch*, the *Chicago Sun-Times*, the *Atlanta Constitution*, the *Tampa Tribune*, the *Tucson Citizen*, the *Miami Herald*, the *Rocky Mountain News* and the *Arizona Daily Star* featured Gran Fury's work. Back in New York, the *Village Voice* and the *New York Daily News* both covered the demonstration with photographs, though the *New York Times* frustratingly declined to report on the demonstration at all. Still, it was an unqualified success. However dainty it felt in person, the photographs made it seem as if ACT UP really had seized control of the FDA. Applewhite and a few other photographers had effectively delivered Gran Fury's bloody handprint to the entire country. What had begun as a project for one now had an audience of millions.

The effects of the FDA demonstration were almost immediate. A week later, the FDA promised to begin releasing drugs more rapidly, a promise they ultimately kept. Soon, the FDA had approved two new medications for people living with AIDS: ganciclovir, an anti-blindness drug that stalled CMV retinitis, and an aerosolized version of pentamidine, a drug that halts PCP pneumonia, AIDS's most deadly opportunistic infection.

The FDA action proved to be ACT UP's first major victory. Nothing won that day could stop the progression of AIDS, but these drugs drastically improved the lives of people living with the virus. People don't really die of AIDS—they die of the opportunistic infections caused by it. Now there were finally treatments for one of the most debilitating infections, along with treatments for one of the most deadly.

And consider the demonstration from the vantage point of the pharmaceutical industry. ACT UP had showed them that there was a growing group of consumers who were demanding treatments, and who were

willing to go to great lengths to expedite the approval of promising drugs—what is often the most costly and arduous process for bringing new medications to market. Once, pharmaceutical companies had declined to investigate new treatments because AIDS was thought to be such a niche disease. ACT UP was beginning to change that perception, and it's hardly coincidental that many pharmaceuticals soon began exploring drugs, besides AZT, to combat the underlying HIV virus.

There was little doubt that ACT UP's lobbying efforts had precipitated this change, and many within ACT UP also saw the FDA demonstration as an example of the kinds of demonstrations that ACT UP should be staging. Conversely, what had been achieved through the weeks-long campaign to harass Stephen Joseph? A panel was convened to reevaluate Joseph's revised estimates, and they ultimately upheld Joseph's conclusions. ACT UP's members may have excised their anger, but little was won. With the FDA, the confluence of ACT UP's media blitzes, actionable demands, hundreds of protesters and the graphic imagery of Gran Fury all came together, a combination that had tangibly improved the lives of people living with AIDS by making two new medications available. It was a winning formula, to say the least, and ultimately served as a template for ACT UP's future victories as well.

Soon after the FDA demonstration, Gran Fury produced a poster that, in a way, can be read as a reflection upon these accomplishments. The opportunity for the poster came from a fellow ACT UP member, Patrick Moore, who was also the PR director for the Kitchen, a downtown multi-hyphenate art and performance space. One of Moore's coworkers at the Kitchen was Maria Maggenti, an ACT UP facilitator and guard from the concentration camp float, who had brought Moore to ACT UP and introduced him to the Gran Fury folks. "Very shortly after arriving in ACT UP, I became friends with Don Moffett," Moore recalled. "And I lusted after Avram, although I didn't know him well." Moore had convinced the Kitchen to allow artists to design its calendars and promotional materials, rather than having a graphic design firm do them. So he commissioned Gran Fury to design one of their upcoming calendars, which would go out to the Kitchen's mailing list and would be

wheat-pasted around lower Manhattan. "I was pretty young and dumb, and it never occurred to me to clear these ideas with anybody," Moore said. "But I gave them complete freedom to do anything they wanted."

With this opportunity, Gran Fury had benefited from a common misconception about the collective. Moore was under the impression that Gran Fury had produced the *Silence=Death* poster, and hadn't yet realized that the *Silence=Death* collective and Gran Fury were two separate collectives, with Finkelstein being the common denominator. But Moore had

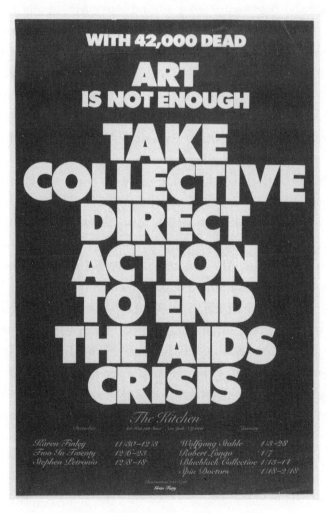

Art Is Not Enough, Gran Fury, 1988.

seen projects that Gran Fury actually had produced and loved those too, namely, the bloody handprint and *Sexism Rears Its Unprotected Head*.

With the calendar they produced, Gran Fury did very little to emphasize the events they were supposed to be promoting. "With 42,000 dead art is not enough," the calendar read. Then, "Take collective direct action to end the AIDS crisis." The actual calendar portion is so small, and the red type fades so easily into the black backdrop, that it's almost illegible.

People hated this poster. After the calendar went out to the Kitchen's mailing list and began appearing around lower Manhattan as a wheat-pasted poster, Moore started to field criticisms of it. "The board of the Kitchen was a little bit upset about it, and they conveyed that to the director, and then it was conveyed to me," Moore recalled. "Basically I just had a great big hissy fit and left, and then made the further mistake of talking to the *Village Voice* about it." Though it might not have been the smartest move for Moore's career—his departure blurred the lines of getting fired and quitting—the *Voice* wound up printing a half-page version of *Art Is Not Enough*, giving Gran Fury an even wider audience.

This iteration of *Art Is Not Enough* is probably Gran Fury's most obnoxious poster. The force with which this statement is declared implies that some people actually feel this way, and it's not clear who actually believes this to be true. The conceptual artist Felix Gonzalez-Torres reportedly read the calendar and quipped, "Whoever said art was enough?"

On its own, there isn't much to say about the poster. It's more interesting in the context of Gran Fury's work, and in the arc of the collective's story. *Art Is Not Enough* can be read as a qualifier on Gran Fury's initial mission statement. Consider that when Gran Fury formed at the beginning of 1988, they described themselves as "using the power of art to end the AIDS crisis." Nothing in that initial statement is tempered, or gestures toward the fact that art alone cannot accomplish this. Over the course of 1988, Gran Fury seems to have recognized that art alone would not end the AIDS crisis, as the handprint demonstrated. George H. W. Bush could enter "read my lips" into the popular vernacular simply by adding it to a speech. But for Gran Fury to have a fraction of this

effect, their work had to be ratified by thousands of other activists and then further disseminated by the media. Gran Fury already had the support of other activists. Now they just needed a bit more support from the press.

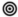

Soon after the FDA demonstration, Gran Fury decided to change the structure of the collective. Since its inception earlier that year, Gran Fury had essentially been an open committee within ACT UP. Anyone could attend a meeting. Sometimes three people would show. Other times, so many would come that it became difficult to have a coherent conversation.

Those who came but decided to not continue with Gran Fury did so for a variety of reasons. There was Anthony Viti, an abstract painter who left Gran Fury because he wanted there to be a separation between his life as an activist and his life as an artist. He also found others in Gran Fury to be a bit mean-spirited. Once while leaving a Gran Fury meeting, someone asked him, "What're you gonna do? Go home and make paintings about your feelings?"

Don Ruddy, who had cast the concrete slabs for *Let the Record Show . . .* , contributed a poster for the Nine Days of Rage but found his time stretched when he had to take care of his partner who was living with AIDS, and he ultimately didn't stay long. There was Richard Deagle, a graphic designer who found Gran Fury's process to be too slow and tedious. "We would spend a two-hour meeting deciding where to put the comma," he said, and lamented some of the more heady, theoretical discussions happening within the collective. Todd Haynes, who had worked on *Let the Record Show . . .* , continued working with Gran Fury after it had formed, but eventually found himself busied by his own film work. Some, like Mark Harrington, left Gran Fury to go do other things within ACT UP, as Harrington had with ACT UP's Treatment and Data Committee.

Amy Heard, who had met Kalin through the Whitney Museum's Independent Study Program and brought him to his first ACT UP meeting,

stayed with Gran Fury the longest of these people but ultimately moved back to California in 1989. Kalin described her as being the odd one out in Gran Fury, not because she was the collective's only woman and only straight person, but because of her disposition. She was very sunny, Kalin said, and was distinctly a Californian, something that couldn't have been further at odds with the rest of the collective. "*Strong* personalities" was how Heard described the rest of Gran Fury, before adding, "And I am not one."

One of the problems with this open and fluid membership structure was that anyone could propose an idea, and often these suggestions weren't really in line with the kind of work that Gran Fury produced. McAlpin recalled that someone once came and suggested that Gran Fury stage a puppet show. Thankfully, this idea was shot down.

Another problem was that anyone could show up. The musician Chris Cochrane attended one of these early Gran Fury meetings and recalled that they were discussing which font to use for a poster. Cochrane was totally lost.

"What's a font?" he asked them.

Cochrane felt that discussing the font of a poster was pointless, and of course, Gran Fury's members felt very differently. None of them would have joined Gran Fury if they thought these sorts of discussions were tedious. The members of Gran Fury didn't seem to have much patience for explaining why this was the case, and Elovich politely told Cochrane that he need not return.

"We don't have any room for musicians in Gran Fury," Elovich told him.

"Avram's a hairdresser," Cochrane protested. "And he's in Gran Fury."

Yes, but Finkelstein knew what a font was, to say the least, and knew that this was an important discussion to be having.

Nor could they seem to make decisions quickly. One week they'd choose which handprint they'd want to use, and then the next week, the people who chose that hand wouldn't show up and three new people who hadn't been there the week before would want to reverse that decision. "It

was impossible to make art collectively in that way," Finkelstein reasoned. And so Gran Fury decided to close itself off to new members.

Two more people joined Gran Fury after it closed its doors to new members. But these two were invited in, under very specific circumstances. Its being a closed group now meant that Gran Fury functioned differently than any other subset of ACT UP, an argument that would soon spill onto the floor of ACT UP.

On September 14, 1989, ACT UP's staged actions inside and outside of the New York Stock Exchange, in protest of the price of AZT. Photograph by T. L. Litt.

CHAPTER 6
ALL THE NEWS FIT TO PRINT

We stand where the power is.

—Robert Vazquez-Pacheco

Around the New Year of 1989, Avram Finkelstein attended a retrospective of the Fluxus art movement at the Museum of Modern Art. Fluxus artists often made their own newspapers filled with prank news stories, many of which were on display here. Noting their example, Finkelstein suggested that Gran Fury create its own rag, and the idea evolved into making a mock front page of the *New York Times*.

For members of ACT UP, coverage in the *New York Times* was paramount in their mission to end the AIDS crisis. "The *New York Times* was, is, and remains the newspaper of record," reasoned Jay Blotcher of ACT UP's media committee. "So if something doesn't appear in the *New York Times*, then it's as if it didn't happen." Mark Harrington concurred, explaining that "the *New York Times* often set the agenda for the rest of the media," and that if ACT UP could get the *Times* to write about their protests, then other publications would follow suit. Policymakers also

took their cues from publications like the *Times*, and so if ACT UP could keep AIDS stories in the news, then they might have a better chance of getting AIDS on the national political agenda. "We really felt that good AIDS coverage in the *New York Times* was a matter of life and death," Blotcher concluded.

While the *Times* was crucial to ACT UP's mission, they were rarely sympathetic to their cause. Their most egregious writing on AIDS took the form of op-eds, like William F. Buckley's proposal to tattoo all HIV-positive persons, which had partially inspired the *Silence=Death* poster. This was not a single or rare instance. A year after Buckley's op-ed, the *Times* published an article warning heterosexual women about the dangers of bisexual men:

> Numbers offer little consolation to the individual woman who fears that one miscalculation could be fatal, especially a middle-class woman who thinks the chance of contact with a drug addict using contaminated needles is remote. For this kind of woman, experts say, the figure of the male bisexual, cloaked in myth and his own secretiveness, has become the bogeyman of the late 1980s, casting a chill on past sexual encounters and prospective ones.
>
> She might also be distressed to learn that bisexuals are often secretive and complex men who, experts say, probably would not acknowledge homosexual activity even if questioned about it. Indeed, some cannot even admit such behavior to themselves.

Rather than advocating for safe sex, the *Times* implied that women should watch out for signs that he's bisexual. "I don't care how much they want to cover it up," one woman told the *Times*. "Their little effeminate ways tip you off."

But as egregious as their op-eds could be, the *Times* was one of the few publications that consistently reported scientific studies on the crisis, such as the report that one in sixty-one babies in New York state were born with HIV antibodies. Publications catering to the gay community wrote about the crisis more frequently, but often published wildly

inaccurate reports and dubious medical studies. America's most widely read gay newspaper, the *New York Native*, characterized this other end of the spectrum, with coverage that oscillated between pseudoscience and conspiracy theories. Some of the paper's most outlandish claims included that HIV was not the cause of AIDS, and that the HIV virus was a government-made contagion released to decimate homosexuals. Within the print media landscape, there wasn't yet an exemplary publication reporting on the crisis. And so Gran Fury resolved to make its own.

As Gran Fury began producing their fake newspaper, Tom Kalin flew out to Ohio to represent Gran Fury on a panel discussion hosted at Ohio State University. It was one of the first exhibitions chronicling art made in response to the AIDS crisis, and the catalog included a redux of Gran Fury's *Art Is Not Enough* poster. Kalin found himself on a panel with another ACT UP member, Robert Vazquez-Pacheco, who had produced an installation for El Museo del Barrio, filling a sixteenth-century baptismal font with condoms.

At one point in the panel discussion, Vazquez-Pacheco jokingly chided Kalin, telling him, "You probably have no people of color in Gran Fury." He was correct. At that point, the collective's membership was entirely white.

Shortly after they returned to New York, Vazquez-Pacheco found a message on his answering machine. It was from Kalin. "Robert!" he said. "Why don't you join Gran Fury?"

It was fitting that Vazquez-Pacheco joined Gran Fury at this moment, given that his experience of the AIDS crisis had begun with the *New York Times*.

On July 4, 1981, Vazquez-Pacheco and his boyfriend, Jeff Leibowitz, had trekked out to Jones Beach with some friends. Leibowitz, an avid reader of the *Times*, brought along a day-old issue. It was here that Vazquez-Pacheco first read about cases of Kaposi sarcoma, one of the telltale signs of advanced AIDS, in the *Times*'s "Rare Cancer Seen in 41 Homosexuals" article. The outlook was bleak: "Eight of the victims died

less than 24 months after the diagnosis was made." This was the first time that Vazquez-Pacheco heard about what would come to be known as AIDS and described it as "our first inkling that something was happening." While he later came to understand this as a pivotal moment in his life, he and his friends didn't immediately react with concern. One friend, sitting on the beach next to Vazquez-Pacheco, dismissed the direness of the article. "Well, you know those sluts in San Francisco," he joked.

Some within New York had already been hearing about this affliction spreading throughout the gay community. "We didn't need the *New York Times* to anoint the AIDS crisis," recalled Finkelstein. "People were hearing about it." Still, this July 3rd article from the *Times* looms large in the collective memory of this generation of gay men, especially for those who weren't living in Manhattan at the beginning of the epidemic. Kalin, who was then living in Chicago, guesstimated that, for gay men his age, "seven out of ten of them, no matter where they were in the country, knew from the *New York Times* first."

Vazquez-Pacheco and Leibowitz both volunteered at the Gay and Lesbian Switchboard, the oldest LGBTQ hotline in the world, and after the *Times* article, they started to increasingly field calls about "the gay cancer." With a limited number of articles being written about the budding crisis, the Switchboard was one of the few places where people could call and learn more about it. "We were trying to get information and no one had any information," Vazquez-Pacheco recalled. "And there's nothing more frustrating, when someone calls you looking for help and you cannot help them."

In August 1981, a month after reading that article in the *Times*, Leibowitz began developing small spots on his skin. His doctor referred him to an oncologist, whom Leibowitz visited on September 19. Vazquez-Pacheco remembers the exact date because it happened to be Leibowitz's thirty-first birthday, and Vazquez-Pacheco had planned a surprise party for him. Hours before the party was set to begin, Leibowitz called Vazquez-Pacheco and asked him to meet him in the lobby of NewYork-Presbyterian Hospital.

Vazquez-Pacheco recalled standing in the lobby and looking toward the bank of elevators. Leibowitz walked out, came over to Vazquez-Pacheco, started crying and collapsed into his arms. Leibowitz had Kaposi sarcoma, the cancer they had read about in the *Times* just months before.

While trying to comfort Leibowitz, Vazquez-Pacheco also figured that he needed to call off the surprise party that would soon be happening back at their apartment. "I know this is not the best time," Vazquez-Pacheco told Leibowitz. "But I really have to pee, so just sit here for a moment and let me pee."

While pretending to use the bathroom, Vazquez-Pacheco called the friend with whom he had been planning the party. "Cancel the party," Vazquez-Pacheco told him. "Jeff is really sick and he is not in the mood for a party."

At that point, Vazquez-Pacheco and Leibowitz had been living together for three months. Leibowitz told Vazquez-Pacheco that he shouldn't feel obligated to stay. "I don't know what's going to happen here," Leibowitz told him. "You don't have to stay with me. You can go, it's perfectly okay."

"I will never leave you," Vazquez-Pacheco told Leibowitz, a statement that proved to be true, though Vazquez-Pacheco didn't quite realize then what he was signing up for.

Later that day, Vazquez-Pacheco and Leibowitz were starting to have sex, and Leibowitz hesitated: "I don't think—"

"Shut up," Vazquez-Pacheco told him. "If you have anything, I already have it . . . so it doesn't make any difference."

One of Vazquez-Pacheco's first responses to Leibowitz's diagnosis was to tell his own family about what little information he could gather. But there was little to find, as papers like the *New York Times* rarely wrote about the virus in the pre–Rock Hudson days of the epidemic. When ACT UP's founder, the playwright Larry Kramer, staged his first performance of *The Normal Heart* in 1985, he painted the following statistic onto an all-white set:

During the first nineteen months of the [AIDS] epidemic, the New York Times *wrote about it a total of seven times.*

During the first three months of the Tylenol scare in 1982, the New York Times *wrote about it a total of 54 times.*

By 1983, AIDS had claimed more than two thousand lives, while seven people had died of Tylenol poisoning.

Information was largely circulated by word of mouth in these early days, and it was through taking care of Leibowitz that Vazquez-Pacheco gathered information that he could share with callers through the Gay and Lesbian Switchboard. "This doctor is not an asshole," Vazquez-Pacheco might tell a caller asking for basic medical information.

One of the pieces of information that defined this early period of the crisis was the question of HIV's transmissibility. Sharing needles and unprotected sex seemed to be the main methods of transmission, but it was initially unclear whether or not HIV could be transmitted through more casual contact. Could mosquitos transmit the virus? Was it safe to share a drink? What about touching? These were all questions that came to the forefront of their lives, particularly during hospital visits. Vazquez-Pacheco's recollections of these visits are nearly identical to Finkelstein's. The orderlies would leave Leibowitz's food in the hallway. The nurses would either refuse to enter Leibowitz's room or else they'd wear biohazard gear.

For Vazquez-Pacheco and Leibowitz, this concern about casual contact came to define their respective relationships with their families, even after HIV's modes of transmission were scientifically established. In 1984, Leibowitz's sister and Vazquez-Pacheco's sister both had babies. When Vazquez-Pacheco's sister had hers, Vazquez-Pacheco and Leibowitz went to visit her in the hospital. A nurse came in holding the newborn. "Give the baby to Jeff," Vazquez-Pacheco's sister said. "Jeff, this is your nephew." By then, the CDC had declared that AIDS could not be transmitted via casual contact. Still, there was a gap between what scientists knew and what the general public believed. When Leibowitz went to visit his sister in the hospital around the same time, his family refused to let him hold

his nephew. "That really hurt him," Vazquez-Pacheco recalled. "And that made him draw away from his family."

Vazquez-Pacheco had never gotten along well Leibowitz's family to begin with, particularly Leibowitz's mother. "Jeff was a nice Jewish boy from Queens," he recalled. "So they were all freaked out about the fact that he had a Puerto Rican boyfriend." When Leibowitz's mother would come over to the apartment that her son shared with Vazquez-Pacheco, she would try to clean their bathroom with water and toilet paper, which would disintegrate into little clumps and cover their walls and counters. Vazquez-Pacheco admitted to being a bit of a smartass with the situation. The next time that Leibowitz's mother came over, Vazquez-Pacheco put out cleaning supplies on the bathroom floor with a note that read, "If you want to clean my bathroom, why don't you do it properly." Leibowitz's mother stopped visiting their apartment soon thereafter.

Initially, Leibowitz had remained in good health, and his ability to bike to work became a marker of his health, as did his ability to traverse the fifth-floor walkup he shared with Vazquez-Pacheco. But Leibowitz's health continued to falter over the course of 1984 and 1985. His doctors recommended a course of chemotherapy to treat his Kaposi sarcoma, and after his hair began to fall out in patches, Vazquez-Pacheco finally decided to shave his head.

As Leibowitz's health deteriorated, his relationship to Vazquez-Pacheco changed as well. Toward the end, Vazquez-Pacheco shifted into the role of a caretaker more so than a boyfriend. It became a juggling act for Vazquez-Pacheco, trying to live the life of a normal twenty-something-year-old while also taking care of his dying partner. Leibowitz encouraged Vazquez-Pacheco to still go out on the weekends. "Both of us shouldn't be sitting here waiting for me to die," he reasoned. Vazquez-Pacheco would often wait till Leibowitz fell asleep, then go out dancing at the Paradise Garage. When he came back in the morning, he'd bring Leibowitz a bagel and a copy of the *Times* and recount the previous night's revels while Leibowitz lay in bed.

In early 1986, Leibowitz began making calls, to both his own family members and to those within the Vazquez-Pacheco clan. Leibowitz even

called Vazquez-Pacheco's grandmother, who was fluent in English but refused to speak it with anyone except for Leibowitz. "When he called me that day," Vazquez-Pacheco's aunt later told her nephew, "I felt as if he was saying goodbye."

One morning in February 1986, Vazquez-Pacheco woke around four o'clock, looked over and realized that Leibowitz had died in his sleep. Vazquez-Pacheco sat in their bed and held Liebowitz's foot, crying. Then he thought, *You know this is ridiculous, let go of the man's foot.*

Vazquez-Pacheco had quit smoking when he began dating Leibowitz, and felt the urge, at that moment, to have a cigarette, despite the fact that it was blizzarding outside. So he went out for two packs, came home, lit a cigarette and dialed 911.

The apartment that Vazquez-Pacheco had shared with Leibowitz was across the street from a police station, and so two officers soon arrived. Vazquez-Pacheco was surprised by how sensitive they were and recalled this being one of the few positive interactions he's ever had with law enforcement. The officers, along with a paramedic, were about to carry Leibowitz's body out of the apartment when one turned to Vazquez-Pacheco. "Light your cigarette and turn around," the officer told him. "You don't want to remember this."

Vazquez-Pacheco looked away. "I was grateful to him for that," he later recalled. "I'm glad I didn't see them take him out."

In his will, Leibowitz had been very specific about the plans for his death. All of his possessions went to Vazquez-Pacheco, but he was very clear about wanting his parents to plan and pay for the funeral. The Leibowitz family went ahead and planned their son's funeral but opted to not invite Vazquez-Pacheco. "His mom was adamant not to tell me," Vazquez-Pacheco recalled.

Unbeknownst to his wife and just hours before the funeral, Leibowitz's father called Vazquez-Pacheco and told him. "Robert, listen," he said. "The service is here. I'm going to take him to the cemetery. You should come."

Vazquez-Pacheco had no way to get to Queens in time, so he called a friend who had a car and explained the situation. Then they drove out to

Queens where the service was being held. Leibowitz's mother apparently wasn't thrilled to see her uninvited son-in-law. "I looked at her like *bitch, I will deal with you later,*" Vazquez-Pacheco recalled.

After the service, Leibowitz's sister, the one who had not let her brother hold his nephew, came up to Vazquez-Pacheco, crying. "Oh, I feel so bad," she told Vazquez-Pacheco. "I'm so sorry."

"Really, you feel bad?" he asked her. "Good. I hope you feel fucking guilty, and guilty for the rest of your life. Do you know how much you made your brother suffer? You and your mother are just monsters."

Leibowitz's coffin was then loaded into a hearse and driven out to New Jersey to be buried. This being a traditional Jewish service, Leibowitz's male relatives buried the coffin after it was lowered into the ground. One of them handed Vazquez-Pacheco a shovel and told him, "It's a mitzvah to do this," meaning, it's a blessing. Vazquez-Pacheco recalled, more than anything else, the sound of dirt hitting the top of Leibowitz's coffin.

"Baby, when I told you that I was with you until the end," Vazquez-Pacheco joked under his breath, "I didn't literally mean *to the end.* All right? I did not sign up for this part."

After Leibowitz's death, Vazquez-Pacheco became active in a consciousness-raising group called Gay Circles. Their conversations centered around questions like, Who are you as a gay man? What is your history as a gay man? What did that mean, living in the world as a gay man, and what was the community that you were in? Vazquez-Pacheco quickly became disillusioned with the group. AIDS was hardly mentioned, to the point that it seemed as if they were putting effort into not acknowledging it. Not everyone in the gay community responded to the AIDS crisis by demanding that the FDA expedite its approval process. Some gays reacted, more or less, with indifference, or proceeded as they had before.

Part of what compelled Vazquez-Pacheco to have a forum for discussing AIDS was learning, for sure, that he was HIV-positive, something that he had long assumed but was now certain of. "I've never been negative," Vazquez-Pacheco recalled, meaning that by the time there was a designation between HIV-negatives and HIV-positives, Vazquez-Pacheco had likely been living with the virus for years.

Gay Circles met on Mondays, on the third floor of the Gay and Lesbian Center on Thirteenth Street, the same building where ACT UP held its weekly meetings. Because of the Center's layout, Vazquez-Pacheco had to pass through ACT UP's meetings when he left Gay Circles. After walking through the room three consecutive Mondays, he and another friend from Gay Circles, David Kirschenbaum, decided to attend ACT UP's talent show. "Let's see how these people hang out," Vazquez-Pacheco told Kirschenbaum. "Let's see how they socialize."

ACT UP would commemorate its anniversaries with a demonstration and a talent show. And this was what appealed to Vazquez-Pacheco—that they wanted to have a good time *and* end the AIDS crisis. That first talent show included, among other acts, Michael Nesline singing a rendition of the *Guys and Dolls* classic, "Fugue for Tinhorns," which he and two others reworked into "Fugue for Clinical Trials."

Vazquez-Pacheco and Kirschenbaum enjoying themselves at the talent show and decided to attend the next Monday's meeting. There, Kirschenbaum asked Vazquez-Pacheco the all-important question—where should they sit?

"We stand where the power is," Vazquez-Pacheco told him.

"Where is that?" Kirschenbaum asked.

"Be quiet," Vazquez-Pacheco told him. "It's there. Come."

Vazquez-Pacheco had indeed fingered the power corner. He soon learned that he was standing next to, as he put it, "all of the big cheese": Maria Maggenti, Maxine Wolfe and their friend Avram Finkelstein.

When Vazquez-Pacheco joined ACT UP, there were few people of color there, and in a group of four hundred white people, it wasn't difficult for those few to spot each other. "We stood out, as my grandmother would say, like a fly in a glass of milk," Vazquez-Pacheco recalled. He soon linked up with Ortez Alderson, a former Black Panther who also had a long history of organizing in gay liberation and anti-war efforts. Alderson and Vazquez-Pacheco soon banded together with the few other people of color in the room, like Kendall Thomas, a Columbia law professor, to form Majority Actions, a caucus to address the needs of people of color in the AIDS crisis. They purposefully eschewed the term *minorities*,

as people of color have always been, and continue to be, disproportionately affected by the AIDS crisis.

The members of Majority Actions often found themselves advocating for larger, more structural changes, as so many of the white people in the room were content to reform the system that had once worked for them, and a treatment or cure was only going to help those who could already access the existing medical system. "That, I think, was an eye opener for a lot of the folks in ACT UP, many of whom were professional middle-class guys," Vazquez-Pacheco recalled. "This was the first time that they ever started really interacting with IV drug users, women and people of color. So part of it was an educational process."

Vazquez-Pacheco soon threw himself into AIDS activism full time, electing to quit his job as a lighting designer. "I had been working with obnoxious rich people while going to ACT UP meetings," he recalled. "And I felt like there was a disconnect." The final straw was having to design a $10,000 chandelier for an heir to the Coca-Cola fortune.

Vazquez-Pacheco began working as the manager for the People with AIDS Health Group, the first buyers club, a semilegal operation that sold herbal remedies, HIV drugs for which a cheaper generic was available overseas and black market HIV/AIDS medications that had been approved in other countries but had stalled in the FDA's approval process. They imported drugs like fluconazole, a treatment for fungal infections that was approved in Europe years before it became the standard of treatment in the United States. Aerosolized pentamidine, one of the drugs approved shortly after ACT UP's FDA demonstration, sold in pharmacies for about $125 a dose. The buyers club was able to import it from England and sell a dose for $40. Vazquez-Pacheco would later describe some of their medications as "snake oils," harmless drugs that ultimately proved to be ineffective, and that gave patients nothing but a sliver of hope. But some of the drugs sold here actually did wind up working. One such medication was DDI, which had first been synthesized in the 1960s and was shown to slow the spread of HIV in 1985. But clinical trials for the drug had languished, and it wasn't formally approved by the FDA until October 1991. Several members of ACT UP who are still

alive today were taking black market DDI in those interim years, and they were purchasing it here.

The People with AIDS Health Group spawned identical groups in cities across the nation, including one depicted in the film *Dallas Buyers Club*. Vazquez-Pacheco recalled that managing the buyers club was a much more mundane job than it was made out to be in the film. It was a lot of clerical work: payroll, supervising the other employees and monitoring supply levels. In the film, Matthew McConaughey's character is inspired to start his own group after reading about Vazquez-Pacheco and his cohorts in a fictionalized version of the *New York Times*. "Bunch of faggots up in New York runnin' a hell of a racket just like this," McConaughey's character tells his lawyer. "That's where I got the idea."

Vazquez-Pacheco became acquainted with Gran Fury's work through their first poster, *AIDS: 1 in 61*. He was surprised to see an entirely white group addressing the AIDS crisis among primarily Black and Brown communities. "Wow!" he joked to himself. "This is great if white people are doing this without supervision."

Vazquez-Pacheco noticed that, around the floor of ACT UP, people started talking about Gran Fury differently once the group solidified its membership. "People imbued Gran Fury with a sense of mystery," Vazquez-Pacheco recalled. Even before he joined the collective, Vazquez-Pacheco thought it was a bit silly that many on the floor of ACT UP talked about Gran Fury as if it were some artistic cabal, when in actuality, all these people were in the room too. Usually this was just the rote ACT UP gossip, but it occasionally became a source of friction. "ACT UP prided itself on transparency," Vazquez-Pacheco recalled. "And it became a source of contention that a lot of people in ACT UP didn't know who was in Gran Fury."

Within Gran Fury, Vazquez-Pacheco felt ambivalent about being the collective's de facto person of color, and he would jokingly refer to himself and Finkelstein as "the ethnics." He hoped that by joining Gran Fury, he could get his foot in the door for more people of color. "It was a burden sometimes," he recalled. "You feel a certain degree of responsibility. I can represent myself and vaguely represent the Puerto Ricans I grew up with.

But sometimes I felt like I had to speak on behalf of all people of color, because if I didn't then nobody would."

Among Gran Fury's members, Vazquez-Pacheco found a particular kinship with Nesline. Besides being the group's two medical practitioners, Nesline and Vazquez-Pacheco also happened to be the only members of Gran Fury who didn't consider themselves artists, and so they often found themselves reeling in the group's more heady, theoretical discussions. "People dismiss Michael because they think he's this bitchy old queen from the South," Vazquez-Pacheco said. "But there's a lot more to him than that." Nesline would probably contend that he's neither bitchy, nor a queen, nor from the South. He's actually from Washington, DC.

Vazquez-Pacheco reasoned that one doesn't decide to become a nurse in an AIDS ward without being a deeply compassionate person, though he acknowledged that Nesline's "acid tongue" didn't always curry favor. Through Gran Fury, Vazquez-Pacheco was getting to see a different side of Nesline. "Michael isn't cruel," he reasoned. "Just accurate."

Around the time that Vazquez-Pacheco joined Gran Fury, they produced a chartreuse sticker that read, "Men Use Condoms or Beat It," recycling a slogan from one of their Nine Days of Rage posters. The sticker could be placed anywhere, but was designed as a facsimile of the official placards found in the backseats of New York City taxis, and could be pasted over them. Vazquez-Pacheco was particularly fond of how they distributed it. At one ACT UP meeting, he and Kalin walked onto the floor with boxes full of these stickers. Kalin explained that it was a new piece from Gran Fury while Vazquez-Pacheco held one above his head and pantomimed the crack-and-peel backside—his Vanna White routine, as he put it. Then he and Kalin walked off the floor, leaving boxes of the stickers for ACT UP's members to take on their way out. Within hours, Vazquez-Pacheco recalled, *Men Use Condoms or Beat It* had carpeted lower Manhattan.

Vazquez-Pacheco's first contribution to Gran Fury was an article for their fake paper, which they had now dubbed the *New York Crimes*, tweaking enough of the *New York Times*'s front page to avoid a lawsuit. A year before, another activist group, the Committee in Solidarity with

Men Use Condoms or Beat It, Gran Fury, 1988. Photo-
graph courtesy of Gran Fury.

the People of El Salvador (CISPES), tried to distribute their own mock
copy of the *New York Times*. From a friend who worked with CISPES,
Finkelstein learned that the *Times* had sued CISPES for copyright in-
fringement, as the *Times*'s header font is copyrighted. Thus, Gran Fury
resolved to make subtle alterations to their paper, in the hopes of avoiding
litigation.

Instead of the *Times*'s "All the News Fit to Print" mantra in the
upper-left corner of the front page, Gran Fury again included their "Men:
Use Condoms or Beat It" slogan, which they continued to recycle. In-
stead of the volume and issue number, they wrote, "Not to be confused
with the *New York Times*." Price of the *New York Crimes*: FREE.

Some of Gran Fury's own members contributed articles. Loring
McAlpin wrote a piece for the *New York Crimes* about AIDS in pris-
ons, and Richard Elovich wrote about how the criminalization of needle

exchange programs facilitated the spread of HIV among intravenous drug users. They also asked other affinity groups from ACT UP to write the articles too. Instead of paid advertisements, Gran Fury inserted a few of their previous projects. "We were good at recycling shit," recalled Vazquez-Pacheco. "Oh, do we not have to make another one? Fabulous."

The *New York Crimes* is undoubtedly Gran Fury's most text-heavy project. But whereas wordiness was often their enemy, "the *New York Crimes* communicated what we couldn't get across in a one-line sentence," said

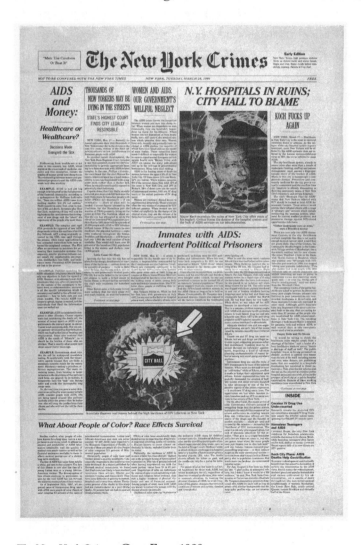

The New York Crimes, Gran Fury, 1989.

Elovich. It was one of his favorite Gran Fury projects, which wasn't surprising considering that he had a reputation for being Gran Fury's most policy-wonky member. It was ACT UP's most thorough articulation of how AIDS is not just a medical issue, and that news coverage of the crisis should reflect this. Being such a text heavy project, the layout took much longer than it would have for a poster. Without any typesetting equipment, the collective had to piece together the project by hand, with X-Acto blades, a roller, a waxer and strips of type.

Gran Fury timed the *New York Crimes* to coincide with ACT UP's largest demonstration to date, Target City Hall, which both commemorated ACT UP's second anniversary and demanded the city of New York spend more on AIDS services. The night before Target City Hall, ACT UP held its weekly meeting at the Center. It was standing room only for the final preparations. After practicing a few chants, Gran Fury's *New York Crimes* project was distributed to those assembled. "Make sure everybody gets one!" somebody yelled out. "If you know of anywhere to drop them off," someone else suggested. "Be creative!" Most fawned over the layout and laughed at the articles. Vazquez-Pacheco, apparently warm, used a copy to fan himself.

Once the *New York Crimes* was distributed, Ann Northrop, a former producer at CBS News and a progenitor of ACT UP's media strategy, came and spoke to the floor about their interactions with the press. "Keep in mind, when you talk to anyone outside this group, they don't know anything," Northrop told those assembled. Don't use jargon, and don't assume that members of the press are familiar with issues like the city's lack of AIDS education in schools, or the overwhelming number of unhoused New Yorkers living with AIDS. In addition to speaking in crisp and succinct sound bites, Northrop also encouraged ACT UP's members to continue engaging with the press after they gave their quote. "Watch the evening news, and time how much of a story is the reporter's narration and how much is the sound bite, and you'll find that the sound bite is a very small portion of the story," said Northrop. "Talk to the reporter before they do the story and educate them, so they will reflect your point of view in their narration." Instead of speaking *to* the

media, Northrop encouraged ACT UP's members to speak *through* the media, and *to* the public. "Teach them what they should be demanding," she told those assembled.

This strategy, of speaking *through* the media rather than *to* the media, became one of the ways that ACT UP disseminated its viewpoints and demands. Their chants often helped with this too. "If it's loud enough, if there are enough of you chanting it, they will use it," Northrop told those assembled. The same could be said of ACT UP's posters and graphics, which inadvertently became another way that ACT UP spoke *through* the media rather than *to* the media. If enough people carried the same sign, that too would become a photo opportunity.

When ACT UP's pre-demonstration meeting concluded, the night was just beginning for the members of Gran Fury. To distribute the *New York Crimes* throughout Manhattan, the members of Gran Fury enlisted a few friends from ACT UP, including Maria Maggenti and Heidi Dorow, whom Vazquez-Pacheco described as "one of the power lesbian couples in ACT UP." With a bit of research, Gran Fury had learned that most of the *Times*'s early-edition papers landed in these vending machines between two and five in the morning. So they split into teams of three or four and trailed the *Times*'s delivery trucks around Manhattan. At the time, newspaper vending machines operated on the honor system—a quarter got you access to the entire lot of papers. Dorow recalled that her team piled into Mark Simpson's van, and that they'd all spring out once the papers were in the machine. With someone acting as lookout and another holding the vending machine door, a third person pulled out all of the morning's issues, removed the actual front page and replaced it with the *New York Crimes*. McAlpin recalled that unwrapping the *Times*'s front page and replacing it with their own was quite unwieldy. The pages had to be removed carefully, so as not to tear, but they had to move quickly enough to not draw attention to themselves. "I don't know that we covered every single box [in Manhattan]," recalled Finkelstein. "But we covered every one we could find within a one-night period." All for a roll of quarters.

This was a bit more high stakes than their usual wheat-pasting. "I remember us being very nervous," recalled Amy Heard. Dorow had a

similar recollection. "It was nerve-racking!" she exclaimed. "Like, we're fucking with property." Nobody really minded if they put up a poster on the wall of a construction site. But stealing the front page from the *Times*, and then placing their own work in the *Times*'s vending machines, carried a much greater risk. "We were so afraid of that project," recalled Kalin. "We thought the legal department of the *New York Times* was going to descend on us." It's noteworthy that, though full of Gran Fury's other projects, the *New York Crimes* doesn't actually include the name Gran Fury anywhere, as their other projects do. It was one of the advantages of operating as an anonymous collective without any fixed address. Gran Fury didn't exist as any sort of formal entity. What could the *Times* have sued?

Like many of Gran Fury's projects, the *New York Crimes* spawned copycat projects with other ACT UP chapters across the nation. In his essay collection *How to Write an Autobiographical Novel*, Alexander Chee described how ACT UP's San Francisco chapter later published the *San Francisco Chronic Liar*, riffing on the *San Francisco Chronicle* and their poor coverage of the AIDS crisis. Chee described how they distributed their paper, first meeting in a Safeway parking lot at five in the morning. before raiding the *Chronicle*'s vending machines. "We didn't know what would work," wrote Chee, "so we tried anything we could think of." Their scheme followed one almost identical to Gran Fury's: three-person teams, where one person held open the vending machine, another replaced the front page, while a third acted as lookout.

Part of the novelty of the *New York Crimes* is that the artifice reveals itself slowly. If you're in a rush, or if you don't thoroughly examine your paper, it really does pass as the *Times*'s front page. Squint and see if you can tell the difference. But once you begin to actually read the paper, the headlines and subtle alterations clue you in to the hoax. With headlines like "Koch Fucks Up Again" it doesn't take much discernment. And most notably, Gran Fury's front page featured an advertisement for Target City Hall.

Target City Hall was set to begin at 7:30 a.m. And so unless the members of Gran Fury stopped off for a quick catnap, they would have had to

head straight for City Hall after distributing the morning's copies of the *New York Crimes*.

Though ACT UP would, at times, berate the media for their coverage of the AIDS crisis, as Gran Fury had done with *AIDS: 1 in 61*, they would also court the media unabashedly at their demonstrations. "We were shameless," recalled Signorile of ACT UP's media committee. As the FDA demonstration had proved, what happened at the demonstration was just as important as the coverage of the event. And ACT UP's media committee was unafraid of directing and corralling gathered members of the press. Signorile recalled that someone with a bullhorn might yell something like, "There's a photo op at the flagpole!" The reporters at City Hall noted and even appreciated this direction. "This is a really well organized demonstration," reported one CNN newscaster who was stationed on the ground. "There are people who are pointing out to us where the next act of civil disobedience is going to be, so that we can get our cameras down there." What Northrop had said about enough ACT UP members cheering the same chant had proved true. The chant "Healthcare is a right!" even appeared on that evening's WNBC New York coverage. Signorile recalled that Brian Williams, who was then a local newscaster, knew that ACT UP would be staging a die-in, and that Williams asked the media committee if ACT UP could time their die-in to happen seven minutes after the hour, so that he could cover it live, right after a commercial break. They happily obliged.

Though Gran Fury was rarely ever credited in these sorts of photo ops, the collective's work constantly appeared in news coverage of the crisis. In effect, Gran Fury became one of the mechanisms by which the discussions happening within ACT UP permeated the world. And that's exactly what happened at City Hall. Chester Higgins Jr., a *Times* staff photographer, happened to be covering Target City Hall and snapped a photograph of an ACT UP member lying on the ground about to be arrested. Along with a small *Silence=Death* sticker, a *Read My Lips* T-shirt and *You've Got Blood on Your Hands* both appeared in this photograph, which made its way to the next day's front page of the *Times*'s Metropolitan section.

Target City Hall became a massive news event. A three-thousand-word profile of ACT UP was timed to appear in that day's *Washington Post*, where ACT UP was described as "the best-merchandised revolution in town." Finkelstein was quoted in the piece describing the efforts of Gran Fury to fundraise and publicize ACT UP's efforts. "I'm not embarrassed to call what we do propaganda," Finkelstein told the *Post*. "That's what we do."

Toward the end of Target City Hall, ACT UP's members began a chant, borrowed from the 1968 anti-war protests at the Democratic Convention in Chicago, which seemed to encapsulate the day's media frenzy. "The whole world is watching!" they chanted. "The whole world is watching!"

The *New York Times* never formally responded to Gran Fury's *New York Crimes*. But privately, reporters from the *Times* did lament the hijacking of their vending machines. "The *Times* was furious," recalled Signorile of ACT UP's media committee.

Three months after the *New York Crimes*, the *Times* ran one of its most callous pieces on the AIDS crisis, and its most explicit attack on ACT UP to date. In "Why Make AIDS Worse Than It Is," the *Times* argued that the direness of the AIDS crisis was being exaggerated by activist groups. Though they didn't mention ACT UP by name, they described their efforts to harass New York City health commissioner Stephen Joseph as indicative of how "advocates for people with AIDS sometimes accept good news badly." The logic of the editorial was that the AIDS crisis would soon abate on its own, as the epidemic was mostly confined to certain groups—mainly homosexuals and drug users. "Once all susceptible members are infected, the numbers of new victims will decline," the op-ed said. And once those groups had died off, the crisis would effectively be over. Therefore, there was no need to be so concerned.

Like most editorials published by the *Times*, the author of "Why Make AIDS Worse Than It Is" was not listed, and it was meant to be read as

the stance of the entire organization. "The editorials are supposed to speak for the *Times*," said Gina Kolata, the paper's beat AIDS reporter. In the minutes from the next ACT UP meeting, Nicholas Wade of the editorial board is cited as the author of "Why Make AIDS Worse Than It Is," though in an interview for this book, Wade denied that he wrote the piece. However, Wade recalled that, in his time as an editorial writer, one of the most frequent pieces of feedback he would receive was to clarify the position of this piece, which was never framed as clarifying his own position but rather clarifying the paper's position. "Where do we stand

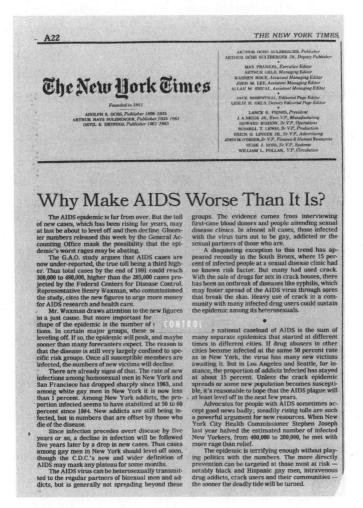

Control (1 of 4), Gran Fury, 1989.

on this?"—"we" being the operative word. And from this editorial, it was clear how the *Times* thought about AIDS.

ACT UP called for a demonstration outside of the home of Punch Sulzberger, the *Times*'s publisher. The members of Gran Fury decided to produce something in conjunction with the demonstration. They had just been commissioned by *Artforum* to produce four full-page ads to appear in an upcoming issue of the magazine, and they used this opportunity to critique the *Times*'s persistently negligent coverage of the AIDS crisis. They reprinted the editorial "Why Make AIDS Worse Than It Is," and in the center added a small green button reading "Control."

Part of what made this gesture so important was that it embalmed and preserved the *Times*'s editorial, which could have otherwise gone unnoticed, as any number of news articles invariably are. If you didn't happen to read that paper, or somebody didn't save it for you, you would have missed it. It was a way of enshrining what the *Times* had written, of pulling it from the deluge of that day's news and pointing to it as something worth noticing. In the same way that *Let the Record Show . . .* established a pattern of neglect, so too did *Control*. In a small way, it was holding the *Times* accountable, even if just for themselves.

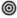

By the fall of 1989, Peter Staley and Mark Harrington had spent much of the year lobbying Burroughs Wellcome to lower the price of AZT. After a failed meeting, they had tried to commandeer an office at the company's headquarters, locked themselves into a room with metal brackets and a power drill, and unfurled a banner demanding a lower cost. But the windows were too thick to saw through, and police were quickly able to dismantle the flimsy office walls barricading them. Burroughs Wellcome decided to not press charges for the minor damage and trespassing, presumably because they didn't want to keep the story in the media.

Since then, two recent developments had made the price of AZT even more significant. The first was that the guidelines had been expanded for when AZT should be administered, meaning that a greater number of people would soon be taking it. The second development was that DDI,

a less toxic competitor to AZT, would soon be coming to market, and no longer solely available through the underground. Harrington and Staley figured that DDI would be priced in relation to AZT, and so a lower price of AZT, theoretically, also meant a lower price of DDI.

ACT UP planned for a lunchtime demonstration on Wall Street, and Staley gave Burroughs Wellcome fair warning. "We're doing a massive demonstration," he told them. "You've got a few weeks. Lower the price before then." Burroughs Wellcome was unrelenting.

In tandem with the larger, more public demonstration on Wall Street, Staley was secretly planning a more covert action: infiltrating the New York Stock Exchange. Peter Staley began recruiting a small team of trusted comrades: James McGrath and Lee Arsenault, who had both locked themselves into the Burroughs Wellcome office with Staley; Gregg Bordowitz, one of the key organizers of the FDA demonstration; Staley's boyfriend at the time, Robert Hilferty; Scott Robbe, a member of the media committee and Richard Elovich from Gran Fury.

Those seven would be infiltrating the exchange itself, if all went to plan, but Staley also recruited a few others to help with the logistics outside the Exchange. Vincent Gagliostro, who had been one of Don Yowell's close friends, but had been kept in the dark about his worsening illness, was one of those that Stlaey recruited. After Yowell's death, Gagliostro and Finkelstein didn't speak for about two years—Gagliostro had felt that betrayed by Finkelstein had kept this all from him. But they had since reconciled, after Finkelstein told Gagliostro about how Yowell had sworn him to secrecy, and now were nearly inseparable after that frosty stretch.

From an ACT UP member who worked on the floor of the New York Stock Exchange, Staley learned that security was surprisingly lax. Everyone had photo IDs issued by the exchange, but nobody actually bothered to take them out of their wallets when entering. The lone security guard at the front entrance usually just looked to see the laminated paper ID card that traders clipped to their jackets.

Many of the stock exchange's security measures had actually been implemented after an almost identical demonstration years before, when

Abbie Hoffman and a few others invaded the stock exchange to protest the ongoing war in Vietnam. At that demonstration, Hoffman and co. had thrown dollar bills from the visitors' gallery, and the sight of day traders grasping at the fluttering cash had generated quite a bit of news. ACT UP was hoping to have a similar effect, albeit with the fake paper cash that Gran Fury had made for ACT UP's last trip to Wall Street.

Staley, Hilferty and another ACT UP member named Charlie Franchino dressed up as tourists and went on a reconnaissance mission. They brought a video camera, and with one posing in front of the stock exchange and another recording, they tracked the flow of day traders coming in and out of the building. Then they zoomed in on a trader and shot some footage of his badge. From that footage, they designed seven fake badges and had them made at a printer in Greenwich Village, explaining that the badges were for a skit in an office Christmas party.

Two days before the action, Staley and a couple of others got dressed up and did a test run, to make sure that their fake IDs would actually get them into the exchange. They noticed that, just outside of the exchange, traders would congregate for a last cigarette right before the ringing of the opening bell. So at 9:25, they started to mull around with the smokers and then filed in with them just before 9:30. "The security guard didn't bat an eye," recalled Staley. "And all of a sudden we were on the floor of the New York Stock Exchange."

They walked around the floor, jotting down notes and trying their best to pretend to be actual stockbrokers. While noting the layout of the floor, an actual Bear Stearns employee walked up to Staley.

"Hey!" he said to Staley. "You're new!"

He started to gladhand and chat up Staley, believing him to be a new coworker. Staley had left his job as a bond trader to devote himself to ACT UP, and so he was familiar with the hobnobbing of New York's finance world. Still, it was nerve-racking to have an actual Bear Stearns employee introduce himself.

Then the trader noticed Staley's badge. "That's weird," he told Staley. The highest numbered badge was supposed to be 1600, the trader said. Staley had picked a random number, and his was over 3000.

"I don't know," Staley told him. "This is the one they gave me."

"I guess they're trying a new system," the trader reasoned. "Well, welcome."

He shook Staley's hand and walked away. Staley and the two others bolted out of the exchange and headed back to the printer.

The day of the demonstration, Staley, Elovich and the others met at a nearby McDonald's, then walked over to the exchange together and again mulled with the smokers. Just before 9:30, they walked in. Elovich stayed on the floor, along with Hilferty, and they readied their cameras, which had been loaded with high ASA film so that they wouldn't need flashes.

Up on the balcony, Staley, Bordowitz and three others locked themselves into place. Staley looked up at a clock. It was 9:29:45. Fifteen seconds later, the morning bell rang, but those on the floor only heard airhorns. As soon as the banner was unfurled and Gran Fury's cash came raining down, Elovich and Hilferty began snapping away. With their photos taken, they unloaded the film and ran out of the exchange. Outside, Gagliostro was waiting for them. A barricade separated Gagliostro from the entrance to the exchange, as police officers had gathered, knowing that an ACT UP demonstration was supposed to take place later that day. Hilferty and Elovich chucked their rolls of film over the police and their barricades. "I had one chance to catch that roll of film," recalled Gagliostro. "And I caught it."

Gagliostro handed off the film to a designated runner, who ran it to the nearby offices of the Associated Press, who would circulate the photos to other newspapers.

Elovich and Hilferty went back into the exchange, worried that the growing mob might attack the five chained to the balcony. "You've seen faggots before," one trader screamed to the others. "Get back to trading!" Officers began to swarm around the five ACT UP members locked to the balcony railing. "Mace the faggots!" another trader screamed at the officers.

By the time the police finally led all seven of them out of the exchange in handcuffs, the photographs that Elovich and Hilferty had taken were

already on the morning wire. One of those photographs appeared the next day in the *Washington Post*, and Staley had alerted the *Wall Street Journal* in advance, who ran the story and the photographs on its front page. But the *Times* waited two days before reporting this story and buried ACT UP's demonstration in a larger piece about Burroughs Wellcome. In this article, the *Times* omitted any mention of the trading delay or Gran Fury's cash, and also failed to mention ACT UP by name. It seemed to epitomize the *Times*'s indifference. ACT UP had shut down the New York Stock Exchange: How could this not be news?

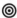

A few weeks after this most newsworthy trip to Wall Street, Gran Fury did manage to gain the *Times*'s attention, albeit for a more minor story.

Photograph courtesy of the New York Public Library.

The Henry Street Settlement, a nonprofit arts organization, had asked Gran Fury to contribute a piece for an upcoming exhibition about artists' responses to the AIDS crisis. Gran Fury refused invitations to exhibit work inside of museums and galleries, and often countered such invitations with offers to mount something on the exterior. Per usual, Gran Fury countered, proposing a banner be hung outside. It was a reprise of *All People with AIDS Are Innocent*, a poster from the Nine Days of Rage.

When the Henry Street Settlement declined their counteroffer, the show's guest curator, Humberto Chavez, threatened to withdraw his show in support of Gran Fury. The *Times*'s chief art critic, Michael Kimmelman, decided to report the story. In addition to giving Gran Fury considerable media attention, this decision also signaled a shift in what Gran Fury meant to the media. While Gran Fury had begun by critiquing and then seeking to influence coverage of the AIDS crisis, Gran Fury's work had now become the story itself.

The dispute over whether a banner constitutes a piece of art seemed like a thin reed for censorship. Chavez told Kimmelman that they refused to hang the banner because it was too political, that in their estimation, it was not a piece of art, nor was Gran Fury a group of artists. But Barbara Tate, a chief administrator at the Henry Street Settlement, felt differently. "We have a policy here that the facade of the building does not take banners. We have had artworks on the front of the building but this is the first request I've had for a banner that is considered a piece of artwork," she told the *Times*. "We just have a rule about banners. Why are we the enemy in this thing?"

Vazquez-Pacheco spoke on behalf of Gran Fury. "Early in Gran Fury, nobody wanted to talk to the press," he recalled. He was often the collective's spokesperson, which sometimes led to a bit of confusion about the makeup of Gran Fury's membership. "When I would speak on behalf of Gran Fury, people would get the idea that it was a collective of people of color," he recalled. "And I was like, that it is *not*."

"It was clear that she wasn't familiar with the kind of work we do at Gran Fury," Vazquez-Pacheco told Kimmelman. "In fact this banner is the most innocuous thing the group has ever done." Most innocuous

indeed! A banner is hardly, say, hijacking the *Times*'s vending machines or shutting down the New York Stock Exchange.

Not long after Kimmelman's article in the *Times*, then borough president and future mayor David Dinkins offered to hang the banner across the street at a municipal building. But in a sense, it didn't matter whether or not the banner went up. Because of the *Times*'s coverage, more people saw Gran Fury's message than would have ever seen it on Henry Street. The members of Gran Fury had always been headstrong, confrontational and uncompromising. But the dispute with the Henry Street Settlement and the ensuing media coverage proved why that pose was so effective. If it gained them media attention, then censorship was not something to avoid. And in a way, censorship became ideal, something the collective could even begin to bait.

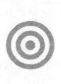

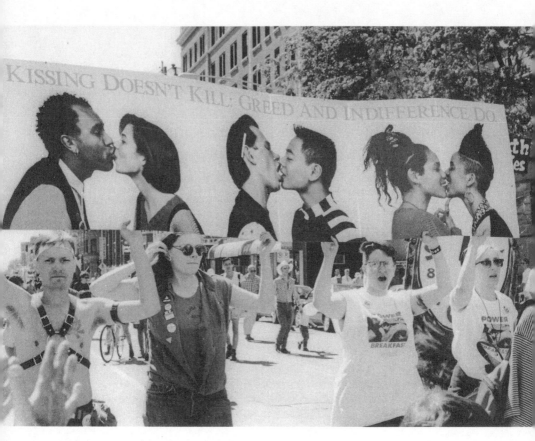

ACT UP's contingent in Chicago's 1990 Pride parade. Photograph by Lisa Howe-Ebright.

CHAPTER 7
POWER TOOLS

It's not going to look like somebody's band poster, and it's not going to look like a wimpy little flower. You're going to look at it and think *that's the voice of power.*

—Marlene McCarty

O n a frigid night in early 1989, the members of Gran Fury gathered a few trusted friends at the intersection of Mercer and West Houston. They brought ladders, brushes and buckets of wheat paste. About half of Gran Fury had just returned from Berlin, where the German curator Frank Wagner had hosted *Let the Record Show . . .* and commissioned a series of billboards to appear in the Berlin U-Bahn. "When a government turns its back on its people," the billboard rhetorically asked, "is it civil war?" Mark Simpson had brought back a few overprints, in the hopes of mounting the billboard in New York, where a critique of the US government might be a bit more poignant. Initially, Gran Fury had contacted Sale Point, a company that rented out billboard space. But when Sale Point saw the billboard's tagline, they backed out, worrying they might lose the business of larger companies like Coca-Cola. So the members of Gran Fury decided to wheat-paste the billboard themselves.

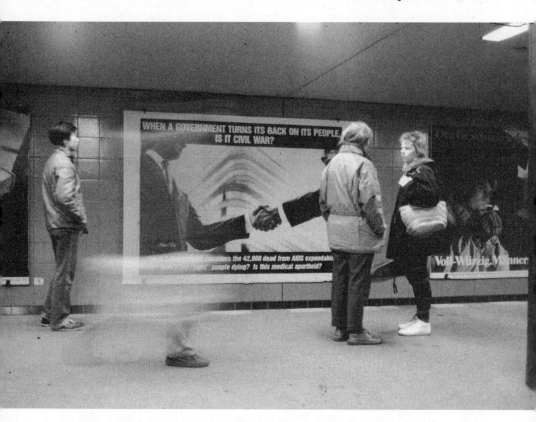

When a Government Turns Its Back on Its People, Gran Fury, 1988. Photograph courtesy of Gran Fury.

This wasn't their usual paste-up job with an 8.5 by 11 sheet of paper. "It was a guerrilla billboard," recalled Heidi Dorow, one of the poor souls who had gotten roped into this, and who also helped distribute the *New York Crimes*. "The materials were huge!" Gran Fury had never tried to wheat-paste something so large. Nor had they ever tried to wheat-paste something so far above the ground—to actually pass as a bill-board, *When a Government Turns Its Back on Its People* couldn't be hung at eye level. Even with ladders, the job proved difficult. "It was fucking freezing," recalled Dorow. "I had no money, and no sense, so I was wearing like cotton socks and three hoodies." The cold didn't bode well for the billboard either. Before it could fully adhere to the wall, the wheat paste froze. By morning, the poster had crumbled into a sad heap at the base of the wall.

The fate of that billboard reflected a hard truth about public art: all of the work and thinking that it entailed were wasted if nobody saw it. And Gran Fury's members were beginning to tire of wheat-pasting their work around Manhattan, as the novelty of these kinds of guerrilla tactics had worn off. "By the time we wheat-pasted our eighteenth project," Tom Kalin recalled, "the thrill was gone." Dashing around lower Manhattan with paint buckets and squeegees ate at the collective's already limited time. "That contractor bucket full of wheat paste was like ten or twelve pounds," recalled Kalin. "It sloshes. It's freezing cold. You have these stiff brushes. You have to carry a rolled-up stack of posters. And you're very vulnerable." Vulnerable in the sense that it was both illegal and dangerous. Gay bashings were still common, even in lower Manhattan.

Furthermore, the members of Gran Fury were starting to feel that wheat-pasting on abandoned buildings wasn't going to accomplish their self-professed goal of using art to end the AIDS crisis. "Wheat paste means you're marginal," reasoned John Lindell. "So it's an effective medium if you want to talk to other people who are marginal." But Gran Fury had no interest in speaking to the converted. Whereas posters like *Silence=Death* had spoken to New York's gay and lesbian communities, Gran Fury craved a larger audience. "We were trying to convince people who *didn't* share our point of view," Lindell reasoned. They needed to speak from a position of power.

Luckily, Simpson had brought back more than one overprint of *When a Government Turns Its Back on Its People*, and Gran Fury's other attempts to wheat-paste the billboard proved to be more successful. It appeared on Avenue A and Tenth Street, in the heart of the East Village, where most of Gran Fury's members lived, and which served as the social center for the larger body of ACT UP. Avram Finkelstein recalled that it stayed up for the better part of a year, and it was their first taste of having a billboard in New York, an appetite that would soon be satiated.

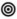

In order to place their work in spaces reserved for more conventional advertisements, Gran Fury began to more consciously adopt the look of

corporate advertising, as a way of seducing the viewer and then delivering something unexpected. And part of what helped Gran Fury adopt this strategy was a new member, one whose experience was most suited to this transition.

Born in Kentucky, Marlene McCarty was of Gran Fury's southern contingent. As early as her junior year of high school, she had had an inkling that she wanted to be a graphic designer. She hadn't been exposed to fine art yet, but loved magazine and LP album covers, her first exposure to the world of graphics. All this ran against what her parents and teachers wanted for her. As the salutatorian of her high school class, McCarty was advised to go to Bryn Mawr and study law. That she would, instead, want to go into graphic design puzzled everyone. And that she wanted to move to New York City was a nonstarter with her parents.

McCarty spent her first two years of college at the University of Cincinnati, which then had one of the nation's premier graphic design programs and whose alumni include luminaries like Michael Bierut and Bruce Blackburn. But it was McCarty's decision to finish her studies in Europe that further shaped her interest in graphic design. The University of Cincinnati, like most other graphic design programs in the United States, was and is, in her words, "a corporate handmaiden," finding ways to brand toothpaste tubes and the like. It was at Schule für Gestaltung in Basel, Switzerland, where McCarty finished her studies, that McCarty started to realize how graphic design could be put to different ends, how graphic design could be about making one's own statement rather than just saying something on behalf of a corporation.

After graduating in Basel, McCarty moved to New York City with her Swiss husband and eventually began working for M&Co., a hip graphic design firm that did album covers for bands like the Talking Heads, and full-page ads in *Paper* magazine. Though it was magazines and album covers that had gotten McCarty interested in graphic design, she now found herself interested in blurring the lines between graphic design and art. When she had settled upon graphic design in high school, she hadn't been exposed to visual art. And now that she had, she found herself going

back and forth over whether she wanted to dedicate herself to graphic design or to her own studio practice.

It was around this time that McCarty was introduced to another East Villager facing an identical predicament. John Lindell was likewise trying to figure out how to use his skill set as an architect to intervene in the AIDS crisis, while also wanting to sustain his life as an artist. And it was through her friendship with Lindell that McCarty joined what became Gran Fury. Lindell, who joined ACT UP in its first year, roped McCarty into working on *Let the Record Show*. . . . It was here that McCarty met the rest of what became Gran Fury.

Though McCarty first met Simpson, Lindell, Donald Moffett, Nesline and Kalin at Terence Riley's offices in the fall of 1987, it took the members of Gran Fury a full year to convince her to join the collective. Nobody remembers, exactly, how it came about, but an ancient Egyptian–themed bar, nightclub and performance space named King Tut's Wah Wah Hut offered Gran Fury an opportunity to stage a piece. Located on the corner of Avenue A and Seventh Street, King Tut's was a sort of typical East Village hangout. On any given night, you might find a then unknown Steve Buscemi trying out stand-up comedy, or a bunch of guys in blue face paint working on their drum routine.

Knowing that it would be dark inside, Lindell and Moffett had the idea to make a projected slideshow of pornographic shots, interspersed with text and photos of ACT UP demonstrations. They asked McCarty to help them find porn that would be attractive to women. "We went through pornography and picked what we thought of as positive pornography," recalled McCarty, who accented the words "positive pornography" with air quotes and an eye roll. "I looked through the women's stuff, which there wasn't much of at that time. They, of course, being gay men all had piles of pornography." Moffett, Lindell and McCarty coupled this slideshow with cocktail napkins printed with safer-sex tips, so that when patrons were handed a drink, they'd also receive safer-sex information too.

Unfortunately, much of this slideshow was later destroyed in Hurricane Sandy. But McCarty does have a standout recollection of it. "I remember this one image of a woman standing on a hill peeing," said McCarty, who

mimicked the image by raising her arms triumphantly. "She just looked so free and empowered."

McCarty recalled the excitement of working on that project, realizing that "all these things I knew how to do, could be put to some kind of use in a way that I felt was really positive, and had a really positive effect upon the social landscape." This slideshow, as she recalled, was the moment when "I got kind of hooked." McCarty remembered the slideshow going off without a hitch, though Lindell recalled the staff at King Tut's not being too enthused about the piece. In Lindell's recollection, the staff asked them to take down the slideshow, which made McCarty even keener to join Gran Fury.

McCarty stood out from the rest of Gran Fury's membership in several ways. She was the only woman in the collective, and Robert Vazquez-Pacheco recalled that he and McCarty would often joke about being Gran Fury's token members. "I did feel an unbelievable pressure to be sure that a woman's standpoint was being considered," she recalled. And though she later came out as a lesbian, McCarty was married to a man while in Gran Fury, making her Gran Fury's ostensibly straight member, something that she would get occasionally teased about. "I felt really accepted by the group," McCarty recalled. "But obviously I also felt a little different."

One night, McCarty went out with the Gran Fury guys, and they took her to one of the all-male leather bars on Manhattan's West Side. McCarty couldn't remember if it was the Spike or the Eagle but noted that she didn't see much difference between the two anyway. "I'm surprised they even let her in," Nesline joked. McCarty quickly surveyed the scene and headed home. But despite these occasional bumps, McCarty felt compelled to stay with Gran Fury. Gran Fury was, in a way, a realization of the kind of education that she had had in Europe: graphic design for social change, not just products. There was also a common understanding that the work they were doing trumped these differences. As McCarty put it, "The incongruities in the room were irrelevant in comparison to what we were trying to accomplish."

McCarty joined Gran Fury as the collective was beginning to place its work in spaces reserved for traditional advertisements. "The move wasn't

about trying to make conventional-looking advertising," she emphasized. "It was about employing a camouflaged guerrilla attack, making people think they were looking at real advertising then realizing from the message that they were looking at something radical." And McCarty was undeniably a key part of making this camouflaging of Gran Fury's work possible, both because of her sensibility as a graphic designer and because of her skill set.

When she joined the collective, McCarty was the only member of Gran Fury who knew how to design graphics on a computer, as her boss at M&Co., Tibor Kalman, had paid for his entire firm to take computer lessons. McCarty recalled how, one night, Gran Fury met at the M&Co. offices, where McCarty used the company computer to design their *Welcome to America* billboard, which the Whitney Museum paid to be installed on Houston and Broadway, one of lower Manhattan's busiest intersections. McCarty recalled how everyone stood behind her and watched in awe as she clicked and dragged the poster's red letters across the screen. To hear her tell the story, it seems to have been the only time that the men of Gran Fury were collectively silent.

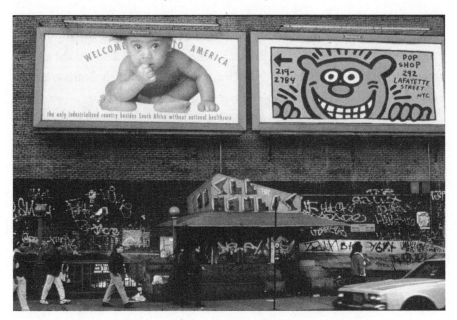

Welcome to America, Gran Fury, 1989. Photograph courtesy of Gran Fury.

McCarty and Moffett were essential to Gran Fury in a singular way. "For most of us, our work ended when the meeting did," recalled Vazquez-Pacheco. "But once the conversation was over, Don and Marlene had to go and make the mechanicals. And that was very labor-intensive work." And that was all on top of their own full-time day jobs at their respective studios. It was through this collaboration with Moffett that McCarty began to reconsider her career in corporate graphic design at M&Co. One day, Moffett pitched an idea to McCarty: What if the two of them formed their own graphic design studio? "Marlene wasn't happy where she was," Moffett recalled. "And I wasn't happy where I was, and I was like, 'Marlene, can't we get happy?'" And so they did. When McCarty told her boss, Kalman, that she was leaving M&Co., he was so enraged that he threw a chair at her, but luckily missed.

Together, Moffett and McCarty formed Bureau, a transdisciplinary design studio. With corporate clients to keep them financially solvent, Bureau designed campaigns for a host of nonprofits, while also allowing McCarty and Moffett time and space for their own artistic practices. Their first office was an illegal sublet in Chelsea, which they were promptly kicked out of. Bureau then began subletting space from Keenan and Riley, the architecture firm that had hosted the letter-cutting parties for *Let the Record Show* Bureau having an office also meant that—after two years of constantly shuttling between people's homes, offices and studios—Gran Fury finally had a regular meeting space.

Terence Riley, the firm's principal who had come to the floor with Simpson to collect supplies for *Let the Record Show* . . . , recalled that these later Gran Fury meetings were a significant departure from the free-wheeling letter-cutting parties where much of Gran Fury had first socialized. "They talked about posters in more depth than any conversation we had about the window," recalled Riley. But he also recalled that these Gran Fury meetings had grown more contentious, something he had noted in the larger body of ACT UP as well.

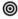

As McCarty joined Gran Fury, the collective was making its most explicit ode to advertising yet.

The opportunity had come about through a personal connection, Ann Philbin, a fellow ACT UP member who worked for Livet Reichard, an arts consulting firm hired by the American Foundation for AIDS Research (amfAR) to fundraise through the art world. Patrick Moore, who had lost his job at the Kitchen over Gran Fury's *Art Is Not Enough* calendar, was now working at Livet Reichard too. Philbin had organized Art Against AIDS, an auction in which donated pieces of artwork would be sold to raise money for amfAR's research and activities. After the success of this, Livet Reichard pitched amfAR a public art component that would be nationwide—billboards, bus stops and buses—images that could double as an advertisement for the auction itself.

Simpson and Nesline used to joke about Gran Fury being a "Cinderella act," because Gran Fury could use these sorts of art institutions to fund their work, and that these institutions would get to say that they were contributing to helping a noble cause, but that these institutions couldn't acquire anything that could be monetized. "Mark was definitely one of the progenitors of that whole strategy," Nesline said. "He sort of understood that it was going to happen before it happened. Or at least, he understood it enough to explain it to me."

"To me, that's the most wonderful thing about Gran Fury," Nesline added. "We played a game with these institutions. They knew that we were playing a game, and we knew they were playing a game too. They got something out of it, and we got something out of it. And they didn't get anything that we didn't want them to, which was a product that could be sold."

There was a growing precedent for this kind of project. Barbara Kruger, whose work Gran Fury had unabashedly ripped off, had mounted her *We Don't Need Another Hero* billboards around New York in 1988 with support from the Public Art Fund, an organization that would later fund some of Gran Fury's work too. What Livet Reichard was proposing was this, but on a much bigger scale, and fully dedicated to the AIDS crisis. Art Against AIDS: On the Road, it would be called. Gran Fury's work would appear on the sides of buses in San Francisco, Chicago and Washington, DC.

"Being a bus poster, we knew that we had to do something large and simple," reasoned Vazquez-Pacheco. So they decided to mimic the work

of Benetton, whose ads often appeared on these same bus panels. Benetton's ads featured very purposefully diverse young people, in bright clothing against a sharp white backdrop. And so Gran Fury decided to do this, but by casting their fellow ACT UPers. There would be one heterosexual, one gay and one lesbian couple. All three would be kissing, in profile.

Gran Fury used this opportunity to refute a widespread myth about HIV transmission—that HIV could be transmitted through saliva. "Kissing Doesn't Kill" was the slogan upon which they settled. It was partially a revisitation of *Read My Lips*. "I had been playing around with kissing imagery in my own work before it appeared in Gran Fury," Kalin recalled. He had an obsession with Andy Warhol's film *Kiss* but had only seen stills of it. "And so in an homage to a movie I had never seen," Kalin recalled, "I started recreating those scenes with anyone who would be willing to kiss for me."

As he became more enmeshed in ACT UP, Kalin began shooting footage of ACT UP members kissing too, much of which appeared in his video *They Are Lost to Vision Altogether*. It had been shot in the hallway and stairwell of Maria Maggenti's apartment, at one of many parties she threw, mostly attended by ACT UP members. This effectively became the test footage for *Kissing Doesn't Kill*, as Gran Fury culled through it and found the most striking people, the best kissers and the hottest couples. They invited a select few to a photoshoot in Loring McAlpin's loft on Great Jones Street.

Heidi Dorow and Maggenti were both invited. They were frequent co-conspirators with Gran Fury, and both had helped with the distribution of the *New York Crimes* in the wee hours before Target City Hall. And Maggenti's Tenth Street apartment also served as a home base for some of Gran Fury's wheat-pasting endeavors, including *When a Government Turns Its Back on Its People*.

Through countless ACT UP meetings, road trips, demonstrations and planning sessions, Dorow and Maggenti had formed tight friendships with many of the Gran Fury guys. Dorow recalled how, the year before, she was trying to commandeer the flagpole at a demonstration, as was commonplace for ACT UP to do—usually they'd lower the American flag and

replace it with something like *Silence=Death* or an effigy of Ronald Reagan. As Dorow was trying to hoist their own flag, a police officer walked up to her with his baton raised and was about to swing at her arm. "Michael Nesline runs up from behind," Dorow recalled. "Grabs me, puts me in a bearhug and pulls me away, just as this cop is about to break my arm."

Dorow said that she was only invited to be part of *Kissing Doesn't Kill* because she was dating Maggenti at the time. Maggenti has zero recollection of being present at the shoot. "But I am sure," she added, "looking back at my twenty-something-year-old self, that I was mad that I didn't make it into the final poster. I'm sure I wanted to be included!"

Dorow recalled that she didn't accept the offer for some particularly noble cause. "For me, participating in *Kissing Doesn't Kill* was less about my concern about the future of lesbian imagery and more about feeling that I had arrived. Getting to participate in a Gran Fury thing was like being invited to hang out with the cool kids."

Kissing was an integral part of ACT UP's culture, beyond just ACT UP's kiss-ins, like the one that *Read My Lips* was intended to advertise. If you saw a friend at an ACT UP meeting, you greeted them with a kiss. It was the same if you met up with an ACT UP friend for drinks or coffee. Dorow described kissing as a blood pact. "Everyone in the world tells me to be afraid of you, and that you're a danger," was how she described its rationale. Kissing someone refuted this. It was a way of saying, "I'm not afraid of you. I'm with you."

But when Dorow agreed to be part of *Kissing Doesn't Kill* she hadn't realized that she'd be kissing people on camera. "I barely understood what was going on," she said. "I just kind of showed up." Once she arrived and realized what was happening, Dorow was a nervous wreck for two reasons. "One, there were super hot girls there, who I longed for from afar," she recalled. "And, I was with Maria, my girlfriend, so I was nervous about that too." Maggenti had a reputation for being competitive and wanted to kiss everyone. "Maria was in her element," Dorow said. "She loves to get her picture taken." Dorow blacked out all the memories of having to kiss other people. "I'm sure I was a horrible subject because I was so anxious," she said. "So the irony that I ended up in the poster is insane."

At the shoot, the Gran Fury folks barked orders, telling people which clothes to try on and suggesting different couples. Finkelstein employed his work as a hairdresser and art director, and focused on the styling. "Avram was doing our hair," Dorow recalled. "Or at minimum, combing our hair, which wasn't at the top of my agenda during that period of my life." McAlpin, a trained photographer, shot the actual photos.

There weren't any actual heterosexuals at the shoot, so Dorow got paired with Vazquez-Pacheco, as Gran Fury's members thought they made for the most convincing straight couple. It made for a pretty sterile kiss. At the shoot, Dorow joked that it felt like the preparty of a high school prom, with all the gays pairing with lesbians, and pretending to be straight for the sake of their parents.

The members of Gran Fury had also contacted Jose Fidelino, another ACT UP member. In Fidelino's recollection, he got contacted to be part of *Kissing Doesn't Kill* by Bob Rafsky, the member of the coordinating committee who, just a year before, had lobbied against funding Gran Fury's posters for the Nine Days of Rage. It's not clear why Rafsky was tasked with this. "I'm sure he slept with somebody in Gran Fury at some point," Fidelino joked.

Fidelino said that he agreed to participate because of Gran Fury's cultural cache. But he also had deeper reasons for wanting to participate in something like *Kissing Doesn't Kill*. Being from Overland Park, Kansas, a suburb of Kansas City, Fidelino grew up seeing nobody that looked like him—bookish, gay and Filipino. "You didn't see any gay people, except for the awful stereotypes in the media," Fidelino recalled. He left Overland Park as soon as he could, but didn't forget this experience. "Part of my ethos was that I have to live my life so that it's easier for younger gay people," he recalled. And of all the work that Fidelino did in ACT UP, *Kissing Doesn't Kill* undeniably became the most notable example of this.

When Fidelino arrived at the shoot, he noticed the clothes that were laid out for them to wear. "Those clothes, in person, were hideous," he recalled. "They were made of this cheap, polyester double-knit." And they were uncomfortable too. Annette Breindel, Simpson's surrogate mother,

had supplied much of the clothing needed to mimic a Benetton ad. Kalin insisted that these were *not* cheap polyester, but rather, luxe cashmere, though he conceded that they might have been uncomfortable, given how warm it was at the shoot.

Either way, this was not what ACT UP's members were accustomed to wearing. By now, ACT UP's signature look—Levi's, black boots, an activist T-shirt and a leather jacket—was practically a uniform. "That East Village, working-class chic look," as Fidelino put it. These clothes were a far departure from that. "Clearly they knew what they were doing," Fidelino admitted. "They looked bad in person. They felt bad when you wore them. But they looked *great* on camera."

The members of Gran Fury made different suggestions for whom Fidelino should kiss, but ultimately settled upon one of their own, Mark Simpson. *How many of these Gran Fury people are getting their pictures taken too?* Dorow wondered. Fidelino had never met Simpson before, and didn't didn't really enjoy their kiss. Simpson was a smoker, as evidenced by the cigarette tucked behind his ear, and Fidelino was not. "Not to speak ill of the dead," said Fidelino. "But it was like kissing an ashtray." As unpleasant as it might have been in the moment, the image was certainly a

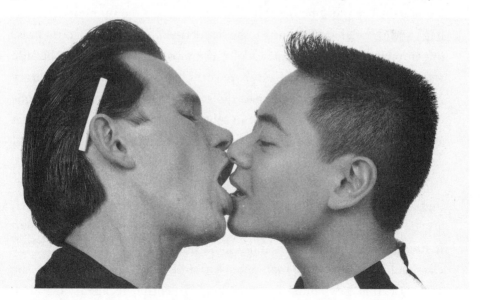

Kissing Doesn't Kill (partial), Gran Fury, 1989.

striking one. "I look like I'm about to get eaten alive," Fidelino said of the final shot. "I'm convinced that I got picked only because Mark opened his mouth and it made for such a strange image."

The third couple included in *Kissing Doesn't Kill* was actually a real-life couple, something that is evident in the final poster. Kalin had likewise shot footage of Lola Flash and Julie Tolentino kissing before they were invited to the shoot. "I grew up not seeing myself," Flash recalled, making something like *Kissing Doesn't Kill* all the more meaningful. "None of the Black people I saw in popular culture looked like the Black people in my family. They were all challenged in some way, financially or mentally. Both my parents are teachers. My friends' parents were doctors. I came from a very middle-class background. But I didn't really see those images of Black people." Images of lesbians were even harder to come by, and she didn't realize that lesbians besides herself existed. "Back then, I thought that just guys were gay," she recalled. She knew that she was into girls, but had no idea that others were too. "I just thought I was like from Mars or something," Flash recalled.

Flash's girlfriend had had the exact opposite experience. Growing up in San Francisco in the 1970s, Tolentino found no shortage of gays and lesbians in her life. She described her mother as "the quintessential fag hag" and there always seemed to be leathermen and radical faeries passing through their apartment. One of the most pivotal events of her life was the assassination of the city's mayor, George Moscone, and Harvey Milk. Tolentino actually attended the same school as Moscone's daughters. Taking the crosstown bus from school that day, she got off at Market and Castro and joined a 25,000-person candlelit march to city hall. "I consider that my coming-out day," Tolentino recalled.

Tolentino also found something like *Kissing Doesn't Kill* to be meaningful, not because it featured queer people, but because it featured such a wide swath of them. When she moved to New York, Tolentino found it strange how the city's gay and lesbian life seemed so segregated. "The class and color lines were more intense than I had ever experienced," she said. "Leather guys hung out together," Tolentino recalled. "Uptown, business, lesbian real estate mogul ladies hung out uptown." In Tolentino's

recollection, the middle-class, butch, Black lesbians hung out in different spots than the middle-class, femme, Black lesbians. And Tolentino found that those class and color lines were very apparent in ACT UP too. *Kissing Doesn't Kill*, and the choice of who appeared in it, was an antidote to this kind of segregation among gays and lesbians, and an attempt to dissolve it. "We weren't yet using the term intersectionality," Tolentino recalled. "That was being done in real time."

You can see also, in this poster, how ACT UP's demographics had changed in the past two years, though Fidelino, Flash, Tolentino and Vazquez-Pacheco all cautioned that ACT UP wasn't quite as diverse as *Kissing Doesn't Kill* would make it seem. Still, the organization had undergone a remarkable shift. Whereas it was once an organization of gay white men in their mid-thirties, ACT UP was beginning to look more like this poster, and less like Larry Kramer.

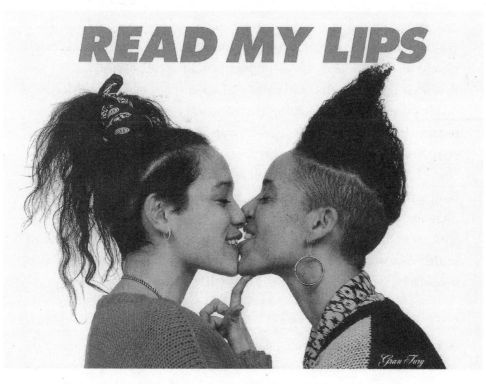

Read My Lips (Women's vers. 3), Gran Fury, 1988.

The shot of Tolentino and Flash also resolved a long-standing issue within Gran Fury's larger body of work. The year before, Gran Fury's attempts at making a lesbian version of *Read My Lips* had resulted in two rather tepid images—both the Victorians and the flappers hadn't matched the verve of the sailors. Now, Gran Fury had the perfect image, and so they did a final version of *Read My Lips*.

In a separate shoot, Gran Fury also made a series of thirty-second video shorts, which were almost identical to the poster version. Flash and Tolentino returned for the video shoot, as did a number of people who were friends with the Gran Fury folks, including David Wojnarowicz and Nan Goldin. The shorts were originally supposed to air on ABC, as part of a television special accompanying the album *Red Hot + Blue*, a charity compilation album. But the channel's executives thought the spots would be too controversial, and so they declined to air them. The video versions of *Kissing Doesn't Kill* did, however, air on MTV Europe.

Toward the end of the video shoot, almost everyone from Gran Fury got in front of the camera together and started dancing. It feels completely unstaged, like they've kept the tape rolling for posterity's sake, and that what they're filming will never end up in the actual video. McAlpin or Finkelstein must be holding the camera, because they were the only ones at the shoot who don't appear. Everyone else's personality is on display. Nesline stands out, only because he's so much taller than everyone else. McCarty, Moffett and Lindell all pal around together. Nesline, then Simpson, sashay up to the camera, ensuring their close-ups. Kalin and Vazquez-Pacheco then enter, parading collapsible reflectors, dancing with them like signs held over their heads. You can tell, by the easiness of it, that they've danced together like this dozens of times before. The video is silent, but wouldn't you love to know what song is playing?

Across the bottom of *Kissing Doesn't Kill*, Gran Fury included one of its most profound statements about the AIDS crisis: "Corporate greed, government inaction, and public indifference make AIDS a political crisis."

It was a way to communicate ACT UP's worldview about what enabled the AIDS crisis, and it countered the mindset that AIDS, or any health crisis, is solely related to the world of science and medicine.

Their attack on corporate greed is a bit incongruous considering who ultimately funded the poster. Creative Time, the arts organization that paid for the poster to appear in New York City, had solicited donations from the tobacco conglomerate Philip Morris, whose products had been boycotted by ACT UP, as the company made substantial campaign donations to senators like Jesse Helms, who actively fought against publicly funded AIDS programs. This wasn't lost on the members of Gran Fury, and Vazquez-Pacheco recalled that they were "sort of horrified" when they found out that Philip Morris had funded one of their projects. Granted, this boycott of Philip Morris products did not stop Gran Fury from accepting their money. Aldo Hernandez, an ACT UP member who worked at Creative Time, described the situation's paradox: He'd spend his lunch breaks demonstrating with other ACT UP members at Philip Morris's Park Avenue headquarters. When he got back to the Creative Time office, he'd get on the phone and haggle Philip Morris for more public arts funding.

Creative Time ultimately didn't take issue with Gran Fury's critique of corporate greed. But the bus poster's other sponsor, amfAR, asked to meet with the collective when they saw the finished version. An amfAR representative delivered some rather troubling news to Finkelstein and Simpson. "I can't possibly go to our funding partners if you use the phrase

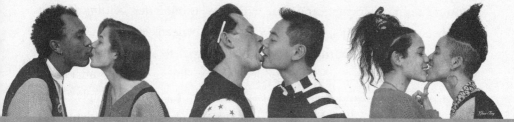

Kissing Doesn't Kill, Gran Fury, 1989.

'corporate greed,'" they said. The organization was going to provide funds for *Kissing Doesn't Kill* to appear in Washington, DC, Chicago and San Francisco. Without amfAR's funding, the poster would only appear in New York City.

Finkelstein protested that the poster wouldn't make sense without the rejoinder text: "But surely any corporate sponsor willing to fund an AIDS project is aware of activist accusations about the institutional hurdles involving drug companies? Besides, we name the government and public as equally responsible. And unless you're going after pharmaceutical money, the piece is not talking about *every* type of corporate greed."

When amfAR's representative told Finkelstein, "Of course we'll be asking for pharmaceutical money!" Finkelstein became so angry that he started seeing spots in his field of vision. "In my head, I remember lunging across the table," recalled Finkelstein. "I doubt I did that, but I can be somewhat excitable, and blunt. And it was tense."

"There's no way we're removing it!" Finkelstein told the amfAR representative.

Simpson then calmly inserted himself and offered a more diplomatic solution: "We'll have to discuss it as a collective, and see if there's any way we can resolve this."

Nobody in Gran Fury was happy about the choice they were being given, and Finkelstein wanted Gran Fury to withdraw the poster. The word "AIDS" only appeared in the poster's rejoinder text that amfAR wanted to censor. Without that rejoinder, it wouldn't immediately be clear that Gran Fury was making a statement about the AIDS crisis. Vazquez-Pacheco likewise felt that the absence of this text deflated the poster's political impact, and that without the rejoinder, *Kissing Doesn't Kill* becomes a statement about how "everybody needs love."

The conversation turned when Lindell began to speak up. He made a case for proceeding with the project despite losing the rejoinder text. "At this point in time, you did not see images of same-sex couples kissing *anywhere*," recalled McCarty. This was two years before television's first kiss between lesbian characters and eleven years before television's first kiss between two gay men. Lindell reasoned that, with the blatant

homophobia enabling the AIDS crisis, an image of these couples kissing would be a powerful statement. Slowly, Lindell began to sway the group. "John is deceptive," Nesline recalled. "Because John will sit back, and not have a lot to say, but will have a whole lot of influence on what is done." In Nesline's estimation, Lindell wielded his power within Gran Fury not by how much he spoke, but by how little. That he was the most succinct person in the room meant that people actually listened to what he had to say, when he was so inclined to speak.

Gran Fury ultimately sided with Lindell, bowed to amfAR's demands and removed the bottom line of text. "When dealing with corporate situations like this, you have to decide whether to compromise or not be present at all," reasoned McCarty. "I think the consensus among the group was that, though this more poignant part has been taken away, the fact that we are presenting this visual is worth participating." Not all of Gran Fury's members felt that the decision to censor themselves was so pure. Vazquez-Pacheco felt that the collective didn't want to rebuff such a powerful arts funder like amfAR: "That's a connection that we need, and we can get funding for more projects through them."

As Gran Fury started to increasingly rely upon the sponsorship of arts institutions, their relationship with the larger body of ACT UP began to fray. There were two rather contentious arguments with the floor of ACT UP, both of which happened around the summer of 1989.

When Gran Fury agreed to censor the rejoinder of *Kissing Doesn't Kill*, one of their stipulations was that amfAR had to pay for the production of a series of *Kissing Doesn't Kill* posters, which Gran Fury would give to ACT UP to be sold in its merchandising catalog. They brought it to the floor of ACT UP, to show them what was being given, and a debate emerged that seemed almost comically petty. A contingent of ACT UP wanted to know why the strip of color at the bottom of the poster was blue and not green.

The members of Gran Fury found this to be a grating discussion, for several reasons, and many of Gran Fury's members recall the blue versus

green debate as being a turning point in their relationship with ACT UP. For one, the poster was already made, and so it wasn't as if Gran Fury could redesign it now. Second, it was the poster's most inconsequential feature—it wasn't as if they were taking issue with Gran Fury's hypothesis on the converging factors that enabled the AIDS crisis. Lastly, Gran Fury didn't feel the need to debate these sorts of decisions endlessly, as some within ACT UP wanted to now. Finkelstein recalled that most of Gran Fury's debates were about content—the exact image that would be used and the text itself. And though they debated commas and prepositions endlessly, the collective was more or less fine with having Moffett, McCarty and Lindell make the choices about the typeface—it was usually one of Barbara Kruger's fonts anyway—and whether it should be against a blue or green stripe.

The other argument had to do with the question of royalties. With the amount of money their posters, T-shirts and buttons raised for ACT UP, Gran Fury wanted a share of these proceeds, to sustain the collective's work. ACT UP members objected to the proposal because no other ACT UP committee received funds without any oversight. It was a debate about status as much as the actual finances themselves. For the rest of ACT UP, every expense had to be approved by the floor, the coordinating committee or both. "Our counterargument," Finkelstein recalled, "was that no other committees are producing fundraising projects." To be clear: Gran Fury's members were not proposing that they be compensated for their work. Rather, they were simply asking that a portion of the proceeds from their own projects be available to finance the production and dissemination of their future projects.

Richard Elovich was tasked with pitching this to the floor on July 3rd. A veteran performance artist, Elovich began by giving a rather bleak outlook. "Gran Fury is operating on the verge of bankruptcy," he told the floor. Albeit true, this wasn't new, as Gran Fury had, since the New Museum window, always operated in this way. Elovich proposed that Gran Fury receive 17.5 percent of the gross on all merchandise that Gran Fury produced, so that it could continue its work to fund projects like the *New York Crimes*.

"It was a bloodbath on the floor of ACT UP," Finkelstein recalled. "People were infuriated by that proposal." McCarty recalled that some within ACT UP even accused Gran Fury's members of profiting off their ventures. To the contrary, McCarty noted that "it was a negative financial investment."

The motion ultimately passed, but by a slim margin. It even became a local news story in the gay press, with the *New York Native* reporting upon the arrangement and noting how fractious the arguments had been.

Gran Fury's arrangement came up again at the July 31, 1989, meeting, with some taking issue with the fact that Gran Fury was a closed group. "Michael Nesline vowed Gran Fury was open to all," read that night's minutes. "And anyone seeking membership need just speak to him after a meeting." Given Nesline's reputation within ACT UP, this was not the friendliest of invitations. Another motion was brought to the floor that would make all merchandise sold in the catalog the property of ACT UP, which would negate the recent agreement with Gran Fury. It was narrowly defeated, and the meeting's minutes note that this "hot, contentious meeting" lasted till about eleven.

Ultimately, that debate soured the relationship between ACT UP and Gran Fury. And though Gran Fury continued to gain recognition, they stopped appearing in the minutes of ACT UP's weekly meetings so frequently. Gran Fury never formally severed itself from ACT UP, and most of Gran Fury's members continued to attend ACT UP's meetings dutifully. But the fallout from this argument marked the beginning of a new way of working for Gran Fury. Whereas Gran Fury had once relied upon ACT UP for the financial support to realize their projects, they were now entirely dependent upon the support of museums, art institutions and their whims.

In the fall of 1989, *Kissing Doesn't Kill* made its debut, and was warmly received in San Francisco. When Finkelstein visited the city that year, he snapped a photograph of a defaced *Kissing Doesn't Kill* poster—the straight and gay couple had been whited out, leaving just lesbians most

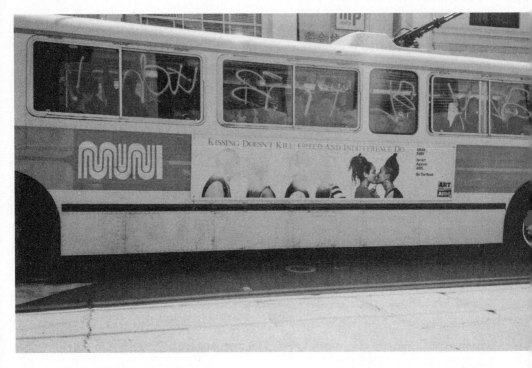

Photograph courtesy of Gran Fury.

visible. It thrilled Finkelstein that someone had reinterpreted and remade Gran Fury's work, and he assumed that the gesture had been inspired by Jill Posener's book *Spray It Loud*, a collection of feminist graffiti interventions in advertising. Others in San Francisco loved the poster as it was. An official from the city's health department called amfAR and asked if they could have a copy of the poster, which hung in the hallway of the city's HIV Research Section for at least ten years.

New Yorkers seemed to like it too. Though AMNI, which sells the ad space on buses, initially said the project was too racy, Creative Time eventually convinced them to run it. Gran Fury even won a prize! The Municipal Art Society of New York awarded them the Brendan Gill Prize, a $5,000 award for art that "best captures the spirit of New York City." Forty MTA buses sported the poster in the fall of 1989, and the Whitney Museum hosted it in its Madison Avenue–facing window. A cousin of Vazquez-Pacheco's saw the poster on a bus in the Bronx and mistook it for an actual Benetton advertisement. She called Vazquez-Pacheco,

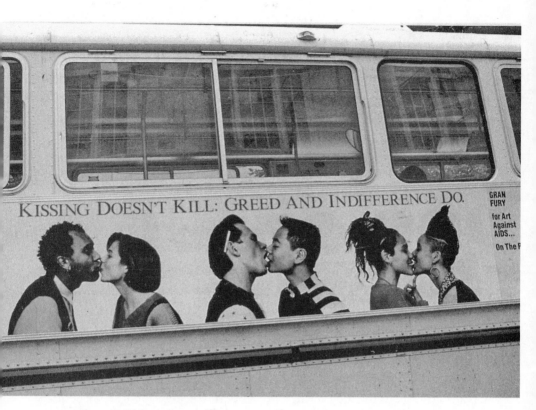

Photograph courtesy of Gran Fury.

confused. "Robert," she asked, "were you in a Benetton advertisement? Kissing a *girl*?" Other New Yorkers made the same mistake, and though Benetton received plenty of calls either praising or complaining about their inclusion of two homosexual couples, the company never officially commented upon it.

That summer, *Kissing Doesn't Kill* was set to appear on sixty Chicago Transit Authority (CTA) buses and in twenty-five El train stations. The backlash began almost as soon as Chicagoans started to hear of it. When a Chicago City Council member named Robert Shaw heard of the poster's content, he proposed that the CTA institute a citywide ban on *Kissing Doesn't Kill*. Shaw alleged, "It has something to do with a particular lifestyle, and I don't think that is something the CTA should be in the

business of promoting." Councilman Shaw also criticized the poster for not actually saying anything about the AIDS virus. Ironically, Gran Fury had the same complaint about their own poster, though it was obvious that the councilman's criticism didn't come from a genuine desire to help people living with AIDS. A second councilman supported the ban, saying, "I deeply deplore the fact that the CTA has become involved in . . . promoting the gay lifestyle," and this idea that *Kissing Doesn't Kill* was "promoting the gay lifestyle" became a rallying point for the city council's proposed ban.

Despite having funded *Kissing Doesn't Kill*, amfAR was reluctant to get involved in the dispute. Both Philbin and Moore recalled that amfAR didn't want to jeopardize their fundraising possibilities by inserting themselves into Illinois and Chicago politics—Chicago's mayor and Illinois's governor were both supposed to attend amfAR's upcoming Art Against AIDS gala, as was Barbara Bush when the gala reached Washington, DC. "It was so disappointing that amfAR wouldn't stick up for Gran Fury," Philbin recalled. In her estimation, that decision actually hurt amfAR in the long term, more so than voicing support for a controversial image ever would have. amfAR's art auctions relied upon artists' donating their work for free, and Philbin recalled that many artists were wary of donating their work to amfAR after seeing how they hadn't supported Gran Fury.

The Chicago City Council ultimately failed to ratify a ban on *Kissing Doesn't Kill*. But the fiasco did gain attention from state-level legislators. In June 1990, a Democratic state representative suggested that commuters boycott the CTA because Gran Fury was trying to "entice young people into their lifestyle," echoing Councilman Shaw's earlier claim that Gran Fury had aimed *Kissing Doesn't Kill* "at children for the purposes of recruitment."

Instead of censoring the poster outright, the Illinois State Senate penned a piece of legislation prohibiting the CTA from displaying any poster "showing or simulating physical contact or embrace within a homosexual or lesbian context" where persons under twenty-one could view it. After one of its sponsors, state senator Frank Watson, made it clear

that the bill had been written in response to *Kissing Doesn't Kill*, Finkel-stein dubbed it "the Gran Fury bill."

None of this necessarily surprised the members of Gran Fury. "We knew it was going to press buttons," recalled Vazquez-Pacheco. "But the intensity of the racism and the homophobia was surprising. We thought that Chicago would be a little more civilized." McCarty had a similar re-action: "We were never surprised by the backlash. It was always coming. But the fact that it got so legitimate in Chicago that they were trying to change state laws was like . . . wow."

On June 22, 1990, the Illinois State Senate passed the Gran Fury bill and sent it to the Illinois House of Representatives for ratification. It was poor timing for the senate, as they passed the bill two days before Pride celebrations across the country. A hundred thousand people attended that year's Pride March in Chicago, making it the city's largest ever, with al-most twice as many attendees as the previous year's celebration. ACT UP Chicago marched with a *Kissing Doesn't Kill* banner defiantly held above their heads. In support of Gran Fury, Chicago's Pride March culminated with a kiss-in outside of a CTA bus maintenance facility, as if a real-life *Kissing Doesn't Kill* had materialized where the poster belonged.

As the state of Illinois attempted to censor *Kissing Doesn't Kill*, a similar debate was unfolding nationwide. The day after that year's Pride celebra-tions, the National Endowment for the Arts (NEA) announced that it had revoked grants for four performance artists, a debacle that became known as the "NEA Four." Karen Finley, Holly Hughes, Tim Miller and John Fleck were among eighteen artists who had been unanimously selected by the NEA's peer-reviewed panel and were set to receive artist grants, until John Frohnmayer, the NEA's chairman, intervened and re-voked their funding. He did so on the basis of a newly passed measure, championed by Senator Jesse Helms, which barred the NEA from fund-ing art that could be deemed "obscene." Helms's definition of obscenity would bar the NEA from funding much of the artwork found in a survey art history textbook, but the measure was selectively enforced to censor

the work of queers and women, the NEA Four being the most notable example.

One of the eighteen artists picked by that year's panel, and who did receive his grant, was Gran Fury's Richard Elovich. Along with Hughes, one of the NEA Four, Elovich penned a *New York Times* op-ed, reasoning that the NEA Four wasn't just a problem for artists or those who worked in the arts. The debate over the NEA Four, and the surrounding culture wars, was never really a debate about arts funding. At its core, this was a debate about whether or not queer people had the right to furnish evidence of their own existence. In the midst of this, *Kissing Doesn't Kill* emerged as a kind of visual antidote. While the work of the NEA Four and Robert Mapplethorpe happened within the confines of galleries and museums, *Kissing Doesn't Kill* was meant to live in public, and it became the most public piece of art to attract this kind of ire, and possibly the most explicitly queer. In the midst of a nationwide debate over whether or not queer people deserve to exist in public, *Kissing Doesn't Kill* became a focal point. Later that summer, in his essay "With Our Eyes and Hands and Mouths," the artist David Wojnarowicz claimed the necessity of public art at this moment and pointed to *Kissing Doesn't Kill* as the kind of public work that could fight back against the censorship epitomized by the NEA:

Public works have never been so important and necessary as they are today. For each grant rescinded in the name of politics and homophobia, public works can be made in response and in anticipation. If they want to make our bodies and minds invisible, let's create more spontaneous public works and glue them on the walls and streets of Washington and the rest of the continent. If the Gran Fury poster is stricken from the transit system in Chicago, let's put up 20 different posters on those same buses and trains. . . . We have all the tools of the corporate world at our disposal— Fax and Xerox machines, automatic 35mm and video cameras. We can construct a wall of reality in the form of words, sounds and images that can transcend the state- and institution-sponsored ignorance in which most people live. We have mirrors, we have cameras, we have typewriters

and we have ourselves and our lovers and friends—we can document our bodies and minds and their functions and diversities. With our eyes and hands and mouths we can fight and transform.

As the debacle of the NEA Four unfolded, so too did the debate surrounding *Kissing Doesn't Kill* in Chicago, where such intense support from Chicago's gay and lesbian community only garnered more intense criticism of *Kissing Doesn't Kill*. Soon after Pride, on July 12, 1990, Mike Royko penned an op-ed for the *Chicago Tribune*, characterizing the poster as "nothing more than a plug for gay sex and lifestyle." He complained, "They shrewdly include an interracial couple kissing." (Actually, they had included three.) "Love isn't an issue at all," he wrote. "Unless you define love as having anal sex with a stranger in a bathhouse." If Gran Fury wanted to make a poster about AIDS, he suggested they "show a couple of glassy-eyed fools jamming the same needle in their arms. Or a couple of guys in a bathhouse saying 'Let's get it on, and we can exchange phone numbers later.'" He then reimagined the poster's messaging: "Love doesn't kill; stupidity, moronic self-indulgence and flat-out ignorance kill." Another pundit at the *Tribune* offered a second reimagining of the poster's text: "Kissing Doesn't Kill: Anal Intercourse Does."

Despite the intense criticism, the Gran Fury bill ultimately failed to pass through the Illinois House of Representatives, and on August 15, 1990, the *Tribune* announced that the CTA would begin installing the poster. The next day, Mayor Richard Daley called for a compromised poster that might be "less offensive," urging the CTA to meet with Gran Fury in hopes of agreeing upon a less controversial poster. Unsurprisingly, Gran Fury's members didn't budge. And why would they have? The more that Chicago's mayor and the state legislature tried to censor it, the more coverage the poster received.

Just before *Kissing Doesn't Kill* was set to be unveiled, Councilman Shaw claimed that several clergymen had contacted him and were threatening to deface the poster if the CTA kept it up. "I don't encourage this," he told reporters at a city hall press conference. "But I have been told that

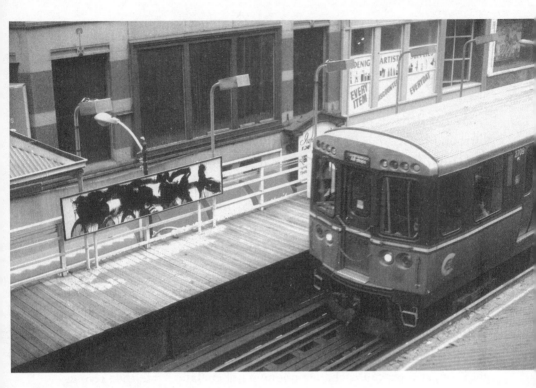

Photograph by Bill Stamets.

a campaign of civil disobedience will begin soon. . . . There are people in this town who are furious."

Less than twenty-four hours after it debuted, the *Tribune* reported that *Kissing Doesn't Kill* was being defaced around Chicago. Within forty-eight hours, virtually all of the city's *Kissing Doesn't Kill* posters had been blacked out. Ultimately, the efforts to deface it were so widespread that few in Chicago saw *Kissing Doesn't Kill* as it was intended.

But in drumming up so much discussion of *Kissing Doesn't Kill*, its critics inadvertently garnered more attention for the poster. (The same could be said of the NEA Four, or countless other efforts to censor artists.) The *Tribune*, which then had a circulation of over a million subscribers, ran dozens of articles about the fiasco, many of which included the image itself. Even if few saw *Kissing Doesn't Kill* as it was first intended, millions more ultimately saw it, and only because of the efforts to censor it.

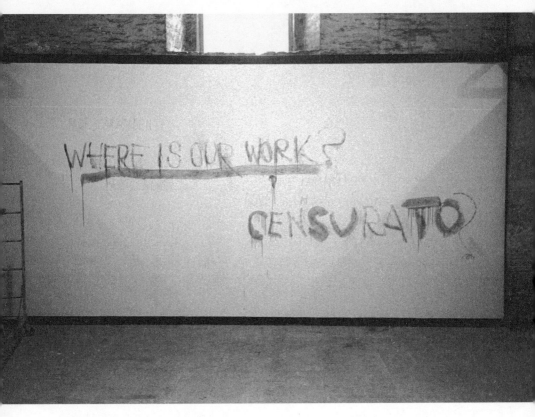

Photograph by Bruno Jakob.

CHAPTER 8
CENSURATO

If they aren't 100 percent effective, the people who try
to censor you are really your best friends.

—John Lindell

I n November 1989, the Catholic Church decided to hold its first in-
ternational conference on AIDS, in part to clarify what, exactly, the
Catholic Church believed about condoms.

For years, American bishops had deliberated over the church's stance
on sex education in public schools, a debate that only intensified as the
AIDS crisis worsened. In December 1987, the National Conference of
Catholic Bishops issued "The Many Faces of AIDS: A Gospel Response,"
a 7,700-word advisory on how the Catholic Church should respond to the
AIDS crisis. The dictum counseled abstinence until marriage but noted
that "some people will not as they can and should. . . . They will not re-
frain from the type of sexual . . . behavior that can transmit AIDS." Thus,
it would be permissible for condoms to be acknowledged as effective in
preventing the spread of HIV, so long as it was first emphasized that only
abstinence was morally permissible. Within days, criticism arose from
other Catholic bishops, namely, Cardinal John O'Connor, the archbishop
of New York, who believed that even the acknowledgment of condoms

was sacrilege and described the report as "a very grave mistake." O'Connor wielded an immense amount of control over local and federal AIDS policy, as he had sat on the President's HIV Commission, and often lobbied members of the New York City Board of Education to block safer-sex curricula in the city's public schools.

By March 1988, the United States Catholic Conference scrapped the memorandum, opting to arrange a closed-door session in June to establish the church's guidelines on contraceptives in the face of AIDS.

Finally, in November 1989, the bishops released "Called to Compassion and Responsibility: A Response to the HIV/AIDS Crisis," the details of which were preached at the 1989 Vatican AIDS Conference. Scheduled as the keynote speaker for the conference's opening day, Cardinal O'Connor reiterated what he had long advocated for. "The truth is not in condoms or clean needles," Cardinal O'Connor said. "These are lies, lies perpetrated often for political reasons on the part of public officials. . . . Sometimes I believe the greatest damage done to persons with AIDS is done by the dishonesty of those health care professionals who refuse to confront the moral dimensions of sexual aberrations or drug abuse." Then he noted what became a most infamous tagline: "Good morality is good medicine."

As O'Connor said this, ACT UP was already planning a demonstration against O'Connor and his outsized influence. Stop the Church, it was to be called, had been in the works for over a month by this point, and such an inflammatory statement equating morality and medicine only bolstered ACT UP's case.

The planning for Stop the Church had begun that October, when Cardinal O'Connor appeared on the cover of *Newsday* magazine, proclaiming that he wanted to join Operation Rescue, antichoice lunatics who harassed and berated women as they approached health clinics that performed abortions.

One night soon after, Vincent Gagliostro, who helped plan the New York Stock Exchange demonstration, was with his friends and fellow

ACT UPers Victor Mendolia and Robert Garcia. They were having a few cocktails on Mendolia's roof and discussing O'Connor's recent comments about Operation Rescue, and were likewise frustrated by how O'Connor had used his power as archbishop to oppose the two most effective HIV prevention measures: condoms and clean needles. Whereas O'Connor had once been content to spread this dogma in the church's schools, he had begun to peddle it in hospitals, public schools and city politics. "If he's going to go meddling in the public schools," Mendolia said to the other two, "then we should just shut down his cash machine."

The next day, Mendolia reached out to WHAM! (Women's Health Action and Mobilization), an activist group that had formed earlier in 1989 in response to the *Webster v. Reproductive Health Services* ruling, which restricted state funds for performing or counseling on abortions. Since its inception, WHAM! had used ACT UP–style tactics and organizing principles, and Mendolia thought that they'd be well-suited allies in their fight against Cardinal O'Connor.

Mendolia was connected to Tracy Morgan, one of WHAM!'s founders. At that moment, Morgan was disillusioned with the reproductive rights movement. She felt that it had grown too tepid, that it eschewed the kinds of tactics that ACT UP was using to great success. "I was excited by the way that ACT UP had branded itself," Morgan recalled. "I was drawn to it because it was dynamic and powerful, even though I was very aware that it was dynamic and powerful because it was a group of mostly men." Morgan also recognized that there were existing connections between ACT UP and WHAM!, in terms of overlapping membership, and some ACT UP members would accompany WHAM! to defend abortion clinics from groups like Operation Rescue. There were also certainly thematic commonalities between WHAM! and ACT UP, as both were broadly concerned with having control over one's body, access to prophylactics and the free distribution of medical information.

Still, Morgan was initially hesitant about working with ACT UP, a concern shared by many when she brought Mendolia's proposal to the floor of WHAM! "There was an understandable fear," Morgan recalled. "Can these men understand what we feel is at stake? Not just

intellectually understand, but can they understand on a felt level? Does it matter enough to them—our sexuality, our freedom to not worry about being forced to be mothers?"

Nor was Morgan immediately convinced when she walked into one of ACT UP's meetings. "It was strange to go from being a women's studies major to being in a room with five hundred men yelling at each other," she recalled. *Oh god*, Morgan initially thought. *This is like gay patriarchy.*

Despite these initial hesitations, Morgan found herself pulled into ACT UP by the gravity of its urgency. "The room itself was crackling with an intensity that I understood as being about life and death," she said. "People would stand up and talk about their T-cell counts dropping, and you knew what that meant." Morgan registered a primal instinct to hold on to life, and an imperative to save each other. "There's nothing more riveting than watching a person fight to live," she said. It ultimately compelled her to stay.

ACT UP decided to stage a Sunday morning demonstration outside of Saint Patrick's Cathedral, the seat of the archbishop of New York, and where O'Connor often preached. From the beginning, ACT UP tried to position themselves as protesting Cardinal O'Connor and his policies, not the Catholic Church writ large, Catholicism or Catholics themselves. The Sunday before the demonstration, they handed out fact sheets to the parishioners of Saint Patrick's, detailing their demands and emphasizing that they did not want to disrupt their right to worship but were organizing the demonstration to protest O'Connor and his interference in public policies. Michael Nesline put it more succinctly: "Who the fuck is the archbishop of New York to decide what is taught at a public school? Well he's somebody, apparently. That was really upsetting to me. As someone who was raised a Catholic, I can apparently—*and I can hear it in my voice now*—become excised about that topic."

Even while planning Stop the Church, ACT UP's members knew that this demonstration would garner a kind of controversy that they hadn't yet dealt with. After they started advertising the demonstration

with wheat-pasted flyers, they noticed a sharp uptick in the number of death threats. Before, ACT UP would usually receive a death or bomb threat once every six months. Now they were receiving three or four such threats a day.

Hearing of the upcoming demonstration, New York City's mayor, Ed Koch, decided to attend the service himself, to "defend the Cathedral." That the city's mayor, who was not Catholic, decided to personally attend this service only reinforced how the division between church and city was blurred too often.

The demonstration had begun as a picket that would encircle the cathedral. But in the process of planning the demonstration, things had started to fray. In addition to protesting outside the cathedral, some ACT UP members wanted to go inside Saint Patrick's and disrupt O'Connor's homily, a part of the service where O'Connor would often lambast public officials for allowing safer-sex education in public schools. Because O'Connor was using these homilies to influence public policy, some ACT UP members reasoned, he had turned his pulpit into a political platform, which made it fair game to disrupt. "You could just feel this energy," Nesline said. "People were really spoiling for this particular fight."

But many worried that disrupting the service would cloud their messaging for the demonstration. "We didn't want it to be seen as just throwing a tantrum at the Church," recalled Mendolia. "We wanted it to be about specific issues." And many worried that, if ACT UP did go into the cathedral and disrupt the homily, then that would become the story, and not O'Connor's interferences in public policy.

"It didn't feel like it was about AIDS," Nesline said of his fellow ACT UP members. "It felt like it was about lapsed Catholics, like myself, acting out their disappointment and rage at the Catholic Church." To Nesline, the demonstration was being elevated to be a referendum on the Vatican and its entire history. "For the purposes of exercising ACT UP into a frenzy of anti-Catholic furor, someone gave the most painfully fractured, thumbnail sketch of the history of the Catholic Church's political machinations in Europe," Nesline recalled. "It was just so stupid. It was without any nuance. It was crude. Not even adolescent—preadolescent in its simplicity." What

had begun as a rather singular demand was now stretching back to Roman times. "When I listened to ACT UP preparing for that demonstration," Nesline said, "I could see that this was going off the rails."

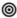

As ACT UP prepared for Stop the Church, the conversation happening on the floor of ACT UP had filtered into Gran Fury's meetings. According to Richard Elovich's notebook, they spent their November 16th meeting brainstorming about the connections between AIDS and abortion. In these notes, you can see a bit of Gran Fury's working process. What are the widespread notions that hinder both movements? "The issue is punishment," Elovich wrote. In brainstorming about the connections between AIDS and abortion, they didn't go for the obvious connection of relating them both to sex, but rather, considered the widely held attitudes that inhibit both causes. They seemed to have settled upon the idea of blame, of how both having an abortion and having AIDS are seen as something that you've brought upon yourself. Both are condemned for being just deserts. "If you're good, bad things don't happen to you," reads one of Elovich's notes. "If something bad happens to you, you must have done something bad." Finding commonalities between the two meant dispelling widespread notions such as these, and fighting against both meant encouraging the public to view them through the lens of medicine, not morality.

But ultimately, Gran Fury didn't produce anything for Stop the Church, though many of their older posters did appear that day. It marked a turning point for Gran Fury, as this was the first time since Gran Fury had formed that it didn't produce something for one of ACT UP's major demonstrations.

On the morning of December 10, 1989, five thousand demonstrators gathered outside of Saint Patrick's Cathedral, despite the freezing temperatures. It ultimately proved to be ACT UP's largest demonstration ever, and the largest demonstration against the Catholic Church yet. Picketing outside the cathedral, it was the usual revelry and fun of an ACT UP demonstration.

"Keep your mass off our ass!"

"Keep your church out of my crotch!"

"Get your rosaries off my ovaries!"

One affinity group managed to construct a twenty-foot-long contraceptive, spray-painted with the words "Cardinal O'Condom" along its shaft. Saint Patrick's Cathedral happens to be across the street from the Sax Fifth Avenue department store, which led ACT UP members to chant, "We're here! We're queer! We're not going shopping!" The day's hallmark poster came from Richard Deagle, the graphic designer who had contributed one of the slogans for Gran Fury's *Wall Street Money* project. "Know Your Scumbags," Deagle's poster read, taking wing from the striking similarity in shape between an unrolled condom and Cardinal O'Connor's ceremonial miter.

Those hoping to infiltrate the church couldn't look like ACT UP members, so they all had to remove their piercings, cover up any tattoos and dress sensibly. For the select few who elected to go into the cathedral, no leather jackets, Doc Martens, *Read My Lips* T-shirts or *Silence=Death* pins would be worn that day.

ACT UP's members sat in the pews throughout the 10:15 a.m. mass, waiting for O'Connor to begin his homily. Just after he began to speak, they dove into the center aisle, and some even chained themselves to the pews. They lay quietly, staging a die-in. Then they were silent no more. When chants of "Silence equals death!" began to fill the cathedral, O'Connor abruptly concluded his homily, asked the congregation to stand and then began reciting the Lord's Prayer, followed by a succession of Hail Marys. Two ACT UP members, standing in their pews, began reading a lengthy statement about the cardinal's malfeasance. Michael Petrelis of the Lavender Hill Mob decided to cut them off and delivered ACT UP's message a bit more succinctly. "Stop killing us!" he started screaming. "Stop killing us!"

The organist futilely tried to drown all this out by continuing with the liturgical music. Priests began to hand out hard copies of O'Connor's abandoned homily. The New York Police Department, familiar with ACT UP's tactics, had brought bolt cutters with them into the cathedral.

They quickly removed the chained demonstrators, dragging them onto stretchers and out of the gothic cathedral. As they carried out Ann Northrop, ACT UP's queen of the sound bite, she seized upon a rare moment of silence. "We're fighting for your lives too!" she shouted to the parishioners. And then the organist promptly resumed playing.

Believing that the cathedral had been cleared, O'Connor continued with the service. But one ACT UP member, Tom Keane, had patiently sat in the pew while his fellow ACT UPers chanted during the homily, waiting for communion.

When Keane arrived at the altar, the priest recited the usual dictum, just as he had for all the other parishioners: "The body of Christ, broken for you." In the Catholic tradition, this is the moment that the communion host is transfigured into the literal body of Christ.

"Opposing safe-sex education is murder," Keane shot back.

Keane then snapped the wafer in half, threw it to the ground and crushed it with his foot. Then he lay on the floor, in front of the priest, and staged a die-in on the altar.

Outside, the demonstration largely went as planned. From Saint Patrick's, ACT UP and WHAM! marched west toward Sixth Avenue and then downtown. As they passed Radio City Music Hall, a few of the Rockettes leaned out their dressing room windows and cheered for them. For ACT UP's show-tune queens, this was the highest praise one could imagine.

But the praise ended there, and the condemnation of ACT UP and WHAM! was nearly universal. Most of the condemnation and press coverage centered around Keane's desecrating the host, which O'Connor compared to the burning of a synagogue. "It was an act that was so sacrilegious to Catholics," recalled Michelangelo Signorile, another of ACT UP's former Catholics who demonstrated inside the cathedral. "I think it's hard then to focus the media attention on the issues." O'Connor told his parishioners that this had been done "by people obviously not fully realizing what they were doing." This couldn't have been further from the truth, and that Keane himself was Catholic was rarely noted in the press coverage of Stop the Church, the rare exception

being an article in the *Village Voice*, written by Esther Kaplan, a fellow ACT UP member.

Vice President Dan Quayle happened to be in New York City that day, as he was attending Cardinal O'Connor's annual Christmas party, which was scheduled for the next evening at the Waldorf Astoria. The vice president condemned it for being "reprehensible, outrageous." "I deplore it," added Mayor-Elect David Dinkins. "Unacceptable," was how Koch characterized it, and Governor Mario Cuomo described them as "shameful" and called for the punishment of those who had demonstrated.

Condemnation in the press followed suit. "Radical homosexuals turned a celebration of the Holy Eucharist into a screaming babble of sacrilege by standing in the pews, shouting and waving their fists, tossing shredded paper and condoms into the air," read the beginning of a typical op-ed. Suddenly every columnist in New York City seemed to have an Irish ancestor who laid a cornerstone of Saint Patrick's Cathedral. John Voelcker of the media committee recalled that this was one of the few times that ACT UP wasn't able to steer the press coverage in a way that they had hoped: "I think it was the first time that we felt, on the media committee, the whole thing was just running in a completely different direction, and we were absolutely powerless to stop this onslaught."

ACT UP was even condemned by most of the country's establishment gay rights organizations. The Gay and Lesbian Task Force, New York's Coalition for Lesbian and Gay Rights, and the Lambda Legal Defense and Education Fund all issued highly critical statements and denounced ACT UP's activities. Even GMHC, the organization that Larry Kramer had founded prior to ACT UP, denounced the protest.

The day after Stop the Church, ACT UP had its usual Monday night meeting. After most major actions, there would be a celebratory mood at the next Monday's meeting. But the tenor of this meeting was starkly different. One ACT UP member, Gabe Rotello, recalled, "That was the only time I remember doing a thing and then coming back on the Monday and having there be this sense in the room of, like, 'Oh my god, did we just go, like, way too far?'"

Some within ACT UP felt that Keane's being a Catholic validated his desecrating the wafer. "He was responding to his own tradition," reasoned Steve Quester, who went into the church too.

Nobody within ACT UP seems to have been personally offended by what Keane did, but many took issue with his actions on the basis of strategy, as Keane crushing the wafer had become the news story, not the issues that ACT UP set out to rectify. ACT UP had made a name for itself with its confrontational theatrics, like shutting down the New York Stock Exchange. But with Stop the Church, some worried that they had gone too far. In the past, ACT UP's audacity had brought attention to their issues. Now, their audacity had become the story itself.

For some within ACT UP, Stop the Church fractured the organization in an irreparable way. Nesline left ACT UP entirely. For David Barr of the Treatment and Data Committee, Stop the Church signaled a turning point in ACT UP: One person's expression of anger now seemed more important than the group's overall strategy. "The church action was," as he put it, "the beginning of the end."

But there were other more intangible outcomes. "Everything changed after Stop the Church," recalled Donna Binder, a photojournalist and ACT UP member. Before, whenever a magazine or newspaper ran a story on AIDS, they usually asked for a photo of someone sick and dying, alone and in a hospital bed. Binder noticed that that changed after Stop the Church. "After that, people wanted pictures of ACT UP. People wanted pictures of ACT UP *demonstrating*. They didn't just want people dying."

Some ACT UP members also felt that, after Stop the Church, public officials and members of the press were more willing to criticize O'Connor's stance on AIDS and condoms. A month later, Cardinal O'Connor announced that his archdiocese would be quadrupling its number of AIDS hospice beds funded by public contracts. Public health officials and members of the press responded immediately with criticism: Wasn't it hypocritical of O'Connor to use taxpayer money to open more AIDS hospices while he continued to block safer-sex information in public schools? In the eyes of Mendolia, an organizer of Stop the Church, that kind of questioning would have never happened before. In storming Saint

Patrick's, he believed, ACT UP had driven a wedge into the public discourse, opened up a space for that kind of criticism and validated these kinds of responses from the press and public health officials.

Even if ACT UP's popularity suffered, many within ACT UP felt that these kinds of incremental changes were worthwhile. "We were not doing what we were doing to get the public to like us," Northrop reasoned. "We were doing what we were doing to accomplish something. . . . And we weren't liked, but we forced people to pay attention and forced change."

And others felt that, by disrupting the service, ACT UP had cemented its reputation as a force with which to be reckoned. When Larry Kramer heard other ACT UP members fretting about the onslaught of bad press they had received, he told them that this was ideal, not something to shy away from. "Are you crazy?" he shot back. "They're afraid of us now! That's the best thing that could ever have happened to us!" In Kramer's estimation, everything that ACT UP later accomplished stemmed from the audacity of Stop the Church. "Drug companies did what we wanted them to do," Kramer reasoned, because it now seemed that ACT UP would spare nothing to end the AIDS crisis.

As the members of Gran Fury watched the Stop the Church saga unfold, the collective received its biggest opportunities to date.

Linda Shearer and Marlene McCarty had become friendly while the two worked together at MoMA in the mid-1980s—Shearer was the curator of contemporary art, and McCarty worked in the Design Department, doing brochures and the like. The two had remained friends after McCarty left for M&Co., and McCarty even sent Shearer one of M&Co.'s famous clocks as a Christmas present. Shearer had been struck by *Let the Record Show . . .* , Gran Fury's installation at the New Museum, and had more recently been impressed with the *Kissing Doesn't Kill* bus sides. So when Shearer was invited to curate the Aperto section of the 1990 Venice Biennale, which highlights younger, emerging artists, she reached out to McCarty and asked if Gran Fury would be interested in participating.

Gran Fury had received such offers from museums and galleries in the past, and had always insisted that their work be shown in public, not in a gallery or enclosed space, a line that many members were adamant about not crossing. They countered, asking to have a billboard in a public space, or something with a public component. The hundred-year-old art fair didn't budge. Gran Fury could show its work in the Aperto, or not at all.

McCarty felt that they should accept the offer anyway. There would be huge crowds and tons of press. Major newspapers from around the world send someone to report upon the Biennale, and this could bring their work to a massive audience. After all, this was how much of Gran Fury's work circulated anyway. Even if it wasn't a public space, they could still get a message out with this platform.

McCarty recalled that the rest of Gran Fury wasn't initially enthused about the whole idea. "Ugh. That's so *art*," was how she parodied the collective's response. This was usually how things went whenever a new idea was pitched to the group, McCarty recalled. There would be an initial reluctance to new ideas, and then they'd start to scratch the surface of what the project might do or be about. A constituency led by Avram Finkelstein felt that the Biennale was nothing more than an art junket and insisted that Gran Fury should decline the offer. Besides the issue that it was an enclosed and private space, it was also unfamiliar territory for the collective's members. What did any of them know about AIDS in Italy? What did they even have to say?

The debate turned in McCarty's favor when the collective began to consider potential targets and the content of these hypothetical posters. This was an opportunity in Italy, home of the pope and the Vatican.

Once this realization was made, Nesline started to get really excited by the idea. It would be an opportunity to both level a critique of the Catholic Church and stay on message, in a way that ACT UP hadn't been able to with Stop the Church. Gran Fury's other lapsed Catholics, Robert Vazquez-Pacheco and Tom Kalin, were now game too. Once they settled upon attacking the Catholic Church, most of Gran Fury got on board.

Still, Finkelstein held out and dug into his position. For him, the disadvantage of being in this space, and doing this without a public

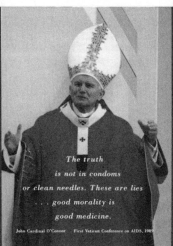

The Catholic Church has long taught men and women to loathe their bodies and to fear their sexual natures. This particular vision of good and evil continues to bring suffering and even death. By holding medicine hostage to Catholic morality and withholding information which allows people to protect themselves and each other from acquiring the Human Immunodeficiency Virus, the Church seeks

The truth is not in condoms or clean needles. These are lies . . . good morality is good medicine.

John Cardinal O'Connor First Vatican Conference on AIDS, 1989

to punish all who do not share in its peculiar version of human experience and makes clear its preference for living saints and dead sinners. It is immoral to practice bad medicine. It is bad medicine to deny people information that can help end the AIDS crisis. Condoms and clean needles save lives as surely as the earth revolves around the sun. AIDS is caused by a virus and a virus has no morals.

The Pope and the Penis (Panel 1), Gran Fury, 1990.

component, outweighed the advantages of critiquing the Vatican on its home turf. It was a familiar position for him—he had initially wanted to decline Bill Olander's offer for *Let the Record Show . . .* for the same reasons. "When I suggested that we walk away from the Venice Biennale," Finkelstein recalled, "it provoked a series of screaming matches."

But the rest of Gran Fury's members were now adamant about participating, as this opportunity would give Gran Fury its largest international platform while also providing space for them to criticize the Catholic Church's stances on both clean needles and condoms. Ultimately, Finkelstein abstained. He wouldn't block a consensus, but he wouldn't be working much on the project either.

Nesline and Vazquez-Pacheco wrote the bulk of the text flanking the images. Here, they attempted to rectify what had gone wrong with Stop the Church by making it clear that they were criticizing the church's interference in sex education, crafting the text so as to not be misconstrued as an attack on Catholicism writ large.

At the center of their poster, they included Cardinal O'Connor's words from the Vatican's first conference on AIDS: "The truth is not in condoms or clean needles. These are lies . . . good morality is good medicine." They laid this quote from Cardinal O'Connor over an image of the pope, insinuating

SEXISM REARS ITS UNPROTECTED HEAD

MEN

AIDS KILLS

USE CONDOMS

OR BEAT IT

WOMEN

The Pope and the Penis (Panel 2), Gran Fury, 1990.

the pope, not O'Connor, had said this. Admitting the billboard's gap in logic, McCarty reasoned, "The pope sanctions it all. So whatever." For their other billboard appearing on an adjacent wall, Gran Fury reprised the erect penis used in *Sexism Rears Its Unprotected Head*, combining it with an enlarged version of their *Men: Use Condoms or Beat It* text.

Gran Fury had the posters printed in Florida, then rolled them into long tubes and had them shipped to Venice. Almost all of Gran Fury would be flying to Venice for the installation and opening. McCarty was joined by her husband, and the rest of Gran Fury doubled up in hotel rooms with whomever they were closest to: John Lindell and Donald Moffett, Elovich and Loring McAlpin, Nesline and Mark Simpson. Before the invitation to the Biennale, Kalin had already decided to spend ten weeks in Spain, working on the script for what would become his first feature film, and planned to meet them in Venice for the opening. Finkelstein, to the surprise of no one, would not be attending.

◎

Gran Fury was not the only art collective invited to that year's Biennale. Shearer had also invited a collective of artists called the Border Arts Workshop, an artist collective that made work concerning the

border between the United States and Mexico. They were doing a huge installation—it was basically a small house with video monitors showing their performance work. And so they had to arrive weeks before to construct it.

On their first day in Venice, they made friends with the security guard. Michael Schnorr, one of the two members of Border Arts Workshop present in Venice, spoke Italian, and Richard Lau, who spoke Spanish fluently, picked up Italian quickly.

"Sandro, we don't have a lot of money," they told the security guard. "Is it okay if we sleep in the gallery?"

"Of course," Sandro said. "Leave when everyone else leaves, then wait a half hour. Come back and I'll open the door for you."

And so for the weeks leading up to the Biennale's opening, Lau and Schnorr slept in the small house that they were building in the Aperto. Every morning, they'd wake up early and pretend that they were the first ones beginning work in the gallery. While sleeping in the Aperto, they overheard someone ranting and raving, apparently about Gran Fury's work. "We were waking up to all this noise," recalled Lau. It was Giovanni Carandente, an Italian art critic and that Biennale's director, who was apparently quite upset about the possibility that American artists would criticize the Vatican. Overhearing Carandente's rants and raves, Lau and Schnorr got the impression that Carandente was trying to find the right authorities to censor Gran Fury's work.

Lau was already familiar with Gran Fury's output, and *Kissing Doesn't Kill* was particularly memorable for him. "I was really excited by how their work was both poetic and tough," he said. Lau reasoned that in the Chicano arts movement, there was a long history of both poster making and art collectives doing explicitly political work, and so they immediately felt a kinship with Gran Fury. "Even though we didn't know the Gran Fury folks," Lau said, "it was like being in a show with our friends." And they were eager to help if Gran Fury got into any trouble with Carandente.

When the members of Gran Fury arrived in Venice, nothing seemed askew. "It was all pretty grand," recalled Nesline. "We were in Venice for god fucking sake." The canals, the architecture, the piazzas, the

gondolas—this was a far cry from the needle-crusted sidewalks and burned-out buildings of Manhattan's East Village, where most of Gran Fury's members lived.

That air of grandness quickly evaporated when they arrived at the Aperto. They walked to the section of the gallery where their work was to be displayed and immediately noticed a serious problem. Their posters were missing.

"We'd never seen these guys, so we figured it must be Gran Fury," Lau recalled. He and Schnorr went over and introduced themselves. Lau recalled that the Gran Fury folks looked rather perplexed.

"Has your work shown up?" they asked Lau and Schnorr.

The Border Arts Workshop guys started talking with the Gran Fury folks and shared the intel they had gathered while camped out in the Aperto. "The director has been here every day, early in the morning," Lau told them. "And we think they're trying to block your shit, man." Lau also told them that Carandente was under the impression that the pope's head had been turned into a penis.

"Dammit!" someone from Gran Fury quipped back. "Why didn't we think of that?"

"All we knew was that our artwork was not delivered and that it was somewhere in customs," Nesline recalled. "But we didn't know what the problem was." Gran Fury's members were put in touch with the US Information Agency (USIA), a now defunct foreign agency responsible for promoting American culture abroad. According to *Newsday*, Shearer had mentioned the poster's content to the USIA, and they had, in turn, told Carandente. But in this game of telephone, the poster's actual content seems to have been miscommunicated. Nesline and McCarty described the poster's actual contents to a USIA official stationed in Italy.

"Oh, well that's not so bad," the official replied. "We thought that the pope's head were the testicles and penis."

While the USIA tried to wrestle the posters from customs, Gran Fury decided to enlist the help of Carandente, which only exacerbated Gran Fury's problems. On Monday, May 21, the members of Gran Fury met with Carandente, asking that he intervene, in the hopes of securing their work for the Aperto's opening. He responded to their pleas by telling

them that AIDS did not exist in Italy, that it was a New York problem and that he would resign if the poster ever appeared in the Aperto. He did not need to see the work, he reasoned, as he was so offended by their attack on the pope. Carandente even threatened to resign if the posters were ever hung.

"You can't criticize the Catholic Church," Carandente reasoned. "The Catholic Church never changes."

Nesline echoed their poster's copy, telling Carandente, "They changed their mind about the earth revolving around the sun."

Betraying his usual diplomatic role, Simpson added, "They changed their mind about the Jews killing Jesus!"

"That's it!" Carandente told them. "This meeting is over!"

Carandente stormed out of his office. In Nesline's recollection, they looked out a window and watched him get into a speedboat with his docents and go zipping across the canal.

The members of Gran Fury then decided to hold an impromptu sit-in, occupying Carandente's office. But after a few hours, no one had tried to remove them. Eventually they got bored and left of their own volition.

The members of Gran Fury then gathered at the space where they were supposed to install their posters and scrawled a short message on an empty wall. "Where is our work? Censored?" Whether or not anyone had actually intervened to stop the billboards from arriving in Venice is unclear. Carandente denied having anything to do with the billboards making it through customs, and it's unclear how he, an art critic, could have exerted enough influence to bar something from moving through Italian customs, though he certainly would have had more power to interfere once the billboards actually got to the Aperto. "To this day, I'm not sure if it was a matter of it being censored, or if it was just customs being disorganized," McAlpin recalled. "But it certainly worked in our favor."

Later that evening, they added a lengthier statement:

Two billboards by Gran Fury are being held in Italian Customs. One billboard, with a picture of the Pope, criticizes the Catholic Church's position on condoms and AIDS education. The other billboard, with a picture of an erect penis, mandates that men use condoms to prevent the spread of

the AIDS virus. The director of the Biennale, Giovanni Carandente, has threatened to resign if the billboards are exhibited. The Biennale officials refuse to intervene to secure the work.

This was the turning point in Gran Fury's Venice trip. When other artists exhibiting in the Aperto learned about Gran Fury's tribulations, they threatened to pull their work from the exhibition, which was just days away. Lau, from the Border Arts Workshop, began circulating a petition throughout the Aperto, along with the help of the artist Cady Noland. They managed to garner twenty signatures, fewer than Lau had hoped, but a consequential number.

Carandente then budged, offering a compromise. Carandente offered to have magistrates from the Italian government judge the work. If they deemed that the work was not blasphemous, then it could be hung. The gravity of this wasn't immediately apparent to the members of Gran Fury, and so Shearer explained it to them. In Italy, blasphemy is a crime punishable by imprisonment. Meaning that if these magistrates deemed the billboards blasphemous, then all of the present members of Gran Fury would be arrested immediately, taken to jail and face charges in an Italian court. The seven of them could spend up to two years in prison.

Gran Fury agreed. When later asked if the collective had hesitated, McCarty replied, "Oh no. Oh no. *Oh no*. You don't know Gran Fury. We were *all* gung-ho."

Elsewhere in the Aperto, a second fiasco was forming. Jeff Koons was showing several new additions to his growing *Made in Heaven* series, a project of paintings, photographs and sculptures in which Koons is having sex with Ilona Staller, nicknamed Cicciolina, an Italian porn star who had retired to become a politician. The series is famously gratuitous. It has close to fifty entries, none of which are particularly different than the others. In just the medium of glass, there are seven near-life-sized statues, the names of which are self-explanatory: *Blowjob, Couch, Ilona on Top, Jeff Eating Ilona* and *Position Three*. Koons staged almost all images so that Cicciolina is usually moaning or gazing at him. He, on the other

hand, holds a neutral expression, looking directly at the viewer, uninterested in Cicciolina.

That both Gran Fury and Koons were employing pornography and only Gran Fury was being censored only highlighted the hypocrisy at hand. While trying to censor Gran Fury, Carandente vigorously defended *Made in Heaven*, dismissing any suggestion that he was being hypocritical. "Eroticism is absolutely permissible," Carandente told the press. "It is so nice to have that in life."

Koons's work had the effect of bolstering Gran Fury's efforts. "Jeff Koons and his project were the perfect foil," Moffett reasoned. That both had used pornography, albeit to very different ends, linked the two within the eyes of the press, and made for a contrast that cast Gran Fury in an extremely sympathetic light. Next to Gran Fury, Moffett reasoned, Koons and his work looked frivolous. Michael Kimmelman, then the *New York Times*'s art critic, surmised the situation in his dispatch from Venice, saying, "Much of the talk about the Aperto among the hundreds of artists, curators, dealers and critics who have converged on this city during the last week has focused on two entries from the United States that have stirred interest more for their apparent capacity to shock than for anything else. Mr. Koons's entry is the first. The other, and for political reasons more important, is a set of posters by Gran Fury."

On the night of Wednesday, May 23rd, the billboards finally arrived in Venice, and the members of Gran Fury were able to retrieve them from customs. This being Venice, they had to transport them by wedging the tubes into a gondola. Sailing back to the Aperto, Lindell recalled seeing that Italian police had congregated at the building's entrance. In what Nesline described as a "protective paranoia," the collective decided to hide the posters instead of confronting Venetian law enforcement. So they instead sailed to the pizza restaurant where they had eaten daily since arriving in Venice. The pizzeria's owner happily obliged their request to hide the posters with the shop's trash. With their posters stowed, the members of Gran Fury proceeded to a party at Peggy Guggenheim's palazzo, with attendees that Nesline described as the "muck de la mucks" of the art world. Here, Nesline struck up a conversation with Ida Panicelli, the editor in chief of *Artforum*, who dished a bit of gossip, which only added to the hypocrisy

of Gran Fury's situation. Carandente was a closeted homosexual, she told him, and this was basically an open secret in the Italian art world.

Around three the next morning, Nesline received a call from one of the Border Arts Workshop guys, who were still sleeping in the Aperto. They told Nesline that the officials had arrived, and that Carandente was screaming at the nightwatchman, demanding to know where Gran Fury had hidden the posters. After some coercion, the nightwatchman relented and told him that they were behind the pizza shop.

The next morning, Nesline frantically called Panicelli. "You have to get us a fucking lawyer," he frantically told her.

Panicelli dismissed Nesline's concerns. "Tell Marlene to bring toilet paper when she goes to prison," she advised.

Within Gran Fury, accounts differ as to whether or not the collective was present at the unveiling and judgment of *The Pope and the Penis*. Nesline and McAlpin remembered that the magistrates judged the posters without the members of Gran Fury in attendance. It's possible

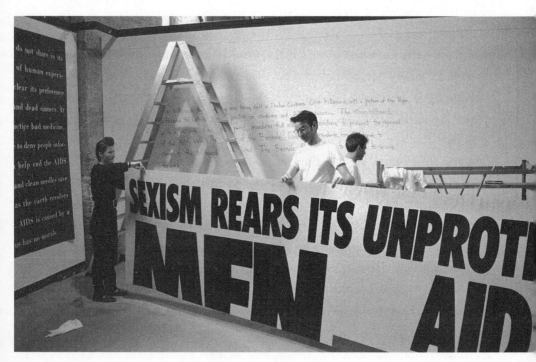

Marlene McCarty and John Lindell. Photograph by Bruno Jakob.

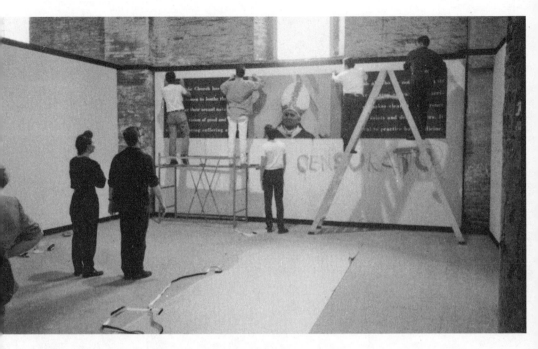

Marlene McCarty and Donald Moffett, directing the members of Gran Fury present in Venice. Photograph by Bruno Jakob.

that only some members were present, as McCarty has a vivid recollection of watching the magistrates unfurl the poster. "I did not have any sinking feeling until we were standing there and the magistrates were looking at the work," said McCarty. *Oh, fuck*, she realized then. *All the boys are going to get arrested together, and I'm going to get sent to the women's jail, by myself.*

Carandente had called Antonio Fojadelli, *sostituto procuratore della Repubblica di Venezia*, the equivalent of a state's district attorney, to judge the work. He communicated his decision upon seeing it on Thursday, May 24. "We don't know if it counts as good art," he reportedly said, "but it's not blasphemy."

Carandente was furious and told the Italian press that Fojadelli would "have to deal with his conscience" for casting this judgment. The members of Gran Fury began to install their posters on that Thursday, and the *New York Times* reported that the billboards had been hung by the end of the day. In front of a cadre of reporters, Nesline asked Carandente for his

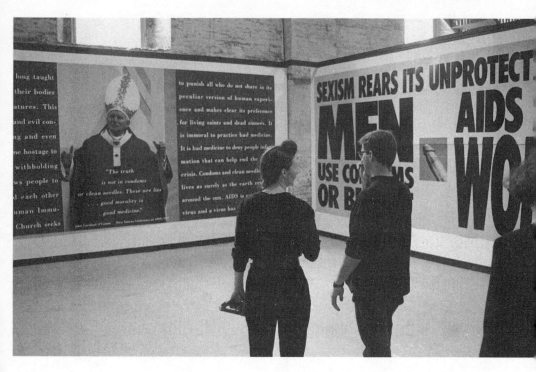

Photograph by Bruno Jakob.

resignation, given that he had threatened to resign if Gran Fury's work was ever hung, which only further enraged Carandente.

Even after the billboards went up, there was still the lingering threat of interference. The day after Fojadelli's decision, on Friday, May 25, Marco Ce, "Patriarcato veneziano," issued a statement condemning the billboards, and another prosecutor, Giovanni Valmassoi, also came to judge the panels at the behest of a police report, accompanied by Paolo Portoghesi, the Biennale's president. By Saturday, May 26, the *New York Times* reported, the Vatican had begun deliberating over whether to pressure the Italian government into removing the posters.

In the Catholic tradition, the pope is conceived of as the intermediary between mortals and the divine. He listens to God and speaks his word. (This is why, some argue, that the Catholic Church is so averse to revising any position previously stated by the pope. Because if one pope contradicts another, it undermines this relationship.) Whether or not the pope had actually considered censoring the pieces, a Sodom and

Photograph by Bruno Jakob.

Gomorrah–esque narrative had formed in the press, a story in which God himself had contemplated whether or not to smite Gran Fury.

But the billboards remained, and the ensuing news stories about Gran Fury brought a new level of attention to AIDS in Italy. Kalin landed in Venice not knowing about the commotion at the Biennale, but learned of the scandal before arriving at the Aperto. The entire city had been papered with a front-page headline, which Kalin understood, even without speaking Italian: "Il Papa e l'AIDS Scandalo in Biennale." In the process of wrangling their posters from customs, litigating with the Vatican and sparring with Koons, Gran Fury's *The Pope and the Penis* had become a front-page story in Italy and a news story worldwide. "We created a conversation where there had not been one before," Nesline concluded. "And anytime we did that, that was a mark of success."

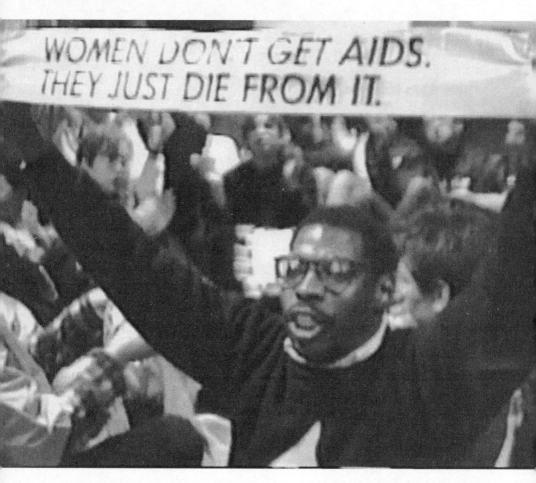

On December 3, 1990, ACT UP occupied the offices of Gary Noble, demanding that the CDC expand its definition of AIDS to include women. Still shot from video made by Ellen Spiro.

CHAPTER 9
RECOGNITION

O n November 19, 1990, five members of ACT UP met with seven of the CDC's top researchers. The meeting, which included Gary Noble, deputy director of HIV/AIDS Programs, was the product of an ongoing campaign organized by ACT UP, which had begun the previous January with a demonstration at the CDC's headquarters, and which had more recently included a class-action lawsuit against the Social Security Administration, along with a tandem demonstration. The issue at hand was the CDC's definition of AIDS, which delineated who had progressed from being HIV-positive to having an AIDS diagnosis.

At the time, the CDC defined someone with AIDS as being HIV-positive and having one of twenty-three symptoms, such as Kaposi sarcoma, CMV retinitis or wasting. This list of symptoms had been anecdotally culled, years before, from a pool of primarily white gay men, and so this list of qualifying symptoms didn't account for the ways in which HIV manifests in a female body. Nor did it use more measurable criterion, such as one's T-cell count or viral load, to determine who qualified for this diagnosis.

Beyond the CDC's ability to track the severity of the epidemic, this definition of AIDS had enormous consequences, as virtually every other government agency relied upon the CDC's definition of AIDS to determine who qualified for what benefits. For example, having an AIDS

diagnosis meant that one could qualify for Medicare or Medicaid. Clinical trials often mandated that their participants have an official AIDS diagnosis too. The Social Security Administration only distributed disability benefits to people with an official AIDS diagnosis—hence the lawsuit against the SSA. For someone who had tested HIV-positive, having an official AIDS diagnosis was the difference between having health insurance or not, collecting the small amounts of money offered by disability, or qualifying for a potentially lifesaving clinical trial.

The meeting began with a presentation from Katrina Haslip, a relatively new member of ACT UP New York. Haslip had spent much of the last six years in Bedford Hills, a maximum security women's prison, serving a draconian sentence for pickpocketing. While there, Haslip helped form Bedford Hills' ACE program (AIDS Counseling and Education), which functioned as a support group for women living with AIDS, in addition to providing educational resources and advocacy. In her time at Bedford Hills, Haslip had received her certified legal assistant credentials, and she became the Bedford Hills law library clerk and a jailhouse lawyer. She was a voracious reader of both policy and criminal law, and often used this self-procured expertise to advise her fellow HIV-positive inmates on their legal rights, particularly HIV privacy issues, such as whether or not a parole board had the right to know their HIV status.

Midway through her sentence, Haslip decided to get an HIV test. She had done so not because she worried about her own health, but because she wanted to encourage others incarcerated there to get tested too. Haslip hadn't expected her results to come back positive. She never learned how exactly she had contracted the virus. She had shot drugs and done sex work, but she had also been stabbed in 1983 and received a blood transfusion before screening the blood supply for the HIV virus had become commonplace. Even though she led an HIV and AIDS support group, Haslip initially hid this from her fellow inmates for fifteen months, saying that it made her feel "dirty." When Haslip finally did come out as HIV-positive, she told her fellow inmates that when she was released from Bedford Hills, she was going to change the CDC's definition of AIDS.

Two weeks after her release, Haslip joined ACT UP's demonstration outside the Department of Health and Human Services (HHS) head-quarters, demanding that they not rely upon the CDC's definition of AIDS to determine who qualified for disability benefits. By then, Haslip's health was already severely compromised. She was experiencing fatigue, weight loss, leg pain and persistent vaginitis. Even with a T-cell count of 47, she still didn't qualify as having AIDS. She had violated her parole to come to Washington, DC, to speak out with other HIV-positive women about their experiences, and Haslip likely violated her parole again to attend this meeting with the CDC's top brass. She brought all of this experience into the room, describing the debilitating opportunistic infections that plagued her and other HIV-positive women she knew.

Next, Tracy Morgan spoke. Though she had joined ACT UP in the midst of planning Stop the Church, Morgan had enmeshed herself through working on the CDC campaign. She was now dating Heidi Dorow of *Kissing Doesn't Kill*, and it was a conversation between the two of them that had sparked the idea of strategizing a long-term campaign. "Let's come up with a year-long campaign to win," Dorow said to Morgan. Over the course of 1990, Morgan had become one of ACT UP's foremost experts on the manifestations of HIV in women, and she brought with her a stack of research, peer-reviewed journals such as the *Journal of the American Medical Association, The Lancet* and the *New England Journal of Medicine*. She also presented testimony from doctors who worked with large numbers of HIV-positive women, all of whom testified to how symptoms like pelvic inflammatory disease, cervical cancer and vaginal thrush were exceedingly common among HIV-positive women but not included in the CDC's list of qualifying symptoms. This medical documentation showed that Haslip's symptoms and experiences were extremely common among HIV-positive women, and hardly idiosyncratic.

This was Morgan's official reason for attending, and she presented these medical journals and testimonies dutifully. But she also busied herself with another task. "While we were there, we were also doing reconnaissance," Morgan recalled. ACT UP was planning a demonstration at the CDC's headquarters in just two weeks, and Morgan figured that it

might be useful to have a layout of Noble's office. Over the course of this three-hour meeting, she sneakily drew out the floor plan in her notebook, noting doors and fire exits. She also jotted down germane details about how they might access the building, like when the mail was delivered, and if they could sneak in then.

Maxine Wolfe delivered the last part of ACT UP's presentation. She detailed how the CDC's definition of AIDS was being used by other government agencies and how important it was for the CDC to adopt a more comprehensive definition. Furthermore, not including the manifestations of HIV in women also meant that women were more often misdiagnosed, as doctors didn't know what symptoms indicated that they might be living with AIDS. During this time, it was a common experience for women to exhibit symptoms of immunosuppression and for their doctor to not test them for HIV, meaning that many women with HIV went undiagnosed until their symptoms progressed even further. The cumulative impact of all this had profound consequences. That same year, a study from the University of Medicine and Dentistry found that the average woman survived 27.4 *weeks* after being diagnosed with AIDS, while the average white male lived 39 *months* from the same diagnosis.

Wolfe also detailed how the CDC's definition of AIDS was tied to the ways in which federal AIDS funding was allocated. In August of that year, Congress had passed the Ryan White CARE Act, a bill that granted federal funds to states and large metropolitan cities to subsidize AIDS care, beginning the following year. The bill divvied funds based on the number of reported AIDS cases, so that cities and states with higher populations of people living with AIDS would receive more funding. But because the bill relied upon the CDC's definition of AIDS, women who were HIV-positive and severely sick, but who didn't qualify by the CDC's definition, wouldn't be counted in the tallies that determined how funds were allocated. This meant that cities like New York, which had large populations of women who would qualify under an expanded definition, wouldn't receive all the funds to which they were entitled. And a city like San Francisco, where AIDS patients were more likely to be men, would receive a disproportionate amount of funding. So without changing the

CDC's definition, the Ryan White CARE Act would only exacerbate the discrepancy in treatment between men and women living with AIDS.

Noble first responded to all this by denying that misogyny or racism could, in any way, be a factor in the CDC's inadequate definition, and assured everyone in attendance that he worked with very fine people. Then he briefly summarized how the CDC had come to its current definition and seemed to imply it could continue to evolve. "The process of AIDS case surveillance has been an evolutionary one," Noble told them. "We did start out with gay men. . . . And, for historical reasons there are some imperfections in the ways AIDS case surveillance came about. If we were creating it, de novo, given what we know today it probably would have some things differently in it." But Noble resisted the idea of changing the definition on the basis of epidemiology, even though the definition didn't fully capture everyone. "Its purpose is an epidemiological tool to track the course of the epidemic," he told them, "and it has proved—despite its flaws, we recognize its flaws—we recognize that there are people who die without a diagnosis."

Ruth Berkelman, who led the agency's HIV surveillance efforts, added that if they were to change the definition of AIDS, then that would hamper their ability to predict the future of the epidemic. She reasoned that scientists would throw a fit if they changed the definition, as they did when they had last updated the definition in 1987. "When we start talking about changing the case definition," she told them, "we get a lot of screams from scientists, from all kinds of places, saying we can't track trends every time you do this because it threw everybody apart for a while." Throughout the entire CDC campaign, this remained the CDC's main objection to changing its case definition, that it would skew their ability to forecast the epidemic, and that other government agencies need not use their definition of AIDS if it didn't suit their purposes.

But how could the CDC accurately predict the course of the epidemic, ACT UP wanted to know, if they weren't fully counting women with AIDS?

Berkelman reasoned that too many HIV-positive women who hadn't progressed to AIDS would be included if they expanded the definition, as

most of the infections that HIV-positive women experience also happen among women without HIV, that just because a woman is HIV-positive and has a yeast infection, doesn't mean that she has AIDS.

Then why not include caveats, ACT UP suggested, such as *persistent* yeast infections, or bacterial pneumonia that doesn't respond to treatment, or *severe* vaginal thrush. This kind of language was, after all, included in the existing CDC definition. Diarrhea, for example, was listed as one of the qualifying symptoms of AIDS, but only if it persisted for more than a month. Why couldn't the CDC include women-specific symptoms with these sorts of caveats? And what's maddening, in reading the transcript of this meeting, is that the CDC never really answered this question. "The whole thing was soul-crushing," Morgan later recalled. "Because I realized that these people might not actually give a shit."

Throughout the meeting, ACT UP's representatives pressed for a more definitive timeline on when the definition would be changed. Noble eventually replied with a maddening response, one that would be comic in its evasiveness if the situation weren't so dire. "We will do all we can," he assured them, "to make sure we are doing the best we can."

ACT UP wanted a firm promise, not a platitude. "You said that you were open to changing the definition," one of its representatives replied. "Is there any kind of timeline? Are we looking at a year or two, a month or two?"

"I can't say," Noble replied. "I don't know." Then he asked his CDC colleagues if anyone else wanted to chime in: "Does anyone else want to answer that?"

"Well, it's an ongoing process," said Bert Peterson, chief of the CDC's Women's Health and Fertility Branch.

"It's ongoing," reiterated Berkelman.

"Depending on the data," added Peterson.

"And when do you anticipate that there will be enough data?" someone from ACT UP asked.

"I really can't say that it's going to be a month or six months," Berkelman said. "I will say that some of this data ought to be helpful—"

ACT UP's representatives got up to leave. "You would save yourselves an awful lot of trouble if you just got together all of these

clinicians and just asked them what they were seeing," one of them said as they stood up.

"I didn't think we'd made any progress," Morgan later recalled. "It was not clear that we had moved the needle at all. There was no reason to call off the demonstration, that was for sure."

It was Haslip who had the last word. "I hold each of you personally responsible for the death of every woman with HIV I know," she told Noble and his coworkers as she walked out the door. "Including myself." And with that, the meeting was over.

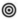

By the end of 1990, ACT UP's demands were well known, as all the top officials at the CDC had been presented with the evidence that women develop symptoms of AIDS that differ from their male counterparts. Even after the January 1990 demonstration at the CDC headquarters, a follow-up demonstration at the HHS headquarters in October, an ongoing class-action lawsuit against the federal government and the November meeting with CDC officials, their demands went unheeded. And so ACT UP spent the next two years lobbying the CDC relentlessly, with an ongoing series of demonstrations, building support among other community organizations, educating the public and pushing congressional representatives to pressure the CDC into changing its definition. ACT UP deployed every single tactic it had ever used, including the work of Gran Fury, who crafted one of its most potent, effective and controversial pieces for this campaign.

Gran Fury's members were all tied to this issue in different ways. Separate from his work with Gran Fury, Avram Finkelstein was in an affinity group called the Costas, many of whose members, like Wolfe and Dorow, were integral to this campaign.

Also separate from his work with Gran Fury, Richard Elovich had piloted ACT UP's needle exchange program, which collected used hypodermic needles and distributed clean ones to intravenous drug users. New York was one of eleven states that criminalized the possession of a hypodermic needle, meaning that intravenous drug users were more

likely to share them, which unsurprisingly drove up infection rates among intravenous drug users. He knew, from this program, that a large number of HIV-positive women had been infected by their heterosexual partners, who themselves had contracted HIV through sharing needles. Furthermore, several of the symptoms that ACT UP wanted added to the CDC's definition of AIDS were most common among intravenous drug users. So from both a prevention and treatment point of view, Elovich understood that the CDC campaign and needles were inextricable. Since beginning the exchange, Elovich and a few others had courted arrest, hoping to challenge the criminalization statute in the courts, and they were awaiting trial when Gran Fury decided to contribute to the CDC campaign.

Marlene McCarty also championed this issue within Gran Fury. "The CDC definition of AIDS was something that was near and dear to my heart," she recalled. Being the only woman in Gran Fury, McCarty described feeling an incredible amount of pressure to be the one making sure that a woman's perspective was being considered in their work, and nowhere did that feel more essential than here.

Michael Nesline, who had by then finished nursing school and was now working as a nurse in the AIDS ward at Bellevue Hospital, saw the effects of the CDC's definition on a daily basis. "I saw it happening firsthand," recalled Nesline. "I saw women who were just as ill as men but were not eligible for the bits of financial support or security or medical help because they didn't meet the CDC's criteria." And he felt that this wasn't an issue that he could address through his work as a nurse. "We did the best that we could," Nesline recalled of the hospital staff. "But sometimes our hands were tied in terms of being able to get individuals the amount of assistance that they needed and the benefits that they needed."

With funding from the Museum of Contemporary Art in Los Angeles and the Public Art Fund, Gran Fury's contribution was going to appear on a hundred bus shelters in New York and more than eighty in Los Angeles.

The CDC's definition of AIDS was a seemingly arcane distinction that had enormous consequences, and they were trying to capture the full

breadth of its ramifications without sacrificing nuances. Furthermore, Gran Fury also had to explain why someone who is HIV-positive would actually *want* an AIDS diagnosis, something that might seem counterintuitive. While working on a completely different slogan, McCarty made an offhanded aside, a quip more than an actual suggestion. "Women don't get AIDS," she remarked. "They just die from it."

That was it. Everyone in Gran Fury instantly recognized that they had happened upon their slogan, even if it was by accident. "No further modification of that line was ever entertained," Finkelstein recalled.

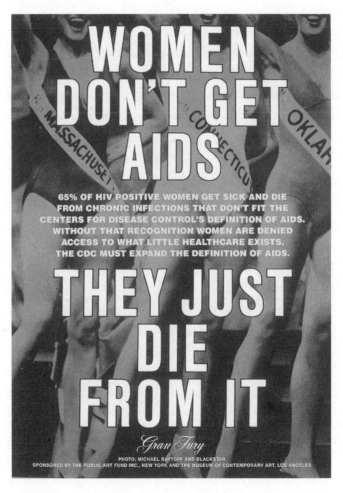

Women Don't Get AIDS, They Just Die from It, Gran Fury, 1991.

Women Don't Get AIDS, They Just Die from It became one of Gran Fury's hallmark slogans, and it was used at virtually every juncture of ACT UP's campaign to lobby the CDC to change its definition of AIDS. But it also represented the culmination of years of work from the collective. Illness, and AIDS in particular, is a very visceral experience, but one that is exacerbated and enabled by institutional forces that can seem invisible or intangible. *Women Don't Get AIDS, They Just Die from It* dispelled this notion that institutional forces and the lived experience of AIDS are somehow unrelated. The slogan's first clause—Women don't get AIDS—alludes to the CDC's definition of AIDS, an institutional distinction. They just die from it encapsulates the lived reality. By placing those two clauses on the same poster, Gran Fury made an argument for their inextricability. And this capacity, for art to make seemingly abstract policies feel tangible, is what made art such an essential tool in working to end the AIDS crisis, and what Gran Fury gave to this campaign.

For the women of ACT UP who worked on the CDC campaign, it perfectly encapsulated the hypocrisy that women were HIV-positive and dying prematurely without an official AIDS diagnosis. "Once that phrase was enunciated," Morgan recalled, "we knew we had to use it."

Women Don't Get AIDS, They Just Die from It had an array of outcomes, including an internal effect on ACT UP. Dorow recalled that having a Gran Fury billboard legitimized the campaign, at least in the eyes of other ACT UP members. And it also encouraged those who had dedicated themselves to the CDC campaign. "It felt very empowering when we got that poster," Dorow recalled. "It gave the campaign more *umph*, more strength, more wallop, more power. And it made it seem like the campaign would have more of an impact."

"It's a slightly baffling slogan," noted Monica Pearl, who was one of Elovich's codefendants in the needle exchange trial while simultaneously working on the CDC campaign. "But it's baffling in just the right way." How can someone die of a disease they don't have? The perplexity of the statement compels you to investigate further, which is also facilitated by that poster. For their bus shelters, Gran Fury added three more sentences, in smaller type, detailing the failures of the CDC's definition and the

ramifications of this: "65% of HIV positive women get sick and die from chronic infections that don't fit the Centers for Disease Control's definition of AIDS. Without that recognition women are denied access to what little healthcare exists. The CDC must expand the definition of AIDS."

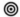

Though the slogan and rejoinder text proved to be some of Gran Fury's most effective, the image they chose, and how they chose it, led to one of the collective's most divisive arguments. John Lindell recalled that either he or Donald Moffett suggested using an image of beauty queens for the background.

Some members of the collective, like Finkelstein, had reservations. "It was meant to serve as a coded reference to the ways women are deployed as cultural symbols while remaining invisible," he recalled. And though he agreed that this critique was important and true, he wasn't totally sure that this particular image would hold up once in public, that the audience would be able to make that leap from what they had supplied. But Finkelstein, at first, went along with it.

McCarty wasn't totally sold on the idea either. "It was beauty queens," she said. "It was this campy, idiotic thing that was already out of fashion but still existed. There was some kind of equation, in the collective mind of Gran Fury, between the obsoletion of this image and the obsoletion of the CDC's definition of AIDS. That link didn't hold up once the image was in the public, and I think I let myself be talked into the campiness, the humor and the two obsolescent ideas."

A few potential options were brought in for discussion, and much of the collective found one image in particular to be quite striking. It's an image of three beauty queens during the swimsuit portion of a pageant. "You believed it when you saw it," Moffett recalled. For him, it was a gut instinct. This one clicked.

But Robert Vazquez-Pacheco took issue with all three of the beauty queens being white women. For him, including women of color felt necessary for a plethora of reasons. First, because the CDC's definition of AIDS disproportionately affected women of color. But it was also a

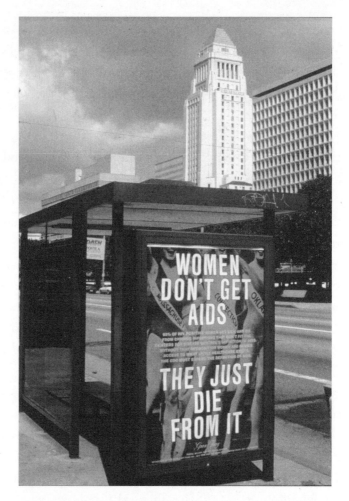

Photograph courtesy of the New York Public Library.

question of audience, and the fact that the posters would be appearing at bus shelters.

"Who do you think takes a bus in LA?" Vazquez-Pacheco rhetorically asked the rest of the collective. "It's not very many white people. It's people of color." And he felt that women of color weren't going to look at a photo of white beauty queens and identify with them.

Much of the collective countered that the conjoining of this image and slogan could serve as a critique of white privilege. "I remember arguing strongly for it," Loring McAlpin recalled. "It's the fetishization of white women like this that means that Black women are excluded from

all kinds of attention, including medical attention." Furthermore, Lindell felt that the tension between the image and the message suggested that this was how the CDC saw women. Using this image, much of the collective argued, could serve as a critique of how women are so often held on a pedestal and fetishized, without actually being cared for, and that the CDC's inadequate definition of AIDS reflected this.

Finkelstein and Vazquez-Pacheco argued that they should try to speak directly to women of color, rather than trying to critique whiteness. "Obviously, I'm not a woman, I do not try to speak for women, but I will just say that I do not think that women of color are going to look at white beauty queens and feel a connection with them at all," Vazquez-Pacheco reasoned. Finkelstein recalled that several of their options did include women of color, and Vazquez-Pacheco even suggested that, if the collective insisted on using an image of beauty queens, then a photograph from a Miss Universe pageant might have a more diverse array of women. But the rest of the collective felt that the image had the ability to critique the ways in which women, and this particular kind of white woman, are prized without actually being valued. "The members who loved the image dug in their heels," Finkelstein recalled.

It should be noted that nobody, not even those who dissented, actually suggested asking a woman of color what she thought about all this.

The debate over this image of beauty queens became one of Gran Fury's most contentious, and lasted several weeks. Even those working on the CDC campaign began to hear about this. "I knew that they were really struggling over this beauty pageant image," Morgan recalled. "It was clear that they were having a visually hard time about what to do, and it seemed like they were quite vexed."

But Morgan decided not to opine about the image. Morgan understood *Women Don't Get AIDS, They Just Die from It* as a poster that was trying to influence those in power, both those within the CDC and those who could pressure the agency into changing their definition of AIDS. "We had to speak to power," Morgan reasoned. "We had to arrest the powerful, and get them to think. And Gran Fury had a way of doing that." To arrest the attention of those in power, Morgan reasoned, they

had to cater to what is prized by the powerful. "An image that showed the reality wouldn't get the powerful interested," Morgan reasoned. Someone like Katrina Haslip being in the room with CDC officials clearly hadn't swayed them.

Morgan felt that Gran Fury's ability to arrest the powerful came from the group's demographics. "Enough of them came from power that they knew how to speak to it," Morgan reasoned. "I don't think that Gran Fury would have worked if some of them didn't have Ivy League degrees or family power, like Loring McAlpin." (McAlpin was actually the only person in Gran Fury who had attended an Ivy League school or came from that kind of family money, but many in ACT UP perceived that this background was shared by more of the collective.) Someone like McAlpin knows how to confront power, Morgan reasoned, because they come from it, because they, their parents, and their siblings share the same demographics as the kinds of people that ACT UP was trying to influence. Morgan understood the image of beauty queens to be a way of doing just that. "I didn't know what those in power needed to see," she recalled. And so she trusted Gran Fury to make this decision on their own.

After weeks of back and forth, the debate finally ended with Vazquez-Pacheco fully exiting the collective. Vazquez-Pacheco doesn't remember who said it, but one member of Gran Fury reasoned, "If I were a woman of color, I would understand this poster."

The self-assuredness of this statement was maddening for Vazquez-Pacheco. *My work is done here*, Vazquez-Pacheco thought. *People have obviously incorporated the experience of people of color into themselves and can now speak for them.*

"I'm done," he told the collective, and he walked away from Gran Fury.

Maxine Wolfe had never seen so much rain before. It was December 3, 1990, and a plane's worth of ACT UP members had traveled to Atlanta to stage a second demonstration at the CDC's headquarters, located on the campus of Emory University. They brought sashes, like the ones beauty

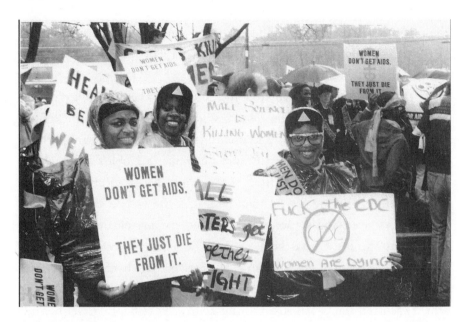

Still shot from video made by Jean Carlomusto.

queens wear, that read *Women Don't Get AIDS, They Just Die from It.* The yellow band with black font made them look like caution tape. Given the day's weather, it proved to be the perfect visual. Because of the pouring rain, everyone was wearing ponchos, obfuscating their T-shirts. But the sashes fit comfortably over rain gear, and also left people handsfree, to hold an umbrella or poster to shield themselves from the rain.

The demonstration was largely organized around HIV-positive women who spoke out about their experiences of not qualifying for the CDC's definition of AIDS. What's really striking about this demonstration is how many HIV-positive women came out bearing Gran Fury's slogan, both as a sash and as a poster version sans beauty queens. A woman wearing one of the sashes concluded her speech by saying, "I have a file at the county hospital that's four inches thick. I'm not sick yet. I have fifteen medications, but I'm not sick yet. I have thirty-five thousand dollars in medical bills, and I'm not sick yet. I am sick. Help me!"

The night before the demonstration, Finkelstein's affinity group, the Costas, had crammed themselves into a hotel room to pore over the schematics that Morgan had hand drawn in their meeting with Noble and

the other CDC researchers. They debated whether to occupy his office or that of his deputy, James Curran, who had a more public presence, but ultimately settled upon Noble.

At the demonstration, everyone in the Costas knew to look out for a signal. When they got it, the Costas slinked away from the picket circling the CDC headquarters and piled into two passenger vans, driving the two and a half miles from Emory's campus to Noble's office. At 26 Executive Drive, they burst from the van and began circling the one-story building, looking for an open door or a fire escape left ajar. Soon, the police arrived and stationed themselves at every entrance, trying to head them off. The Costas kept circling the building, looking for a way in, and finally found a postwoman as she arrived to deliver the day's mail.

ACT UP's members stood on either side of the entrance as a police officer escorted the postwoman to the door. "We're happy to let her in!" they shouted, with a bit of taunting. The officer asked the videographer to shut off her recorder, which of course she didn't. As soon as the officer turned the key, someone started chanting, "Murder by omission! Change the definition!"

Then, when the door was open enough, a strapping Irishman with long, bright red hair named Bill Monaghan managed to grab hold and pull it open.

"Door's open!" somebody screamed.

Security and the police tried to push back everyone from ACT UP, but at least one person managed to wedge themselves through. "They're in!" someone screamed out. "Go around!"

This was, as Dorow put it, a Costas move. They just needed one person inside to open a door for all the others. Soon, the Costas had overrun the building. "We want! Gary Noble!" they chanted as they ran through the maze of cubicles, looking for Noble's office. They found his secretary, who was almost apologetic and informed them that his boss was out for the day. "Here we are," Morgan joked. "A direct confrontation with a secretarial staff."

So instead of occupying Noble's office, they decided to commandeer the phone and fax machines, sending out information about the CDC's

inadequate definition of AIDS. Soon, the press arrived and crowded up against the one-story building's floor-to-ceiling windows, in hopes of catching a glimpse or some footage. The Costas took off their *Women Don't Get AIDS, They Just Die from It* sashes and held them above their heads, like banners, for the press to see.

"We'll leave when the CDC changes its definition of AIDS," they told the officers.

That day was probably the first time that Noble's staff had been confronted with this slogan. Though the siege of his office didn't garner much press attention, those who worked under him weren't likely to soon forget the consequences of their malfeasance, that because of them, *Women Don't Get AIDS, They Just Die from It*.

Soon after the demonstration, *Women Don't Get AIDS, They Just Die from It* debuted on bus shelters in New York and Los Angeles. It cemented Gran Fury as being canonical. Christopher Knight, the *Los Angeles Times*'s Pulitzer Prize–winning art critic, wrote of its debut and noted, "Gran Fury has produced the most substantive and successful political graphic art of the postwar era in the United States."

But the project also debuted at a moment when the collective was fracturing. Even before Vazquez-Pacheco's departure, Gran Fury was very consciously aware of the fact that, of its ten members, the collective only had one woman and one person of color. "We were self-conscious and self-critical about it," recalled Tom Kalin. "But not enough to open our membership and really do something radical." When Vazquez-Pacheco was still working with Gran Fury, he once suggested that the group could begin bringing in new members. "Towards the end, as everyone in Gran Fury was getting tired and talked about disbanding, I suggested that everyone wanting to leave the group could replace themselves with somebody else—that way we could get more women and people of color involved," he recalled. "That went over like a fart in a church." Nesline actually recalled making the same suggestion and receiving a similarly unenthusiastic response.

There were other problems festering within the collective too. The question of Gran Fury's relation to the art world—whom should we accept funding from, and under what circumstances—had been an ongoing discussion within the collective and was something that they constantly had to reevaluate and navigate. But as individual artists within Gran Fury started to show signs of career success, others began to question different people's motivations within the collective. "Avram used to complain to me about everybody in the group being interested solely in their own art career," recalled Nesline. "And that the only reason that Donald or John or Marlene or Tom were in Gran Fury was because it looked good on their resume."

This griping went both ways. "And from everybody else, I'm hearing about how Avram is a fucking pain in the ass," Nesline recalled. "I heard it from both sides. It began to feel like this group of people was not working as a group of people anymore, and that inter-person conflicts were inhibiting the functioning of the group."

Gran Fury tried to deal with these two problems—its overwhelming white maleness and its interpersonal conflicts—by collaborating with other groups. This hadn't gone well in the past. In 1989, the members of Gran Fury had met with the Guerrilla Girls, the art collective who self-described as the conscience of the art world, and who dedicated themselves to fighting its racism and sexism. They were, and are, known for appearing in public wearing their signature gorilla masks, but the members of Gran Fury hadn't expected that they'd be wearing them to the meeting as well. "They came to the meetings in those fucking gorilla heads," McCarty recalled. And the Guerrilla Girls refused to take them off. "It was really annoying," said Nesline, "and I remember not being alone in that opinion." He wasn't. Everyone else from Gran Fury has an almost identical recollection of not wanting to work with a collective of people who refused to show their faces.

But with the growing awareness of their overwhelming white maleness, the members of Gran Fury were willing to try again at collaborating with other groups. After *Women Don't Get AIDS, They Just Die from It*, Gran Fury tried to collaborate with PONY (Prostitutes of New York),

an alliance of the city's sex workers, for a window installation at the New Museum. *Love for Sale* it would be called. One PONY member, Tracy Quan, joked that the members of Gran Fury seemed relieved to be working with people who didn't insist upon wearing plastic masks at their meetings. The piece was to appear in February 1991, in the same window where *Let the Record Show* . . . had. It could have been a way of recentering themselves around the space that had given birth to Gran Fury, reconnecting them to their roots, and resetting the collective. Instead, it devolved into one of their most scattered efforts. It was supposed to

Love for Sale . . . Free Condoms Inside, Gran Fury, 1991. Photograph courtesy of Gran Fury.

resemble the window of a sex shop, but the final project didn't quite capture that effect. Finkelstein, one of the only members of Gran Fury who speaks kindly of the project, fondly recalled how Mark Simpson affixed dildos to a spinning wheel you might find at a county fair, trying to create an educational sex game.

Nesline recalled that the process for *Love for Sale* was almost identical to the process for *Let the Record Show . . .* In Nesline's recollections, anything that anybody wanted appeared in *Let the Record Show . . .* It was a bit of a free-for-all but ultimately cohered around the central concept of a restaging of the Nuremberg trials. "With *Love for Sale* we did the exact same thing," Nesline said. "Whereas the first window really cohered and pulled together into a solid thing, the *Love for Sale* window just flew apart." Nesline believed that *Let the Record Show . . .* was just beginner's luck. But *Love for Sale* lacked a literal and conceptual center. Whereas *Let the Record Show . . .* conceptually revolved around restaging the Nuremberg trials and was graphically centered around the mural that Kalin had printed, *Love for Sale* had no driving concept, nor did it have a central graphic element around which the rest of the window revolved.

From Nesline's perspective, working with other groups was the worst thing Gran Fury could have done to deal with its interpersonal conflicts. "It wasn't a solution to Gran Fury's problem," Nesline reasoned. "The solution to Gran Fury's problem was not to farm the problem out to somebody else." As Nesline put it, "We're having problems communicating and so we bring in more people so that we can avoid communicating?"

"It didn't feel good when we were doing it," Nesline recalled. "The meetings felt like a chore." He wasn't the only one who felt this way. "I slogged through that one," McCarty said. "After that, I was like, I don't know if I can do this anymore." McCarty's burnout stemmed, in part, from the fact that she and Moffett were managing their own graphic design firm while simultaneously making their own artwork *and* working with Gran Fury. But for McCarty, she was also beginning to feel that her activism was needed elsewhere. The year after *Love for Sale*, McCarty joined the Women's Action Coalition (WAC), a direct action group

formed in response to the 1991 Clarence Thomas hearings on his assault of Anita Hill. WAC was largely modeled after ACT UP's organizing principles and style of demonstrating, and employed graphic design to a similar effect. With WAC, McCarty lent her graphic design skill set and codesigned one of WAC's most well-known posters, *WAC Is Watching*, with Bethany Johns, a fellow WAC member and M&Co. alum. *WAC Is Watching* functioned as a sort of logo for the group, in a similar way that *Silence=Death* had for ACT UP. But by the time that WAC came into being, McCarty's attention was no longer focused on Gran Fury. "I was like, all right, guys, I need to deal with me and my kind," she recalled. McCarty didn't leave Gran Fury, but by the time of *Love for Sale*, she was beginning to feel that her talents were needed elsewhere.

As *Women Don't Get AIDS, They Just Die from It* debuted on bus shelters in New York and Los Angeles, the slogan was about to receive an even larger platform. As early as January 1991, ACT UP had debated whether to take out a full-page advertisement in the *New York Times* for the CDC campaign, an idea that launched a rather fraught discussion. Since Gran Fury's *New York Crimes*, ACT UP had consistently protested against the *Times*'s AIDS coverage, and particularly against Gina Kolata, the paper's beat AIDS reporter. Some within ACT UP, even those who had supported Gran Fury's work in the past, felt that this didn't square with their decision to purchase advertising space in the *Times*. "One day we go march around the *New York Times* offices, and complain about their AIDS coverage, and the next day we spend $15,000, supporting their advertising revenue," said Patrick Moore, the ACT UP member who had commissioned Gran Fury's *Art Is Not Enough* project. "And those things didn't reconcile to me."

There was also the question of money and how ACT UP was spending it. The previous year, ACT UP had fundraised over a million dollars, which allowed it to stage some of its most elaborate demonstrations, and which provided the funding for several service organizations, including the needle exchange program piloted by Elovich and Housing Works, an

organization dedicated to providing housing and support for unhoused people living with AIDS.

By the summer of 1991, ACT UP was having trouble maintaining its previous levels of fundraising. In early May of that year, ACT UP's fundraising committee wrote an open letter to the floor, detailing how they would run out of money before the end of the month. In the same letter, the current fundraising committee announced that they would be stepping down. "We find that it is no longer possible for such a small group of people to do the job alone," they reasoned. Later that year, ACT UP's treasurer and assistant treasurer both quit for similar reasons. All of this highlights a problem that only became increasingly dire over the course of 1991: everyone had plenty of ideas for how to spend ACT UP's money, but fewer and fewer people were thinking of new ways to raise it.

Still, there was enough support within ACT UP for this full-page advertisement in the *New York Times*. As ACT UP readied this advertisement, the CDC campaign received one of its strongest tailwinds. That May, the American Medical Association (AMA) wrote to the CDC director, imploring him to change the definition of AIDS. "We already have significant information about the manifestations of HIV disease in women," wrote Roy Schwarz, a vice president of the AMA. "Recent reports have documented the association of HIV infection with various gynecological disorders such as chronic vaginal candidiasis, acute pelvic inflammatory disease, and rapidly progressing cervical cancer." When ACT UP's representatives had met with Gary Noble the previous November, Wolfe, Morgan and Haslip had advocated for these sorts of caveats. Now, ACT UP had the American Medical Association on their side, pushing the CDC for the same kind of change.

ACT UP used the AMA's letter to the CDC as the basis of its full-page ad in the *Times*, which appeared on June 19, 1991, and was timed to coincide with that year's International AIDS Conference. The full-page ad featured Gran Fury's slogan, in large block type, with smaller text detailing the CDC's inadequacies in defining AIDS, between each line of larger text. It's not as eye-catching as the bus shelter iteration, but it instead offers a more detailed account, in a way that a bus shelter can't. Just

as Gran Fury had recognized with the *New York Crimes*, a newspaper is a perfect forum for lengthier explanations of complex issues.

What is perhaps most powerful about this full-page ad is the list of people who endorsed it, which occupies the bottom third of the page. Morgan spearheaded the effort to garner these signatures. "We were doing old-fashioned political organizing," Morgan recalled, cold-calling organizations, or working their existing connections, and making the case for them to sign on to this message. They lobbied everyone from Dianne Feinstein to tiny neighborhood community health centers. Publicly condemning the CDC in the *New York Times* could be perilous for the smaller groups, as many of them received CDC funding and grants, and they were nervous that the CDC might revoke their funding in retribution. "There could be punishment," Morgan reasoned. "They knew that, and we knew that, and I think that really added fuel to our fire."

Still, Morgan and the rest of the CDC Working Group managed to garner a broad coalition, all of whose signatures appeared underneath Gran Fury's slogan. This list included politicians from across the nation, at every level of government, including the mayor of San Francisco, Deborah Glick, a New York State Assembly member, and Joe Lieberman, a US senator. Leading doctors who specialized in HIV and AIDS care lent their support too, along with OB-GYNs, nurses and other health practitioners; deans and professors from medical schools like Columbia and Johns Hopkins cosigned this, as did epidemiologists from research centers like the University of California at San Francisco; legal organizations like the Center for Constitutional Rights and the Lambda Legal Defense and Education Fund contributed too, as did a lawyer from the ACLU; hospitals and smaller community health clinics vouched for this as well; artists, arts organizations and curators too; and last on the list, over twenty ACT UP chapters from around the country.

A smattering of AIDS health groups endorsed this ad, with one notable exception. Gay Men's Health Crisis, the organization that Larry Kramer had founded before starting ACT UP, refused to lend their endorsement. When GMHC formed, its founders—all gay, white men— had settled upon this name because the term AIDS hadn't even been

coined yet, and because they anecdotally saw the crisis happening among their peers. But almost ten years had passed, and to those who worked on the CDC campaign, GMHC's refusal of an endorsement seemed to reflect that they still saw AIDS as a crisis of gay men alone.

When this iteration of *Women Don't Get AIDS, They Just Die from It* entered the world as a cosigned statement, it imbued in Morgan an even greater sense of needing to rectify the CDC's definition, as Morgan understood what many of these groups had risked by signing on to it. "Given the risks they were taking," Morgan recalled, "we knew there was nothing we wouldn't do to make it real." It engendered in her an even greater urgency. As she put it, "We have to win."

In November 1991, AIDS made news in a way that it hadn't ever, when Magic Johnson of the Los Angeles Lakers made the sudden announcement that he had tested HIV-positive. Johnson was, at the time, the most well-known American who had publicly announced that he was living with the HIV virus, and for many Americans, Johnson's announcement that he had contracted the virus through heterosexual sex shattered the stereotype that HIV was something that solely affected gay men and intravenous drug users.

That Johnson disclosed he was HIV-positive while still in good health, and that he publicly dedicated himself to educating the American public about the AIDS crisis, represented a notable shift in how public figures announced their HIV status. Until this point, most celebrities and public figures only announced their HIV status at the end of their lives, as death was imminent. Freddie Mercury, the lead singer of Queen, is perhaps the most noteworthy example of this. Just weeks after Johnson's announcement, Mercury revealed that he was living with AIDS, the day before he succumbed to it.

For years, ACT UP had campaigned against this kind of secrecy, espousing that people with AIDS aren't resigned to dying, but that they live out and publicly, without shame, fighting to save their own lives. *Silence=Death* and *Kissing Doesn't Kill* are two of the most noteworthy

examples of this, though you could see this in ACT UP's leadership fig-
ures, like Vito Russo and Bob Rafsky, and in ACT UP's demonstrations
writ large. This attitude had now materialized in one of the most recog-
nizable and well-known athletes in America. And it's hard to imagine
the possibility of Johnson coming out in this way—publicly and early in
his diagnosis, and committing himself to fighting for his own life and
educating others, and to such public fanfare and widespread support—
without ACT UP preceding him.

Writing for the *Village Voice*, Robert Massa of ACT UP noted an am-
bivalence felt by many AIDS activists. While Massa praised Johnson and
his handling of the announcement, he voiced a larger frustration with the
public response, and the widespread sympathy that Johnson had garnered.
Where was this sympathy and concern for the 125,000 Americans who
had already died of AIDS? A hundred thousand Americans having died of
AIDS was on page eighteen of the *New York Times*, but a single basketball
player who tested HIV-positive was the biggest news story that year.

Johnson's announcement also demonstrated how quickly the govern-
ment could move to address the AIDS crisis, when it felt so compelled.
Just days after Johnson's announcement that he had tested HIV-positive,
President Bush invited him to join the Presidential AIDS Commission,
something that many found vexing. There were researchers and activists
who had spent years of their lives learning about HIV and AIDS, the
mechanisms of the virus and its transmission, how AIDS manifested in
different bodies, how different communities were impacted by AIDS,
and how the triangulation of government neglect, pharmaceutical greed
and public indifference had facilitated this crisis. Conversely, Johnson was
very open about the fact that he didn't know much about HIV and AIDS
when he was appointed to the council, which is understandable, consid-
ering that he was invited to join the council just days after he announced
that he had recently tested positive. What ACT UP had espoused for
years, that the government moved at a glacial pace in fighting the AIDS
crisis because it was seen as just deserts for gay men and intravenous drug
users, seemed to be confirmed in the swiftness with which President
Bush had reacted to Johnson's announcement.

By then, the members of Gran Fury were meeting less regularly. Still, they tried to channel all of these sentiments about Magic Johnson, and the responses from both Bush and the wider public, into a billboard. "We need more than Magic," the billboard read. "We need George Bush to end the AIDS crisis." And then, in smaller type was Gran Fury's least subtle gesture toward the world of advertising: "Just do it." The work itself was clearly suffering. "We just didn't have an issue that was baked into it," McAlpin reasoned. "It was this jazzy visual thing, but there was nothing inside it."

Though everyone in Gran Fury agrees that the quality of their work had declined by this point, the collective's members offer differing explanations as to why this was the case.

Years later, a few of Gran Fury's members reflected on the collective's end in an essayistic pamphlet titled *Good Luck, Miss You*. In it, they broadly characterized Gran Fury's end as being the result of an increasingly complex and international AIDS crisis, one that wasn't conducive to the kind of sloganeering that had once been their signature.

The timing and success of *Women Don't Get AIDS, They Just Die from It* complicate this explanation. While Gran Fury was divided over the

Just Do It, Gran Fury, 1991. Photograph courtesy of Gran Fury.

image as a whole, the slogan itself is undoubtedly one of their best. It's a slogan about a complex issue with international ramifications, the very kind of slogan that, according to *Good Luck, Miss You*, they were unable to continue making. Gran Fury was able to craft these sorts of slogans as late as the end of 1990. Why then couldn't they do the same six months or a year later?

Nesline insisted that there were factors at hand besides a changing AIDS crisis. "Gran Fury didn't die because the issues became too complex to boil into a sentence," he reasoned. "It died because nobody wanted to be in the same room anymore."

This is a perspective held by Nesline alone, and may say more about him than it does about the collective. Lindell, for one, dismissed this explanation because Gran Fury's meetings had always been argumentative, and it wasn't as if everyone had suddenly become new people. "We always disagreed," concurred McCarty. "It's what made us strong and sharp."

One thing that had changed, however, was that Gran Fury found it increasingly difficult to fund its projects. "The art world is fickle," McCarty reasoned. "It cycles through things all the time. There's no long-term consistency. And I think Gran Fury passed out of fashion." In the years that Gran Fury had received most of its commissions from arts institutions, there had been a string of high-profile, blue chip visual artists who died of AIDS: Paul Thek in 1988, Robert Mapplethorpe in 1989, Keith Haring in 1990. Of course, artists who weren't as well-known, curators and arts professionals had died before, and continued to die afterward too. But it wasn't until Felix Gonzalez-Torres's death in 1996 that the art market lost another blue chip artist to AIDS. As long as blue chip artists were dying of AIDS, it seemed as if Gran Fury could find funding for its projects. As soon as there weren't, garnering that same funding became difficult. "Gran Fury is slipping off the ice cream cone," Kalin told a friend around this time. "No one is answering our calls anymore."

This explains why Gran Fury's output slowed, but doesn't account for why the quality of their work declined too. Moffett noted that a growing sense of burnout and fatigue made it difficult to continue working, or to find ways to reinvent the collective. Fatigue surely contributed to

Gran Fury's end, but it's worth noting that Gran Fury didn't actually stop meeting for some time. "The dissolution of Gran Fury wasn't quick," emphasized Lindell. "We kept meeting and meeting," McCarty added. "Trying to figure out how to make Gran Fury more current." They considered pivoting into making safer-sex campaigns designed for specific communities, and Kalin recalled that they even considered remaking themselves into an AIDS messaging think tank that could consult other organizations.

Maybe Gran Fury's most insurmountable problem wasn't a more complex AIDS crisis, but rather, the decline and fracturing of ACT UP, which had always offered a way of navigating the crisis's complexities. Because this notion, that an increasingly complex AIDS crisis outpaced the possibilities of sloganeering, doesn't really align with the trajectory of the epidemic. In 1991 or 1992, there weren't any new, revolutionary treatments that changed the crisis. Nor had there been any political sea change yet—the Bush administration was still in power. And AIDS had hardly been a simple, or local, problem before. But ACT UP was changing during this time, and not for the better.

By this point, ACT UP was hemorrhaging members, to both death and burnout. At the beginning of every meeting, a list of those who had passed that week would be read aloud, and most members of ACT UP recall a particularly rough stretch in November 1990.

The tenor of the room was beginning to change as well. Early in 1991, ACT UP had one of its most divisive arguments ever, over the clinical drug trial 076, a placebo-controlled trial that gave AZT to pregnant, HIV-positive women, in the hopes of preventing transmission to their fetuses. The trial had a host of problems, and ACT UP was largely divided over whether they should try to stop or reform the trial, and if they were to reform, then how so? The argument grew so divisive that many who worked on the CDC campaign actually left ACT UP afterward.

There was also a question of access to those in power, and whether certain ACT UP members were becoming too close to those in power, and if that closeness was neutralizing dissent. There is an often cited example of two ACT UP contingents bumping into each other in a hotel lobby

in Washington, DC: One contingent had come to stage a demonstration against Anthony Fauci. The other contingent was in town to attend a dinner party with him.

And as Gran Fury had found before, working autonomously from ACT UP had its advantages. The most visible example of ACT UP's fracturing came in January 1992, what became known as "the split," when Mark Harrington and a few other members of the Treatment and Data Committee left ACT UP and formed a new organization called Treatment Action Group (TAG). Only twelve members left, but "the split" left an irreparable chasm within ACT UP. The members of Treatment and Data had been some of ACT UP's most knowledgeable on the designing of clinical trials and drug research, and they were also some of its central leadership figures. Though TAG didn't officially form until January 1992, it had seemed obvious that something like this would eventually happen. Morgan likened "the split" to a couple filing for divorce: it's often apparent a marriage has died long before the actual paperwork is filed.

Treatment and Data wasn't the only group leaving ACT UP around this time. The needle exchange program piloted by Elovich began working on its own, as did ACT UP's Housing Caucus, which became the nonprofit Housing Works. Both left because they had once depended upon ACT UP for financial support, and now, ACT UP could no longer fund their work. On a more micro level, many in ACT UP went to go work for AIDS nonprofits and found that they didn't have the energy to go to a contentious Monday night meeting after spending their day doing AIDS work.

Several ACT UP members, particularly women who worked on the CDC campaign, even began experiencing relentless and anonymous harassment, and it's unclear, to this day, whether this came from within ACT UP or if ACT UP was subjected to COINTELPRO-style disruptions. Both Morgan and Dorow began receiving threatening phone calls in the middle of the night. People they had never seen before would approach them on the street and ask about ACT UP demonstrations. Someone took a CD from the ACT UP workspace, cut it in half, and slipped it under Morgan's door at her apartment in Brooklyn. Anonymous

and threatening notes directed at them would be left on the back table at ACT UP meetings, where articles and literature would be distributed. Some people had personal belongings stolen from the ACT UP workspace and then shoved into the mailboxes of their buildings. One day, Morgan came back to her apartment and found that the engine of her car had been removed and left on the hood. "I wanted my life back," Morgan recalled.

Gran Fury's inability to continue making successful work ultimately says more about its relationship to ACT UP than it does about its individual members. Even after Gran Fury informally severed itself from the larger body of ACT UP, its members still attended ACT UP meetings and demonstrations, and virtually all of the collective's work took wing from ACT UP. In short, as ACT UP began to fracture and decline, Gran Fury lost their source material. Gran Fury's demise becomes clearer when examining the collective in this light. What is an advertising agency without a client?

By the beginning of 1992, the outlook for ACT UP's CDC campaign was bleak. "Things felt like they were going to fall apart," recalled Morgan. In November 1991, the CDC had announced that it would be revising its definition of AIDS, to include any person with HIV and fewer than 200 T-cells, but not adding any of the debilitating symptoms most common to HIV-positive women. The 200 T-cell threshold was helpful but insufficient, as many women began experiencing debilitating symptoms before their T-cell counts dropped below 200. By the end of the public commenting period in February, the CDC had shown no indication that they were considering a more expansive definition.

Morgan and Dorow settled upon a last-ditch effort to try and shape the definition. They had learned of a meeting that the CDC was to have with several AIDS organizations, taking place just a few days after the end of the commenting period, to discuss the CDC's proposed changes. "We had the sense they were going to make a decision," Morgan recalled, and that this could be their last chance to influence the course of the CDC's

definition of AIDS. Dorow later wrote that they saw "this essentially se-
cret meeting as perhaps the last chance to confront the CDC on its pro-
posed changes to the AIDS definition." After repeated attempts to garner
an invitation for ACT UP, they decided to attend, albeit uninvited.

On February 18, 1992, thirty members of ACT UP barged into the
offices of the American Public Health Association where the meeting
was being held. Morgan commandeered the podium, demanding that
a public hearing be held instead of a closed-door meeting. Then, three
ACT UP members handcuffed themselves to the meeting's participants,
specifically choosing representatives from other AIDS service organiza-
tions rather than officials from the CDC. "It was a last act of desper-
ation," Morgan recalled. The implications of the handcuffs were clear.
They could continue the meeting with ACT UP present, or they could
leave handcuffed to ACT UP's members, but the meeting would not
continue without them. A two-hour standoff ensued, with pointed and
barbed comments being exchanged between those from ACT UP and
the other service organizations.

In the whole of their campaign to change the CDC's definition of
AIDS, the handcuffing action was one of its most controversial within
ACT UP, in both its tactics and its effectiveness. While Morgan believes
that their efforts ultimately delayed the CDC from making its final de-
cision, and stopped them from proceeding without any of the manifesta-
tions of AIDS in women, others within ACT UP saw it as action that had
gone awry. Though no one from ACT UP was thrilled that the CDC was
holding a secret and private meeting to discuss its definition of AIDS,
many didn't feel, as Morgan and Dorow did, that this single meeting
was going to cement the CDC definition. That Morgan, Dorow and the
others had handcuffed themselves to other AIDS service organizations
moving too slowly, and not to the CDC officials, called into question how
they selected their targets. These were the groups that ACT UP needed
to be working with, others felt, not protesting against.

Dorow recalled that part of the meeting's purpose was to extend the
CDC's public comment period until May 1, in the hopes that ACT UP
could use this time to sway more established groups like amfAR and

GMHC to lobby for a revised definition of AIDS that included symptoms common in HIV-positive women, and not just the T-cell count. "We were just buying time," Morgan recalled. Though the CDC didn't extend it officially, Morgan believes that their disruption ultimately delayed the decision to change the definition, a delay that proved to be fortuitous. Just five days after the handcuffing incident, a few ACT UP members disrupted a campaign rally for Bill Clinton in Sioux Falls, South Dakota, demanding that Clinton take stronger action on AIDS. Asked what he would do to end the AIDS crisis, Clinton responded by promising, among other things, that he would push the CDC to expand its definition of AIDS. This was the moment that the CDC's definition of AIDS entered into the Democratic primaries, and by April of that year, two congressional subcommittees—the Subcommittee on Social Security and the Subcommittee on Human Resources of the Committee on Ways and Means—had begun hearings on the CDC's definition of AIDS. That same month, the other Democratic primary candidate, Jerry Brown, endorsed ACT UP's twenty-five-point plan to end the AIDS crisis, which included expanding the CDC definition of AIDS. With both the Democratic frontrunners promising to change the CDC's definition of AIDS, and two different congressional subcommittees concurrently holding hearings on its definition, it would have been infeasible for the CDC to change its definition at this juncture. And Morgan believes that, without the handcuffing action, the CDC and other AIDS advocacy groups would have agreed upon an incomplete definition back in February.

Others within ACT UP didn't share this viewpoint, and in April 1992, a separate contingent of ACT UPers started to form a coalition with some of the same groups that Morgan and Dorow had protested. That group included Marion Banzhaf, an ACT UP member who simultaneously represented the New Jersey Women and AIDS Network, and Terry McGovern, an ACT UP member who also worked with the HIV Law Project, and who had filed a class-action lawsuit against the Social Security Administration on behalf of women who were unable to access benefits because of the CDC's definition of AIDS. Linda Meredith, who

had helped plan the previous demonstrations at the CDC headquarters, was the official representative of ACT UP New York, though she had known Banzhaf and McGovern for years through organizing around the CDC campaign. The three of them partnered with GMHC, the ACLU AIDS Project, Housing Works and others, writing a statement on which all of the groups could agree. This coalition agreed to demand that cervical cancer, pulmonary tuberculosis, recurrent bacterial pneumonia and a T-cell count of 200 or less be added to the list of the CDC's qualifying symptoms. Building consensus among such a large group meant sacrificing some of ACT UP's demands. "We knew we were making compromises," Banzhaf recalled. "But it was time to compromise." Pelvic inflammatory disease was ultimately left out of their demands, because they couldn't rally enough support for including it. If ACT UP were to hold out longer and try to win pelvic inflammatory disease too, it would have meant that women with AIDS would have to wait longer to reap the benefits of an expanded definition. What was left out was mostly going to get covered by the 200 T-cell count threshold, Banzhaf reasoned. McGovern talked with the clients that she represented, one of them being Katrina Haslip. They agreed that this was the best deal, and that they shouldn't try to hold out longer and win pelvic inflammatory disease.

ACT UP made its final push to expand the CDC's definition of AIDS that summer. In June 1992, the *Los Angeles Times* reported that the CDC had again delayed making a decision on expanding its definition of AIDS, giving ACT UP more time to push for expanding the definition beyond just the T-cell count threshold. As 1992 wore on, public health officials began expressing concern that the CDC was being pressured into delaying their revised definition. NPR's *Morning Edition* reported, "Some state health officials have confidentially expressed concern that the Bush administration may be pressuring the federal agency to hold back until after the election. A change in definition that's expected to add tens of thousands of new cases to the toll of the AIDS epidemic, they say, may look bad."

In retrospect, that speculation doesn't seem unwarranted, and it was, in a way, confirmed later that summer. At the 1992 International AIDS

Conference in Amsterdam, ACT UP members from around the globe interrupted a talk being given by James Curran, holding signs that read, "Women Don't Get AIDS, They Just Die from It," in both English and Dutch. Haslip had originally planned to attend but wasn't well enough to travel. Banzhaf and other women from ACT UP's New York, Los Angeles and Amsterdam chapters then cornered Curran, demanding that he meet with them at the designated ACT UP workspace.

"We have a proposal that includes pulmonary tuberculosis, bacterial pneumonia and cervical neoplasia," Banzhaf told him, presenting him with the proposal they had drawn up in April. "And what we're asking you right now and right here is to speak to that proposal."

"Well, what I'm saying is that we're gonna, we're gonna, we're gonna, we're looking at it seriously," Curran replied. "When we got on the eve of starting to change the case definition, all the letters come in saying you must not change the case definition until you have a national public meeting in this election year. Congress, women and everyone else . . . the letters are not coming to me, they're coming above me," Curran told them.

"But what's wrong with the proposal?" Banzhaf pressed.

Garance Franke-Ruta, another member of ACT UP New York, could read between the lines. "So what you're saying is that you can't organize this meeting until after the election," she told him.

"I'm not saying that," Curran replied, though he was willing to concede that something besides epidemiology was keeping them from holding a public meeting on the definition. "The meeting isn't about the case definition. The meeting is about other things."

Banzhaf again pressed him for a timeline.

"Well, I wanted to get the case definition changed," he told them. "I wanted to get it changed six months ago. I wanted it changed next month. I'd like to get it changed this year."

A representative from ACT UP London demanded to know whom they should pressure if not him.

Curran denied that this was the implication, but again reiterated that his superiors were being pressured into not budging on this definition and told him, "They're coming from people in Congress. Letters are coming

in saying the CDC must not change the case definition until we have a national meeting to get consensus of the community."

Curran told them that the CDC needed to consult with different health departments before they could expand the definition.

Resi Kompier, a member of ACT UP Amsterdam, then tried to give Curran a global perspective on the implications of the CDC's definition. "Don't you think it's a bit ridiculous that people here in Europe are sort of waiting for what the New York Health Department is going to decide? I mean here in Europe and in Africa and everywhere else women are dying—"

"I don't think they are," Curran interrupted.

"—because we are stuck with this ridiculous CDC definition," Kompier continued. "We can't do a fucking thing about it because you are not changing it. That's the problem we're facing here. And we go to the Dutch Ministry of Health and we tell them, 'Please change it just for Holland, change the definition.' Do you want to know what they say?"

"What do they say?" Curran replied sarcastically.

"They say that will be a nightmare for the statisticians," Kompier told him, and then contrasted this with ACT UP's position: "And we feel that this will be a nightmare for the women. . . . We don't give a damn for the statisticians."

"So you're not concerned about the nightmares for the statisticians?" Curran asked.

"No!" Kompier said.

"I mean we changed the definition in 1987 and that was a nightmare," Curran said.

Banzhaf reiterated their demands, pushing for cervical cancer, pulmonary tuberculosis, bacterial pneumonia and a T-cell count of less than 200 to be added. "Would the CDC move forward on that and give us a timeline for moving forward on that change in the definition?"

"I said we're going to talk about it when we get back in the US, and give you a timeline," Curran replied. "We want to do it. Believe me, all the people working on this problem at the CDC want to change the definition. They wanted to do it eight months ago."

"Why can't you just stand up to the administration then?" Franke-Ruta replied.

"It's not the administration," Curran replied.

"It sure is!" Banzhaf said. "Then what is it?"

After a brief discussion of the science about tuberculosis being added, Ellen Bay from ACT UP New York pressed again for a meeting. "How about Monday, August 3rd?" she asked.

"Is noon a good time?" Curran asked sarcastically.

"We *need* to set a date," Bay reiterated.

Curran deferred by blaming the Congressional Women's Caucus for pressing a public meeting. "A bunch of Congress people writing in to the administration and saying we want to have a national public meeting in Washington, about this issue and related issues like healthcare and all that stuff, is not getting the case definition through. It doesn't help."

Franke-Ruta again suggested that politics was what kept the definition from changing.

Curran told them, "The administration says, *It sounds to me like you don't have consensus on this case definition, that there's too many people against it, maybe you do need a public meeting. Why don't you plan one for later sometime—*"

"Later after the election?" Franke-Ruta interrupted.

"Yeah, but what's a public meeting going to be about? The letter said the meeting ought to be about this, this and this, the CDC can't do. So we have a meeting on surveillance only in Atlanta. You know, does that get us anywhere?"

The meeting ended with ACT UP pressing Curran to schedule a call for August 3rd to discuss the timeline, and Curran saying that he had been joking about talking at noon.

"Do we have his number?" Kompier asked.

"Oh, they have my number," Curran said, apparently referring to all the harassing calls that he'd gotten. "They've had it for a long time."

That September, ACT UP got the public hearing it had pushed for in Amsterdam, with Linda Meredith, Marion Banzhaf and Terry McGovern from ACT UP New York presenting at the CDC's headquarters in

Atlanta, along with scientists, epidemiologists and other representatives from AIDS advocacy organizations. Banzhaf presented their demands for cervical cancer, pulmonary tuberculosis and recurrent bacterial pneumonia to be added to the definition, and lamented their compromises. "We chose these three conditions," Banzhaf told them, "because they had the most thorough documentation. . . . Many of us continue to have serious reservations about the exclusion of other conditions, such as endocarditis, sepsis, pelvic inflammatory disease and chronic vaginal candidiasis. However, we propose this consensus statement because time is of the essence. Including these three conditions will result in a more inclusive and accurate surveillance definition. None of us can wait any longer."

Banzhaf then told the story of ACT UP's years-long campaign, how they had first met with Curran in November 1989 and staged a demonstration at the CDC's headquarters in January 1990, how it had poured rain at their follow-up demonstration in December of the same year, and how over the course of 1991 they had garnered support for the *New York Times* ad and a concurrent mass mailing reading, "Women Don't Get AIDS, They Just Die from It." It was September 1992 now, three years since their first meeting with Curran, and the CDC had yet to budge. "The coalition offers this consensus statement," Banzhaf concluded, "if accepted in its entirety, as a workable solution to the stalemate on the definition."

The insinuation of this promise was that ACT UP would continue to hound and embarrass the CDC if they didn't accept it. And though ACT UP didn't really have the resources to continue this, nor did many of its members have much stamina left, this wasn't necessarily obvious to those outside the organization. "They were so afraid of us by that time," Wolfe recalled. "We had done all these demonstrations. We had gotten groups that were so diverse, to support this campaign, from all over the country. We showed that we could get Congress people who would start to investigate the CDC. We used every single tactic that you could possibly use." Banzhaf was essentially promising that ACT UP would relent if the CDC included these three symptoms along with the 200 T-cell count threshold.

◎

Finally, on October 28, 1992, the CDC expanded its definition of AIDS to include the 200 T-cell count threshold and three symptoms that ACT UP and its coalition had demanded. That the definition would go into effect on January 1, 1993, only stoked the suspicion that its delay had been motivated by the November presidential election. "It's bittersweet happiness," Banzhaf told the *Times* when the CDC announced the expansion. "This should have happened years ago."

As the CDC announced that it would finally be changing its definition of AIDS, Katrina Haslip was on her deathbed. With six T-cells left, she still did not qualify for the CDC's definition of AIDS. That November, Haslip was interviewed by the *New York Times* shortly before her death and was asked about the CDC's decision to change the definition. "They didn't change it," she replied. "We did." Haslip died just weeks later, without the AIDS diagnosis she had spent the last years of her life fighting for. Had she lived till January, she would have had one.

At the end of 1992, there were just under sixty thousand Americans living with an official AIDS diagnosis. By the end of 1993, that number had more than doubled, largely because of the CDC's expanded definition of AIDS. By April 1993, over twenty thousand people had qualified because of the new definition. And by the end of 1993, fifty thousand people—mostly women, intravenous drug users and low-income people with AIDS—were newly able to qualify for the healthcare and benefits entitled by the CDC's expanded definition of AIDS. Though the SSA had divorced itself from the CDC's definition of AIDS midway through ACT UP's campaign, Clinton soon directed the SSA to include cervical cancer, pelvic inflammatory disease and other gynecological conditions in HIV-positive women as qualifying disabilities, a list that included many of the symptoms on which ACT UP had had to compromise in assembling their coalition. With this new definition also came a more equitable distribution of federal AIDS funding, especially for cities hit hardest by the crisis, funding that provided better medical care and services for people with AIDS. And though ACT UP had only managed to win a single female-specific symptom, their years-long campaign brought an incredible amount of attention to the fact that women

contract HIV too, and to the symptoms that might signal an advanced case of AIDS in a female body.

The epidemic hadn't actually gotten worse because of the January 1st change, but a fuller picture of it was now available. Almost two hundred thousand Americans had died of AIDS by the end of 1992. A million Americans were now living with HIV, and by the end of 1993, 125,000 of them had progressed to AIDS. Without any promising treatments on the horizon, all of them lived with what seemed like a certain death sentence.

Beyond the benefits won for women with AIDS, Banzhaf reasoned that the CDC's expanded definition brought a new urgency to the AIDS crisis in America, as the actual direness of the epidemic had become clear. In Banzhaf's estimation, politicians stopped seeing people with AIDS as an anomalous group, and began to instead see them as a significant voting bloc, a large constituency of people whose votes were worth courting. And whereas pharmaceutical companies had once dismissed AIDS as a niche disease, the potential profit motive for a treatment was now fully apparent.

Some of the effects of this are still being fully realized. Years later, Monica Pearl, a codefendant of Elovich's who worked on the CDC campaign, began writing a book-length academic study of AIDS in literature and quickly noticed something: there are no novels written by women with AIDS about their experience of the virus. That trend extends beyond the form of the novel. Whereas there is an entire body of long-format artwork concerned with the male experience of living with AIDS, art made by women with AIDS tends to be of shorter forms, like poetry, short stories and essays. Pearl reasoned that this stemmed, in part, from the fact that the average woman with AIDS died twice as quickly as a male counterpart, and that the form of the novel was not possible because of that time constraint. Tory Dent, a poet who often wrote about her experience of living with AIDS, detailed this predicament in her 1993 collection *What Silence Equals*. "People always assume they have a future," Dent wrote. "But only the sick know how life is very, very short."

ACT III

CHAPTER 10
FALLOUT

Mark Simpson wasn't surprised when his HIV test came back positive. "Mark had always thought that he was positive," recalled Rebecca Cole, who had been one of his best friends in the earliest days of ACT UP. "It was the truth he always knew." This was a fairly common sentiment among his generation of gay men. To have been sexually active before the advent of safer sex, but after the beginnings of the crisis, made testing positive feel unavoidable.

An interview that Simpson later gave for the public access television program *Living with AIDS* would place his test results coming back positive sometime in the fall of 1990, though he also noted, in this program, that he suspected that he was positive as early as 1982. Tom Kalin, who was Simpson's roommate throughout much of Gran Fury, believes that Simpson was probably experiencing symptoms of HIV well before he got tested. "I suspect that he probably had all kinds of opportunistic infections, or related symptoms, that he wasn't expressing," Kalin said. "I bet he was having night sweats many nights of the week and would wake up and be like *I gotta deal with this.*"

What finally compelled Simpson to get tested was a trip to the dentist. When he looked in his mouth, the dentist said to Simpson, "Mark, you have the most awful case of thrush. You *need* to go get tested." If Simpson did have such an advanced case of oral thrush when he tested positive, he would have immediately qualified as having progressed to an official AIDS diagnosis.

By the time that Simpson tested positive, he had been in more regular communication with his Texas family for the past two years, as his sister Linda would see him while she was on work trips to New York. Simpson came back to Texas sometime in 1990, and told his siblings about his diagnosis. Though he was now in more regular contact with his biological family, it was still a strained relationship. All of them had been raised in the Southern Baptist Church, but Simpson had shed these beliefs as an adult, while his siblings largely maintained them. "We are all stronger believers, and we are from the Bible Belt," his sister Linda said. "So homosexuality, as a viable choice, is not something that we believe is scripturally valid."

But despite this familial homophobia, Simpson did maintain a relationship with his siblings, especially Linda, whom he made the executor of his estate. Simpson's New York friends liked Linda quite a bit. Apparently, seeing homosexuality as being scripturally invalid didn't stop her from going out with Simpson and his queer friends whenever she was in town.

After Simpson came back to Texas and told his family that he had tested positive, they began hosting annual reunions for just the siblings—no parents, stepparents, spouses or stepsiblings were allowed. Linda recalled that at one of these reunions, Simpson brought along a lesser-known Gran Fury piece that he and Avram Finkelstein had worked on, a pamphlet called *The Christian Agenda Revealed*, which they made in response to a video called *The Gay Agenda*, which was circulated throughout the religious Right, and alleged that gays were recruiting others into a homosexual lifestyle. Their pamphlet was styled as the sort of text-heavy brochure that a proselytizer might hand you on the street. Simpson showed it to Linda and asked what she thought of it. "Mark and I did have an argument about whether or not homosexuality was a form of brokenness," Linda recalled. They agreed to disagree on the matter.

One of the biggest lifestyle changes that Simpson made, after he tested positive, was to stop drinking, as he had previously characterized himself as an alcoholic. "Mark started drinking nonalcoholic beers," Kalin recalled. "Which were the most miserable thing ever invented. Nonalcoholic beer is gross. And I was like, why the fuck even drink it? Just drink a diet ginger ale! But he really missed beer." Many who tested positive took the opposite route, turning to substances to cope. It's understandable, especially at this point in time, considering there were still no effective medications for HIV, and little hope that any would come along soon.

Simpson recognized that, barring an unexpected medical break-through, he was going to need help taking care of himself, and that he would be relying upon the family he had created for himself in New York if his health were to deteriorate, which it almost certainly would. "When Mark got sick," Finkelstein recalled, "he naturally assumed that Michael Nesline would be his caretaker." This was virtually everyone's impres-sion. "I think Mark expected Michael to sweep in and really take care of him," Kalin concurred. It's understandable why Simpson would want this. Nesline worked as a nurse in the AIDS ward at Bellevue Hospital, which had one of the better AIDS wards in the city, and also saw the largest number of AIDS patients of any hospital in the country. Because of this, Nesline was privy to the newest information about AIDS treat-ments and saw their effects firsthand. "Michael had his ear to the ground about experimental treatments," Kalin recalled. This was a moment when ACT UP was finally seeing the fruits of its labor, with expanded access to experimental treatments and clinical trials. It wasn't just AZT or no AZT anymore. Medications were finally coming down the pipeline, and Nesline would be the first in their friend group to know if any of them seemed promising.

Furthermore, Nesline was one of Simpson's best and oldest friends. The two had been in each other's orbit since the early 1970s, having met in Austin and reconnected in New York after both of them moved east. What cemented their friendship though, was the death of Joe Hollis, then Nesline's partner and Simpson's best friend, whose death also com-pelled Nesline to enroll in nursing school. Since Hollis's death in 1985,

Nesline and Simpson had seemed inseparable, and working together in Gran Fury only strengthened this bond.

Nesline knew, from both caring for Hollis and working in an AIDS ward, that if he agreed to be Simpson's caretaker, his home life would essentially become an extension of his work in the hospital. "Michael was just bombarded with people dying," reasoned Hali Breindel, Simpson's surrogate sister. And it was understood, among this friend group, that Nesline was someone who needed to compartmentalize his life as a way of coping. "I was pretty good about not taking my work home," reasoned Nesline. "After I became a nurse, I understood pretty quickly that I wasn't going to be able to survive this if I personalized everything that was happening at the hospital." Still, Simpson thought that Nesline was going to fill this role in his life, as Nesline had with Hollis. "Mark was asking for help, but he imagined it to be a rhetorical question," Finkelstein later wrote. "And there was hell to pay when the answer was no."

Simpson was furious when Nesline declined to be his caretaker. Finkelstein empathized with Simpson's anger and told him that Nesline had been coldhearted. But privately, Finkelstein had a more complicated reaction that he didn't share with Simpson. "Declining to be someone's caretaker is not something that should be disrespected," reasoned Finkelstein, who knew the horrors of this firsthand from taking care of Don Yowell. "It's a tremendous ask."

Kalin likewise sympathized with Nesline's predicament and understood that Nesline's work as a nurse in an AIDS ward made the prospect of caring for Simpson that much more daunting. "Michael had a challenging job. Those were grinding days for him," Kalin said. "When Michael had had a long day at work, Mark just seemed like another needy mouth to feed."

Since Hollis's death, Nesline and Simpson had been nearly inseparable. After Nesline declined to be his caretaker, Simpson permanently froze him out, and they never reconciled. The crisis that cemented their friendship had now also ended it.

◎

This is possibly the easiest story to tell about the fallout between Nesline and Simpson, and some understood it in this way, that it was simply an issue of caretaking and whether or not Nesline would fill that role. And it's hard to entirely dismiss this understanding, as it is shared by many who ultimately filled the roles once assumed to be Nesline's. "There is something to be said for the fact that so many people perceived that Mark felt let down by Michael not filling the role as his caretaker," Kalin reasoned. "That is accurate, and I stand by it. That's part of the picture. But that's not the whole picture." Kalin understood that there were underlying tensions beyond the issue of caretaking, that Simpson and Nesline had a long friendship that stretched back years. "I do not believe that the breakup of Mark and Michael's friendship is neatly and solely about issues around caretaking and HIV," Kalin reasoned. "I think it's more complicated. You can only hint at the iceberg of a friendship that goes for that long."

But Nesline insists that the issue of caretaking was entirely beside the point. When told that this was how many understood their fallout, Nesline replied, "That's not accurate." According to Nesline, it was mutually understood that Nesline would fill this role for Simpson, and that Nesline was willing to do this. "I don't remember having the conversation with Mark about whether or not I would be his caretaker," Nesline recalled. "We may have, but if we did, I said yes, because I wanted to do that. But I don't ever remember having that conversation."

Instead, Nesline recalled that their friendship ended because of underlying personal conflicts, stressing that it wasn't about his willingness or ability to care for Simpson. "Gran Fury was sort of going on autopilot," Nesline recalled. "And Mark had become deeply depressed." Once, Simpson had been always out and about, at art openings, parties or ACT UP meetings. Now, Simpson hardly wanted to leave the house, and would instead ask Nesline to come over, pick up some marijuana in Tompkins Square Park and roll them joints while they sat around Simpson's apartment. "Mark loved history," Nesline recalled. "And so he wanted to hold forth and talk about how it was that the Renaissance started, and blah blah blah blah blah." Nesline began to resent this emerging dynamic in

their friendship and felt that he was becoming Simpson's only connection to life outside of this apartment. "I had become Mark's tether to the world," Nesline said. "It just was wearing me to a nub, and I was building up a lot of resentment about it."

"So we started squabbling all the time," Nesline continued. He remembered one particular evening that epitomized the growing coldness in their friendship, at an art opening for their Gran Fury comember, John Lindell. "If Mark was on the left side of the room, I made sure I was on the right," Nesline recalled. "And vice versa." In April 1991, Lindell had a double opening at two separate galleries on the same night, so it's very possible that the standoff happened at one of these two events. After the opening, Nesline caught a cab, and heading across Houston, he saw Simpson walking. It was pouring rain, and with no umbrella Simpson was getting soaked. Nesline contemplated asking the cab driver to pull over so that they could let Simpson in, but decided against it, figuring that such an invitation would be rebuffed.

This sort of coldness was becoming routine in their friendship. "We were trying to hash out our issues, and being unsuccessful, and the situation was getting worse," recalled Nesline. Others within their circle began to notice too. Hali Breindel suggested that Nesline and Simpson go see Simpson's therapist, Paul Pavel, a well-known psychiatrist among downtown artists and writers, to try and resolve their issues. Pavel is perhaps best known as the therapist of Art Spiegelman, and he served as the inspiration for the character of Pavel in Spiegelman's graphic novel, *Maus*.

Nesline was initially enthused about Breindel's suggestion, and figured that the two of them seeing a therapist could help break this logjam. "It seemed like a sensible thing to do," Nesline reasoned. "Because it mattered to both of us but we just couldn't resolve it."

At this session, Nesline was finally able to articulate what was bothering him. He wanted the dynamic in their friendship to change, and he was tired of Simpson expecting him to sit around, smoke pot and listen to lectures about the Renaissance. "Had I been able to say that before, we wouldn't have had to go to therapy," Nesline reasoned. "And it probably all would have been fine."

"I hadn't been clear enough in my own head," Nesline added. "It's not like I knew that I was purposefully suppressing saying that. I just hadn't known what to say. And in the course of that session with Pavel, that's what I said. And indeed it was true, but it had cataclysmic consequences."

Toward the end of their session, Pavel asked Nesline to summarize their problem.

"Here's the problem," Nesline told them both. "Mark's life is completely broken down, he's just a thorn in my side, and he's bugging the shit out of me. And whether or not he's dying, he needs to get his shit together."

"Suppose he doesn't get his shit together," Pavel said to Nesline. "Would you still love him?"

"I don't know," Nesline replied.

Pavel then told them their time was up, and that he would see them next week. "And it's just left hanging in the air like that," Nesline recalled.

Simpson and Nesline left Pavel's office and walked in silence toward Central Park. Around West Seventy-Sixth Street, they cut diagonally through the traffic of Central Park West, and Nesline turned to Simpson. "Look, Mark, no matter what I say—"

Simpson was seething. "Fuck. You." he told Nesline. "All I wanted was a friend. Fuck. You."

"He walked away," Nesline recalled. "And that was the end of it."

Despite this spectrum of understandings, everyone's story syncs here. Kalin, who had been roommates with Simpson throughout all of their time in Gran Fury, volunteered to fill this role as Simpson's caretaker. "Tom and I never spoke about it explicitly," Nesline recalled. "But we both understood that he was taking my place, and stepping into that role." A passing of the baton was how Nesline put it.

For Kalin, the decision to fill this role was almost instinctual. "There wasn't a choice," he recalled. "I loved him. He was somebody I wanted to be with as long as I could." They had a familial relationship, one that Kalin described as being brotherly. "I made a promise to Mark very clearly,"

Kalin recalled. "I'm in this for the long haul. If you want me to be around, I will be there till your last moment." But having taken on this role, Kalin felt the need to establish a bit of distance from Simpson, and he told Simpson that they could no longer be roommates if he were to become his caretaker. "Things had gotten complicated, and it wasn't just Mark's diagnosis," Kalin reasoned. "Mark's relationships were in a big state of flux, in that moment, and living there was quite intense."

There were other reasons Kalin wanted to move. His bedroom offered little privacy, as it had no door and was next to the apartment's entrance. Simpson also kept his Gouldian finches here. "I slept in a room with a wall of birds," as Kalin put it. He had lived like this for about three years, and had understandably grown tired of it.

"I'm not leaving you," Kalin emphasized to Simpson. "You are still my dearest friend. But I need a little separation. I need to move out. But I'm not going to go away."

Kalin then moved into an apartment on Attorney Street, a ten-minute walk from where Simpson would now live alone, and shared it with Robert Vazquez-Pacheco, who continued to have a friendship with Kalin despite having left Gran Fury. This sequence of events—the fallout between Nesline and Simpson, Kalin filling the role once assumed to be Nesline's, and Kalin moving to Attorney Street because of this—must have all happened by early October 1991, as Kalin has a firm recollection of watching the Anita Hill hearings in his year at the Attorney Street apartment.

The fallout between Nesline and Simpson ultimately radiated to their surrounding social circle, and even into Gran Fury. "Mark really expected people to take sides," recalled Finkelstein. Nesline's recollection is identical, at least in this respect. As he put it, "In the divorce, Mark got Gran Fury."

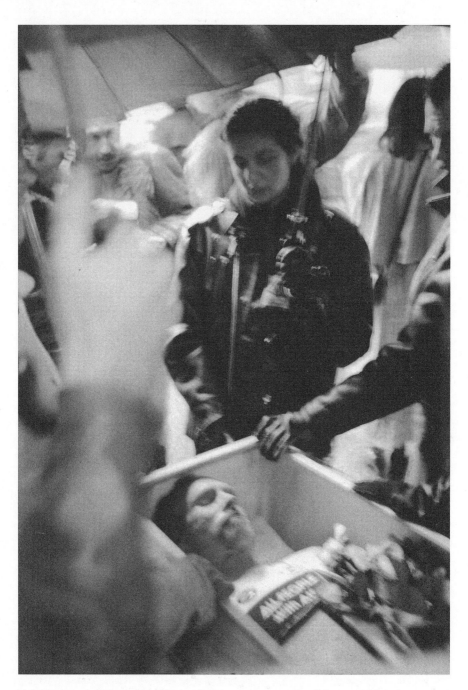

ACT UP's political funeral for Mark Fisher. Photograph by Stephen Barker.

CHAPTER 11
THE ELEGY

There's only so much the art can do.
—Mark Simpson

A sense of hopelessness, despair and exhaustion had become endemic within ACT UP. After four years of working tirelessly, the implicit promise of *Silence=Death*, that speaking out could save your life, remained unfulfilled. No matter how much ACT UP had shouted and screamed for the past four years, the number of dead continued to climb, as did the number of infections, and the crisis seemed no closer to ending than it had when ACT UP formed in 1987.

A series of demonstrations called the political funerals has come to define these later years of ACT UP. They were staged by an affinity group called the Marys, and three of these political funerals included the actual corpses of deceased ACT UP members, who while alive had volunteered their bodies.

In the midst of these funerals, a few remaining members of Gran Fury made the collective's final poster, which they called *The Four Questions*. *The Four Questions* is specific to Mark Simpson's life and can be read, in one sense, as a project made in response to his diagnosis, the ensuing fallout between him and Michael Nesline, and the simultaneous

dissolution of Gran Fury. But *The Four Questions* is also a product of its moment, one defined by the Marys, their political funerals and the sense of loss engendered by the feeling that ACT UP was ending. Though *The Four Questions* and the political funerals are stylistic opposites, the two are inextricable, like fraternal twins, and one is integral to understanding the other.

"The Marys first formed for Stop the Church," recalled one of its members, James Baggett. "But before that I was just sort of a loner." After coming to New York in 1983, Baggett had joined GMHC's buddy program. He cycled through nineteen different buddies, caring for them as they went through the gruesome stages of AIDS. After each one died, Baggett would get reassigned and begin it again.

Baggett became close friends with his last GMHC buddy, John Stumpf, who like Baggett became a member of ACT UP and later the Marys. Baggett first started attending ACT UP meetings in 1987, but his peak involvement didn't come for a couple of years. On a six-month work stint in Knoxville, Tennessee, Baggett shattered his right leg and foot after trying to deface an anti-abortion billboard, and wasn't able to walk for twenty-two months.

By the time of Stop the Church, Baggett was ambulatory. He and a few friends formed an affinity group, and they chose the name the Marys, as a double entendre of the Virgin Mary and the old-timey epithet for gay men. They stayed outside the cathedral, distributing condoms and safer-sex information before getting hauled away along with more than a hundred other ACT UPers.

After Stop the Church, the Marys continued as an affinity group and assembled a fairly illustrious group of creatives. There was Tim Bailey, a menswear designer for Patricia Field, a fashion house that served as the unofficial atelier for the ballroom scene. Mark Fisher was a meticulous architect for James Polshek and Partners, where he worked on projects like the Arata Isozaki redesign of the Brooklyn Museum. Laurie Weeks, another Mary, was a poet who later wrote the screenplay for the Hilary

Swank film *Boys Don't Cry*. The Marys also counted the novelist Michael Cunningham among their ranks, whom Baggett met at an ACT UP demonstration. "I did not know that he was *the* Michael Cunningham," he said. This was years before Cunningham won the Pulitzer Prize for his novel *The Hours*, but Baggett was already a fan of Cunningham's fiction, as he had read an excerpt of Cunningham's *A Home at the End of the World* in the *New Yorker*. Baggett himself was a journalist and editor, and he holds the distinction of being one of the last people to ever interview James Baldwin.

At the time, Baggett was a managing editor at *Elle Decor*, and through this he met Joy Episalla, who would become his coconspirator for some of the Marys' most well-known actions. One day, Episalla and Baggett were hanging out in his cubicle and she saw a bunch of ACT UP posters and graphics pinned to his walls, which piqued her interest. Baggett then brought her to an ACT UP meeting, where she met the rest of the Marys. "I was home," she said. "That was it. From that moment in time I felt like I found my people, my tribe."

Episalla's first action with the Marys was at the Waldorf Astoria, where George Bush Sr. was set to speak at a Republican fundraiser. While the bulk of ACT UP members marched from the New York Public Library to the Waldorf, the Marys and a few affinity groups snuck into the hotel itself. The Marys had managed to book a street-facing hotel room for the day of the fundraiser, and when they saw the procession of ACT UP members approaching the hotel, they threw out fake dollar bills that read, "George Bush, You've got blood on your hands," and dropped a banner that read, "Read Our Lips: AIDS Action Now."

Both components of their action would seem to take wing from the work of Gran Fury. But Baggett emphasized that any synchronicity between the Marys and Gran Fury had more to do with their friendships with the Gran Fury folks, rather than a grand and concerted effort between the Marys and Gran Fury. There was an ethos within ACT UP of freely borrowing from what worked without expecting some homage or tribute. If Gran Fury's fake money had worked on Wall Street, why not try something similar for the Waldorf Astoria? Just as Gran Fury

had borrowed from Abbie Hoffman and Barbara Kruger, so too did the Marys borrow from Gran Fury.

After they dropped their banner and threw out their fake money, the Marys chained the banner to the hotel room's furniture, left the room, and broke off the tips of lead pencils in the door's locks, delaying security from entering the room and pulling their banner back in. Having dressed themselves up in conservative drag, the Marys filed out of the hotel in heterosexual pairs and made for such convincing guests that the hotel security actually escorted them through the ACT UP demonstration, which the Marys then promptly joined.

The Marys further established themselves as one of ACT UP's most audacious affinity groups, largely through their Target Bush campaign, a months-long effort to hound George H. W. Bush. It began with a demonstration outside of George Bush's vacation home in Kennebunkport, Maine, where he spent the summer of 1991. It became one of ACT UP's most famous demonstrations, in part because of how bizarre it looked to have thousands of ACT UP members overrunning this quaint New England town and parading past Barbara Bush look-alikes. That demonstration launched a month-long effort of direct action to lobby Bush, and culminated with a demonstration at the White House, where the Marys and others from ACT UP chained themselves to the White House gates and stamped it with bloody handprints. The timing of the demonstration did not bode well for Bush, as the press soon latched on to the fact that, while the Marys were demanding a more comprehensive plan to address AIDS, Bush had spent his Monday at Disney World.

Just two weeks after chaining themselves to the White House gates, the Marys lost their first member, Dennis Kane. His death was still fresh when the Marys decided to attend a reading of the work of David Wojnarowicz, who had just published his collection of essays *Close to the Knives*. It was a benefit for ACT UP's needle exchange program, staged by Ann Philbin and Patrick Moore, who had commissioned and shepherded Gran Fury's *Kissing Doesn't Kill*. And it was this reading that set the political funerals into motion.

Wojnarowicz was a beloved figure within ACT UP and the wider downtown art scene. Especially toward the end of his life, Wojnarowicz began writing increasingly biographical essays, the ones he was to read that night. After a violent and chaotic childhood, he had run away from home and engaged in survival sex to support himself, walking a stretch of Forty-Second Street where older men often went to pick up under-aged boys. He barely finished high school and had no formal education beyond that, but he made art constantly and was a collagist in all these forms: drawing elaborate murals in the abandoned rooms of the West Side Piers, writing poetry and essays, and making music, paintings, and photographs. He had been born into an objectively awful life and had made something beautiful out of it.

Wojnarowicz later befriended the photographer and East Village denizen Peter Hujar, the only person Wojnarowicz counted as a mentor. The two were inseparable. Hujar was diagnosed with AIDS in January 1987, and didn't live to see the end of the year. After Hujar's death, Wojnarowicz moved into his loft at the corner of Second Avenue and Twelfth Street, where Wojnarowicz would live the last five years of his life.

When Hujar was diagnosed with AIDS, he essentially stopped making work. Testing HIV-positive had had the opposite effect for Wojnarowicz, and he launched the most productive stretch of his shortened life. He also joined ACT UP, and though he wasn't a mainstay at the weekly meetings, he attended some of its most important demonstrations, including the FDA, where he famously wore a jacket that read, "If I die of AIDS—forget burial—just drop my body on the steps of the F.D.A."

By the time of the needle exchange benefit, Wojnarowicz's health had deteriorated. "We didn't know if David would be well enough to read," recalled Moore. "Or even alive." In case he wasn't well enough to attend, Moore and Philbin invited a group of downtown luminaries to read from his work, including Kathy Acker, Hilton Als, Karen Finley, Richard Hell, Hapi Phace and Simon Watney. The day of the reading, Philbin learned that Wojnarowicz wasn't feeling well enough to attend. Still, they managed to field a great turnout, packing the Drawing Center with folks from ACT UP and the downtown art scene.

About halfway through the reading, Philbin learned that Wojnarowicz had changed his mind and would attend. "David's coming," someone told her. She decided not to announce that his arrival would be imminent, in case he decided to back out. But then Philbin looked over and saw Wojnarowicz coming in through the door. "He was being held up on both sides," Philbin recalled. "He was so sick and so frail but was clearly determined to be there."

For over half an hour, Wojnarowicz read pieces of *Close to the Knives*, interspersed with an unpublished piece, "Spiral." It was lost upon no one that his death was probably imminent. The poet Eileen Myles, who had known Wojnarowicz for years if not decades, was in attendance. "He was reading fast as hell," Myles recalled. "You got some of the words and you didn't get all of them." According to Myles, Wojnarowicz didn't seem to care whether or not the audience understood everything he said. "He tumbled over his own words," Myles recalled, "and that movement carried the message. It was such a performance. And that was the last time I saw him."

At this reading, Wojnarowicz read a passage from his essay "X-Rays from Hell," which is now famous in part because of what it inspired the Marys to do:

One of the first steps in making the private grief public is the ritual of memorials. I have loved the way memorials take the absence of a human being and make them somehow physical with the use of sound. I have attended a number of memorials in the last five years and at the last one I attended I found myself suddenly experiencing something akin to rage. I realized halfway through the event that I had witnessed a good number of the same people participating in other previous memorials. What made me angry was realizing that the memorial had little reverberation outside the room it was held in. A tv commercial for handiwipes had a higher impact on the society at large. I got up and left because I didn't think I could control my urge to scream.

There is a tendency for people affected by this epidemic to police each other or prescribe what the most important gestures would be for dealing with this experience of loss. I resent that. At the same time, I worry

that friends will slowly become professional pallbearers, waiting for each death, of their lovers, friends and neighbors, and polishing their funeral speeches; perfecting their rituals of death rather than a relatively simple ritual of life such as screaming in the streets. I worry because of the urgency of the situation, because of seeing death coming in from the edges of abstraction where those with the luxury of time have cast it. I imagine what it would be like if friends had a demonstration each time a lover or a friend or a stranger died of AIDS. I imagine what it would be like if, each time a lover, friend or stranger died of this disease, their friends, lovers or neighbors would take the dead body and drive with it in a car a hundred miles an hour to washington d.c. and blast through the gates of the white house and come to a screeching halt before the entrance and dump their lifeless form on the front steps.

Goddamn right, Episalla thought. "We were at the exact same place," she recalled. "We were sick of constantly going to memorial services." Hearing Wojnarowicz's words was, as Episalla put it, a eureka moment for the Marys.

After the Wojnarowicz reading, the Marys brainstormed how they could answer his call for a more confrontational kind of memorial service. They began to research the history of what are known as political funerals. In South Africa, the apartheid state had passed laws prohibiting the country's Black majority from congregating in large numbers. Funerals were one of the few legal exceptions and thus became a way of organizing politically, with services that were more akin to a political rally than a traditional memorial service. Political funerals were similarly used by the IRA in Northern Ireland, who were likewise banned from congregating in public. Political funerals, at least in these situations, were often seen as a measure of last resort, and it seemed as if ACT UP had reached a similar place.

That June, the Marys put out an open call for people with AIDS to participate in a political funeral. Avram Finkelstein and his affinity group, Anonymous Queers, assisted with the distribution of this flyer,

which read, in large white type against a red backdrop, "After I Die of AIDS Leave My Body on the White House Steps," a reference to the jacket that Wojnarowicz had worn at the FDA demonstration four years earlier. Below, in much smaller type, the Marys outlined their call for bodies:

> Throughout the AIDS crisis, furious activists with advanced HIV disease have been saying they want their deaths to help further the fight against this country's neglect and incompetence in the face of AIDS. But until now, the idea of political funerals has remained just that—an idea. Political funerals aren't part of the American activist tradition, as they are in Ireland, South Africa, and other countries. For years, the desires of activists who want to make a final statement with their bodies have gotten lost in a flurry of bereavement, familial wishes and the plain American terror of death. We think it's time our premature deaths carry some of the fury and focus that have marked our lives. We're establishing an organization that can carry out the directives of fellow PWA's who want political funerals. Whether that means a procession down Fifth Avenue, delivery of the coffin to the White House, or whatever. We're taking this action out of love and rage. The times are only getting more desperate.

This call for bodies would have been unimaginable when ACT UP first formed. Before settling on the idea of a concentration camp float for the 1987 Pride Parade, someone had proposed carrying coffins through the parade, an idea that was quickly shot down, with some reasoning that such a gesture would be disempowering and fatalistic for people with AIDS. But now, years later, it seemed as if nothing else could fully express the kind of widespread loss and grief that had consumed ACT UP.

The "organization" the Marys created was really just a PO box listed as Stumpf/Kane, to honor their own John Stumpf and Dennis Kane: Kane had died just before the Wojnarowicz reading, and Stumpf had passed the following January.

Concurrent with this call for bodies, the Marys approached Jean Foos, a close friend of Wojnarowicz's, and asked her if Wojnarowicz would

want to have his body used in a political funeral. Wojnarowicz had called for this exact kind of demonstration, and the Marys felt that this would be the best way to honor him, his work and what both meant to this community. Foos conferred with those within Wojnarowicz's circle and then told the Marys that Wojnarowicz was too sick to make that kind of decision. By the summer of 1992, Wojnarowicz was suffering from AIDS-related dementia, and those closest to him felt that he wasn't capable of making that kind of a decision so late in life.

When Wojnarowicz passed a month later, the Marys felt compelled to do something, even if it wasn't the exact kind of political funeral for which they had advertised in their Stumpf/Kane announcement. They settled upon a procession with a banner, sans corpse. Episalla went and conferred with those in Wojnarowicz's circle, to ensure that they were comfortable with this, and found that they were divided about the Marys' proposal. Some were even outraged. The discussion got so contentious that Episalla left shaking. But soon after, she received a call. Wojnarowicz's partner, Tom Rauffenbart, was enthusiastic about the idea, despite the protests from some of Wojnarowicz's other friends.

The Marys began planning for the procession, ordering a banner that could be set aflame, to create a pyre. The flyer for the demonstration included the bit of Wojnarowicz's writing that had prompted such a service: "I worry that friends will slowly become professional pallbearers, waiting for each death, of their lovers, friends and neighbors, and polishing their funeral speeches, perfecting their rituals of death rather than a relatively simple ritual of life such as screaming in the streets."

The procession began at the corner of Second Avenue and Twelfth Street, just outside of the loft that had once belonged to Hujar, and where Wojnarowicz had lived the last years of his life. ACT UP assembled on the northwest corner and then spilled out into the street, taking the whole of Second Avenue.

It was unlike any ACT UP demonstration to date. There were no chants, and it was virtually silent, save for the drummers who slowly beat a marching rhythm. All of the humor and exuberance were gone, and the twinned feelings of exhaustion and despair were palpable. They held

posters of Wojnarowicz's work, like his photograph of buffalos running off a cliff, and led with their flammable banner, which read,

David Wojnarowicz
1954–1992
Died of AIDS
Due to
Government Neglect

Episalla and Baggett of the Marys, along with Finkelstein and Vincent Gagliostro, marshaled the procession through the East Village, where Wojnarowicz had lived for much of his adult life and which constituted the social center of ACT UP's universe. A single police car, with lights but not sirens, escorted them. The procession wound its way to Cooper Union, where ACT UP was now holding its weekly meetings. What broke the near total silence of this demonstration was the sound of Wojnarowicz's writing being read aloud, concluding with the passage of his writing that had launched his political funeral.

Using their banner as tinder, the Marys lit a pyre in the middle of the street. "I knew it was unsafe, but it couldn't be stopped," Finkelstein said. "It was so dangerously close to spinning out of control and being unsafe, but it had to happen." It felt like a necessary actualization of the despair and grief that had become endemic to ACT UP. One by one, everyone threw their signs into the pyre. The drums started up again, and everyone watched the flames until they died out.

In all of 1992, Gran Fury managed to complete only one project. They debuted a new poster in May of that year, after securing a commission from the Musée d'art contemporain de Montréal. "Je me souviens," the poster read. It was an appropriation of the official motto of Quebec, which translates to "I remember" or "Never forget."

It was supposed to serve as a warning to Canadians, to not adopt America's mistakes in their handling of the AIDS crisis, but many

confused it for a commentary on the Quebec sovereignty movement, which frequently uses this slogan. "The American government has let 140,000 of its citizens die of AIDS," it read in smaller text. "Say no to the disaster prescribed by the US." Then below, "For fucking, use a condom. Don't come in anyone's mouth." It was a confusing mix of very practical safer-sex info and a commentary upon Canadian geopolitics. What does coming in someone's mouth have to do with Quebec's sovereignty?

Maybe the biggest failure of this poster is that it felt so disconnected from their present moment. Gran Fury's best work always embodied something essential about a particular moment, helped articulate something that was on the cusp of being said or came to be representative of a

Je Me Souviens, Gran Fury, 1992. Photograph courtesy of Gran Fury.

moment in time. It's clear that Gran Fury had lost the thread of the conversation. Compare this poster with the Wojnarowicz political funeral. Whereas the Marys were managing to capture and articulate the widespread feelings of loss and despair, Gran Fury was floundering.

By then, Gran Fury was meeting irregularly, if at all, and it would be another full year before Gran Fury finished another poster, one that proved to be their last. Gran Fury hadn't died yet, but to those still in the collective, it certainly seemed as if the collective was fading.

While the Marys tried to realize Wojnarowicz's call for a political funeral, another ACT UP member, on the other side of the country, was separately beginning to envision something similar.

David Robinson had first seen Warren Krause at the 1989 Pride Parade and was thrilled to see him again, sitting in the front row of the next ACT UP meeting. Krause was visiting from Atlanta, and after meeting in New York, they began a long-distance relationship, as Krause didn't want to move to New York, nor did Robinson want to relocate to Atlanta. Robinson attended both actions at the CDC headquarters, which doubled as opportunities to see Krause, and was part of the affinity group that broke into Gary Noble's office in December 1990.

"In the first few months, when we were starting to see each other long distance," Robinson recalled, "he got a book of children's crafts for the Jewish holidays. Warren was dyslexic, and so he wasn't going to be able to read a book of Jewish history and write me something about that, so he started sending me these little crafts that he had made. And it just won my heart." Eventually, they moved to San Francisco together, as Robinson had gotten into graduate school there, and Krause found it to be more suitable than New York.

Krause had told Robinson that he was HIV-positive when they first met, but Krause had remained in decent health, up until about six months after the two of them moved to San Francisco together. Krause developed a fungal infection (Robinson thinks it was cryptococcal meningitis), for which the approved treatment was amphotericin, nicknamed

"ampho-terrible" because of its side effects. When he was seventeen, Krause's parents, who were Jehovah's Witnesses, had kicked him out of the house for being gay, and so Robinson knew to not expect any help from them. "I was pretty isolated in San Francisco," Robinson recalled. "And I knew that my New York friends were pretty on top of things, so I called Avram to tell him what was going on."

Finkelstein suggested that Nesline was the better person to talk to. "Nesline is a nurse," he told Robinson. "Let's ask him."

Like Nesline, Robinson had been one of ACT UP's main facilitators, though unlike Nesline, Robinson had managed to keep this job, and continued to facilitate the meetings up until he moved to San Francisco in the summer of 1990. Robinson would often facilitate in half drag and was, at first, a bit wobbly in the pumps that he had gotten from Lee's Mardi Gras. Finkelstein and Nesline pulled him aside at one meeting. If you're going to wear those, they told him, you need to learn how to *walk*. Nesline and Finkelstein suggested that he practice by wearing heels while he vacuumed. Robinson did, and soon found himself walking more steadily. "In some ways, Michael was a gay role model for me," Robinson said of Nesline, who was more than a decade older than him. "Michael was unapologetically a fag, but he combined that with really good politics. There wasn't that separation, like there usually is."

When Robinson called Nesline to talk about Krause's fungal infection, Nesline relayed what he had noticed in the AIDS ward at Bellevue. For the infection that Krause had, some doctors had begun prescribing fluconazole and seemed to have more success than the doctors prescribing amphotericin, and with fewer side effects. Nesline also passed along some research supporting what he had seen anecdotally. The Bellevue AIDS ward tended to be a few steps ahead of other AIDS wards in the country, and Nesline was witnessing a shift in how severe fungal infections were treated in people with AIDS. In just a couple of years, fluconazole would actually replace amphotericin as the standard of care.

Robinson and Krause decided to pursue fluconazole. Krause's doctor was initially reluctant, but they ultimately swayed him, and Krause actually rebounded from his infection.

Robinson spent much of 1991 and early 1992 caring for Krause and watched as Krause became angrier as both his physical and mental capacities left him. "For his sake, I wanted him to find some sort of peace and resolution," Robinson recalled. "But he was *really* angry and felt cheated, which he was."

They began to have a series of conversations about how a person can make an impact upon the world, even after they've died. "The less he was physically able to act out in the world, the more he still wanted to have some impact," Robinson recalled. But in the last months of Krause's life, he began to experience the dementia that's common in the late stages of AIDS, which put an end to these conversations. "Warren died angry," Robinson said. "He was not at peace."

After his death in April 1992, Robinson went through some of the conventional ways of memorializing Krause and found them to be unfulfilling. He made a panel for the AIDS Memorial Quilt, the massive collection of three-by-six-foot panels each dedicated to a person who had died of AIDS. At the time, Robinson recalled, making quilts was so common that an entire store in San Francisco's Castro district was dedicated to selling supplies for them. Krause's quilt was black with a pink triangle, his name and the dates of his life in white. "Dead because of your inaction," it read. Not exactly the typical quilt panel.

Robinson recalled how one night, he went to a candlelight vigil for people who had died of AIDS. A friend of Robinson's from ACT UP New York, G'dali Braverman, had also moved to San Francisco by then, and so Braverman accompanied Robinson, to support him. "I had been crying," Robinson recalled. "But at some point, I began to wail."

Someone else in the crowd shushed Robinson, and chastised him for grieving like that in public. "You should do that at home!" Robinson was told. For Robinson, the way he had been shamed for public grieving felt deeper and more pervasive than just this one instance. "This is a fucking AIDS candlelight vigil," Robinson reasoned. "It's about grieving about AIDS."

Robinson started to think about what he would do to mark the anniversary of Krause's death. He first considered mailing Krause's ashes to

the White House, but quickly decided against this. It would be too private, he reasoned. "What I remember, more than anything, is wanting to honor him by enabling him to have an impact," Robinson recalled. "Even after death."

Robinson began to talk with friends back in New York about organizing a demonstration with the ashes of people they had lost. "It felt to me like we had exhausted symbolic means of protests," he reasoned. ACT UP would often use symbolic props or gestures at its demonstrations, like cutout tombstones, chalk outlines or the bloody handprint instigated by Gran Fury. These sorts of gestures no longer felt like they could fully capture what was being routinely lost. Robinson wanted an action that did away with all that symbolism. No more props, gestures or metaphors.

They decided to bring their ashes to the White House and leave them upon its front lawn, what became known as the Ashes Action.

Though the writing of David Wojnarowicz, and his call to dump bodies on the steps of the White House, is often credited as the impetus for the Ashes Action, Robinson said that he isn't sure whether or not he was familiar with David Wojnarowicz's writing by this point. If he wasn't influenced by this, then he was clearly thinking the same thing. It's almost more noteworthy if he wasn't, because it would demonstrate the extent to which this feeling was so widespread.

Initially Robinson had trepidations about parting with Krause's ashes, knowing that once he dumped these on the White House lawn, he wasn't going to get them back and they would be gone forever. "Warren was gone," he reasoned. "Nothing was bringing him back. And this box that I had been given by the funeral home, with a baggie in it that contained ashes and bone chips—that wasn't him. And no matter what I did to dress it up with an urn, or with anything else, it wasn't going to be him. So, although I had those feelings of not wanting to lose more of him, I got over that pretty quickly. And what I held onto was this was a way of me helping him to continue to impact the world, and that felt meaningful to me. It still does."

"I was in no state to do the nitty-gritty of the organizing," Robinson recalled. And so his cohorts from ACT UP New York did it instead.

They timed the Ashes Action to coincide with a mass unveiling of the AIDS Memorial Quilt panels.

"I think the quilt itself does good stuff and is moving," Robinson told a reporter the day of the action. "Still, it's like making something beautiful out of the epidemic and I felt that doing something like this is a way of showing that there's nothing beautiful about it." Then he gestured to the box of Krause's remains. "This is what I'm left with," Robinson continued. "I've got a box full of ashes and bone chips. There's no beauty in that."

Though Gran Fury was no longer making work on a regular basis, their hallmark pieces still appeared at ACT UP's demonstrations, and Robinson decided to wear his bloody handprint T-shirt. It was fitting, given the bloody handprint had been born out of the campaign to harass Stephen Joseph, and Robinson was one of those who had been arrested occupying his office. On the back of the shirt was a statistic of AIDS deaths in America, and as the crisis intensified, Robinson would scratch out the statistics on the back of the shirt and update them using a Sharpie, to reflect the growing number of Americans dying of AIDS. When Gran Fury first designed this shirt, it read, "One AIDS death every half hour." Robinson first crossed out "half hour" and wrote in "8 minutes." Later, as the crisis continued to worsen, he had to cross out the 8 and replace it with a 5. "I didn't give a second thought to crossing that out," Robinson recalled. "Because that's what Gran Fury was doing. They always made it clear that they were making stuff for the activism. They were not making high art. They made it to be used." None of this work was meant to be precious. These posters, pins and T-shirts were meant to be worn and written over, or cut into a tank top, to be lived in.

ACT UP had made a new shirt with a more relevant statistic, but Robinson preferred his own, scrawled out with Sharpie. "In a way, ruining the shirt, and not in a neat way, made sense," he recalled. "The Ashes Action, as I intended it, was supposed to be unvarnished." For him, taking this stylized, aesthetic thing, and destroying it in a really primal way, epitomized the rawness and urgency of this action.

The quilt had been unveiled on the National Lawn, in the shadow of the Washington Monument. Finkelstein, who hadn't come with any

ashes but was there to support Robinson, recalled that the march toward the White House started slow, with a single drum beating. For much of the procession from the National Lawn to the White House, they silently marched, without any chants. Closer to the White House, they began chanting: "A hundred and fifty thousand dead. Where was George?" and "Bringing the dead to your door. We won't take it anymore."

They first came at the White House from the north side, hoping to dump their ashes in front of the White House's Pennsylvania Avenue–facing postcard facade. But they were met by a cavalry's worth of policemen on horseback and doubled back, hoping that they could move more quickly and nimbly than the police could.

Circling around the back of the White House, they passed the quilt again. It was common for people visiting the quilt to bring the remains of their loved ones, and people began handing over the ashes of their loved ones to ACT UP members, entrusting strangers to throw the remains of their loved ones over the fence. These were people who had never attended an ACT UP meeting or demonstration, people who had maybe never even heard of ACT UP before. Others joined impulsively, wanting to throw their ashes themselves. A woman from the Midwest, holding her son's ashes, came up to an ACT UP member and told him, "I'm really scared and I'm frightened." She had never done anything like this before. "Would you throw them for me if I can't do it?" she asked him. He said yes, marched with this complete stranger and together, the two of them threw her son's ashes when they got to the fence.

As they approached the White House's southern side, a wave of ACT UP members linked arms, approaching the fence in a triangular formation. Shane Butler, an organizer of the action, was a PhD student of classics and knew that the Romans had used a similar strategy in war: the cuneus or the wedge. Butler and one other person led the triangle and grabbed onto the fence when they reached it, creating a barrier between the police and those holding the ashes. Robinson ran up through the middle and managed to pull himself up onto the fence by grasping one of its spires. Holding the fence with his right hand, he tucked the box of Krause's ashes into the crook of his arm. He threw a few handfuls and

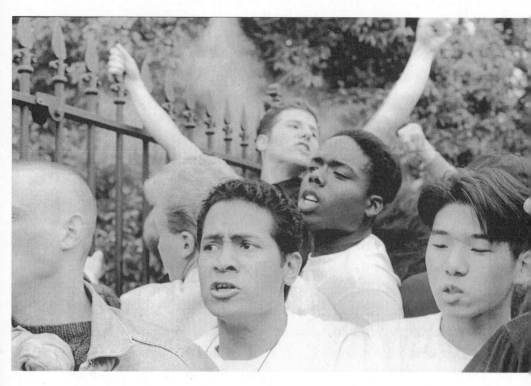

Ashes being thrown at the White House gates. Photograph by Meg Handler.

then climbed up higher onto the fence, pulled out the plastic bag, and dumped the rest of Krause's ashes onto the lawn.

As Finkelstein watched Robinson and the fifteen or so others throwing ashes over the White House fence, it occurred to him that he had no idea what had become of Don Yowell's ashes and figured that Yowell's family must have them. He imagined himself throwing Yowell's ashes onto the lawn, how cathartic it would feel to release them from his hand.

Finkelstein then walked back to the National Mall and went looking for Yowell's quilt, wanting to see it before the rain started. "There it lay in the oldest part, under the blackened sky," Finkelstein later wrote. "It was bleeding a little, from exposure, and rumpled from years of refolding. It had obviously seen a lot of action. As much a portrait of me as of him, I wanted to snatch it up and heave it over the fence, where it really belonged."

◎

Joy Episalla didn't hear about the Ashes Action until months after the fact. That same month, another of the Marys, Tim Bailey, had been hospitalized with a collapsed lung, momentarily pulling her away from ACT UP.

The Wojnarowicz political funeral had only emboldened the Marys, and they began to consider doing a political funeral with an actual corpse. Since their Stumpf/Kane announcement, they had received a few inquiries, but nothing had come of them. Being a group of meticulous planners, the Marys had also begun researching the logistics of making a political funeral possible. They met with estate lawyers, morticians and funeral directors. Researching different kinds of coffins, they found that caskets made in accordance with Orthodox Jewish tradition had a slip lid, leaving the top half of the body in view. The Marys chose to work with Redden's, what had become the de facto funeral home for ACT UP members, because for years, they were the only funeral home in New York City that would accept people who had died of AIDS.

What the Marys realized, in meeting with estate lawyers, was that it would be virtually impossible to stage a political funeral without the full cooperation of the person's executor. It was becoming clear that the political funerals would have to be done with the bodies of their own members. Three of the Marys who were living with HIV—Mark Fisher, Tim Bailey and Jon Greenberg—all decided that they wanted their fellow Marys to stage political funerals if they died of AIDS. "It was very important, to all of them, that they were able to keep using their bodies," Episalla said. "With us helping them along in their journey." The three of them finalized their decision by making the other Marys their executors.

Their next death came sooner than any of them had anticipated. Mark Fisher had seemed to be in good health when he and another friend from ACT UP, Russell Pritchard, took a trip together to Italy. But on this trip, Fisher's Hickman catheter got infected. He called his doctor back in New York, who suggested that Fisher go to the hospital. They were in southern Italy, and Pritchard recalled how at one hospital there were stray dogs walking around the emergency room.

Fisher decided to return home for medical care, so he and Pritchard caught the next flight out of Rome. Their plan was that an ambulance

would meet them on the tarmac at John F. Kennedy Airport and take Fisher to Saint Luke's–Roosevelt Hospital, where Episalla would be waiting for him. Fisher and Bailey had the same AIDS doctor, and Episalla was already at Saint Luke's–Roosevelt, caring for Bailey, when she got the call that Fisher would be returning early.

During the flight, the infection in Fisher's Hickman catheter began to spread into his bloodstream, and he went into toxic shock. Twenty minutes outside of John F. Kennedy Airport, Fisher died of sepsis. Instead of an ambulance driving Fisher to the hospital, his corpse was taken to Redden's.

"We were in shock," Baggett recalled. "And we weren't ready." They had neither prepared themselves emotionally for Fisher's death, as none of them expected Fisher to go this soon or so suddenly, nor planned the funeral itself. "But he had asked us to do it," Baggett reasoned. Fisher's wishes had been clear—he had wanted a political funeral—and the Marys felt compelled to honor them.

They soon came to a realization. Fisher had died on October 29 and the 1992 presidential election was four days away. A demonstration against Bush seemed perfectly fitting for Fisher, who had organized much of the Mary's thirty-day Target Bush campaign. The Marys knew Fisher well enough to understand that this is exactly what he would have wanted for his service. "Mark would have appreciated that, in death, he was doing exactly what he wanted to do in life," Episalla said. And so they decided to hold his service on the eve of the 1992 presidential election.

The Marys only had four days to plan Fisher's political funeral. His body had to be embalmed, a drop-lid pine casket was needed and they had to arrange for an actual service at Judson Memorial Church, in addition to alerting the wider community of ACT UP. Scrambling to honor his wishes, the Marys hardly had time to grieve.

For his service, the Marys dressed Fisher's corpse in a T-shirt bearing a Gran Fury slogan: "All People with AIDS Are Innocent." The Marys had loved this slogan so much that they had decided to make T-shirt versions of it the year before, independently of Gran Fury, and they wore them constantly at demonstrations. Michael Cunningham and Episalla both decided to wear matching ones for Fisher's political funeral.

The morning of Fisher's service, Episalla looked out her window and saw that it was raining. Knowing they couldn't get Fisher's corpse wet, Episalla and her girlfriend rushed to the garment district and bought enough black umbrellas for the procession. Then the Marys assembled at Judson Memorial Church before the actual service. Redden's delivered the embalmed body to them there, and the Marys practiced lifting Fisher's coffin. All of them were surprised by how heavy it was.

At three in the afternoon, the service began. It was standing room only, filled with Fisher's friends and comrades from ACT UP. Baggett stood off to the side, clutching Jon Greenberg, another of the Marys who had also elected to have a political funeral upon his death. "What breaks my heart," Baggett recalled, "is that we didn't know we'd be doing the same thing for Jon within a year."

Another Mary, Barbara Hughes, spoke first. "Mark and I are a part of the Marys," she told those assembled. "We're an affinity group of ACT UP. We're brothers and sisters who are united together in this struggle, putting our bodies on the line to end the AIDS crisis. Today, our brother Mark does this one last time."

Steve Machon, the Mary who had been Fisher's executor, spoke next, talking about what it had been like to help Mark plan his own funeral, to meet with the lawyer to discuss the language that needed to be used so that his funeral could be executed, and what it was like to sit with Fisher as they met with an undertaker to talk about the coffin he would lie in, and to talk about the different lids, and which ones would show his body. "He was fucking extraordinary," Machon concluded.

Episalla was the final speaker. "I'd like to read something that Mark wrote," she began, "and wants us to do today." It was a last will and testament that Fisher had written with the help of the other Marys. He titled it "Bury Me Furiously," and Episalla read it aloud in its entirety:

I am a person with AIDS.

I think about what's happened to my life since I was diagnosed over two years ago. I think about all the passion and precious time I've spent fighting this government's indifference toward me and all people with AIDS.

And I realize that a lot of people out there—gay, lesbian and straight—still do not believe that the AIDS crisis is a political crisis.

My friends and I have decided we don't want discreet memorial services. We understand our friends and families need to mourn. But we also understand that we are dying because of a government and a health care system that couldn't care less.

I think of the late David Wojnarowicz, who wrote:

I imagine what it would be like if friends had a demonstration each time a lover or a friend or a stranger died of AIDS. I imagine what it would be like if, each time a lover, friend or stranger died of this disease, their friends, lovers or neighbors would take the dead body and drive with it in a car a hundred miles an hour to Washington D.C. and blast through the gates of the White House and come to a screeching halt before the entrance and dump their lifeless form on the front steps.

These words sharpen my thoughts and plan. I have decided that when I die I want my fellow AIDS activists to execute my wishes for my political funeral.

I suspect—I know—my funeral will shock people when it happens. We Americans are terrified of death. Death takes place behind closed doors and is removed from reality, from the living. I want to show the reality of my death, to display my body in public; I want the public to bear witness. We are not just spiraling statistics; we are people who have lives, who have purpose, who have lovers, friends and families. And we are dying of a disease maintained by a degree of criminal neglect so enormous that it amounts to genocide.

I want my death to be as strong a statement as my life continues to be. I want my own funeral to be fierce and defiant, to make the public statement that my death from AIDS is a form of political assassination.

We are taking this action out of love and rage.

After a few rounds of "ACT UP! Fight Back! Fight AIDS!" everyone stood up. There was one last opportunity for those in attendance to pay

their respects. Someone came up, kissed his own hand and then touched his fingers to Fisher's lips. Flowers, along with a photograph of Fisher holding a megaphone at an ACT UP demonstration, had been placed at the foot of his coffin for the service. They were removed, and then Fisher's casket was wheeled to the front door.

As the pallbearers raised Fisher's casket onto their shoulders, they heard a siren. Everyone froze, until they realized it was just a passing ambulance. "Okay, let's go," one of the pallbearers said.

From Judson Memorial Church, they headed west, carrying Fisher's casket headfirst, with a concentric circle of umbrella holders surrounding the pallbearers. When they reached Sixth Avenue, they turned right and started a long march uptown.

A team of marshals, with red bands knotted around their biceps, ran ahead of the procession. At each intersection, they'd join hands to form a line, blocking the oncoming traffic until the procession had passed. Then they'd run ahead to the next intersection, leapfrogging the procession uptown. Hundreds of drenched ACT UP members trudged through the rain, and the Marys carried Fisher's casket for over forty blocks, alternating pallbearers along the way.

In this context, Fisher's corpse wearing an "All People with AIDS Are Innocent" shirt adds a layer to the slogan's meaning of "innocent." Wearing this shirt was a way of challenging the procession's illegality, of challenging the idea that any of ACT UP's activities were illegal, and a way of justifying that no person living with AIDS is guilty for trying to save their own life. This sentiment was, in a way, validated as the procession moved up Sixth Avenue. When the police arrived, they stood aside, removed their hats and silenced their radios, allowing the funeral to proceed.

When they reached Forty-Third Street, they turned right and lowered Fisher's casket in front of George H. W. Bush's reelection campaign headquarters.

According to the *New York Post*, four of Bush's staffers came down to watch the service. "Oh, that's disgusting," one staffer said to a coworker. "What's wrong with these people?" They giggled and then went back upstairs.

Cunningham was the first to speak, and he told the story of how Fisher had helped organize the demonstration that the Marys had staged outside of Bush's summer home in Kennebunkport, Maine. "Later in response to a reporter's question," Cunningham said, "Bush said that he cared far more about unemployment than he did AIDS, because 'unemployment affects families.' We're here to tell Bush and all the other hatemongers that we are Mark Fisher's family. We have suffered an irreparable loss. . . . Mark Fisher was a hero. We will never quit the battle Mark fought until the moment of his death. Some of us, like Mark, may not live to see the battle won. But we will win. We will fight the hatred so powerful and pervasive it's no different than murder. There will always be more of us and we will never be silent."

Bob Rafsky, who was then just months from dying, then delivered a final eulogy for Fisher:

Let everyone here know that this is not a political funeral for Mark Fisher—who wouldn't let us burn or bury his courage or his love for us any more than he would let the earth take his body until it was already in flight. He asked for this ceremony—not so we could bury him—but so we could celebrate his undying anger.

This isn't a political funeral for Mark. It's a political funeral for the man who killed him, and so many others, and is slowly killing me: whose name curls my tongue and curdles my breath.

George Bush, we believe you'll be defeated tomorrow because we believe there's still justice left in the universe, and some compassion left in the American people. But whether or not you are—here and now—standing by Mark's body, we put this curse on you. Mark's spirit will haunt you until the end of your days. So that, in the moment of your defeat—you'll remember our defeats, and in the moment of your death—you'll remember our deaths.

. . . Let the whole earth hear us now: We beg, we pray, we demand that this epidemic end. Not just so that we may live, but so that Mark's soul may rest in peace at last. In anger and in grief, this fight is not over 'til all of us are safe.

After Rafsky's speech, the Marys loaded Fisher's corpse into a hearse to take his body back to Redden's, and Episalla went back to the hospital, to be with Bailey.

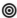

This was the backdrop against which Gran Fury made its final poster. It was unlike anything they had made before. Against a large gray background, four questions appeared in small black type. It is the only Gran Fury poster that could possibly be described as quiet or serene.

Only Loring McAlpin, Finkelstein and Simpson worked on this poster. Without Donald Moffett or Marlene McCarty, they needed a bit of help with the poster's actual design, and they enlisted the help of Vincent Gagliostro. Though never a member of Gran Fury, Gagliostro occasionally helped out with the printing of some of the collective's projects, like the *New York Crimes*, and played an important role in the collective's story. Gagliostro had been one of Don Yowell's best friends and was integral to ACT UP shutting down the New York Stock Exchange. Vincent understood, when asked to work on this project, that this would be Gran Fury's swan song. But more importantly, he also understood that this was a poster for Simpson. "It was really Mark's project," Gagliostro recalled.

When Gagliostro first arrived at a planning session for Gran Fury's final project, he recalled that they were discussing something much grander than what they would eventually produce. In Gagliostro's recollection, the collective was discussing building a physical monument, a massive triangle that could occupy one of the triangular patches of green space that dot either side of lower Seventh Avenue. To Gagliostro, this idea seemed entirely unfeasible, both because there were no prospects for who might fund such a monument and because there was no indication that the city of New York would be willing to host it. After a few planning sessions where this idea was discussed, Gagliostro got fed up. "You're all out of your fucking minds," he told them. "We're not building anything."

Gagliostro recalled that they initially struggled with the project. "We were really nervous about our community at the time," he said. The

moment of ACT UP had passed, and there were no promising treatments on the horizon. After weeks of going back and forth over what to say, whom it would be for, and how they would say it, Gagliostro told the rest of the collective, "I always leave here with more questions than I have answers. Maybe there's something to that."

They borrowed an already established structure—the Haggadah text of the Passover Seder. Both Finkelstein and Simpson had a deep connection to Passover. Before ACT UP, Finkelstein, Chris Lione and Simpson would sometimes attend a Passover Seder hosted by the Breindels, Simpson's surrogate family. And during the ACT UP years, a cohort of friends from ACT UP began hosting their own. It began with Finkelstein, Maria Maggenti, Maxine Wolfe and David Robinson, and then Finkelstein and Wolfe began hosting their own (which continues to this day). "Since it's the story of freedom from oppression," Finkelstein said, "it always involves hours and hours of conversations about the political meanings of the holiday, and lots of shouting, kibitzing and joking." Over the years, Tom Kalin, Nesline and Simpson all attended this seder, which features a rotating cast of characters, mostly culled from ACT UP. For years, one ACT UP member, Lee Schy, always insisted upon reading the Wicked Son portion of the Haggadah, and after Schy died of AIDS in 1995, Finkelstein began reading it at the seder, in memory of him. "It is my favorite holiday," Finkelstein said.

The Passover Seder is ordered as a retelling of the book of Exodus, the story of the Jewish people freeing themselves from slavery and returning to their homeland. In the Haggadah, the text that sets the order of the Passover Seder, four questions are asked by the youngest person at the table. The actual four questions are preceded by an overarching one, asking those present to consider why they have assembled. "Why is this night different from all other nights?" Then the four questions go as follows:

"Why is it that on all other nights we do not dip even once, but on this night we dip them twice?"

"Why is it that on all other nights during the year we eat either leavened bread or matzoh, but on this night we eat only matzoh?"

"Why is it that on all other nights we eat all kinds of vegetables, but on this night we eat bitter herbs?"

"Why is it that on all other nights we dine either sitting upright or reclining, but on this night we all recline?"

What is noteworthy about the four questions in the Haggadah is that these questions are not a predetermined call and response but intended to provoke conversation, and at seders, it's common for hours to be spent arguing over the answers and their nuances.

The remaining members of Gran Fury decided to use this template of four sequential questions and adapt it to their own moment. Once they settled upon this concept, Gagliostro recalled, the poster quickly fell into place. Simpson would always carry around a yellow legal pad, on which he would write down notes and brainstorm ideas. The genesis of *Let the Record Show . . .*, which birthed Gran Fury, began in a similar way, with people throwing out suggestions and Simpson writing them down on his yellow legal pad. In these writing sessions, they were attempting to triangulate the converging and conflicting emotions that defined this moment: the sense of fatigue, having worked tirelessly for the past five years, and the ensuing feeling of despair from seeing the death toll continue to rise without abatement; the obligation of HIV-negatives, the harder question of what is owed to people living with AIDS and the tandem question of who should provide that; how the dead should be mourned, what should be done with their remnants and what is expected of the living; what an actual end to the AIDS crisis would look like; and the insurmountable grief that had become pervasive.

Simpson and Finkelstein filtered all of those converging emotions into these questions, which centered around the feeling of ACT UP and Gran Fury ending and the political funerals and their sense of desperation, but they were just as much about the fallout between Nesline and Simpson and the larger questions of caretaking. These questions made no demands, offered no prescriptions and sought no outcome, other than to encourage introspection. "It was not a poster aimed at the public," reasoned

McAlpin. "This was a poster for ACT UP, the Lower East Side and gay men in New York. We were talking to ourselves."

The list of questions that Finkelstein and Simpson compiled included the following, among others: Have the numbers become meaningless? Do people with AIDS bring you down? What did you do with your rage? How many more have to die? What is stopping us from ending the AIDS crisis? Do you think you're off the hook? Did you expect miracles? Has AIDS become a normal way to die? Do you just want your friends back?

From that longer list of questions, Gran Fury culled four:

Do you resent people with AIDS?
Do you trust HIV-negatives?
Have you given up hope for a cure?
When was the last time you cried?

Four Questions (Partial), Gran Fury, 1993.

They printed these questions in small black type on a huge gray sheet. Though it's unlike any of Gran Fury's other pieces, *The Four Questions* does share a graphic similarity to *Silence=Death*, in that both rely upon a huge amount of negative space. In both, the massive amount of blank space distances its content from the surrounding landscape. Whereas the black background of *Silence=Death* insinuated the pervasive silence around AIDS, the gray space of *The Four Questions* insinuated the lack of answers to these questions. The amount of gray space could have invited people to write in answers, but there's no evidence that anyone ever did.

Choosing a gray background was very much a shift from Gran Fury's previous work, which is very black and white, in both its color schemes and in its didacticism. That choice also spoke to the changing temperament of this moment. "There was a period in ACT UP," recalled Maria Maggenti, "to sustain itself, to do the things we were doing—it was not a gray matter. It was the right thing to do, or the wrong thing to do. And that was very, very helpful." But after years of this didacticism, many found that kind of black-and-white worldview became impossible to sustain. "I wanted to retreat into gray," recalled Maggenti, who had once been a fixture in ACT UP but found herself unable to sustain the kind of didacticism that had once propelled the organization.

Finkelstein recalled that they had initially thought of this first question as being directed at younger gay men, a way of asking if they felt that AIDS had robbed them of a carefree adolescence. But it's a question that implicates every HIV-negative person, especially in this community. Regardless of their HIV status, AIDS had shaped the lives of every single person who had joined ACT UP. Questioning HIV-negatives, and asking them to consider where they've placed their resentments, was a way of facilitating introspection. Do you resent having to spend your twenties visiting your friends in the hospital? Is all that you're missing the loss of carefree sex? Did the AIDS crisis rob you of the adolescence that you wanted? Do you resent spending your thirties with someone who can't grow old with you? Would you have joined ACT UP if you knew that a cure would never happen in your lifetime? Where are you directing

328

Do you resent people with AIDS?

Do you trust HIV-negatives?

Have you given up hope for a cure?

When was the last time you cried?

Four Questions (Full), Gran Fury, 1993.

your resentment? Do you blame people with AIDS, even just a little bit? Would you admit it if you did?

If the first question, about resenting people with AIDS, implicitly speaks to an HIV-negative audience, then the second question, about placing trust in HIV-negatives, establishes that this poster is trying to bridge a gap between HIV-negatives and HIV-positives, what has become known as the viral divide.

What that does, for its HIV-negative audience, is make them conscious that such a divide exists, without explicitly telling them so. Like all of Gran Fury's best work, *The Four Questions* facilitates a transformation of consciousness. But whereas much of Gran Fury's propaganda advocates that you think about the world differently, *The Four Questions* pushes you to think about yourself and your own HIV status differently. It's about a shift in consciousness, recognizing your own HIV status (positive or negative) as something that influences your way of moving through the world in an untold number of ways. But it also demands, if you are HIV-negative, that you recognize the unknowableness of being positive, that you recognize the limits of what you can fathom and understand.

That may seem like a small gesture, but it is an enormously powerful one. People who are HIV-negative often don't see themselves as such, in a way that's similar to how white people are often unaware of their own whiteness. And part of the poster's power is to gently coerce you into making this consideration. If you are HIV-negative, it's difficult to see this poster and not consider your own place in the world as such. It is, in that sense, one of Gran Fury's most propagandistic poster, and yet it, at least visually, has no trace of propaganda to it.

The question of trusting HIV-negatives both forces an HIV-negative audience to consider their own serostatus while also asking a larger question of what HIV-negatives owe to people with AIDS. In a way, it's the question most explicitly directed at Nesline, someone who is HIV-negative and devoted himself to caring for people with AIDS, even as he continually lost friends and friendships to the crisis. It's a way of asking what Nesline owed to Simpson, or what any HIV-negative person owes to a person with AIDS.

That question of trusting HIV-negatives was also a way of interrogating the end of Gran Fury. "Mark felt really abandoned," McAlpin recalled. "He was pissed off about what was happening to ACT UP and angry that Gran Fury was falling apart. His stake was higher. For Mark, it was clear: this is my health and this is my life." For Simpson, to lose Gran Fury was to also lose his ability to fight against the feeling of his death being inevitable. "The place that made him most able to fight against his own sense of being marked and being sick was what went on within Gran Fury meetings," Kalin recalled. "Mark was very heartbroken. Gran Fury was a kind of family for him. He missed the meetings and did really want us to come together. And *The Four Questions* is a real plea for that."

In the third question, about giving up hope for a cure, the idea of a "cure" might seem like the operative word. But this is just as much a question about despair and persistence. It was a way of asking its audience what it would mean to end the AIDS crisis. Have you lost your ambition to end AIDS? Are you content with AIDS being a long-term, manageable condition?

One might think that in a group like ACT UP, where serial loss was endured and where emotional outbursts were commonplace, an expression of grief, like crying, would be a regular occurrence. But actually the opposite is true, and the last of the questions speaks to this. "There were not very many tears in ACT UP," recalled Maggenti. "It was just not a crying group, because everyone thought that they would just channel all their sadness into anger. And that was the other thing that got to be exhausting, was just being angry all the time and not being able to be sad." The *Silence=Death* poster, in its small type at the bottom, instructed its audience to "Turn anger, fear, grief into action," and Gran Fury had advocated for something similar in its work too. This question, asking when you last cried, was a challenge to this attitude, a refutation of the idea that one could unendingly metabolize this kind of grief into action. *The Four Questions* confronts the inevitability that this becomes impossible after a certain threshold is passed. What have you done with your grief? Where has it gone? It is a question that perfectly captures the moment

of the political funerals and the Ashes Action, which made no demands other than that their grief be seen.

What remained of Gran Fury's membership had timed *The Four Questions* to coincide with that year's Pride celebrations. They wheat-pasted it around the Lower East Side and East Village themselves, the neighborhoods where most of ACT UP's members lived, and the cultural center of their world. It was a return to the early days of Gran Fury. The project had received no funding (unless you count them billing the printing costs to the cosmetics company Avon, where Gagliostro freelanced) and had no backers or sponsorship. But unlike their previous work, it seemed, at least to Finkelstein, that no one registered its existence, or even saw it.

There's a photo that McAlpin took of Simpson wheat-pasting *The Four Questions* himself. Gagliostro knew, when they had begun working on the poster, that Simpson wasn't well, but the photo still says much about his decline in the last three years of his life. Simpson is outside, and standing on his own, a level of physical activity that would become impossible for him in the coming years.

The day after that year's Pride, another of the Marys passed.

Tim Bailey had been in the hospital since just before Mark Fisher's funeral, and his condition had steadily worsened. As the CMV retinitis spread to his brain, Bailey descended into dementia. He kept forgetting that he wasn't allowed to smoke in the hospital, and would repeatedly ask for cigarettes. The Marys pacified him by keeping a dirty ashtray next to his hospital bed, so that whenever he asked for a cigarette, they would show him the ashtray and say, "You already had one."

Eventually, the hospital staff had to secure Bailey to his bed because he had tried to get up, and a fall could seriously injure him. Bailey had been the menswear designer for Patricia Field, and one night he mistook his bedsheets for fabric. He had gotten out of bed, draped himself in his

bedsheet and tried to fashion it into a gown for himself. "Would you help me gather it here?" he had asked the nurses.

In the midst of this, Episalla wondered if Bailey still wanted to go through with his political funeral. Bailey had outlined as much, both in his will and in conversations with the Marys. But all of that had preceded Bailey's entering the hospital, and Episalla wanted to be sure that these were still his wishes.

One day, while Episalla sat with him in the hospital, Bailey snapped into a rare moment of lucidity. "All of a sudden, he was wide awake," Episalla recalled. "He was there—very present. And, it was my moment." They had a full conversation, and Bailey seemed cognizant enough to make choices for himself. She asked Bailey if he still wanted a political funeral. "Yup," Bailey told her. "You're going to do it just like we talked about."

Toward the end of Bailey's life, it became clear that the only care the hospital could provide would be palliative. While still cogent, Bailey had told the Marys that he didn't want to die in a hospital, and so in accordance with Bailey's wishes, the Marys brought him home in the last days of his life. "One of the best days of my life was getting Tim out of the hospital and carrying him up to his apartment, and letting him die at home," Baggett recalled. "It's one of the best things I've ever done in my life." Especially after Fisher had died so suddenly, and on a plane crowded with strangers, it was soothing to have Bailey pass in his own home.

Baggett drove Episalla's car up to Saint Luke's–Roosevelt and collected Episalla and Bailey. The two of them got Bailey into a wheelchair, and then into Episalla's car. It was a beautiful summer day, and as they drove down the West Side Highway, Baggett told them about a new Taylor Dayne song, a cover of Barry White's "Can't Get Enough of Your Love." Then Baggett turned on the radio, only to find that exact song playing. Baggett turned up the radio, and Bailey was even feeling well enough to dance a little in his seat. "He was wearing his light blue denim shirt, and he put on his leopard skin printed silk scarf and his sunglasses," Episalla said of Bailey. "And he looked his fabulous self."

Bailey lived at the corner of Sixth Avenue and Washington. He was too weak to climb the stairs to his top-floor apartment, and so Baggett

carried him up. "Tim was just a wisp of a person by then," recalled Baggett, who guessed that Bailey's weight had dropped to about 110 pounds.

Episalla and Bailey's childhood best friend spent the last two weeks of Bailey's life with him in his apartment. Just before he died, Bailey asked Episalla to attend that year's Pride on his behalf. When he had been healthy, Baggett recalled, Bailey would walk through Pride wearing nothing but a jockstrap, clear hot pants and Doc Martens, passing out pink carnations. The day after Pride, Bailey was having trouble breathing. "We just kept saying that we were right there with him," Episalla recalled. They put on an Ella Fitzgerald record for him, and let Bailey pass.

Episalla called the Center. It was a Monday night, and she knew that the Marys would be at ACT UP's weekly meeting. The other Marys walked the few blocks to Bailey's apartment, had a round of martinis together and said goodbye to Bailey. Then they called Redden's, who collected his body and began preparing for Bailey's political funeral.

When alive, Bailey had asked that the Marys throw his corpse over the White House gates. The other Marys told Bailey they couldn't do this, that they loved him too much to treat his corpse like this.

"All right," Bailey had replied. "Do something formal and aesthetic in front of the White House. I won't be there anyway. It'll be for you." He had even set aside some money to charter two buses for his own funeral, which would bring about a hundred ACT UPers along.

On July 1, 1993, the Marys drove Bailey's body to Washington, DC. The plan was to meet the hundred or so ACT UP members at the Capitol Reflecting Pool and carry Bailey's casket to the White House. The stretch of Pennsylvania Avenue in front of the White House was still open to traffic then, and as the Marys drove to the meeting spot, they passed right by the White House gates. The Marys briefly considered forgoing the procession, pulling over and pulling out Bailey's coffin there. But they decided to stick with their plan, meet up with everyone else and not go it alone.

When the Marys pulled up to the meeting spot, they were immediately swarmed by the police. The buses delivering a hundred ACT UP members had gotten there about an hour before. A hundred people

milling around the Capitol Reflecting Pool with posters reading "We Will Not Rest in Peace" had drawn the attention of law enforcement. "The next thing I know," Episalla recalled, "this huge man jumps through the passenger window and he's holding my arms, and trying to get the keys from me." He managed to wrestle away the keys, rendering the van immobile, and leaving Episalla bruised with black and blue marks all over her arms.

"Surround the van!" one of ACT UP's marshals, Jamie Bauer, yelled out. "Surround the van!"

Everyone from ACT UP quickly linked arms, tightened into a circle around the van carrying Bailey's body and sat down. With ACT UP's members surrounding the van, and the Capitol Police holding the van keys, an hours-long standoff ensued. ACT UP debated whom to call, trying to think of which connections could possibly help. Episalla stood on the van's bumper, trying to negotiate with the police.

"Who's in charge?" the ACT UPer kept yelling. "Who's in charge?"

"What the hell are you afraid of?" yelled David Robinson. "That maybe ordinary citizens will see exactly what our government is doing?"

Baggett stayed in the van, next to Bailey's casket. "He was my best friend," Baggett said. "When you see footage of Tim's funeral, you don't see me because I was protecting his coffin inside the van, because I wasn't going to leave his side."

After negotiating proved futile, Episalla and the Marys decided to try and force the coffin out of the van and push through the line of police. Everyone in ACT UP rose, arms linked, shuffling their feet to create a small clearing at the rear of the van. Then they slid Bailey's casket out of the van and lifted it into the air.

For about a minute, Bailey's casket hovered at eye level, as his pallbearers tried to push through the line of police, and the police tried to push the coffin back into the van, crashing the foot of the casket into the bumper. In the skirmish, the head of Bailey's casket rose, while the foot dipped, so that his face was fully visible to those still in the van. Bailey's pallbearers then guided the casket back into the van, not wanting to damage his corpse.

Episalla got onto the roof of the van with a microphone. If they couldn't proceed with Bailey's funeral as he had wanted it, she was at least going to make his wishes known:

Tim told me that he wanted his political funeral to be fierce, formal and defiant. He wanted his fellow AIDS activists to deliver his body to the steps of the White House. He wanted the world to bear witness to the reality of AIDS in the United States in 1993. Bill Clinton, we are here with Tim Bailey to remind you that while you continue to pay lip service to the AIDS crisis, the epidemic continues to rage on. . . . We have brought Tim to your doorstep as a representative of the nearly two hundred thousand Americans who have died of AIDS.

Tim was truly amazing. . . . He was the most in your face, fierce AIDS activist you ever met. Tim was my gay brother, and I was his lesbian sister, and together with the rest of our gay brothers and lesbian sisters, the Marys, we made a very queer, loving family. . . .

We are here today to bear witness. It is our responsibility to tell the stories of the millions of people affected by HIV, even if you, Bill Clinton, don't want to listen. We are angry. We are disgusted. And we have nothing to lose. . . .

Tim wanted his body to serve as an indictment to Bill Clinton, Hillary Rodham Clinton, Congress, the medical establishment, the pharmaceutical industry, the insurance companies, and the religious Right for their total denial of the worst epidemic in the history of the world as we know it. . . .

I dare you, Bill Clinton, to take action against AIDS. All of us who are living with HIV dare you to exhibit the leadership necessary to end the AIDS crisis. . . .

We will accept nothing less than action. No more Band-Aids. We want a cure. No more lip service. We won't tolerate any more broken promises, and quite frankly, we have nothing to lose except our lives, which are already being taken away from us at a rate of one every five minutes. . . .

After a few more speeches, the Marys got into the van and started driving back to the funeral home in New Jersey. The police were unwilling

to let them go unescorted. Police cars formed a motorcade around the van carrying Bailey's casket, and when they steered the van into one of Washington, DC's primarily Black neighborhoods, Episalla understood that they were just trying to keep the procession away from DC's tourists.

They opened the van windows and began throwing out the flyers that they had made for Bailey's service, ones that they had planned on passing to onlookers during their procession to the White House. The flyer was a photograph of Bailey, with a short message from the Marys:

> This is the body of Tim Bailey. He was a friend, a lover, a brother, and a son. He was also an AIDS activist—a hero in the fight against the epidemic. We're giving him a hero's funeral. . . . He wanted his death to help more Americans understand that while the government drags its heels, real people are dying. . . . In our outrage and our despair, we're carrying the body of Tim Bailey along the same route traveled by the bodies of other slain heroes. After you've read this, we ask that you observe a moment of silence for Tim. A funny, smart, impassioned 35-year-old man who could have been your friend. Your son. Your brother. Your lover. Then, after you've observed a moment of silence, do whatever you can to tell this country's leaders that their indifference and inefficiency cannot and will not be tolerated. We are all dying of it. There's no more time.

Looking out the window, Episalla saw that Black folks were picking up the flyers, reading them and lining up on the sidewalk, giving the Marys the raised-fist Black power salute.

Even as they reached the outskirts of Washington, DC, the police continued to trail them, with full lights and sirens going. The Marys tried to pull over once, but the police yelled to keep driving, making it clear that they weren't actually trying to arrest the Marys, just getting them away from the White House.

By the time the police had chased them to Baltimore, a full hour's drive north, Hughes realized that they were running out of gas. "I'm running out of gas!" she yelled out the window. After they had passed through Baltimore, the procession pulled off the highway and into a gas

station. Hughes got out of the van, walked up to the squad cars that had escorted them off the highway and asked if the officers planned to follow them all the way back to New Jersey.

"No, no," one officer replied. "I think we've had enough for one day."

Less than two weeks after Tim Bailey's political funeral, the Marys lost another member, Jon Greenberg. But by then, Episalla said that the Marys were too shellshocked to try and stage another political funeral like the ones they had orchestrated for Bailey and Fisher. And Greenberg had wanted a very different kind of funeral. Part of the Marys' ethos was that each of the political funerals was meant to honor the respective personhood of its participant—Fisher had spent the last years of his life hounding Bush, and so it made perfect sense that his funeral would end at Bush's campaign headquarters on the eve of his election loss. Bailey had asked explicitly that his body be taken to the White House. Greenberg was a very different person than either of them, and as such, his funeral would be different too. "Jon was a complete pacifist, in every single aspect of his life," Baggett said. "He didn't want anything angry to do with his funeral."

The Marys did a relatively tame procession, carrying Greenberg's casket to Tompkins Square Park, where he lay in state. While Greenberg's friends came to pay their respects, the performance artist John Kelly sang the Mourner's Kaddish.

In the midst of planning the funerals for Fisher and Bailey, the Marys had allowed themselves no time to grieve, as their funerals had taken place just days after their deaths. "The loss is not only the loss to you, losing this person you love," Episalla reasoned. "It's also the loss of what they could have given to the world." The Marys found themselves debilitated by this, and effectively disbanded after Greenberg's service.

When I interviewed Joy Episalla for this book, I asked her how she felt about the political funerals being used as the end point of books and

films about ACT UP. Nonfiction and documentary efforts—both the books and film versions of David France's *How to Survive a Plague*, Elinor Burkett's *The Gravest Show on Earth: America in the Age of AIDS* and Sarah Schulman's *Let the Record Show*—as well as more academic texts like Deborah Gould's *Moving Politics*, all end with the political funerals. Even when ACT UP's Paris chapter was fictionalized in the film *BPM*, it ends with such a scene. Of course, both the AIDS crisis and ACT UP continued beyond the funerals, as did the lives of the Marys who outlived the crisis, but one would hardly know this based upon how the political funerals are used.

Episalla found it strange too, but for a different reason. "I've never seen them as an end point," Episalla said. "I see them as a transformation." For Episalla, the political funerals had a transformative effect in two ways. There was, first, the way in which the political funerals transformed Mark Fisher, Tim Bailey, Jon Greenberg and, to a certain extent, David Wojnarowicz. In Episalla's conception, these funerals were the beginnings of Fisher, Bailey, Greenberg and Wojnarowicz finding a new way to have an impact upon the world. David Robinson recalled the Ashes Action, and his use of Krause's ashes in almost identical terms. For this kind of a funeral to be an end point doesn't honor that sense of transformation.

But Episalla also emphasized that these funerals were transformative for those who carried them out, people like her, James Baggett and the rest of the Marys. "After we did the political funerals," Episalla reasoned, "we were never going to be the same." The transformation that the Marys made was that they weren't just living for themselves any longer, but that they were also living for the people whom they had lost. "The reason I'm alive is to tell their stories," Baggett said to me. Episalla had an almost identical transformation. "We are the witnesses," she told me. "We are what's left. We got to live. They died. So I always feel like I have the responsibility of living for them too."

Though born out of the same despair that motivated the political funerals, *The Four Questions* also offers the possibility of finding a way of

living after them, as this was, after all, a poster made for those who had dedicated themselves to ACT UP. It both named their despair and offered them a way of figuring out what life after ACT UP might look like. Looking back at your time in ACT UP, where do you place your resentment? What are you doing for AIDS now that the moment of ACT UP has passed? What have you done with your grief?

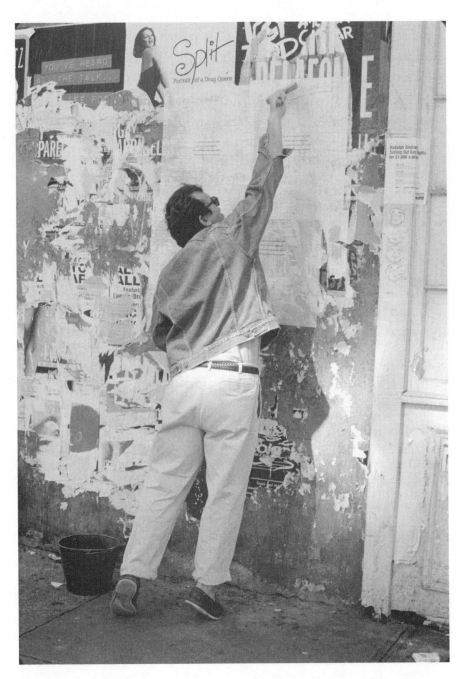

Mark Simpson wheatpasting *The Four Questions*. Photograph courtesy of Gran Fury.

CHAPTER 12
IMPERFECT ENDINGS

It's not the beginning of the end. It's the end of the beginning.
—Michael Nesline

Most members of ACT UP recall the years between 1993 and 1996 as their bleakest. The peak of ACT UP's efficacy was clearly in the past, and nothing had filled its void. And this was while the AIDS crisis continued, the annual numbers of deaths worsened each year and there was nothing to suggest that any kind of end was in sight.

Every major city in America, and many smaller cities too, had once boasted a healthy ACT UP chapter. Now, only a tired few remained. ACT UP's New York chapter was intact, though tattered, and continues to this day. But throughout the rest of the country, ACT UP's most prominent chapters began to shutter, as death and burnout depleted their ranks. San Francisco's ACT UP chapter was eventually hijacked by HIV denialists, while the Chicago and Los Angeles chapters of ACT UP slowly petered out. Debra Gould, of ACT UP Chicago, recalled that after a long and slow demise, the chapter finally ended in January 1995, at

a meeting that wasn't intended to be its last. The meeting started with a report from the treasurer, who noted that they had almost no money, bills coming and rent due. With fewer than ten people in attendance, they voted to stop meeting in public spaces, because of the cost and since such a small group could easily meet in each other's homes. Then the treasurer brought up the issue of the PO box, which received almost no mail worth reading, and so the floor then voted to shutter it, in hopes of saving money. Then, the treasurer reported upon their voicemail, which similarly received no messages, and so the floor voted to shutter that too. Lastly, the treasurer detailed how their bank kept deducting fees from their account because their balance rested below the minimum, and since there were no fundraising prospects, the floor voted to close their bank account too. Slowly, the few people in attendance started to laugh, and then cry, at the absurdity before them: they had just voted ACT UP Chicago out of existence. It proved to be the chapter's last meeting. Other major chapters ended similarly. At the last meeting of ACT UP Los Angeles, three people attended: one voted to continue the organization, and two voted to end it.

Most members of Gran Fury used ACT UP's demonstrations to organize their memories. And so many of them have difficulty recalling the years between 1993 and 1996, other than in the broadest strokes of their bleak emotional tenor. "I don't know where I was, or what I was doing in those years," Loring McAlpin said. "I've blocked it all out." Then he paused and ruminated upon this a bit more. "Actually, I do know what I was doing," he continued. "I was watching Mark die."

Still, even though the moment of ACT UP had passed, a few members of Gran Fury continued their AIDS activism. In 1993, Avram Finkelstein began working with David Robinson, the progenitor of the Ashes Action, and Maxine Wolfe, one of the leaders of the CDC campaign, on the utopic vision of finding a cure for AIDS. "Everyone was talking about individual treatments," Robinson recalled. "No one was talking about a cure. It wasn't even in the vocabulary." So they, along with a few others

from ACT UP, began to think critically about what it would take to cure AIDS.

One of Bill Clinton's unfulfilled presidential campaign promises was "a Manhattan Project for AIDS." Grand as this sounded, Clinton hadn't actually detailed what exactly such an effort might entail. And so Finkelstein, Wolfe, Robinson and their cohorts began considering what this would look like, drawing upon the structure of the original Manhattan Project to think about how a cure for AIDS could be found.

With the original Manhattan Project, the US Army Corps of Engineers had upended its usual course of building weapons and had instead brought the leading scientists in their respective fields to collaborate together in one shared space. Putting the best scientists all in the same room would yield the quickest and most effective result, they reasoned, and it was often over lunch in between meetings, or chatting over coffee before work, where most of the major breakthroughs took place.

Finkelstein, Robinson, Wolfe and the others figured that something similar could be effectively used to find a cure for AIDS. Rather than having pharmaceutical companies compete against each other, or researchers vie for the same pool of funding, they envisioned an institute, separate from any existing structures, dedicated to curing AIDS and free from these constraints, letting scientists do science together.

Naming it "the Manhattan Project" was shot down, Robinson recalled, because of the project's association with death and destruction. So they instead named it after Barbara McClintock, a scientist who made invaluable contributions to the field of genetics, and whose work was overshadowed by her male counterparts in her time but who later received the recognition she deserved.

Of course, building a bomb is different than finding a cure, and so while the project took wing from the Manhattan Project and its structure, it was also grounded in the practicalities and logistics of scientific breakthroughs. Wolfe knew someone who put them in touch with Peter Salk, a doctor of infectious diseases and the son of Jonas Salk, the inventor of the polio vaccine. By then, Jonas Salk had turned his efforts toward an HIV vaccine, and the younger Salk consulted them on some of the

more logistical aspects of developing their institute to cure AIDS, like information about equipment, and the kind of space needed for a research facility.

With the help of Salk, they began writing out their proposed research institute. It garnered almost no support from other AIDS groups. Those who had been part of ACT UP's Treatment and Data Committee, and who left to form TAG, thought it was absolutely delusional and actively campaigned against it, instead pushing their own congressional bill to strengthen the NIH's existing Office of AIDS Research.

The kind of overhaul that Finkelstein and co. envisioned would require legislation, and so they decided to court the support of Jerry Nadler, the newly elected representative whose congressional district included much of downtown Manhattan and the primarily gay neighborhoods of Chelsea and Hell's Kitchen. Steve Quester, another ACT UP member who worked on the project, recalled that they interrupted a community forum where Nadler was discussing building a tunnel from New Jersey to Brooklyn. When Nadler invited questions, they began demanding he address the crisis killing his constituents and enact their plan as legislation. Nadler was surprisingly receptive. "Let me read it," he told them. "Let's have a meeting."

"We had the meeting in his office," Robinson recalled. "And he listened, and he thought it was a smart idea." They shared their materials with Nadler, and he rewrote it as a piece of legislation. The Barbara McClintock AIDS Cure Act (H.R. 3310) was first introduced in the House of Representatives in October 1993, and was referred to the Committee on Energy and Commerce the same day. A month later, it was referred to the Subcommittee on Health and the Environment, where it stalled. The problem with naming it after McClintock, Robinson reasoned, was that first you had to explain her life story before you could explain the actual bill. When he reintroduced the bill, in May 1994, Nadler fortunately renamed it the more self-explanatory "AIDS Cure Act," and the bill followed an identical trajectory to its previous introduction, first being referred to the Committee on Energy and Commerce, and again referred to the Subcommittee on Health and the Environment.

This time, the bill actually picked up traction among cosponsors. Twenty representatives, including John Lewis and Bernie Sanders, all cosponsored it, joining a number of Democratic representatives hailing from metropolitan districts.

But despite this initial promise, the bill stalled again in committee. In 1993, Henry Waxman, the chair of the Subcommittee on Health and the Environment, had championed TAG's bill to strengthen the NIH's Office of AIDS Research. The AIDS Cure Act would have effectively undermined this, which had been one of Waxman's signature legislative accomplishments in the previous year. As committee chairs are largely responsible for setting their committee's agendas, maybe it's unsurprising that the AIDS Cure Act never received serious consideration in Waxman's committee.

The AIDS Cure Act died in committee, as most bills do. In the 103rd congressional session, 505 bills were referred to the Health and Environment subcommittee. Only 63 of those 505 even received consideration within the committee, and only 13 of those received consideration from the larger floor of the House. Only one became law. For those ACT UPers who had worked on the AIDS Cure Act, it was a hard lesson in the realities of trying to work through Washington, as opposed to the direct action tactics that had been so effective for the past six years. A year's worth of work never even made it out of committee.

As Finkelstein and co. were learning the realities of working through the legislative process, another former member of Gran Fury was similarly learning about the difficulties of trying to work through Washington. Around this time, the NIH was beginning to explore the idea of an AIDS vaccine, and had begun looking at proposals. Cladd Elizabeth Stevens, an epidemiologist at the New York Blood Center, approached several community-based AIDS organizations to discuss this and solicit feedback and opinions, including the Minority Task Force on AIDS, where Robert Vazquez-Pacheco was then working as their director of education.

"She did a presentation about the vaccine," Vazquez-Pacheco recalled. "And at one point she said something, my friend David and I looked at each other like, *Wait a minute. Are they going to be testing the vaccine by putting live HIV virus into people to see if it works?*"

This immediately raised concerns for Vazquez-Pacheco, and so he authored a report, "A Discussion of Community Concerns," which he later delivered at the first HIV Vaccine Conference in the United States, and it was later published in the *HIV Vaccine Handbook*. When Stevens was asked to join the National Institute of Allergy and Infectious Diseases (NIAID) HIV Vaccine Working Group, she instead deferred to Vazquez-Pacheco, who agreed to join.

The NIAID HIV Vaccine Working Group had been formed in 1992, with the hopes of moving the agency's research toward actual trials. Vazquez-Pacheco joined as a community representative, serving as a voice for the people who would actually be enrolling in these trials, and those who would be receiving a vaccine if it proved to be effective. His role, to give the perspective of people in the communities most affected by HIV and AIDS, wasn't always appreciated by the scientists there. "When I would open my mouth," Vazquez-Pacheco recalled, "they would look at me like something in a Petri dish was starting to talk."

The Vaccine Working Group reported to the NIAID director, Anthony Fauci, which proved to be a memorable experience for Vazquez-Pacheco. "Fauci had the annoying habit of calling me Bob," *Robert* Vazquez-Pacheco recalled. "I corrected him once. He continued to ignore the correction, so Tony Fauci is one of three people in the world who is actually allowed to call me Bob."

As part of the working group, Vazquez-Pacheco would evaluate proposals for HIV vaccine trials from research universities. He couldn't believe how tone-deaf some of the proposals could be. One such proposal came from Tuskegee University, which immediately concerned Vazquez-Pacheco, who was all too familiar with the university's Tuskegee Syphilis Experiment, coordinated with the CDC and Public Health Service, which observed the progression of untreated syphilis in Black men for forty years by deliberately withholding treatment. As part of Tuskegee

University's HIV vaccine trial, the university promised to give participants transportation to and from the trial. Vazquez-Pacheco balked at this. "You're proposing going into Black neighborhoods with a van that says 'Tuskegee' on it," Vazquez-Pacheco told the designers of the study. "Do you actually think that Black people are going to get in?"

Ultimately, the NIAID's Vaccine Working Group failed to bring about a vaccine. "One of the things that I learned is that vaccines are really complicated and difficult to produce," Vazquez-Pacheco reasoned. "There was only so much money they were willing to put into it."

Elsewhere, Richard Elovich gave up his career as a performance artist and began a long career in public health, albeit in more legal ways than he had with the needle exchange program he piloted through ACT UP. He took a job at GMHC, as their policy officer of substance use and HIV prevention, while also holding an appointment on the New York City Mayor's HIV Planning Council, and chairing the council's Alcohol and Other Drug Services Work Group. Within GMHC, he rose to be director of substance use counseling and education, and eventually to their director of HIV prevention. Part of Elovich's work at GMHC was designing public health campaigns—posters, billboards, bus advertisements and the like. So he naturally reached out to Donald Moffett and Marlene McCarty to produce these campaigns, as their studio Bureau had garnered a reputation for producing top-notch work. Their corporate clients included Calvin Klein, Comme des Garçons, Elektra Records and MTV, which allowed them to also produce work for nonprofits like the ACLU and Doctors Without Borders.

Bureau also designed a streak of film posters and credits, one of those films being Tom Kalin's debut feature film, *Swoon*. Throughout Gran Fury, Kalin had managed to build an impressive body of short films, and he had begun working on this first feature too. Virtually every member of Gran Fury contributed, in some way, to *Swoon*'s production. McCarty and Moffett designed the opening credits and poster. Michael Nesline, Vazquez-Pacheco and Simpson all had minor roles in the film. A few

of Gran Fury's early members, along with some ACT UP contemporaries, appeared too. Todd Haynes and Gregg Bordowitz made minor appearances as phrenology models. Douglas Crimp leant a faux mugshot as well. Neil Spisak, the production designer who had helped with *Let the Record Show . . .*, served as a creative consultant. Of all the Furies present in the film, Elovich had the longest scene, testifying as an expert witness in a climactic trial scene.

Swoon brought Kalin a more international level of recognition. Over the course of 1992 and 1993, *Swoon* won a slew of awards at international film festivals, including Sundance, and was even nominated for the festival's Grand Jury Prize, its most prestigious accolade.

After *The Four Questions*, Mark Simpson's health started to worsen. "Mark really started to get sick after Gran Fury broke up," McAlpin recalled. In July 1994, Simpson was interviewed for a *New York Times* article about how the city's AIDS services had been impacted by the administration of Mayor Rudy Giuliani, who had taken office the previous January. In the first six months of his administration, nearly one in seven employees had left the city's Division of AIDS Services, a service agency designed to help people with AIDS secure what few benefits were offered by the city. The Giuliani administration had first promised to curtail the agency, or eliminate it entirely, but had backtracked when faced with intense criticism from community AIDS organizations. Instead, the Giuliani administration offered a severance package designed to reduce the agency's workforce, while also capping the number of agency employees, despite a growing number of cases. When interviewed for this article, Simpson said that the reduced number of employees had had adverse consequences. He was behind on his rent, broke and taking on increasing amounts of debt just to cover his basic necessities.

By the time of this article, it was becoming physically difficult for Simpson to do the freelance construction work that had supported him for most of his adult life. Simpson's trajectory underscores how he had approached Gran Fury in a way that was different from the rest of the

collective. Most of Gran Fury's other members had their own business, an artistic practice, a career, or something else that they nurtured outside of their work with the collective. Simpson had dedicated himself to Gran Fury to the point that his own artistic practice as a painter began to lapse, and he hadn't insulated himself in the way that Gran Fury's other members had. Simpson had even been the collective's most public face, having appeared front and center on *Kissing Doesn't Kill*. There's an entire generation of queer people for whom Lola Flash, Julie Tolentino, Jose Fidelino and Simpson were the first queer people they had ever knowingly seen, and they had broken through a massive cultural stigma. It's hard to imagine Gran Fury having flourished without Simpson's singular dedication, and it's why Simpson took the ending of Gran Fury so hard, why he felt so abandoned by the rest of the collective when they stopped working together. "For Mark, there was a way in which Gran Fury was his family," McAlpin recalled. "He tried to stand up for everyone there. So to suddenly feel like Gran Fury was falling apart, he felt like he was being abandoned."

Within Simpson's orbit, there were concentric circles of people who assumed varying degrees of responsibility when it came to his caretaking. At the center, closest to Simpson, were Hali Breindel and Kalin, the two people Simpson made his medical proxies. They were with him the most, and at his most private moments, doctor visits and the like.

Surrounding them was a circle of people who were friends with Simpson and would help run errands. These were usually people who lived in the neighborhood, people for whom it would be easy to pick up a prescription or get him some soup. McAlpin typified this role, though he noted that it wasn't as if he were part of a team. Those who helped Simpson in the last years of his life all had one-on-one relationships with him, which didn't necessarily involve Simpson's other caretakers. Unless there was a preexisting friendship, as was the case with Chris Lione and Finkelstein, Simpson's respective caretakers wouldn't see each other on a weekly or even monthly basis. The exception was whenever Simpson was hospitalized. That's usually the only time that everyone in these concentric circles would interact.

"Loring was amazing to Mark," Kalin recalled. "He helped him financially in a way that was incredibly gracious and didn't have a trace of obligation attached to it. He was so self-effacing about it."

Circling them was a group of friends whose form of caretaking was even more removed from Simpson's medical care. One of McAlpin's close friends, the English literature scholar Jeff Nunokawa, typified this circle, and for him, caretaking was often bringing Simpson some takeout, and spending a night in with him smoking weed and watching a Bette Davis movie. Nunokawa described a sense, among this community, that everyone had their turn when it came to caretaking. "You just sort of knew when it was your turn to do a little bit more. Everyone had their turn and it was just a question of whether or not you took it," he recalled. "And with Mark, I knew it was my time."

Nunokawa was the only person in this circle who came to be friends with Simpson after the heyday of Gran Fury. Even then, it was apparent to Nunokawa that Gran Fury had been a really core part of Simpson's identity. "The way that Mark talked about *The Four Questions*," Nunokawa recalled. "It felt less like an intervention and more like a last testament."

In these years, Nunokawa said, Simpson came to realize the limitations of the kind of work that Gran Fury produced. "There came a moment where all of the art, all of the activism, all of the cleverness and all the in-your-face politics could only do so much when it came to the day-to-day realities of people dying," he recalled. This couldn't have been more at odds with how Gran Fury had begun, with its ambitious proclamation of using art to end AIDS. Simpson's declining health seems to have extinguished some of this optimism. Reflecting on Gran Fury, Simpson once told Nunokawa, "There's only so much the art can do."

Toward the end of Simpson's life, Nesline made a final attempt to reconcile their friendship. "It took me a long time to miss Mark," Nesline said. "But I did."

In all the hours that I spent interviewing Nesline for this book, he cried only once, and it was not while recalling the actual fallout between

him and Simpson, but rather, in describing the remorse that he continues to feel. He said, "If there was one thing, in all of my life, that I could go back and change, it would be to say, 'Well, of course,' when Pavel asked, 'Would you love him, whether or not he changed?' Because the repercussions from that just spilled forth beyond imagination. It breaks my heart. It breaks my heart right this minute."

"I knew that I had done something very destructive," Nesline said, "and that we could never regain what we had lost. But I hoped against hope that we might be able to have some version of a friendship. And I wrote him a letter saying that to him."

Simpson responded to Nesline's letter by cutting out a cartoon from the *New Yorker*, published in February 1995, and mailing it back to him. The cartoon was of a man lying in a hospital bed talking on the phone. The caption reads, "Look I'm dying. Gotta go."

What's particularly vicious about sending this particular cartoon is that there are a priest and three others hovering around the dying man on the phone, the implication being that the person on the other end of the phone couldn't be bothered to be present when others could. Sent to Nesline, against the backdrop of their falling out, it was an accusation of abandonment. Nunokawa, Lione, Kalin, Finkelstein, McAlpin and the Breindels could all be here, yet you couldn't? It was also a way of telling Nesline that this was too late to change.

Kalin was present when Simpson cut out the cartoon and tried to dissuade him. "Are you absolutely certain?" Kalin asked him. "Can't you mail the cartoon to him *and* a note? You really just want to mail the cartoon?" But when Simpson made up his mind, there was no dissuading him, and he sent the cartoon. "Michael took it in stride," Kalin recalled. "Michael has enough of a sense of humor to have even had a laugh about it. But it must have been a painful thing to receive." It would prove to be the last correspondence that Simpson and Nesline ever had. "By the time I did miss him," Nesline recognized, "too much time had passed."

In the summer of 1995, Simpson was hospitalized with meningitis, and it was his most debilitating ailment to date. Hali Breindel called Simpson's

sister Linda, the executor of Simpson's estate. Simpson's three sisters each came to New York for two-week shifts: Linda and then Nancy were with him in the hospital, and then Karen helped him move back into his East Village apartment when he was finally discharged and helped get him set up with in-home care. Simpson survived the bout of meningitis, but felt like he never really recovered from it.

Even before this hospitalization, Simpson had developed CMV retinitis, an HIV-related retinopathy, which made it hard for him to see. Sunlight became especially difficult to tolerate, as it also aggravated his skin. "He couldn't sit in his apartment in the afternoon and have sunlight in his face without him feeling like a vampire, and feeling scorched," Kalin recalled. "So, the simplest things he enjoyed were no longer accessible to him."

"He was dying to go down into his studio and paint again," Kalin added. "He hadn't lost his spirit. But his will could no longer override the failure of his body."

In September 1993, scientists from Merck Pharmaceuticals had become tentatively excited over a new drug. They had begun testing Crixivan, a protease inhibitor, and the results initially seemed promising. Rather than destroying the HIV virus, a protease inhibitor disrupts the virus's ability to multiply itself. Blood pressure medications work similarly, as the protease of HIV is remarkably similar to that of the enzyme renin. Merck put Crixivan into a clinical trial, and for the first week, the HIV viral load in all the trial's participants dropped to nearly zero.

But that success was punctured in the second week. Just as they watched patient after patient have their viral load drop to nearly zero, their viral loads soon went back up, and by the end of the second week, all of patients' viral loads had returned to their pretrial levels, indicating that Crixivan alone only had short-term benefits. Though AZT had never had this much of an effect on people's viral loads, it too had a short-term efficacy, and so many were quick to dismiss Crixivan as just another way of repackaging AZT's failed hope.

All but one enrollee had this experience. Patient 142, as they became known, maintained a low viral load for weeks, and then months, after beginning to take Crixivan. Merck's scientists were now hopeful. If one patient could achieve viral suppression, they reasoned, then others could too. They just needed to figure out how to replicate Patient 142 elsewhere.

These findings told scientists something they hadn't previously known about the HIV virus: the HIV virus can reproduce tens of billions of itself within a day, but all of those individual particles have a short life span. So if a drug could disrupt the reproduction of new HIV particles, then the existing HIV virus particles would soon die off.

Of course, other pharmaceuticals were quickly following suit, and by May 1994, Hoffmann–La Roche had asked the FDA to fast-track their own protease inhibitor, saquinavir, as did a number of other companies.

A full year after the Merck study, Patient 142 maintained a viral load so low that the HIV virus wasn't even showing up on lab tests. They hadn't been cured, but it seemed as if the HIV virus had been all but eliminated from their bloodstream. Merck began a second study a year after their first, hoping to enroll patients with a similar profile to 142. They wanted to enroll patients who were still healthy overall, who hadn't taken any drugs before, who had high viral loads, but also high CD4 counts. In their first study, they had tested Crixivan at two different doses, and in this next iteration of the trial, they gave all of these participants the dosage that had proved successful for 142. Most importantly, they began combining Crixivan with other drugs, a cocktail approach that would soon become the standard of care.

By January 1995, the results of the second Crixivan trial seemed promising, and Merck began ramping up its production. Eleven hundred people were taking it by the summer, and by early 1996, the results had shown something previously thought impossible. Protease inhibitors, in combination with other drugs, brought levels of the HIV virus from one million copies in the blood to under fifty. Of course, if one were to discontinue protease inhibitors, those levels would rise again. It wasn't a cure, but it meant that people now had the possibility of living

long lives. The new term for people who had had the HIV virus all but cleared from their bloodstreams was "undetectable," meaning they wouldn't even test positive if given an HIV antigen test. And with an undetectable viral load, scientists later learned, it's also virtually impossible to transmit the HIV virus to others.

Representatives from pharmaceutical companies began speaking at community events, touting the efficacy of these drugs. At one NYU event, an executive interrupted his very mannered presentation to speak more candidly, as the ramifications of these drugs hadn't seemed to register with the audience in front of him. "Maybe you are not understanding what I am saying," he told them. "This is the biggest news ever in this epidemic. This stuff is actually clearing virus out of people's bodies. People are getting better. We don't know for sure yet, but we think these drugs—this whole class of drugs—might allow people to live a normal life."

Everyone in ACT UP had been hardened by years of hearing about imminent new treatments, which were supposedly going to end the crisis but then didn't. So many were understandably skeptical when they heard for the umpteenth time that a miracle cure had been found. But the efficacy of these drugs soon became clear, not through the charts being presented at scientific conferences, but in just seeing people on the street.

It became known as the Lazarus effect. "You would see people who were bone thin putting on that weight," Kalin recalled. Fifty thousand people had died in the year before protease inhibitors became widely available. With the advent of protease inhibitors, the number of AIDS deaths turned downward for the first time in the history of the crisis.

That is, undeniably, a condensed version of how protease inhibitors came to be, and one that does not fully account for the sheer number of hours and ingenuity involved in their development. But there are three aspects of this story, which don't necessarily have to do with the molecules themselves, that are unimaginable without ACT UP's influence.

The first is that scientists had even bothered to study protease inhibitors. Though the possibility of a protease inhibitor had first been

hypothesized in the late 1980s, they went unstudied for years because they hadn't been championed by those who dictate research priorities. For years, the NIH's AIDS Clinical Trials Group had tested and retested AZT—in different doses and different delivery methods, all to no avail. One of ACT UP's most persistent critiques of the way drugs are studied was to expand the kind of research being done. Rather than testing the same drug over and over again, ACT UP pushed for a more diverse range of studies to be funded, to not just study more drugs, but to also study combinations of them. Like many of ACT UP's best ideas, they hadn't thought of this idea themselves but rather had given these ideas a platform they otherwise wouldn't have had.

That there was money to fund these studies was likewise a consequence of ACT UP. It was, for years, one of their demands: more funding for AIDS research. "Pump up the budget," was one ACT UP slogan. During the peak of ACT UP's efficacy, the federal government began spending drastically more on AIDS research. With that funding, a greater range of studies became possible, though it conversely meant that funding dried up for other research. Vazquez-Pacheco recalled that, as soon as protease inhibitors started to show the most remote promise, such was the case for an HIV vaccine.

Lastly, the speed at which protease inhibitors came to market would be unthinkable without ACT UP's prior work concerning the FDA's approval process. When three protease inhibitors were brought to market in 1996, they were then the three fastest drugs ever approved by the FDA.

Save for synthesizing the drugs themselves, ACT UP facilitated virtually every step of actualizing protease inhibitors.

At the height of the crisis, fifty thousand Americans died of AIDS in a single year, and were it not for the advent of protease inhibitors, the annual number of AIDS deaths would have surely kept rising. Once protease inhibitors became available, the number of American AIDS deaths began rapidly declining, and has continued to decline ever since.

Given that the profit motive for finding an AIDS treatment had become so overwhelming with the ever-increasing number of AIDS cases, pharmaceutical companies would have undoubtedly brought protease

inhibitors, or some other treatment, to market eventually. But that protease inhibitors came at this moment, and that they didn't come years or a decade later, is undeniably because of ACT UP.

When protease inhibitors came to market, the two members of Gran Fury who had tested positive had to decide when to start taking them. Vazquez-Pacheco told his doctors that he wanted to wait two years, to see how protease inhibitors would work. Even though he had few T-cells left, Vazquez-Pacheco had managed to stave off any opportunistic infections. "I didn't jump on it immediately," he recalled. "I had learned too much about how medications are developed, and I didn't want to be the guinea pig." When AZT had first come out, Vazquez-Pacheco had decided against taking it because a disproportionate number of Black people were developing chronic anemia. His decision to not take it proved to be a wise one for other reasons too. He had seen how AZT had initially been issued at a dosage that proved to be horribly toxic, and was later shown to be just as effective in smaller, less toxic quantities.

His suspicion about the first wave of any new drug proved to be well-founded when it came to protease inhibitors too. Saquinavir, the first protease inhibitor, which had come to market just a few weeks before its competition, proved to only be effective for about sixteen weeks, as it had a low bioavailability, meaning that most of it was filtered out through the liver. Despite this, its producer, Hoffmann–La Roche, had fast-tracked it, believing that this problem was insurmountable and that all protease inhibitors would face this. They turned out to be wrong, and thankfully, other producers of protease inhibitors tried to synthesize drugs that wouldn't be filtered out as readily.

Vazquez-Pacheco had to change his plans when he was hospitalized with a fever of 105 and began dropping a significant amount of weight. "After I got through that," he recalled, "I decided that I might as well start taking medication, that this was probably a good time to start." He began taking protease inhibitors and started to regain all of the T-cells that he had lost over the years. Vazquez-Pacheco had been living with

HIV for at least fifteen years and took no medications for it the entire time. It's impossible to overstate how miraculous it is that he lived to see the advent of protease inhibitors and that he is still alive today.

Mark Simpson didn't have the option of waiting. He had developed a staph infection in the Hickman catheter that had been inserted into his chest, and it proved to be the most consequential problem that he endured. "He would describe the burning and discomfort as the medications went in his Hickman catheter," Kalin recalled. "You could just see how hard it was for him to take the treatments." It slowly eroded him away, and as Finkelstein put it, "That infection was the cascading force behind every decision Mark would soon make about his life and death."

Simpson was one of the few for whom protease inhibitors didn't work, as his chronic staph infection had eroded too much of his immune system to be salvaged. "It was like a horrible cartoon," Kalin said. "Where they're holding on to a rope, and then it's a series of ten strings, and then it's a piece of dental floss. And then, it's stretching, and then it snaps, and they fall and they're gone, while other people are climbing up and totally fine."

Though Mark Simpson's memoir was almost entirely about his childhood and early adult life in Austin, he did write about living with AIDS once, in the memoir's prologue, which he titled "Almost Fifty." It's a story of him, Annette Breindel and Chris Lione all going on a trip upstate together, and struggling to get out the door. Chris's cat had gone missing just as they were about to leave, and all of them were in a panic trying to find it, worrying that it might have jumped. Chris and Annette were neighbors and lived on the thirty-third floor of their building, so if the cat had fallen, that would have surely been its end. They eventually found the cat, which had been accidentally locked into a cabinet by the maid. "Thank god he hadn't jumped," Simpson wrote. "Chris might have followed."

They finally began the three-hour drive to Kingston, where Annette had a nearby country home. The rain had slowed them, and they arrived around midnight. There, Simpson developed a spot in his field of vision, a manifestation of his HIV retinopathy. "The spot leapt from the lower right to the mid left across my field of vision," he wrote. He first thought it was a mouse, and decided to not tell Annette because of her phobia of rodents, and then seems to have realized what it actually was.

Chris said that he couldn't place the story in time, that there had been so many trips upstate that it could have happened at any point in the last ten or maybe even fifteen years of Simpson's life. Nesline, Finkelstein, Lione, Kalin, Simpson, Hali and Annette had all been there so many times, and in different permutations, that the trips blurred together.

"It's all that's ever been important to me, really, this relation stuff," Simpson concludes. "The painting, the political action, the writing, the parties—all that was only time-fill, or therapy, activities between the void. I'd never expected to live too long. But now I'm determined to make it to fifty." He lived to be forty-six.

On November 10, 1996, Chris Lione decided to stop by Simpson's apartment, unannounced. Lione was heading out of town, to a country home in rural Pennsylvania, and wanted to check on Simpson before he left. The two had been friends for about twenty years, so it wasn't unusual for Lione to pop in without prior notice.

When Lione walked into Simpson's apartment, he could tell that something was off. Kalin and his partner were there with Simpson, and Lione detected that his timing had been inopportune. "It was like I walked into something that I wasn't invited to," Lione recalled. "There was an enormous coldness. Not that they were cold towards me, but I just didn't know what I had walked into." While he settled in, Lione sensed that Simpson had pulled Kalin and his partner aside and asked them to leave for a bit and come back later. Kalin and his partner abruptly left, saying that they wanted to go look at Simpson's garden, which felt to Lione like a hastily made excuse.

Years before, Lione had gifted Simpson a set of felt appliquéd pillows with an art deco design, which had begun to fall apart over the years. So whenever he would visit him, Lione would work on sewing these pillows back together, as he did that day.

"Put the pillows down," Simpson told him.

Then Simpson explained what was happening. With the assistance of Kalin, Simpson was going to end his own life, and Lione had walked in just hours before this was going to happen.

Simpson's plan, to end his own life, had been in place for at least a week. He had conferred with his doctors, who agreed that it was a sensible choice. Besides the CMV retinitis and the staph-infected Hickman catheter, he was effectively homebound by the fact that he couldn't control his bowels, and he was having a hard time getting up and down the stairs of his apartment building. Simpson's doctors wrote him a prescription for Compazine and Darvon, a combination that's commonly used in physician-assisted suicides. "The function of those prescriptions was absolutely clear," Kalin said.

Simpson had called his family in the days leading up to November 10. "I've decided I'm ready to go," he told his sister Linda, though she didn't immediately register what he meant. In New York, the news that Simpson would end his own life had trickled out through Hali Breindel and Kalin, though it seems as if Chris Lione hadn't gotten word, even though everyone else had.

Over the past week, Simpson had readied himself, making his final arrangements, eating his favorite foods and hanging out with Kalin. "We talked and just did everything you could possibly do with your closest friend, before they went," Kalin said.

The day before Simpson ended his life, Kalin went to Russ and Daughters to get caviar for him. "Mark had never had beluga caviar," Kalin said. "To me, this was not acceptable." While fetching the caviar, Kalin bumped into Michael Nesline, who lived on Second Street, between Avenues A and B, just around the corner from Russ and Daughters. Nesline could tell that something was wrong with Kalin. "His eyeballs were spinning around in his head," Nesline recalled.

"What's going on?" Nesline asked. Kalin then told him that Simpson would be ending his life the next day.

In preparing for his death, Simpson gave away all his possessions. That day, he gifted Lione a set of four Portuguese majolica plates with a yellow cabbage leaf design. Lione had the matching cups and saucers, which he'd gifted to Simpson one Christmas, and then Simpson had regifted them back to Lione. They had had a long-running joke about who would ultimately gift their pieces to the other, thus completing the set. Years later, with the advent of the internet, Lione learned that this pattern was hardly rare, and easy to find. "We had no idea how common this majolica was," Lione said. But in the years that Simpson was alive, this majolica set had been a token of their friendship, a running joke and a set of mementos, something they had once shared and that would now be Lione's.

Lione stayed for about an hour, and then Simpson asked him to go. Simpson made it very clear to everyone in his life that he wanted Kalin, and Kalin alone, to be there when he passed.

Simpson walked Lione to the door and said goodbye. "It was about the strangest thing that I've ever experienced in my life," Lione said. "Because we hugged and kissed, and I knew that, the next day, he might be gone."

After he left Simpson's apartment, Lione drove out to the house in Pennsylvania. He spent the rest of the day staring at the phone, wondering if he should call Simpson and try to talk him out of his plans. "I have to respect his wishes," Lione realized. "I can't call him. I can't do anything. I just have to wait till morning." Lione recognized that Simpson's dying was all but inevitable, that he had to honor the purposefulness of Simpson's decision. He reasoned that Simpson chose this time because he wanted to spare himself from the AIDS-related dementia that plagued so many toward the end. "Mark never lost his mind," Lione recalled. "He had it until the very end. And maybe that's why he chose the time that he chose." Lione then took a handful of Xanax and had a couple of drinks to knock himself out for the night.

That same day, Hali Breindel came in the afternoon to say goodbye too. No one else was there, she recalled, but Simpson did phone one of

his sisters and left a message saying that he loved her. "It didn't feel real," Breindel said. Then she left, and Kalin returned to the apartment.

The night that he took his own life, Simpson got completely naked in front of Kalin, something he had never done before. Having been roommates throughout virtually all of Gran Fury, they had seen each other in various states of undress, coming or going from the shower. But this was the first time that Kalin had ever really seen Simpson naked. "We never spoke about it," Kalin said. "But I feel like he wanted me to witness his body." The degree to which AIDS had ravaged Simpson only became fully apparent as Kalin saw him now. "He was so devastated by the staph infections that he dropped a huge amount of weight," Kalin said. "His ass was like a flat board." Kalin guessed that Simpson had once weighed 160 or 170 pounds. Naked, he looked to be about 110.

Simpson took a last bath, then swallowed his fatal dose of pills around eight. He started to nod and then fell asleep. Simpson's friends knew him to be a snorer, but as the drugs began to have their effect, his snoring became particularly loud and guttural. Kalin sat with him, waiting, and then dozed off. When Kalin awoke, he saw that Simpson was no longer snoring and knew that he was dead.

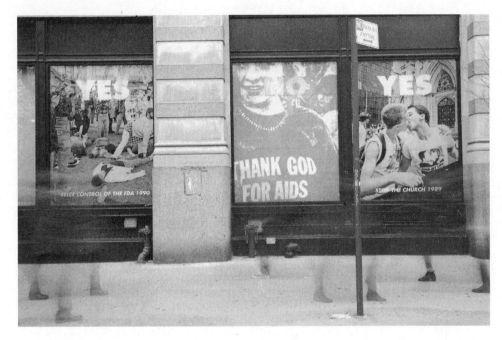

Exterior of Gran Fury's retrospective at 80WSE. Photograph courtesy of Gran Fury.

CHAPTER 13
AFTERGLOW

Survival is a spot between the rock of guilt and the hard place of memory.

—Robert Vazquez-Pacheco

om Kalin wanted to go home, shower and change his clothes before calling the coroner. The night had been long, and Kalin knew that he was also going to have to call Simpson's family soon, something he dreaded. That morning, Kalin saw a day-old *New York Times*. On the front page of the *New York Times Magazine* section was a now infamous story written by Andrew Sullivan, "When Plagues End." A year after the first protease inhibitor, Sullivan declared that AIDS "no longer signifies death. It merely signifies illness."

To have just watched his best friend die, and then read this, absolutely infuriated Kalin. It seemed as if the world was ready to move on from AIDS, despite the fact that the death toll had only slowed, not stopped, and that those who had outlived the crisis were now burdened with unimaginable trauma. "Things were improving, but that didn't really take care of the psychic damage," Kalin reasoned. "Protease inhibitors didn't fix the problem of all the corpses. It didn't bring Mark back. In some ways, Mark's death became even more painful, knowing that he had just missed the gap."

The AIDS crisis had begun long before the *Times*'s first article describing the prevalence of Kaposi sarcoma in young gay men, and continues to this day, despite Sullivan's proclamation that it had ended. But those two articles seemed to bookend the queer community's involvement. "I really truly believe that the LGBT community officially abandoned AIDS with Sullivan's article in the *New York Times*," reasoned Charles King, a former ACT UP member who had by then become the CEO of Housing Works. "And the reason they abandoned it was [because] for them it was over. It was now a Black disease, not their disease." Robert Vazquez-Pacheco noticed something similar among AIDS organizations. All of the gay white men seemed to be finding new jobs. "Suddenly, international work became interesting," he recalled. "Or people started doing something else. And it was like, wait a minute—the epidemic hasn't changed in communities of color."

For those who could access protease inhibitors, the crisis was virtually over. For those who couldn't, virtually nothing had changed.

Around 6:30 a.m., Hali Breindel and Kalin met back at Simpson's apartment. "It was very cold out," Breindel recalled. "It wasn't a sunny day. Quiet." They let themselves in and found Simpson's corpse on the sofa. "It was very surreal," Breindel recalled. "He was sitting upright with his eyes open." Kalin and Breindel sat opposite Simpson, in the two chairs across from the sofa. They were mostly silent. Then Breindel went and made them all a pot of coffee. "I know it sounds weird," she said. "But in the moment, it felt like the normal thing to do, that Mark would be having coffee with us. And we just sat with him."

Finally, they called 911. "When the police and the medics came," Breindel recalled, "they didn't ask any questions. It was so common and he looked so depleted." Then they watched the coroner strap Simpson's body to a gurney and take him out of the apartment.

Then they called Simpson's sister, Linda. "Mark put us in a really horrible position," Hali recalled. "We had to call Linda to tell her that he had died, but he didn't want us to tell her that he had committed suicide."

They initially withheld the fact that Simpson had taken his own life, allowing Simpson's family to believe that Mark had died of AIDS. In a sense, he had.

Simpson's family came to New York to claim his body and stayed for the memorial service that Hali hosted at her apartment. Even at the memorial service, his sister Linda still hadn't realized that her brother had ended his own life. But eventually she did. "It was a slow awakening," she said, and so she called Kalin to ask him.

"Do you think Mark took his life?" she asked Kalin.

Kalin was relieved when she finally asked. "Yes, of course, Mark took his life, and God bless you for asking," Kalin told her. "I was so afraid you'd never know."

Contrary to what Simpson had thought, she was completely understanding. "Look, my husband died of cancer," she told Kalin. "If he hadn't died of cancer when he died, we were going to pursue euthanasia. He was going to take an overdose or take his own life, because he couldn't deal with the suffering."

This response shocked Kalin. "Mark had described them and made them seem incapable of dealing with something that, sadly, they weren't incapable of dealing with," Kalin said. "And that was something that really broke my heart." It devastated Kalin to realize that there was such a gap in understanding between Simpson and the rest of his family, that Simpson had died not knowing that at least Linda would have accepted his decision.

Simpson had given Kalin a will of sorts, detailing who would receive what of Simpson's possessions. Everything was detailed, all the way down to the house plants. And this also included all of Simpson's pets. Kalin's partner, Craig Paull, was to receive three of Simpson's Gouldian finches, Sweet as Pie One, Two and Three. Hali's brother, Scott, was to receive Simpson's cat, Precious Darling. "After Mark died and the coroner came, Precious Darling climbed under the sink, into the bowels of Mark's apartment and refused to come out," Kalin recalled. "It was a fucking horror show." So for weeks and then months after Simpson died, Kalin and Scott Breindel had to keep returning to Simpson's apartment, trying

to lure Precious Darling out from underneath the sink. They would leave food for it, hear it crying and kept trying to coax it out. "We finally realized that the cat was dead and had to fish it out," Kalin recalled. "You could not find a more bleak rejoinder to Mark's death."

The following January, Simpson's family made another trip to New York and closed out his apartment. He had left them six paintings, which they loaded into a U-Haul and then drove back to Texas.

After Simpson's death, Kalin fell into a years-long depression: "1996 to 2000 was the bleakest time in my personal life," he recalled. He had once been Gran Fury's most animated member. For years, he had juggled a full-time job producing AIDS educational videos, making his own feature-length film while regularly attending ACT UP meetings and demonstrations. Now he couldn't get off the couch. And like so many other ACT UP alums, he began drinking heavily in these years, self-medicating from the toll of the last ten years.

Initially, Kalin thought he was just exhausted, depressed or a combination of the two. Among those who had dedicated themselves to ACT UP, there was widespread burnout and fatigue in these years. Coupled with this was the exhaustion of having been Simpson's caretaker, and the emotional toll of losing his best friend. Understandably, Kalin felt permanently fatigued.

But Kalin's partner, Craig Paull, worried that something else was wrong. "I wasn't acting like my normal, healthy energetic self," Kalin recalled. "My work, especially, became almost impossible for me to do." Paull suggested Kalin take an HIV test. Kalin's last test had come back negative and he was diligent about practicing safer sex, but it had been some years since his last test, and Paull encouraged Kalin to see if this was hampering his ability to function.

When they drew his blood for the test, Kalin had a premonition that the results would come back positive. And they did. But testing HIV-positive by the end of the 1990s meant something profoundly different than it had even a few years before. Since the first protease inhibitors had

come out in late 1995 and 1996, more medications had come to market, and a regimen of Sustiva and Combivir had become a very standardized combination. "By the time I knew I was HIV-positive," Kalin recalled, "people had been taking the Sustiva-Combivir combination, tolerating it well and putting weight back on and getting good T-cell results."

"I think it's telling that among the first that I told were members of Gran Fury," Kalin said. "Michael was really concerned and helpful in the early stages, giving me advice and checking in on how I was tolerating things and making sure I felt supported."

Kalin actually felt a sense of relief when he received his test results, in part because he now knew why he felt so fatigued all the time, and because he also understood that this was now fixable. "It was an enormous relief to realize, okay, I didn't lose it somewhere in my mid-thirties. I didn't have all my great ideas when I was twenty-eight years old," he said. "I actually still am capable of being a functioning artist, and I've been operating with a massively elevated viral load and suppressed T-cells."

One of Kalin's first reactions to testing positive was to secure himself a more stable job, one that could provide him with reliable health insurance, something he now knew that he would need for the rest of his life. "The minute I knew that I needed to be insured and have a more solid situation, I made that happen," he recalled. "Because I just knew that I wasn't going to survive without it." Since *Swoon*, Kalin had continued making his own video work while writing and producing feature-length films—it was steady work, but didn't provide him with the kind of health insurance that he now needed. He took a teaching position in the film department at Columbia University. It's easy to see why Kalin was able to secure a full-time teaching position at an Ivy League university. He had written, edited and directed an acclaimed feature film, all just before turning thirty. And with a decade's worth of video work under his belt, it was clear that he had a mastery of the very practical skills of filmmaking. He was also someone who had strong theoretical training, having been a student of critics like Craig Owens, and he had written reviews and essays for publications like *Artforum*.

He had also taught one-off courses as an adjunct at Brown and Yale. Kalin was a catch.

But Kalin's situation illustrates the precariousness of the American healthcare system that continues to exacerbate the AIDS crisis. Being able to immediately secure a job with good health insurance is something not available to all, and for those who can't access that kind of healthcare, little changed once protease inhibitors came to market.

Especially in his first years, Kalin was unnerved by the kind of pervasive wealth that's prevalent at a place like Columbia. Some of his students seemed to have bigger production budgets than he did. This discomfort was amplified by the fact that he wasn't much older than some of his students. "It took me maybe three years at Columbia to be like—*you're* the teacher, calm down," Kalin said.

As he began teaching at Columbia, Kalin experienced immune reconstitution inflammatory syndrome (IRIS), a condition that arises when a suppressed immune system begins to recover, then overresponds to a previously acquired opportunistic infection. All of the skin on Kalin's hands and feet peeled off. A bowling ball–sized swelling developed in his thigh, then began moving down his leg, first to his knee, then to his ankle. His colleagues weren't always helpful, and he would hear things from them like, "God, you look thin."

But Kalin eventually did acclimate to his medication regimen, albeit with one lasting side effect. He began dreaming much more intensely, a common side effect, but one that was only supposed to last for the first week or month and lasted for about a year and a half. "It's like taking LSD and dreaming," Kalin described. "But they're pedestrian and normal ordinary dreams . . . things that sound laughable when you describe them—Craig leaves me for my sister—but you wake up wrenched and weeping and convinced that all your life has crumbled apart. And then you got to go and teach, or get up and do your work."

When Sarah Schulman interviewed Kalin for the ACT UP Oral History Project in 2004, he reported that he had regained the energy he had lost in the years after Simpson's death and was now feeling well enough to begin working on his second feature. That film, *Savage Grace*,

premiered at Cannes three years later, starred Julianne Moore and proved to be a breakout role for the actor Eddie Redmayne. Since then, Kalin has continued to make short and feature-length work and still teaches in Columbia's graduate filmmaking program.

After Kalin acclimated to his new regimen, he began to recall his work with ACT UP and Gran Fury in a very different way. He had spent all of his time in ACT UP and Gran Fury thinking of himself as an HIV-negative person, but now he believes that he seroconverted in the late 1980s, meaning that he was actually living with HIV for much of the time that he was in Gran Fury. Finding himself on the other side of that divide recast the personal significance of his involvement with both. Kalin had joined ACT UP and Gran Fury to save the lives of his friends. He wound up saving his own life too.

In 2010, Debra Levine, a former ACT UP member, was writing her doctoral dissertation on ACT UP and its performance of affinity. One of her dissertation chapters centered on Gran Fury's *The Four Questions*, and so she interviewed Kalin, Avram Finkelstein and Michael Nesline, in part to reconstruct the fallout between Nesline and Simpson. While unearthing some archival material for Levine's dissertation, Nesline came across the *New Yorker* cartoon that Simpson had mailed him and realized that there was something about it he had forgotten. The cartoon was pasted to a letter, which gave the cartoon a more humorous, less caustic tone. It read,

Michael,

The events of the past are as far as I'm concerned, in the past. Let sleeping dogs lie. Thank you for your apology, it made me feel better. And hoping to give you peace, I forgive you.
Sincerely,

Mark

Nesline had forgotten about this, and until he reread it fourteen years after Simpson's death, had not allowed himself to believe that Simpson

had forgiven him. Kalin recalled being present when Simpson cut out the *New Yorker* cartoon and urging Simpson to send something additional— he likewise recalled that Simpson hadn't included anything in addition to the cartoon. But indeed, he had. Chris Lione similarly recalled that, when he saw Simpson just hours before he took his own life, Simpson had voiced his frustration with people who he felt had disappointed him. In Lione's recollection, Simpson never forgave Nesline. But the opposite is true. Simpson had forgiven Nesline, and here was irrefutable proof.

It's understandable that Lione or Kalin would misremember aspects of this story, as it wasn't entirely out of character for Simpson to hold grudges if he felt crossed. But Nesline's misremembering is harder to square. Blocking out traumatic life events is a well-documented and commonplace coping mechanism. But blocking out an act of forgiveness was hard for me to understand until I started to reconsider my own interviews with Gran Fury's other members. The very first interview I did for this book was with Richard Elovich, at his home in Brooklyn, which he shares with Daniel Wolfe—they've been together since they first kissed during ACT UP's Stop the Church demonstration. As we sat in his backyard, Elovich told me something that, at first, I thought was impossible.

"I don't remember whether certain friends of mine are alive or dead," he said.

Surely he is exaggerating, I first thought. And at my most cynical, I wondered, *Are you really friends with someone if you can't remember whether or not they've been alive for the past thirty years?* Especially with the internet—Elovich is on Facebook, as are most of the people I interviewed for this book—how could you not know? But as I continued the research for this book, I started to understand what Elovich meant.

Many of the ACT UP alums I interviewed described conflicting feelings, wanting to both retain their memories of this time, but also needing to do away with them. I saw this most clearly in my interviews with Kalin, particularly in how he recalled aspects of Simpson's decline and death. In his 2004 ACT UP Oral History interview, Kalin recalled that Simpson had taken protease inhibitors, but that they hadn't worked for him. When I interviewed Kalin for this book in 2019, he said that he couldn't remember

which protease inhibitor Simpson had taken. But in our final interview for this book in 2021, Kalin said that he actually wasn't sure whether Simpson had even tried to take protease inhibitors, or if Simpson's health was too compromised by the time they came to market for them to even be worth trying. In this last interview, Kalin told me, "I always wondered: Had he just given up hope and he wanted to die? And if in fact he had taken those drugs, would it have saved him or changed things? But that's one of those painful questions of life that I've had to let go, because it was too hard to leave that as an unresolved question."

I reminded Kalin that, in his 2004 Oral History interview with Schulman, he definitely said that Simpson had, in fact, taken protease inhibitors. "Maybe he didn't tolerate them, actually," Kalin responded. "I know there was a reason he didn't continue to take them, and from what I understood, it was tied to the fluconazole and the ongoing MRSA staph infection he was dealing with." Kalin is more trustful of his memory from the 2004 interview, given that it was closer to the time of Simpson's death, and so it seems as if Simpson *did* take protease inhibitors, but that they didn't work for him.

"You have to make your peace with the unresolved questions," Kalin reasoned. "For me, grieving isn't forgetting. Grieving is agreeing with myself to stop asking the question again. It's cauterizing certain questions." I've seen a version of this with many of the people I interviewed. During our last interview, Donald Moffett told me that he had recently come across the obituary for his partner, Bob Earing, and that he'd send it to me. And Moffett did begin to look for it, but ultimately decided to not pursue it. "I poked around for his obit," Moffett later wrote to me. "I have it, but didn't want to find it." I understood this to be an act of self-protection, one that said more than an obituary ever could.

"I've had to let go of some things to move on," Marlene McCarty said. "Decades later, we're starting to realize that we all have PTSD."

McCarty is not being hyperbolic, and the prevalence of PTSD among former ACT UP members is well documented. In 2018, a study of former ACT UP members was conducted by Treatment Action Group, Columbia University's Department of Psychiatry and the New York State Psychiatric

Institute, "Trauma and Growth: Impact of AIDS Activism." It was an assessment of the lingering trauma that the AIDS crisis had had upon former ACT UP members. Among those who experienced PTSD, a number of cofactors emerged. People who were HIV-positive, the primary caretaker for a sick person, the widow of a partner or had lost many friends (as opposed to some or none) all tended to have higher incidents of clinically diagnosed PTSD. ACT UP often framed the fight against AIDS as a war—Gran Fury's *When a Government Turns Its Back on Its People* billboard is just one of countless examples. So perhaps it's unsurprising that many of those who dedicated themselves to ACT UP and Gran Fury later found themselves confronting one of war's most common lingering effects.

Like others who live with PTSD, those in ACT UP have coped in a remarkably similar way. Many of those who had dedicated themselves to ACT UP, and outlived the crisis, began to self-medicate in the post–protease inhibitor years as a way to deal with their losses. The 2018 study of PTSD among former ACT UP members found that almost half of them reported having had past problems with substance use. "Everyone went into their corner to nurse wounds," Kalin recalled. "Many of us struggled with substance abuse and started drinking to cope with the enormity of what we had gone through." Gran Fury is no exception. Some of this predates the collective, as with Elovich's heroin usage or Simpson's alcoholism. And some of this substance use flourished during the collective's tenure. Moffett even described drinking as being part of the fatigue that was one factor in the nexus of Gran Fury's demise. "We were incredibly busy," Moffett recalled of the end days of Gran Fury. "But also incredibly broke and incredibly drunk most of the time. And we just had to change that dynamic because it just hit a wall."

Much of the substance use described in the 2018 study mushroomed in the years after ACT UP dissolved, as a second epidemic consumed many ACT UP members who had outlived the AIDS crisis. By the new millennium, crystal methamphetamines had become the defining drug of this generation. Statistically, crystal meth usage in the larger gay community was relatively small. But among former ACT UP members, it's left quite a footprint. Nesline said that he had been "high to the gills" on

crystal meth when interviewed for the ACT UP Oral History Project in 2003. One of those in Simpson's caretaking circle recalled those years in similar terms: "Some of that deep, dark mischief I got into in the early 2000s had to do with—not survivor's guilt, nothing so simple—but just the unrealness of being alive. Like, how the fuck did I miss that bullet?"

Many of those I interviewed for this book described how the lingering trauma of the AIDS crisis has impacted their generation's abilities to fully enjoy the kinds of civil liberties that some queer people have since won, and watching this has surely exacerbated that "unrealness of being alive." The campaign for gays to serve in the military was baffling for many of this generation, especially against the backdrop of increasingly morally dubious wars in the Middle East. For some members of Gran Fury, their activism had begun by dodging the draft for the Vietnam War. They had fought to stay out of the military, not to join it. So it was baffling to them that gays would actively campaign to join the military, especially in the midst of wars that were, in many ways, so reminiscent of Vietnam.

Even marriage is something to which many of them are averse. Just as Andrew Sullivan proclaimed AIDS to be over, gay marriage was taken up as a hallmark legislative issue pushed by gay rights organizations. To those who had worked for years to end the AIDS crisis, it seemed as if the world was ready to move on to the next issue, while the carnage of the last fifteen years was still strewn about. "We are of a generation that didn't ever imagine, or want, gay marriage," said Loring McAlpin. He characterized his generation's experience of the AIDS crisis, the lack of concern from straights and the way in which this weighs upon their memory as being a hindrance to participating in this hallmark of straight culture. "Knowing what gay people have gone through with AIDS," he reasoned, "why would I want to be a part of this institution? And for people who didn't grow up with that battle, they don't have that relationship. They don't understand the distance."

In the course of interviewing members of ACT UP and Gran Fury, I often heard them describe gay marriage and gays in the military as token gestures that don't actually compensate or account for what they lost. "Gays got marriage and the military, but this country has never

acknowledged the trauma of what we went through," Elovich said. "It's why Holocaust survivors spend their whole life talking about their experience. People don't know what happened."

Elovich noting this, that there has never been any sort of widespread reckoning with the sort of serial loss that was endured, raises a set of questions: What would such a reckoning look like? How could that reckoning actually serve the people who lived through this? And what would help future generations grapple with the mistakes of the AIDS crisis, and help us avoid making them again? It's impossible to answer these questions without talking about Gran Fury, how their work has been used, and very frequently misused, to memorialize the AIDS crisis.

In the years after Gran Fury's dissolution, museums and other institutions began acquiring the collective's work, and one of the earliest examples of this was facilitated by Terence Riley, the architect who had joined ACT UP after seeing its Post Office demonstration. Though Riley didn't stay with Gran Fury, he was integral to *Let the Record Show . . .* and had leased some office space to Bureau, where Gran Fury regularly held meetings in its later years. By 1991, Riley had become MoMA's chief curator of architecture and design, and soon into his fourteen-year tenure there, he acquired Moffett's *He Kills Me* poster for the museum's permanent collection. Though not a Gran Fury poster, it represented a shift in how museums saw the output of Gran Fury. Once, Gran Fury had been something to be used in the present. Now it was something to collect, as a way of memorializing history.

Riley has a telling anecdote about the *He Kills Me* poster, its acquisition at MoMA and how museums have become the resting place for Gran Fury's work. Not long after MoMA acquired *He Kills Me*, the museum began a fundraising campaign for the Yoshio Taniguchi renovation. David Rockefeller, MoMA's chairman, wanted to begin the fundraising campaign with a dinner hosted in the Painting and Sculpture Galleries. Unsurprisingly, the curators at MoMA weren't too thrilled about this idea. Something about canapés in the same room as *The Starry Night*

didn't sit well with them. "Rockefeller leaned on me," said Riley. "And so we decided to hold the dinner in the Design and Furniture Galleries." *He Kills Me* presided over Rockefeller and about twenty guests, who dined at one long table. "It was hung on the wall right behind me," recalled Riley. "Anytime somebody looked in my direction, they wound up looking at Ronald Reagan. I got to watch a whole variety of reactions."

Gran Fury's work is now held in the permanent collections of the Metropolitan Museum of Art, MoMA and the Whitney and has been shown in most major museums in America. When exhibited in these museums, Gran Fury's work most often appears framed, squared on a white wall and without any context recognizing that posters were one nexus in a multitude of factors that made ACT UP successful, and without acknowledging that the AIDS crisis still persists. Displaying Gran Fury's work in this way is of disservice to their legacy in every way imaginable. Rarely is there any indication of how it was used or why it was useful. Hung there, they're objects to be ogled for their aesthetic beauty, which would be fine if they didn't look so dull up against a white wall.

I remember first feeling this while walking through the Whitney Museum's "An Incomplete History of Protest" exhibit, which featured a smattering of Gran Fury's posters. I was a year into writing this book and felt a pit in my stomach when I happened upon the wall where their posters were gathered together. They just looked so boring hanging there, and I began to worry that I had just spent a year of my life consumed by the personalities and interpersonal drama of Gran Fury, while the work itself was a collection of duds. These worries consumed me until I revisited the photographs and footage I had amassed of Gran Fury's work—at ACT UP demonstrations, on buses and bus shelters, on billboards and the sides of buildings, all the places where their work was first meant to appear. In those images, I saw the real importance of Gran Fury's work, not in the posters themselves, but in how they came to be used.

In 2010, McCarty was preparing for the first ever retrospective of her own visual art at New York University's 80WSE gallery. The design firm that

McCarty and Moffett had started, Bureau, had disbanded around the new millennium, as both McCarty and Moffett had fully established themselves as gallery-showing visual artists. In the course of preparing for this show, its curator, Michael Cohen, asked if McCarty wanted to include any of her work with Gran Fury. McCarty declined, as it would go against the ethos of Gran Fury to show the collective's work in the setting of an individual's retrospective. Cohen then asked if the whole of Gran Fury would be interested in its own retrospective, something that had never happened before. McCarty told Cohen that she would ask everyone else, but warned him that the answer would most likely be no.

But among Gran Fury's other members, there was an appetite for Cohen's offer. All but two members, Elovich and Moffett, agreed to participate. Since leaving GMHC as its director of HIV prevention in 1999, Elovich had gone back to school and eventually received his PhD in sociomedical sciences from Columbia University. He's now a foremost leader on HIV prevention in post-Soviet countries, the region of the world with the fastest growing AIDS epidemic. His work with the Soros Foundation and other NGOs keeps him in Uzbekistan for much of the year.

After the dissolution of Gran Fury, Moffett had taken up cake decorating, wanting to give himself a reprieve from the constant awfulness of the AIDS crisis. Up until that point, Moffett's visual art had mostly been photographic and text based, but after he found that he loved the feeling of pushing around icing, he began to experiment with paint and resin, which became a core part of his practice. Shortly after the disbanding of Bureau, Moffett began showing with Marianne Boesky Gallery, and his work is now held in most of America's foremost art museums. Moffett is someone who seems more intent upon focusing on the present, rather than rehashing the past. In one of our interviews, he half-jokingly told me that he only participated in this book so that he never has to answer a question about Gran Fury again. And though much of his visual art is very abstract and coded, he still occasionally makes more explicitly political pieces for public consumption. During Trump's presidency, Moffett had a piece that read "Break

his little Twitter Finger" pasted around New York, which he signed on behalf of "Unhinged homos."

But the rest of Gran Fury was game for the retrospective. Everyone still lived in New York, and no one had gone far. John Lindell, McAlpin and Nesline still lived in the apartments that they had had since their ACT UP days. Their first meeting was held in the gallery space where the show would be mounted and was a reunion of sorts. Save for a 2003 interview with *Artforum*, this much of Gran Fury probably hadn't been in the same room in about twenty years.

Finkelstein noted that virtually nothing had changed with the group's dynamic. "There was a fair amount of talking over one another and jockeying to be heard," he later wrote. In the midst of this first meeting, someone posed a question to the rest of the group: "If we were to mount one of the works in the streets of New York now, which one would still be relevant?"

Almost everyone settled upon *Welcome to America*, as the only alteration needed to make it relevant would be to remove the qualifier that South Africa doesn't have a national healthcare plan. Finkelstein agreed, but offered another suggestion: *The Four Questions*. "You could have heard a pin drop," Finkelstein later wrote. According to Finkelstein, some people in Gran Fury hadn't ever seen *The Four Questions* before. He described it as Gran Fury's third rail, given that only a handful of its members had actually worked on the poster and that it's so intertwined with Mark Simpson's death.

That first meeting, and Finkelstein's suggestion to include *The Four Questions*, highlighted one of the first challenges of organizing this retrospective. There was no existing list of Gran Fury's work, and there were several projects, like *The Four Questions*, that fit into a gray area of whether or not they constituted Gran Fury projects. Especially in its first year, Gran Fury had functioned as a loose and ad hoc collective. The emphasis had been upon making work, not crediting it. What would be made of works like *He Kills Me* and *Silence=Death*, projects made by Gran Fury's members that predate the collective and undoubtedly influenced their work but are often misattributed to Gran Fury. How would

Let the Record Show . . . , which technically predates the formation of Gran Fury but is likewise part of their story, fit into this? There were also side projects that had to be debated. For example, there's some video footage from the *Kissing Doesn't Kill* shoot in a video piece that Kalin had made, *They Are Lost to Vision Altogether*. Would it go against Gran Fury's ethos of prioritizing the collective, not individual personalities, to show his work?

Gran Fury began meeting again, much as they had during the height of ACT UP, to work through these questions and ideas of what would be included in the show. The most laborious part of the retrospective, however, proved to be remaking the work itself. Though Gran Fury's work was widely photographed, many of the original mechanicals weren't saved, or were only saved in incomplete pieces. And so in order to remount the show and assemble a definitive catalog, they basically had to digitally remake almost all of their own work, scanning the original mechanicals and then photo editing them to look as close to the originals as possible. In this process, they discovered some minor errors. A portion of *Kissing Doesn't Kill*, for example, was actually one degree askew, something that only became apparent when held to the precision of a computer. They also decided to reprint the *New York Crimes*, and had to shrink it, as the size of the *Times*'s front page had been reduced so much since 1989.

This work could be tedious, but it was still fulfilling. "It was as close to being Gran Fury again as we will ever get," Kalin reasoned. As traumatic as the AIDS crisis had been for them, Gran Fury remained one of the most important parts of their lives. "It was really pleasant for all of us to be together, and all enjoying it," Nesline said. "We all went through this experience together, and a lot of time has passed and it was really pleasurable to see each other."

A few of their old ACT UP comrades came to the opening, including Vincent Gagliostro, who had worked on *The Four Questions*. Gagliostro was a bit miffed that the catalog hadn't mentioned his involvement in *The Four Questions* and was then surprised when he got invited to a post-opening dinner with all the Gran Fury folks. "They totally fucked

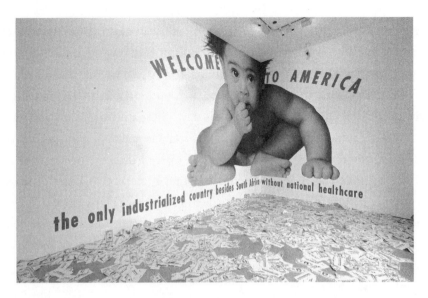

Photograph courtesy of Gran Fury.

me over without any acknowledgment of *The Four Questions*," he joked. "And now they want me to come to dinner?"

Gagliostro described this dinner as like attending another family's Thanksgiving. "To be at the table, with all of them at the same time, was an eye opener," he said. They seemed to bicker endlessly. "It was this weird kind of innocuous arguing where they were jockeying with each other," Gagliostro recalled. "You know when somebody says something under their breath, but it's loud enough for you to hear? It was that kind of thing."

"This is what you dealt with on a regular basis?" Gagliostro asked Finkelstein, in an aside.

"Daily," Finkelstein said, as if he wasn't a frequent source of tension too.

The argument Gagliostro recalled was over the inclusion of Kalin's videos, which included short snippets of the *Kissing Doesn't Kill* shoot. Someone made a hostile kidding-not-kidding joke about Kalin's contributions overshadowing the rest of the collective.

"I was like: *Oh my god. Who cares?*" Gagliostro recalled.

But those videos did provide some actual footage from the *Kissing Doesn't Kill* shoot. What's revealed here is that they didn't pose statically

for their shots and that they were really actively making out with each other. There's a short snippet of Mark Simpson kissing Jose Fidelino, which lasts for about ten seconds. Simpson was still well at the time, and he's so clearly seductive here. The kind of southern charm for which everyone remembered him is on full display. There's no audio, so you can't hear what's said, but before they kiss, Simpson makes a joke to disarm Fidelino, who recoils in laughter. Simpson kisses Fidelino, then returns for the lower lip and chin, reapproaches Fidelino each time to kiss a different part of his mouth. Then Simpson turns to the camera being held by Kalin, and you can tell by the way he looks through it that he's trying to telegraph something to his best friend. Simpson winks and then goes back for another kiss.

In preparing for their retrospective at 80WSE, Gran Fury also assembled a catalog that included a series of group interviews and a few interviews they had done while Gran Fury was still active. It opened with an introductory essay, collectively written, ruminating upon the circumstances under which Gran Fury had formed and the dearth of activism since the early 1990s. "We wrote this essay that was like, *There is no activism! What the fuck is going on!*" Kalin recalled. "And then while the catalog was at the printer, Occupy Wall Street happened."

There seemed, at least at the beginnings of Occupy Wall Street, to be some possibility of modeling itself upon ACT UP's use of graphics. The original occupation of Zuccotti Park was initiated by a group called Adbusters, a group of Canadian activists who design projects that rely upon traditional advertising techniques and tropes, in a now famous advertisement of a ballerina pirouetting atop Wall Street's famous Charging Bull. The tactics of Adbusters bear a resemblance to those of Gran Fury, and that their poster prefigured the actual Occupy movement was reminiscent of how *Silence=Death* and *He Kills Me* prefigured ACT UP.

Furthermore, Occupy coincided with a wave of renewed interested in ACT UP and its legacy. A month after the Gran Fury retrospective came Jim Hubbard and Sarah Schulman's film, *United in Anger*, which largely

drew from the testimonies collected in their ACT UP Oral History Project. Later that same year, the documentary version of *How to Survive a Plague* premiered too.

Though Occupy Wall Street proved to be the first significant protest movement since ACT UP, its strategies and tactics eschewed many of the tactics that made ACT UP so successful. "Occupy Wall Street was not talking to the 1 percent," McCarty said. "The 99 percent are talking to each other." This could not have been more different than the approach embodied by ACT UP and Gran Fury, who made no bones about speaking to power. When discussing how graphics speak to the public, McCarty differentiates between horizontal and vertical conversations. Most successful activist movements manage to do both, and there are examples of Gran Fury's work that fit squarely within each of these camps. A vertical conversation is one in which activists speak from a position of power and confront power directly, assuming a similar position to that of an advertising executive: "We, the creative, know what's best for you, our client, and the audience," as McCarty put it. A horizontal conversation is one that happens among an activist group, a conversation among each other. The importance of this is not to be dismissed, as much of what we now take as common parlance for discussing wealth inequality comes from Occupy. But Occupy, as a movement, was almost insistent upon solely existing within the category of a horizontal conversation.

In a 2017 lecture hosted by Cooper Union's Typographics series, McCarty noted that this desire to talk with each other, rather than speak to power, is being signaled through the use of handcrafted materials, rather than the digital tools and printing methods that are now easily accessible. These activists show an understanding of branding, McCarty notes, as demonstrated by the Pussyhats, which so many wore at the Women's March on Washington. She wryly noted the materials that have now become commonplace: cloth appliquéd, hand-cut letters and embroidery on cotton; fake leather, satin, dotted Swiss fabric, hand-cut letters, sewn and glued to cloth; tempura paint on cardboard; crochet; paint on fabric; paint on canvas; more paint on posterboard; hand-cut letters on fabric; embroidered typography on a dress; a needlepoint poster.

McCarty refers to these efforts as "craftivism" and doesn't necessarily use the term endearingly. "Clean type and legibility are definitely not primary factors," she said, and illustrated the difference between Gran Fury and more contemporary activists by showing a sign she had brought to the 2016 Women's March in Washington, DC. "Mr. Minority President," the poster reads, "Meet the popular vote." It combined two of Gran Fury's signature fonts: their cursive script logo and the Futura Extra Bold aped from Barbara Kruger. "I should have crocheted the thing," McCarty joked. "Nobody gave a hoot about a legible message or nice typography."

Though now in vogue, craftivism is much older than Occupy Wall Street, or even ACT UP. McCarty pointed to one of the anti-war movement's most circulated images, a postcard reading "War is not healthy for children and other living things." Nor was AIDS activism spared from this trend. The AIDS Memorial Quilt is probably one of the most prominent examples of craftivism ever. Even activists repurposing old ACT UP slogans are doing so with markers and cardboard signs, not the kind of slick aesthetic that made Gran Fury's work so effective.

Following the 2016 presidential election, Kalin recalled, there was a renewed interest in Gran Fury's work, much of which came from a new group, Rise and Resist, which borrowed much of ACT UP's structure and tenets but focused upon the much broader charter of "opposing, disrupting, and defeating any government act that threatens democracy, equality, and our civil liberties." Kalin found it odd that one of the first things that Rise and Resist did was try to copyright its own logo. This could not have been further from the ethos of Gran Fury, whose work all remains in the public domain.

There are, of course, downsides to allowing this work to exist in the public domain, something that became very apparent during the summer of 2019, around the fiftieth anniversary of the Stonewall Riots, when the fashion label Marc Jacobs decided to merchandise one of Gran Fury's graphics. Gran Fury's *Riot* had begun as a large-scale square painting, made by Mark Simpson in the basement studio of the building where he lived up until his death. It was a provocation and a challenge to more tepid responses, particularly that of the art collective General Idea and

their *AIDS* project—a mimicry of Robert Indiana's *LOVE*. Gran Fury had shipped their *Riot* painting to Berlin, where it appeared with the European staging of *Let the Record Show* It was later hung in the room where ACT UP held its weekly meetings, and in video footage of ACT UP's planning for Stop the Church, you can see it hanging in the background.

Because Gran Fury's work exists in the public domain, the collective had no authority to stop Marc Jacobs from producing these shirts. High fashion had co-opted Gran Fury's work before. Opening Ceremony had already made a *Four Questions* T-shirt by this point, and Nike had made a *Silence=Death* themed trainer. Still, there's something especially pernicious about Marc Jacobs making T-shirts out of this particular Gran

Riot, Gran Fury, 1988.

Fury piece. It's hard to even say anything about the whole ordeal besides the most obvious critique, that it is just one more countless example of the corporatization of Pride. Nesline recalled that the genesis of *Riot* was Moffett musing to the rest of Gran Fury that "I just feel like telling somebody to riot." What could be further from an incitement to riot than a Marc Jacobs T-shirt?

Still, Kalin maintains that having their work exist in the public domain outweighs these occasional pitfalls. "I find it somewhat troubling," Kalin reasoned. "There's a feeling that people want Gran Fury to make a handbook, where we explain all the rules. Gran Fury didn't have a handbook. We understood leftist organizing technique and had Barbara Kruger's typeface. That's it. It wasn't some magic."

"Rise and Resist is *so* self-serious," Kalin added. "That's what drove me out of it. I miss all the fun of ACT UP." McAlpin was left with a similar impression of the group. When we met for our second interview, he had attended a Rise and Resist meeting the night before and didn't seem intent upon going back. "It was a very old room," he said. "I have nothing against old people, as I am an old person myself, but there was nothing sexy about last night's meeting. I would *never* go there to pick up anyone."

A room's cruising potential might not seem like the best gauge for its activist vitality. But this is part of what made ACT UP cohere. When I interviewed Maria Maggenti, she offered a similar perspective on why a community like ACT UP didn't emerge in the wake of Trump's presidency. "I've tried to get involved with different movements since 2016," she said. "And I wonder why these things don't gel. And then I realize it's because nobody is falling in love with each other. Nobody is having sex with each other. Nobody is going out to bars afterwards. We don't all live in the same neighborhood. And these are the things that really kept ACT UP together. ACT UP was founded on profound friendships. The glue was that people deeply, deeply loved each other."

When I interviewed McAlpin the day after he attended a Rise and Resist meeting, he told me that after the meeting, he was texting with one of Rise and Resist's organizers, an old friend from ACT UP, and

lamented the lack of young people involved. I attended only one Rise and Resist meeting and left with a similar impression, as I recall seeing only one other person who was in their mid-twenties. McAlpin's friend reasoned that it's hard for young people to participate in activism now, because of higher costs of living, lower wages and increased student loan debt that my generation is saddled with. McAlpin didn't seem convinced by this explanation, and gestured towards something more specific to Rise and Resist. Though McAlpin's own family wealth surely made his involvement in ACT UP and Gran Fury much more possible, I was left with a similar impression, that it had less to do with generational constraints, and more to do with the breadth of its charter.

That free time is one of the biggest barriers to activism was, in a way, proven in the summer of 2020, as the protests over George Floyd and the slew of other Black lives lost became the most attended protests in American history. Up to twenty-six million Americans participated, a number that would be unthinkable were it not for the converging COVID-19 epidemic and the unprecedented amount of free time that accompanied it.

Later in the summer of 2020, Jenna Wortham profiled the Minneapolis-based Black Visions Collective for *New York Times Magazine*, and I was struck by some of the similarities between Black Visions and ACT UP, especially when it came to using Gran Fury–esque tactics. Black Visions Collective is widely credited with popularizing calls to defund police departments and reallocate these resources toward education, housing and healthcare. Calls to defund the police fit squarely within McCarty's definition of a vertical conversation. It's a way of saying that we, as taxpayers living in this community, know what is best for us. In one of their most well-known actions, Black Visions made cutout tombstones with George Floyd's face on one side and the word "DEFUND" on the other. They brought stacks of them to the home of each city council member, leaving them on their front lawns. (Imagine one of these tombstones hanging in a gallery, without any explanation of the story behind it, and you'll get a sense of how Gran Fury's work is often disserviced by museums.) By the end of that summer, Black Visions had swayed

the Minneapolis City Council to unanimously vote to dismantle the city's police department.

What I find most reminiscent of ACT UP is the way in which Black Lives Matter has used Gran Fury–like sloganeering to try and change people's mindset or worldviews, in addition to the work of policy reform. In the midst of the summer of 2020, the educator and author Dwayne Reed tweeted out this very Gran Fury–esque aphorism that was widely shared: "White supremacy won't die until White People see it as a White issue they need to solve rather than a Black issue they need to empathize with." It reminds me of Gran Fury's work because it seeks to bring about a wider shift in people's worldview, rather than advocate for a given set of reforms. Reed does not claim that white supremacy will end the moment that this shift happens, but rather, suggests this as a first step, the reorientation of seeing white supremacy as a white problem being a necessary prerequisite to actually solving it.

Countless polls have shown that the wider Black Lives Matter movement truly has shifted and swayed opinions about race and policing in this country, and I think that these kinds of statements, demanding that people change their minds, are integral to that. It proves something that constantly riddled Gran Fury's members. During the height of Gran Fury, its members often hemmed and hawed over whether their work was having an effect. Black Lives Matter has shown that this kind of work surely can, and does.

On the morning of September 5, 2019, three AIDS activists walked into a courthouse. Bridging his roles as activist and plaintiff, Robert Vazquez-Pacheco wore a *Silence=Death* T-shirt underneath a black blazer. He was accompanied by Peter Staley, his longtime ACT UP comrade, and Brenda Goodrow, a much younger AIDS activist. All three of them are long-term HIV survivors. Staley and Vazquez-Pacheco have been living with the virus since the early or mid-eighties, and Goodrow was born HIV-positive in 1996, around the time that protease inhibitors became widely available. For Staley, it was almost

thirty years to the day since he and a few others from ACT UP had snuck into the New York Stock Exchange with Gran Fury's fake cash, and the three of them had convened at the US District Court in San Francisco for remarkably similar reasons.

The previous May, the three of them, along with a few others, had filed a class-action antitrust lawsuit against Gilead, the pharmaceutical company with a near monopoly over HIV treatment and prevention medications in the United States. Mark Lemley, a Stanford Law professor and director of the school's Law, Science and Technology Program, signed on as the lead attorney.

More than 80 percent of Americans living with HIV take a Gilead drug, and Gilead holds a complete monopoly on PrEP (pre-exposure prophylaxis) drugs in America, once daily pills that virtually eliminate the possibility of HIV infection. Staley and the other plaintiffs claim that Gilead broke antitrust laws by conspiring with other pharmaceutical companies, mutually agreeing to not include generic compounds in their drugs, even after the patents on these compounds had expired. Essentially, they argue, Gilead strong-armed its competitors into promising that they would not use cheaper compounds when synthesizing drugs. They argue that this violates antitrust laws and artificially inflates the cost of HIV medication and prevention. One of the most noteworthy examples is that of Truvada, which is used for both HIV treatment and PrEP. A month's supply of Truvada costs $6 to make, and retails for about $2,000. Its prohibitive cost is considered to be one of the main reasons why the drug is not taken more widely. Abroad, a month's supply of PrEP costs about $25 and, unsurprisingly, is more widely used by those most at risk of contracting HIV. Staley, Vazquez-Pacheco and their other co-plaintiffs filed the lawsuit in the hope that breaking Gilead's monopoly on HIV medications for treatment and prevention will allow for cheaper generics to come to market, thereby increasing their use.

Vazquez-Pacheco and his co-plaintiffs took their seats and watched as a seemingly never-ending stream of lawyers representing Gilead and its pharmaceutical partners walked into the courtroom. "I don't have a poker face," Vazquez-Pacheco said. "I'm never tactful. And I just started

laughing." It seemed like such overkill, using lawyers to outnumber them, three to one, for a hearing convened to set a trial date.

The trial is currently set to begin in early 2022. If they succeed, it could dramatically lower the cost of most HIV treatments and prevention and lead to one of the most significant price reductions of HIV drugs ever. ACT UP's efforts to lower the price of AZT would pale in comparison.

EPILOGUE
AN ACTUAL END

Though Gran Fury often called for an end to the AIDS crisis, only one of their posters described what an actual end would look like. It was a square advertisement, designed to appear in the New York subway system and sponsored in part by a memorial fund for Bill Olander, the New Museum curator whose invitation brought about *Let the Record Show* The poster was called *Wipe Out* and is largely forgotten because of its illegibility. It was to appear in the dead of winter, and the concept of the poster was that it would mimic an advertisement for a tropical vacation, seducing winter-weary subway riders into fantasizing about its beach scene and then delivering its text. This experiment failed, as the color of the text blended too easily into the backdrop, and Gran Fury's members now jokingly call this poster "the eye chart."

Despite its visual failing, this subway advertisement contained one of Gran Fury's most important and enduring slogans: "AIDS isn't over for anybody until it's over for everybody."

What would it take to achieve this kind of end, an actual end to the crisis in which AIDS is over for everyone?

Wipe Out, Gran Fury, 1990.

As I write this, some encouraging news has emerged: an HIV vaccine that uses the same mRNA technology as some COVID-19 vaccines has shown promise and will be put into clinical drug trials that will conclude in 2023. It's good news, but even if an HIV vaccine is proven effective, I'm skeptical about its ability to end AIDS. If deploying an HIV vaccine is anything like the rollout of the COVID-19 vaccine, it will surely exacerbate the differences revealed by the epidemic, but not end the crisis itself. Nor would a vaccine help the thirty-eight million people worldwide who are already living with HIV.

Even if a cure were to be found, our present situation shows that this is unlikely to end the crisis either. Worldwide, eleven million people living with HIV are unable to access these lifesaving medications, largely because of their prohibitive costs, and a cure is unlikely to be any more affordable. This problem is not specific to the developing world. In America, one in two gay Black men will test HIV-positive in their lifetime, and the situation is even more dire for Black trans women. About a third of Americans living with HIV are not receiving medical care for it, and every year, thirteen thousand Americans are lost to what is now a largely preventable death. The epidemic has not gone anywhere, even and especially here.

With medications that already exist, the Joint United Nations Programme on HIV/AIDS (UNAIDS) claims that we *could* end the AIDS crisis by 2030, as we already have a daily pill that virtually eliminates the possibility of HIV infection, and medications that, along with giving people the possibility of a full life, virtually eliminate the possibility of HIV transmission. UNAIDS's metric for the crisis to be over—when 90 percent of HIV-positive people know their status, 90 percent of those people can access medications and 90 percent of those people achieve viral suppression—is not one shared by all, as this would mean 73 percent of people living with HIV achieve viral suppression. Still, reaching this target would be a significant step toward actually ending AIDS, though the possibility of achieving this grows increasingly slim. According to former UNAIDS executive director Michel Sidibé, a lack of funding remains the greatest hindrance. Funding increases have stagnated, and each year, the gap widens between their target levels and their actual funding. In 2019, their annual budget was about $7 billion short of their target level. The Pentagon spends as much in about three and a half days.

One of ACT UP's offerings was to frame AIDS as a political problem, not just a medical one, and this has never been truer than it is today.

At this juncture, I think the biggest hindrance to ending the AIDS crisis is that too many people who are HIV-negative and don't think they're at risk of seroconverting, or who are living with HIV and can access these medication, see the wider AIDS crisis as a problem with which

they should sympathize, but don't see the need for a larger, more structural solution. As long as this attitude persists, so will the crisis.

I don't think that AIDS is going to end because of a scientific breakthrough, a cure or a vaccine. Rather, I think that ending AIDS is now a matter of enough people, and enough of the right people, wanting to actualize a world without it. It's the sort of mindset shift that Gran Fury often tried to bring about, and actualizing this shift might be more difficult than finding a cure.

"AIDS isn't over for anybody until it's over for everybody." It's hard to imagine an actual end to the crisis until enough people believe this to be true.

ACKNOWLEDGMENTS

It seems fitting that it would take such a collective effort to produce a book about a collective such as Gran Fury.

First and foremost, thank you to the members of Gran Fury, for allowing me to interview you and for allowing me to tell this story. Thank you for the work that you all have done, and for the work that you all continue to do. And thank you to everyone else from ACT UP who agreed to be interviewed for the purposes of this book. Thank you for helping me see the ways in which Gran Fury was integral to ACT UP's efforts, but that a hundred other things were integral to ACT UP too.

Any research-intensive project is indebted to those who have helped preserve this history. The ACT UP Oral History Project was absolutely foundational. There is no other source that I relied upon so frequently and that was so essential to the writing of this book. A special thanks to the archivists at the New York Public Library (NYPL), New York University Fales Library and the Lesbian Herstory Archives. And thank you, Jim Hubbard, for helping me locate a number of crucial tapes needed to continue this book while the NYPL was closed due to COVID.

This book began as my master's thesis while in the MFA nonfiction program at Columbia University, and there are a few who deserve special mention for helping with the initial interactions of this manuscript. There, I was blessed with the most wonderful teachers: Margo Jefferson, Wendy Walters, Leslie Jamison, Phillip Lopate, Morgan Jerkins and Brenda Wineapple. Rebecca Sonkin, Shelby Wardlaw, Paul McAdory, Matilda

Douglas-Henry, Brysen Boyd, Jake Nevins and Paulina Pinsky were all the most incredible readers. A special thanks to Allaire Conte, who probably read more versions of my first chapter than any other human.

I am also indebted to Amanda Petrusich, Ben Ratliff, Cris Beam and Alex Halberstadt for their early encouragement, and for helping shape my sensibilities as a writer.

To my agent, Rob McQuilkin: you are a godsend, and any writer would be thrilled to have you as their advocate.

The entire Bold Type team deserves special thanks, especially my editors, Ben Platt and Remy Cawley. Remy, thank you for championing this book at such an early stage, and Ben, thank you for helping clarify this book's vision and shepherding it to completion. Thank you to the rest of the Bold Type team, especially for the editorial labors of Hillary Brenhouse, Claire Zuo and Brynn Warriner, to my copyeditor Jennifer Top, and to Pete Garceau for the spectacular cover.

To my parents and my sister, Katie: thank you for supporting me in every way imaginable. To my wonderful friends, for your encouragement and the respite you've always provided. And to my dearest Dana: thank you for your endless love, your constant encouragement and your undying support.

Thank you all.

NOTES ON SOURCES

In lieu of a traditional bibliography or list of references, I've detailed how each chapter came to be, whom I talked to and the sources I consulted and relied upon. This is not meant to be a comprehensive list of every source I encountered but rather is meant to serve as a road map and a description of those that were most useful. I hope that by detailing the following, I can show how I went about writing this book, and how other books like this one might be written.

Besides the interviews that I conducted with Gran Fury's living members, the ACT UP Oral History Project, organized by Jim Hubbard and Sarah Schulman, was one of the most essential sources. Gran Fury's archive is held by the New York Public Library and also deserves special mention. Both the New York Public Library and the Lesbian Herstory Archives hold archives of ACT UP, and both were essential to the writing of this book.

CHAPTER 1: OUT OF SILENCE

Avram Finkelstein's story was assembled through several sources, including various interviews he has given, his own book *After Silence* and other writings. I also consulted the archive of Finkelstein's materials held by NYU Fales. Beyond supplying the epigraph for this chapter, the journal that Finkelstein kept during this time period was particularly useful. Finkelstein and I also did two lengthy interviews, where we discussed much of the social context surrounding this period, in addition to his

work with Gran Fury. The other members of the *Silence=Death* collective were also interviewed, but much of this chapter is particularly indebted to Chris Lione.

I also spoke with Bill Bahlman and Michael Petrelis of the Lavender Hill Mob. Bahlman's apartment is more like a living archive, and much of the context for the Lavender Hill Mob's action in Atlanta came from sources he has kept. Petrelis was perhaps the only person I interviewed who actively discouraged me from writing this book, as he believes that ACT UP's New York chapter has been overwritten. I'm thankful that he discouraged me, because this discouragement both egged me on and forced me to sharpen my thinking on why this book was so necessary.

CHAPTER 2: OFF THE WALL

Mark Simpson's childhood and pre–New York life were largely drawn from the memoir that was unfinished at the time of his death. The portrait of him as an artist and activist was largely assembled through interviews with those who knew him best: Alan Barrows, Michael Nesline, Chris Lione, Avram Finkelstein, Jeff Nunokawa, Loring McAlpin, Rebecca Cole, Hali Breindel, Tom Kalin and Mark's sister, Linda.

Michael Nesline's ACT UP Oral History interview with Sarah Schulman was the perfect springboard for our longer and more extensive conversations. My conversation with Peter Staley also filled in some details on Nesline's life and his role in ACT UP's early days.

After I interviewed Terence Riley for this book, he pointed me toward a profile of him that ran in *7 Days*, a now defunct magazine, which helped round out his story. Sadly, Riley passed just before this book was completed, and I think it's unfortunate that none of his obituaries mentioned his work with ACT UP. Riley is best known for being MoMA's chief curator of architecture and design, a post he held for about fifteen years. While that work is surely important, I hope that this book offers a fuller picture of what he contributed to this world.

I interviewed Donald Moffett several times over the course of writing this book, and though I consulted other interviews he had done, nothing was as essential as his 2011 conversation with Douglas Crimp, which

appeared in *Donald Moffett: The Extravagant Vein*, the catalog of his first survey exhibition.

Dating the progress of ACT UP in its early days was largely completed through the archives of ACT UP's ephemera held by the New York Public Library and the Lesbian Herstory Archives, both of which are thankfully digitized and available online. The minutes of these meetings were especially useful.

In addition to footage shot by Jim Hubbard, the details of the concentration camp float were assembled through interviews that I conducted with many of those who worked on it and eventually saw it, including Richard Elovich, Donald Moffett, Rabbi Edleson, Frank Jump, Maria Maggenti, Maxine Wolfe and Dan Butler.

Jean Carlomusto's documentary on Larry Kramer is perhaps one of the best resources currently available for learning about his life and work, though Bill Goldstein's forthcoming biography on Kramer will undoubtedly provide a comprehensive and thorough study as well.

CHAPTER 3: COLLECTIVITY

In both of the interviews that I did with Marlene McCarty, she emphasized how much fun they had had making *Let the Record Show* This perspective was integral to both the book as a whole and this chapter.

Tom Kalin's backstory is partially detailed in his ACT UP Oral History interview. He also agreed to four interviews, which were some of the most important for this book.

Douglas Crimp's issue of *October* magazine dedicated to AIDS is a foundational text for understanding why something like Gran Fury was so necessary. I assure you that it is worth trudging through the academic jargon. It, along with Richard Meyer's *Outlaw Representation: Censorship and Homosexuality in Twentieth-Century American Art* and Crimp's *AIDS Demo Graphics*, is foundational for any academic writing about ACT UP's posters.

CHAPTER 4: FALSE STARTS

I owe much of this chapter to the interview that I conducted with Jim Eigo, who was able to provide the arc of how Gran Fury came to win

over the entirety of ACT UP after its initial missteps and eventual first successes.

The documentary *Doctors, Liars, and Women: AIDS Activists Say No to Cosmo* is probably the most comprehensive detailing of the controversy surrounding Robert Gould's article.

Loring McAlpin's backstory was compiled through his ACT UP Oral History interview and the three interviews that he agreed to for this book. A bit of McAlpin's writing on his own life can also be found in Tommaso Speretta's book *Rebels Rebel*.

CHAPTER 5: SEEING RED

I wasn't surprised that Stephen Joseph agreed to be interviewed for this book, but I was surprised by what he said. In our interview, he recalled ACT UP in a markedly different way than he did in his memoir, *Dragon Within the Gates*, which details some of ACT UP's harassment directed at him. He was oddly appreciative of ACT UP, possibly because we spoke over the phone just as the COVID pandemic was beginning to grip the United States. "Wouldn't you like to see some people in the streets now?" he asked me rhetorically. "I sure as hell would."

The paper ephemera held by the New York Public Library and the Lesbian Herstory Archives—particularly the meeting minutes, internal memos and news clippings—were integral to establishing the timelines and sequence of events surrounding the Stephen Joseph harassment campaign.

Richard Elovich's backstory was largely assembled through his interview for the ACT UP Oral History Project and the several interviews that I conducted with him.

David France's book *How to Survive a Plague* includes an incredibly detailed account of how the FDA action came to be, but the most complete and articulate detailing of ACT UP's demands comes from *Seize Control of the FDA*, a video produced by GMHC's Living with AIDS program, offers the fullest account of ACT UP's demands and their rationale.

CHAPTER 6: ALL THE NEWS FIT TO PRINT

Here and in other chapters, Michelangelo Signorile was an incredible source for relaying how Gran Fury's posters fit into the larger media strategy of ACT UP. The New York Public Library and Lesbian Herstory Archives, and the press clippings they assembled, were integral to corroborating his account of ACT UP's success on this front. I relied upon those clippings throughout the book, but they were most integral to this chapter.

Robert Vazquez-Pacheco's backstory was compiled through my interviews with him, in addition to several interviews he's given to other sources, namely, the Smithsonian's Archives of American Art's Visual Arts and the AIDS Epidemic: An Oral History Project. Vazquez-Pacheco is currently at work on a memoir, which will surely offer a more complete telling of his life than I could ever.

CHAPTER 7: POWER TOOLS

Much of this chapter owes to interviews that I conducted with the living participants of *Kissing Doesn't Kill*. Heidi Dorow's interview for this book was especially helpful, as she was often one of the ACT UPers who most helped Gran Fury wheat-paste its posters. Interviews with Ann Philbin and Patrick Moore provided many of the details on amfAR's inner workings. News clippings held by the New York Public Library and the Lesbian Herstory Archives were integral to establishing the timelines of when *Kissing Doesn't Kill* was censored.

CHAPTER 8: CENSURATO

When Michael Cohen curated Gran Fury's 2011 retrospective at NYU's 80WSE, he also organized a series of group interviews with much of Gran Fury's living membership. Those interviews were useful elsewhere too, but their collective recounting of the Venice Biennale made it possible to begin stringing together the series of events. Both domestic and Italian newspaper clippings made it possible to fill in some of the details, like the name of the magistrate who examined the work.

When I interviewed Richard Lau from the Border Arts Workshop, he provided an outsider perspective on both Gran Fury and the events of the Biennale. Linda Shearer, the curator who invited Gran Fury, was also integral to this.

The events of Stop the Church were largely assembled through footage that ACT UP's members shot of the demonstration. Robert Hilferty, who was also one of the photographers who snuck into the New York Stock Exchange, deserves much of this credit, as his documentary *Stop the Church* provides the most comprehensive video account of the demonstration.

Sarah Schulman's ACT UP Oral History interviews are singular in their depictions of Stop the Church. Nothing else gives one the fullest picture of just how contentious this action was within ACT UP, and how its members reflect upon and remember it so differently. Those interviews were integral to this entire book, but this is probably the section of the book where this is most apparent.

CHAPTER 9: RECOGNITION

The Lesbian Herstory Archives were essential to this entire book, and nowhere is this more apparent than in this chapter. Having the transcripts of ACT UP's meetings with CDC officials was absolutely essential, as was their collection of news clippings related to the campaign. Their holdings also contained much of what I was able to reconstruct about the life of Katrina Haslip. My interviews with some of the core members of the CDC campaign—Heidi Dorow, Tracy Morgan, Maxine Wolfe and Marion Banzhaf—were equally integral to this chapter.

A special thanks to Jim Hubbard, who was able to provide me with much of the footage that I needed to watch while the New York Public Library's video archives were inaccessible due to COVID. Nowhere was this more important than in detailing the CDC demonstrations.

For a more complete telling of how ACT UP's CDC campaign fits within the larger arc of activism surrounding women and AIDS, see Harriet Hirshorn's documentary *Nothing Without Us*.

CHAPTER 10: FALLOUT

This chapter is almost entirely hearsay. There aren't really any sources to credit, other than the interviews conducted with its living participants.

CHAPTER 11: THE ELEGY

My writing on the Marys was largely influenced by my conversations with Joy Episalla and James Baggett. Episalla had been interviewed many times before, for both the Archives of American Art's Visual Arts and the AIDS Epidemic: An Oral History Project and the ACT UP Oral History Project. Still, we found much fresh ground to cover. Particularly when discussing how the political funerals were not intended to be an endpoint. It was something we thought through together, and I'm deeply appreciative of how she put forward so much intellectual and emotional effort into helping me think through this. Debra Levine's doctoral thesis details much of the Marys' planning sessions, and James Wentzy's footage details the events themselves.

Avram Finkelstein and Loring McAlpin both contributed to my reconstruction of how Gran Fury produced *The Four Questions*, but my interview with Vincent Gagliostro provided much of the arc for how the poster actually came to be. My interview with Gagliostro also provided invaluable insight into how Don Yowell handled his AIDS diagnosis, the New York Stock Exchange demonstration and *Stop the Church*.

CHAPTER 12: IMPERFECT ENDINGS

Those who provided details about Mark Simpson's life were often those who also spoke about his decline and death. But Tom Kalin and Hali Breindel were essential to reconstructing this story, and I am infinitely grateful that they trusted me with this story.

My detailing of protease inhibitors, and how they came to be, is largely dependent upon David France's book *How to Survive a Plague*, which is a somewhat controversial source, as is his documentary of the same name. Watching his documentary, one leaves with the impression that the Treatment and Data Committee constituted the whole of ACT UP.

Nonetheless, his book provides the most comprehensive detailing available of how protease inhibitors came to be.

CHAPTER 13: AFTERGLOW

This chapter is almost entirely based upon my interviews with Gran Fury's members. But Debra Levine's thesis again deserves mention here, as it resurrected the forgotten letter that Mark Simpson sent to Michael Nesline.

INDEX

Gregory Wikstrom

Jack Lowery is a writer and teacher. His writing has appeared in *The Atlantic*, the *Times Literary Supplement* and *The Awl*. He completed his MFA in nonfiction writing at Columbia University, and also taught in the school's Undergraduate Writing Program. As an editor, he has published the poetry of David Wojnarowicz. He lives in Brooklyn.